Digital Photography with
Photoshop® Album

Jennifer Fulton
Scott M. Fulton, III

SAMS
Teach
Yourself

Sams Publishing, 800 East 96th Street, Indianapolis, Indiana 46240 USA

JAN 2006

Digital Photography with Photoshop Album in a Snap

International Standard Book Number: 0-672-32568-3

Library of Congress Catalog Card Number: 2003102929

Printed in the United States of America

First Printing: April 2004

07 06 05 04 4 3 2

Trademarks

All terms mentioned in this book that are known to be trademarks or service marks have been appropriately capitalized. Sams Publishing cannot attest to the accuracy of this information. Use of a term in this book should not be regarded as affecting the validity of any trademark or service mark.

Warning and Disclaimer

Every effort has been made to make this book as complete and as accurate as possible, but no warranty or fitness is implied. The information provided is on an "as is" basis. The author and the publisher shall have neither liability nor responsibility to any person or entity with respect to any loss or damages arising from the information contained in this book.

Bulk Sales

Sams Publishing offers excellent discounts on this book when ordered in quantity for bulk purchases or special sales. For more information, please contact

U.S. Corporate and Government Sales

1-800-382-3419

corpsales@pearsontechgroup.com

For sales outside of the U.S., please contact

International Sales

1-317-428-3341

international@pearsontechgroup.com

Acquisitions Editor
Betsy Brown

Development Editor
Alice Martina Smith

Managing Editor
Charlotte Clapp

Project Editor
George Nedeff

Production Editor
Benjamin Berg

Proofreader
Wendy Ott

Indexer
Chris Barrick

Technical Editor
Dallas G. Releford

Team Coordinator
Vanessa Evans

Designer
Gary Adair

Page Layout
Kelly Maish

JAN - - 2006

About the Authors

Jennifer Fulton, iVillage's former "Computer Coach," is an experienced computer consultant and trainer with more than 20 years of experience. Jennifer is also the best-selling author of more than 100 computer books written for both the education and retail markets, including *Paint Shop Pro 8 in a Snap* and *Sams Teach Yourself Adobe Photoshop Elements 2 in 24 Hours*.

Scott M. Fulton, III is a 20-year veteran author, writer, and editor. In the 1980s, he was contributing editor to *Computer Shopper*, and cofounder of the C*SIX online service. As "D. F. Scott," he authored the groundbreaking *Visual Basic by Example*, plus eight other books on Visual Basic programming. More recently, he was senior editor for networking and security affairs for CMP Media's Planet IT Web site. He and his wife (who, incidentally, was his editor in 1991) comprise Ingenus, an editorial services provider for technical publishing.

Scott and Jennifer live in the Midwest with their daughter, **Katerina**, an author-to-be. They live together in a small home filled with many books, some of which they have not written themselves.

Dedication

To my father-in-law, Scott, and his lovely wife Annette, for their loving support. You bless our lives every day with your presence.—Jennifer

To the memory of my grandmother, Ruby Era Pool, who taught my family the true meaning of honor, compassion, and service.—Scott

Acknowledgments

First, we'd like to acknowledge the invaluable contributions to this book by Jennifer's brother, Michael Flynn, a professional photographer, and thus an incredible source of excellent how-to advice and even more incredible photographs.

We'd also like to thank the staff at Sams Publishing. They always listen to our suggestions with an open mind and then trust us to bring our combined vision into life.

As a final thank-you, we'd like to acknowledge the contributions of our wonderful editor, Alice Martina Smith. Her editing skills are precise and elegant, and her comments and questions add real value to the finished product.

Tell Us What You Think!

As the reader of this book, *you* are our most important critic and commentator. We value your opinion and want to know what we're doing right, what we could do better, what areas you'd like to see us publish in, and any other words of wisdom you're willing to pass our way.

You can email or write me directly to let me know what you did or didn't like about this book—as well as what we can do to make our books stronger.

Please note that I cannot help you with technical problems related to the topic of this book, and that due to the high volume of mail I receive, I might not be able to reply to every message.

When you write, please be sure to include this book's title and author as well as your name and phone or email address. I will carefully review your comments and share them with the author and editors who worked on the book.

Email: graphics@samspublishing.com

Mail: Mark Taber
 Sams Publishing
 800 East 96th Street
 Indianapolis, IN 46240 USA

Reader Services

For more information about this book or others from Sams Publishing, visit our Web site at www.samspublishing.com. Type the ISBN of the book (excluding hyphens) or the title of the book you're looking for in the Search box.

PART I

Introducing Photoshop Album and the World of Digital Photography

IN THIS PART:

1

✔ Start Here

Surely some of the most important things you own are your photographs. They capture moments in time that you can never get back again. With the advent of digital photography, you can easily capture even more of these "life moments," perhaps making a single individual photo less important, and yet making the collection of images even more precious because they represent a larger "snapshot" of your life. With all these important bits of your history floating around on your computer, it's time to get them organized. And with Photoshop Album's help, you can organize, share, and print your images with ease.

By the way, although this book includes many digital photography tips and techniques, you don't have to own a digital camera to use Photoshop Album. However, if you choose to take photos the traditional way, you should purchase a good scanner to scan printed photos into your computer—you'll get some tips on choosing a good quality scanner later in this chapter. While you've got your wallet out, another purchase to consider is a good graphics editing program such as Photoshop, Photoshop Elements, or Paint Shop Pro. With a *graphics editor*, you can make adjustments and corrections to your images, such as improving their contrast, color, and sharpness. True, you can make some of these changes within Photoshop Album—and I'll show you how to do that in this book—but if you want more control over those changes and you're looking for a more professional result, a good graphics editor is a must.

KEY TERM

Graphics editor—An application that allows you to edit your digital images.

What You Need to Get Started in Digital Photography

Resolution—In digital imaging, the number of pixels per inch/centimeter. The more pixels or dots of color, the more detail an image holds. Higher resolution images are full of color variations and sharpness but are also larger in file size.

It wasn't too long ago that anyone interested in taking a good photograph simply wouldn't give a digital camera a second glance. Back then, digital cameras produced only low *resolution*, slightly blurry photos—good only for getting a quick shot of something you didn't want to print larger than 3"×5", and certainly didn't want to keep forever. Well, times have changed, and you can now get quality results under most lighting conditions with a digital camera that won't cost you an arm and a leg. In this section, I'll show you what to look for when purchasing a digital camera and which accessories you might want to add. If you already own a digital camera, there's stuff in this section for you too—such as an overview of what all those buttons are for and the lowdown on the best scanners and printers to use.

Camera Anatomy 101

Although there's a great range of digital cameras available for purchase, from low-quality inexpensive models to high-priced professional ones, most digital cameras offer the same types of components. Take a moment to familiarize yourself with these common features:

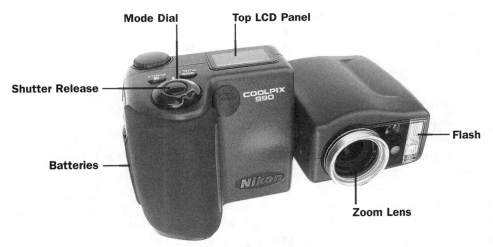

A typical digital camera, viewed from the front.

- **Shutter release**. Press the shutter release halfway and hold it down for a second or two to allow the camera to focus on your subject, then reframe the picture if desired, and press the shutter release the rest of the way to take the picture.

- **Mode dial**. Use the mode dial to change between automatic, manual (sometimes called *programmed mode* because the camera sets the *aperture* and *shutter speed*, allowing you to adjust other settings such as the flash and the amount of exposure compensation), and playback mode. Your camera may also have preprogrammed modes on this dial, such as Landscape, Snow/Beach, Night, Portrait, Sports, and Movie.

- **Top LCD panel**. Some cameras display important information on an LCD panel on the top of the camera, such as how many more pictures you can fit on the memory card, the current resolution (quality) setting, the current flash setting, and the remaining battery life.

- **Zoom lens**. Most digital cameras include a zoom lens that you can use to get a closer shot of faraway subjects. You adjust the zoom level with two side-by-side buttons—press one to zoom in, and the other to zoom back out.

- **Flash**. Most digital cameras have some type of onboard flash, convenient for illuminating close objects (up to 7 feet away) in low-light situations.

- **Batteries**. Inexpensive digital cameras rely on standard AA batteries, which run out of power fast. Better digital cameras use NiMH or Lithium ion (Li-ion) rechargeable batteries.

 When shopping for rechargeable batteries for your digital camera, first make sure that they are compatible with your specific camera model. Then select either NiMH or Lithium-ion, which are both rechargeable. Check labels carefully; standard Lithium batteries (ones not marked as Lithium-ion or "Li-ion") are not rechargeable, although they do offer a longer life and slightly more power than AA batteries, and can be used in place of them.

- **Viewfinder**. Use the optical viewfinder when the LCD panel is turned off. Because the viewfinder is offset from the position of the camera lens, you should not use it when the subject is close or you will likely cut off part of the subject when framing it in the lens.

KEY TERMS

Aperture—The size of the lens opening when an image is recorded; the larger the aperture, the more light is captured. Also known as the *f-stop*.

Shutter speed—The speed at which the shutter opens and closes. Faster shutter speeds can record moving objects without blurring them.

TIP

Digital cameras have an optical zoom and a digital zoom. The optical zoom level describes the actual telephoto capability of the camera's lens; the digital zoom level describes the additional amount of magnification you can get through image manipulation. Because a picture taken using a digital zoom is actually a computer–enhanced version of the real view, you lose picture quality whenever you engage the digital zoom.

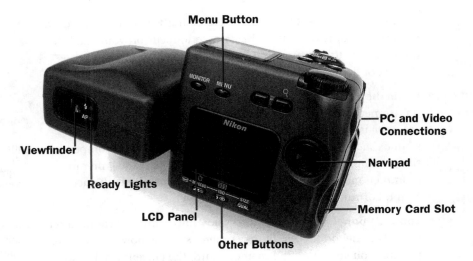

A typical digital camera, viewed from the back.

- **LCD panel.** The LCD panel shows the exact image you will capture when you press the shutter release, so it's the perfect tool for framing your subject (or for double-checking an image you've already captured). You also access various menu commands using the LCD panel as a display screen. You'll find a button for turning off the LCD panel close by—here, it's labeled **Monitor**, although it might be labeled **Display**. Typically, this button cycles through several settings, such as panel on/off and display on/off (display of current settings such as current mode, shutter speed, f-stop, number of pictures remaining on the memory card, flash setting, and image resolution).

- **Menu button.** Push this button to display the menu on the LCD screen so that you can select various options such as white balancing, red-eye reduction, image resolution, and memory card management. You'll also find selections for various flash levels, aperture settings, and shutter speeds such as landscape mode, backlight mode, and portrait mode. Typically there's a single button called a *navipad* for browsing and selecting menu options—on this kind of selection control, you press the top of the navipad to move the cursor up, press the bottom to move the cursor down, and so on, then press the center of the navipad to select.

- **Other buttons and ready lights**. Obviously, cameras vary a lot from model to model, but most models include buttons for easy access to common options such as flash on/off, LCD screen on/off, macro, and timed-release modes. You'll also find buttons for browsing through the images you've taken. You can tell when certain options are set and when the camera is ready to go by looking at the various ready lights you'll find on the back of the camera.

- **PC connection**. Upload your images to the computer for printing and processing through this connector. Some cameras offer a docking port that you use instead of these cable connections to connect the camera to the computer.

- **Video connection**. Some cameras offer a video connection that you can use to send your images to a television for viewing or to your VCR for recording.

- **Memory card slot**. Images are typically stored on some type of removable memory card; you'll find a slot along the side of the camera for removing a full one and replacing it with an empty memory card.

The process of using a digital camera is similar to that of using a film camera, but with some notable differences. First, you turn the camera on. Then you change camera settings as needed to suit the lighting conditions and the type of image you want to take. Although focusing with a film camera is similar to using a digital camera (you press the shutter release halfway to focus on the subject), it's when you press the shutter release the rest of the way down that the camera records the image from information collected by the light detector chip (in contrast, a film camera advances to the next frame). Film cameras record images at higher resolutions, so the quality of a digital image will not be as good as one you can get using a film camera, especially in low-light conditions. And with most digital cameras, you won't be able to capture images in sequence as quickly as you can with a film camera.

Unless you purchase a very inexpensive digital camera, your camera will come with some kind of removable memory. When the memory card is full of pictures, you transfer the images to your computer and then erase the memory card. The transferring process may involve

TIP

Refer to your camera's documentation for details about your model's buttons and ready lights.

NOTE

Memory cards (or memory sticks, if you prefer) come in several varieties for digital camera use: CompactFlash, SmartMedia, SD/MMC, xD-Picture Card, and Sony's Memory Stick.

TIP

With a digital camera you can view your image immediately by looking at it on the camera's LCD screen. If somebody blinked, or if the image is too dark or too blurry, you can change the settings and take another shot. Immediacy is one of the biggest advantages of digital photography.

placing the camera in a docking port that's already attached to the computer, connecting the camera directly to the computer through some kind of cable, or removing the memory card from the camera and inserting it into a memory card reader attached to the computer. You may even go through a process where you insert the memory card into your photo printer and upload the images to the computer through the printer's connection. The process of copying the images to your computer is typically accomplished through some kind of software program such as the one that came with your camera, photo printer, or card reader; however, you can also use Photoshop Album for this process. See **41** **Import Images from a Digital Camera**.

After you have the images stored on your computer, you should back them up onto a CD or DVD (see **47** **Copy Items onto CD-ROM or DVD**). After that, you can make corrections to the images using Photoshop Album or a graphics editor such as Photoshop or Paint Shop Pro. You can print your images at home (see **117** **Print Images**); take them to a kiosk for printing (you'll find kiosks all over—at the drug store, discount store, or local copy shop); take them to a local photo store, or upload selected images to Shutterfly, Snapfish, Ofoto, or any number of a growing list of Internet-based photo sharing and printing Web sites for professional printing. See **120** **Print Images Using an Online Service**.

What to Look For in a Digital Camera

The single most important factor in getting a good digital photo is *resolution*. As you learned earlier, resolution is defined by the number of pixels (dots) that make up the stored digital image. Bottom line: The more pixels an image uses, the more detail it can store, and the better it looks. Granted, you can use a graphics editor such as Photoshop or Paint Shop Pro to increase an image's resolution by having the application add more pixels (through a process that basically guesses what color and brightness the new pixels should be). But because guessing is involved (albeit using sophisticated mathematical algorithms, but still it's just guessing), the resulting image, although higher in resolution, is typically much less sharp than the original.

Resolution for a digital camera is expressed in megapixels; 1 megapixel is roughly equal to one million pixels. For printing good quality 8"×10"

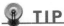
TIP

You can also take a digital photo using a digital video camera, if you own one, but video cameras use lower resolution than most digital still cameras. Still, if all you have is your digital video camera, you might use it to capture an image suitable for the cover insert of the resulting DVD.

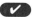

prints, you'll need a camera with a resolution of at least 3 megapixels. With a 4 or 5 megapixel camera, you can print larger images with even better quality. Keep in mind that buying a camera with a lot of megapixels will do you no good *if you don't use them.* This means that, unless you're shooting images you don't intend to print (for example, your friend is goofing around and you want to send a photo of him to some of your other friends via email, or post the image to your Web page of embarrassing moments), you'll want to use the highest resolution available on your camera—typically listed on the camera as **High** or **Fine**.

After resolution, the next most important feature to look at is the zoom. First of all, as a minimum, get a camera with an adjustable, motorized zoom lens rather than a fixed lens. For a digital camera, zoom is typically listed as two numbers: *optical zoom* and *digital zoom*. Zoom is listed as a multiplication factor, such as 3x. A 3x zoom, for example, can capture an image at up to three times its "normal" size (where "normal" is an object's size when you view it through the lens with no zoom). If your subject is far away and looks only about an inch high, a 3x zoom lens can make the subject appear about three inches high, or three times its normal height. A digital zoom reinterpolates this image to increase the zoom level by an additional multiplication factor. For example, a 3x optical zoom and a 10x digital zoom combine to enhance distant objects up to 30 times their normal size. A digital zoom performs its magic by basically cropping the image and digitally enlarging the selected area, resulting in a lower-quality enlargement of a portion of the original image. Similar but better results can be achieved using the cropping tool of an imaging program such as Photoshop Elements on a portion of a high-resolution image where digital zoom was not employed. When you compare zoom levels on various cameras, look for a high *optical* zoom level (3x minimum), and forget about ever using digital zoom except where image quality and sharpness are not as important as simply capturing the image in the first place. Some digital cameras allow you to turn the digital zoom off, so you won't accidentally use it when taking the majority of your photos. (If you like the idea of having a "safety net" against the decreased quality associated with using the digital zoom, you might look for a camera that offers this option.)

KEY TERMS

Optical zoom—The natural zoom limit of a digital camera lens.

Digital zoom—A process that extends the natural limit of a digital camera's lens by cropping a portion of that image and increasing its size by adding pixels. The result is a convincing "fake" or "educated guess" at what those pixels in the far distance truly represent.

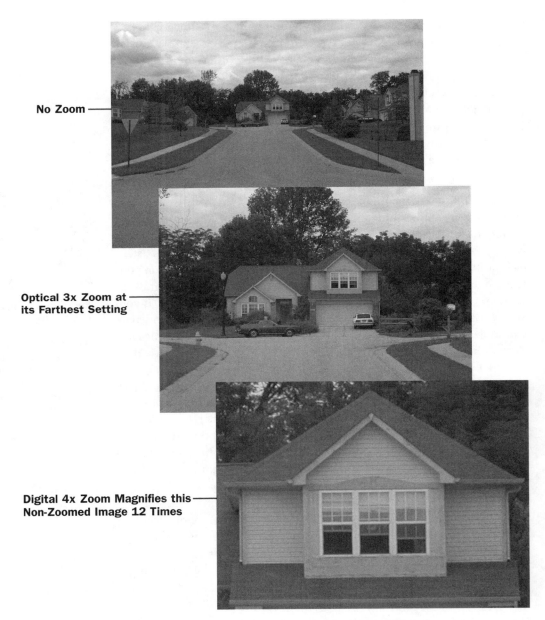

No Zoom ——

Optical 3x Zoom at its Farthest Setting ——

Digital 4x Zoom Magnifies this Non-Zoomed Image 12 Times ——

A far away subject, taken with an optical and a digital zoom.

Now, I wish I could tell you just to look for a camera with a 3x optical zoom and leave it at that. But even if two cameras are listed as having a 3x zoom, you should still compare them, and here's why: First, the "3x"

part refers to a multiplication of the camera lens's normal *focal length*. So a digital camera with a 3x optical zoom and a lens with a focal length of 2.7 millimeters (mm) has a *focal range* (a range of focus) equivalent to lens sizes 2.7mm to 8.1mm (2.7 times 3). If you're comparing two 3x optical zoom cameras, and they have lenses with different focal lengths, then they'll provide you with different focal ranges or fields of view (what you see when you look through the viewfinder with the camera set at the widest [zoomed in] setting and the telephoto [zoomed out] setting).

You'll find the focal range of a digital camera, along with other information, on the front of the lens. The focal range provides photographers with an indicator of how much the lens is capable of "seeing." The only problem with trying to compare the focal ranges of several digital cameras is that you may end up comparing apples to oranges. You see, digital cameras do not work with film; they instead capture images using a light detector (a light-sensitive computer chip, either a CCD or CMOS chip, depending on the technology your camera uses). It's the relationship between the focal length of a digital camera's lens and the size of its light detector that results in a specific field of view. Because digital cameras use light detectors of various sizes, it's difficult if not impossible to determine the relative focal ranges of two digital cameras using only the information printed on the camera lens.

To properly compare the focal ranges of two different digital cameras, you need a common frame of reference. Lucky for you, digital camera manufacturers list their focal ranges in 35mm SLR (film) terms in the camera's manual or sales brochure. For instance, the data for one model's lens on its manufacturer's Web site showed an actual focal range of 7.8mm to 23.4mm. But the specifications also converted that data to its 35mm SLR equivalent of 38mm to 114mm. This is roughly the equivalent of a 35mm SLR lens with a focal range from a moderately wide angle to a moderate telephoto zoom. Dividing the maximum focal length by the minimum gives you the true optical zoom factor of 3x. Suppose that another digital camera has a 28mm SLR equivalent lens and a focal range extending to 84mm. What does this mean? Well, the focal range describes the capacity of the lens—how far away and how close it can focus. So choosing the camera with the 28mm lens in this case would mean you'd get a camera that could focus closer than the camera with the 38mm lens, but not as far away. Knowing this, you could select the camera that provides the focal range that better suits

🔍 KEY TERMS

Focal length—The distance in millimeters (mm) between the center of the focusing lens and the film—or, in the case of a digital camera, the light detector chip—when the lens is sharply focused on the most distant object in its field of view. Photographers use this number to estimate a lens's field of view. The smaller a lens's focal length, the wider its field of view.

Focal range—The extent of a lens's minimum focal length when the lens is zoomed out, and maximum focal length when it is zoomed in.

your needs. For example, if you plan on shooting mostly close objects, the 28mm to 84mm SLR equivalent camera would be the best match.

Here's a table to help you understand the focal ranges of lenses once they're converted to SLR.

35mm SLR Equivalent Focal Length	Capacity
<20mm	Extreme wide angle
21–35mm	Wide angle
50mm	Normal, about what your eyes see, with no magnification
70–200mm+	Telephoto (zoom)

Another important bit of information typically shown on the lens is the *f-stop* range. A small f-stop equals a large aperture, which means lots of light is being recorded. A camera with an f2.8 lens will be able to shoot much better in low-light conditions than one with an f4 lens. So if you're comparing two digital cameras that seem to share a lot of the same features—3 Megapixels, 3X zoom, and several scene modes—but different f-stop range, choose the one that offers the lowest f-stop. For example, choose the camera with the f2.8 lens rather than the one with f5.6, since you'll be able to use the first camera in situations where there is less light.

The next concern whencomparing digital cameras is image storage and transfer. Typically, you'll want a camera with removable storage (so that you can upgrade it by buying larger capacity memory cards), and a simple, fast method for transferring those images to your computer—either through a direct connection (using USB, FireWire, SCSI, serial, or a docking port) or a card reader. If you end up transferring images through a cable connection, USB 2.0 and FireWire provide the fastest transfer rates; modem-style serial connections are very slow and should be avoided.

Your digital camera will probably accept only one or two different types of memory cards, and although the differences between the various types are usually unimportant (because most are of equal quality), you will want to compare the price and availability of the particular memory card types your camera uses such as SD/MMC, CompactFlash, or SmartMedia. Not only do prices vary between memory card types, but some types are simply not available in a high capacity (256MB and larger), which means you'll have to buy a lot of small capacity ones if

you intend to shoot a lot of images before offloading them to the computer. While we're on the subject of memory space, make sure that your camera offers the ability to store images in an uncompressed mode—compressing an image makes it smaller, while sacrificing a certain amount of quality. You can compress an image later on if you want to make it smaller for email or Web usage, but you don't want to start off with a less-than-great quality image to begin with.

Here's a quick list of the current memory cards available for use in digital cameras:

- **CompactFlash.** Most high-end digital cameras use this type of memory because it contains a controller chip that allows the memory card to speed up the transfer of data. CompactFlash comes in two varieties: Type I and Type II, so make sure that you get the right type for your camera. CompactFlash cards are basically just low-capacity PCMCIA cards, and with an adapter, they can be inserted into your laptop's PCMCIA slot.

- **SD/MMC.** Short for Secure Digital/Multimedia Card, this type of memory card is very small, making it the ideal choice for use in tiny cameras, PDAs, MP3 players, personal organizers, cell phones, and so on. The type marked "Secure Digital" has a write-protect switch that prevents loss of data; otherwise, the two types are the same.

- **xD-Picture Card.** Very tiny, this type of memory card is perfect for use in small digital cameras (such as most Olympus and Fuji cameras). It can also be used in CompactFlash cameras, with an adapter.

- **Memory Stick.** Created by Sony for use in their Cybershot digital camera models, so they are typically incompatible for use in any other camera although you can use them in other Sony products such as Sony MP2 players and PDAs.

- **MicroDrive.** Actually just a miniature hard drive within a Type II CompactFlash memory case. These memory cards offer very high capacities and can be used in CompactFlash Type II-compatible digital cameras. The downside is that they contain moving parts, so they may break down and cause you to lose your images. Also, they are a bit slower, so copying images to and from them takes longer than with CompactFlash memory.

TIP

An alternative to purchasing a lot of memory cards is to buy a portable digital storage device, which allows you to offload your images while traveling or out on location, and quickly reformat and reuse the memory card.

NOTE

The **SmartMedia** memory card was fairly popular at one time, but in Olympus and Fuji cameras (at least) it's been replaced by the xD Picture Card, so you probably won't find a new camera that uses this type of memory.

TIP

No matter what type of memory card your camera comes with, buy more and at larger capacities. The larger capacity storage media enable you to capture more images, without having to either sacrifice quality (resolution) or offload the images to your computer first.

How automatic do you want your camera to be? Are you looking for point-and-shoot ease, or do you want the ability to adjust settings to fit lighting conditions, creating more professional results? Most cameras offer the capability of changing from one mode to another so that you can quickly set the aperture and shutter speed to suit the light conditions (such as indoor, outdoor sunny, outdoor overcast, evening, snowy or beach conditions, and so on). More expensive cameras allow you to switch to aperture priority, shutter priority, or to completely manual mode (where you select the aperture and shutter settings yourself).

Be sure to test out your camera before making a purchase. Factors to consider include handling, LCD panel brightness, power type and capacity, menu system, and shot delay (the time it takes to record an image).

- **Handling**. Does the camera feel bulky, or does it fit your hand nicely? Can you take a one-handed shot if needed? How about an over-the-crowd shot? Can you zoom in and out and change settings easily?

- **LCD**. Cheap cameras may not even include an LCD panel, or the screen may be of low intensity, making it virtually impossible to view in bright sunlight.

- **Power source**. When considering the camera's power source, look for NiMH or Lithium-ion batteries rather than AA batteries (which run low on power too fast) or NICad batteries (which must be completely drained before being recharged). If given a choice, Lithium-ion batteries are the best because they allow you to work longer (they have a larger capacity) and they hold their charge much longer than NiMH batteries (a critical factor for people who use their digital cameras only occasionally). In addition, Li-ion batteries do not have a memory problem, so they do not have to be completely drained before being recharged. NiMH batteries have only a slight memory problem, in that they must be conditioned first (charged, discharged, and charged again, several times before first use), and occasionally reconditioned thereafter. If you get NiMH batteries, make life easier on yourself by getting a *conditioning recharger*, which automates the process of conditioning the batteries. Regardless of the type of batteries your camera uses, get a set of extra batteries and carry them with you.

TIP

An LCD panel you can tilt may be useful in reducing glare on the screen, shooting above a crowd, or around corners.

NOTE

The most important thing to remember when shopping for rechargeable batteries is to check for compatibility with your specific camera model. Choose only NiMH or Lithium-ion batteries because they are rechargeable. *Plain lithium (non-lithium-ion) batteries are not rechargeable.*

- **Menu system**. Play with the camera's menu system and buttons, looking for commonly used options such as deleting a bad photo to free up memory, white balancing the camera, formatting memory, reducing the flash output, and adjusting exposure. How easy are these options to find and set? Are they even available? Does the menu system make sense to you, or will you be constantly fumbling through it looking for a particular command?

- **Time to record an image**. While you're handling the camera, pay particular attention to the time it takes to record a picture at high resolution. Also, print out a photo if you can, at the print size you're likely to use (such as 4"×6"). Make a note of the type of light-sensing device the camera uses to record images—generally speaking, *CCD sensors* are higher quality (less *noise*) than *CMOS sensors* (which consume less battery power and cost less to produce). So a camera that uses a CCD sensor will capture images with higher quality and light sensitivity than a camera that uses a CMOS sensor. Printing an image taken from both CCD and CMOS cameras will help you judge this distinction better.

One final consideration before you lay down your money: the on-camera flash. Not only should your camera have one, it should also offer you the ability to turn it off when needed. Other flash features include red-eye reduction, slow-flash sync (essential for nighttime photography), and flash reduction (great for adding a subtle fill light rather than a harsh flash).

Because the on-camera flash built into your digital camera is woefully inadequate for illuminating anything other than fairly close objects (within 5 to 7 feet), you will probably want to purchase an external flash someday. Mid- to high-end digital cameras typically allow you to directly connect an extra flash to the camera through a flash sync connector or *hot shoe.* Manufacturers of such cameras recommend that you directly connect only their specific brand of flash, which may sound like a bad thing since it limits your choice of flash units. But in fact, it's really a good thing because using a *dedicated flash* enables you to coordinate the extra flash's output more closely with the on-camera flash; the dedicated flash, through its direct connection, knows what aperture, shutter speed, and flash settings you're using. It will also know whether you are using a lens filter, the zoom, or any special scene mode such as **Night Portrait**.

KEY TERMS

CCD sensor—Light-sensing device used in high-end cameras because of its superior light sensitivity. In addition, a CCD sensor produces little noise during the conversion to digital data.

CMOS sensor—Light-sensing device that uses less power than a CCD sensor, and costs less to produce. It also produces images of lower quality than a CCD sensor, so CMOS sensors are found more often in low-end digital cameras.

Noise—The amount of graininess or lack of sharpness in an image. You'll notice noise mostly in low-resolution or low-light images, especially when viewed in a large size.

Hot shoe—A connector that allows an external device to be easily connected. For example, a flash hot shoe allows you to slip an external flash onto the top of your digital camera.

If you do not purchase a mid-range to high-end digital camera, there will probably be no way to directly connect an external flash to it. But don't fret, because you can always purchase an external flash that's triggered to go off in sync with the on-camera flash through a *slave unit*. Keep a couple of things in mind when considering a digital camera that forces you to use a slave flash because of its lack of any direct connection. First, the slave flash will not know what aperture, shutter speed, and flash settings you're using, so it will simply fire at full power each time. This may result in a few overexposed images. Second, the slave flash you buy must be designed to work with digital cameras (the vast majority are not) because the built-in flash on a digital camera typically fires twice, and you want the slave unit to respond to the second flash and not the first.

Assuming that you have a choice when purchasing a flash for your camera, compare the *guide number* of each flash. A higher guide number indicates that the flash has more power, and thus, the ability to cover greater distances.

Compare how long it takes for each flash to recharge before it can fire again. If you tend to use the flash in situations where the subject is moving or you want to take several pictures right in a row, a quick-charging flash is a plus. A flash with a tilting flash head allows you to bounce the flash and soften its effect. If the head swivels as well as tilts, you can direct the flash exactly where you want it. If you plan on doing a lot of macro photography or photographs of small objects for sale, a *ring flash* may prove useful. Flash accessories you might consider include a light stand, a flash bracket (sometimes called an L bracket) for holding the flash and camera together as one unit, a flash hood or flash umbrella for bouncing the flash, a diffuser for diffusing the flash output, gels for coloring or warming the flash, and a portable battery unit for using the flash over an extended period of time (at a wedding, for example).

In summary, when looking for a digital camera, consider the following features and specifications:

- At least 3 megapixels of resolution.

- Minimum optical zoom of 3x. The ability to purchase and use other optical lenses (such as a wide-angle lens) and filters (such as a polarizing filter) is certainly a plus.

- Removable, upgradable image storage. Be sure that the type of memory your camera requires is easy to find, relatively inexpensive, and available in large capacities. Including the memory card that comes with the camera, get a minimum total memory capacity of 256MB. If you think you'll shoot all your images at the highest resolution, then go for a minimum of 512MB. When comparing memory card capacities and types note that most manufacturers list the number of images you can store on their cards basing that number on the assumption you will use a high resolution, JPEG, compressed file type. If you choose to take photos using a higher resolution in the RAW or TIFF file format, you'll be able to store fewer images on the memory card you select.

- Fast and easy transfer of images from the camera to your computer. Remember that USB 2.0 and FireWire will provide you with the fastest cable transfer method, although it's hard to beat the ease of using a floppy disk or CD-R for image storage and transfer.

- Consider battery type—does the camera accept Lithium-ion batteries (which last the longest) or NiMH? When looking at battery chargers, look for one that offers fast recharging, plus a reconditioning setting for use with NiMH. (Yes, you can recharge the camera's batteries using the AC adapter that comes with it, but it takes a lot longer than if you purchase and use a separate battery charger.)

- Look for an external flash sync socket or a hot shoe if you prefer the ease of using a dedicated external flash that works automatically with the on-camera flash to produce a correct exposure. However, don't make this issue a deal breaker because you can always purchase a slave flash.

- If you plan to purchase a tripod, ask whether you can use an electronic cable release to trigger the camera's shutter while it's on a tripod (that way, you don't touch the camera and perhaps jostle it). When looking for a tripod, go for a heavy, sturdy kind with legs that adjust individually, so that you can level the camera on rough, uneven surfaces. On the other hand, an inexpensive tabletop tripod is handy for steadying the camera on a ledge, desk, wall, or even against your own body—and its small size makes it easy to tote along wherever you go.

 NOTE

To give you a rough idea of what 256MB of memory holds, with my 3.3Mp camera, I can store about 27 pictures, using the highest resolution (which is uncompressed TIFF), on a 256MB memory card. If I switch to fine resolution (the next level down, which uses uncompressed JPEG), I can store about 163 images. I tend to shoot most of my images using the Fine setting. At normal resolution, I can store about 324 images, and with basic resolution (the lowest setting), I can store about 641 images.

 TIP

Handle your camera, testing its LCD visibility, menu system, and buttons for ease of use.

 TIP

If you're the outdoor type or you like simplicity, a monopod (one-legged tripod) allows you to balance a camera even on a walking trail, producing sharp images with no jitter.

- Other niceties to consider when comparing digital cameras: the ability to record a short movie with sound (not all digital cameras record audio although many will let you record short video clips); the ability to annotate (caption) an image with audio; a video output connector for displaying images on your television; the ability to take multiple shots quickly (continuous shooting or burst mode) one right after the other; the ability to turn the digital zoom off; the ability to manually focus the camera and to select between different auto-focus modes such as multi-spot, center-spot, and center-weighted; and the ability to send images directly to a printer after selecting the ones you want to print (Digital Print Order Format or DPOF compatibility). This last feature is no good unless your printer also supports DPOF; however, most printers that print directly from memory cards do support DPOF.

- Finally, consider how you intend to use the camera and where. Size and weight might be a factor that's important to you, especially if you hope to keep the camera handy (in the glove compartment of the car or in a purse) for those quick, candid shots. If you're the outdoor type, a sturdy body and a general rugged exterior might be a factor as well.

🔦 **TIP**

After you buy new NiMH batteries, you'll notice that each time you recharge them, they seem to hold a bit more of a charge. This is normal; NiMH batteries build up their charge capacity slowly, until they reach full capacity around the third or fourth time they are recharged. NiMH batteries also lose their charge gradually over time, so recharge them just before using them whenever possible. Also, be sure to *precondition* NiHM batteries before first use, and then recondition periodically thereafter, when they seem to hold less of a charge.

Accessories Worth Their Prices

Well, you've bought your digital camera, and it probably came with everything you need to get started. Still, in the long run, there are a few accessories you will want to purchase. The most important accessories you should buy right away are extra batteries, a battery charger, and extra memory cards. Purchase two complete sets of rechargeable batteries, and keep the extra set charged and ready to go.

Supplement your camera's memory card with two standby cards of larger capacity—two 256MB memory cards are usually enough for most beginners. Yes, memory cards are expensive, and you may be tempted to purchase only one 256MB card. But even if a 256MB memory card will hold enough images for one photo session, if you have only one card, you will either find yourself offloading images frequently (because a 256MB card holds only about 27 images at very high resolutions) or start skimping on quality by lowering the resolution so that you can store more pictures on that card. If your camera offers four resolution levels—high, fine, normal, and basic (low), you might be able to get by with fine resolution, but you won't be able to print fine-res images larger

than 8"×10" and still maintain the highest quality. At fine resolution, you should be able to store about 160 images on a 256MB memory card.

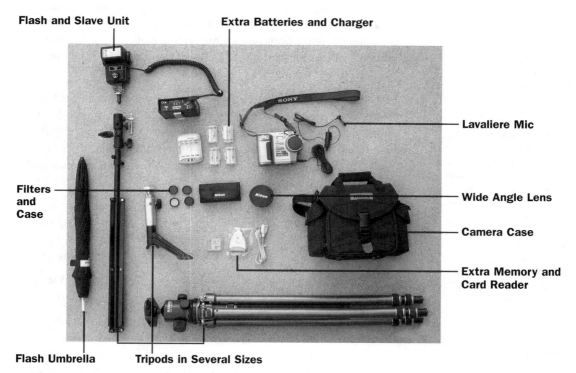

Flash and Slave Unit

Extra Batteries and Charger

Lavaliere Mic

Filters and Case

Wide Angle Lens

Camera Case

Extra Memory and Card Reader

Flash Umbrella **Tripods in Several Sizes**

Some typical digital camera accessories.

Here are some other accessories you might want to consider:

- **Camera case.** If you didn't buy one when you purchased your camera, you really should get one now. A good case protects your camera from scratches and dings, and is roomy enough for a variety of must-have accessories.

- **Memory case.** Be sure to purchase an inexpensive memory wallet, to keep all your memory sticks organized and in good working order.

- **Neck strap.** A neck strap attaches to your camera and is worn over your neck, preventing the camera from falling should you let go of it accidentally. Think of this little accessory as cheap insurance against slippery hands, clumsy feet, ice, rain, steep hills, and other tricky conditions. Look for a wide, padded strap for the most comfort.

 TIP

Be careful when using a neck strap in situations where if you fall, it could get caught on a nearby branch or other outcrop.

- **Card reader**. Depending on the type of direct connection your camera uses, it will probably be faster to transfer images to your computer using a card reader. A card reader also frees up your camera for use while you're transferring images, and of course, saves the camera's batteries. Finally, if you have several digital cameras, a card reader typically allows you to transfer images from many different types of memory cards.

- **PC Card adapter**. Allows your digital camera's memory card to be used in a laptop computer's PC Card (PCMCIA) slot, providing a simple method for transferring your images to a laptop computer. Many PC Card adapters are compatible with multiple memory card types, so the specific type of memory your camera uses should not be a factor here.

- **Portable image storage device**. They're known by a variety of names such as Clik!, PicturePAD, Image Tank, Photo Wallet, Super DigiBin, eFilm Picture Pad, Phototainer, and Digital Wallet, but they are all devised as a temporary storage area for your images.

- **Lens shade**. A lens shade is a flexible, collapsible hood that screws onto the camera lens, preventing lens flare by shading the lens from the sun at all angles.

- **Accessory lenses**. Many digital cameras can be fitted with additional lenses, such as a *wide angle*, *fisheye*, and *telephoto*. Of the three, you'll probably find the telephoto lens the most immediately useful because it will let you enlarge small, faraway objects without engaging the camera's digital zoom feature.

- **Polarizing filter**. A polarizing filter reduces glare and bright reflections from metal, glass, and water in much the same way as polarizing sunglasses work. It instantly removes glare from lakes, rivers, store windows, car windows, and so on. It also adds depth to a washed-out sky on a sunny day, instantly creating better landscape photos. Even if your camera lens doesn't provide a way for attaching lens filters, you can always hold or tape a polarizing filter to the front of the lens when needed. Glare is a very difficult effect to remove from a digital photo during retouching, so a polarizing filter should be your number one accessory.

- **Lens cleaning kit**. Do not clean your camera's lens with water or tissues because these can scratch the lens or leave it covered with

tiny fibers. Instead, purchase an inexpensive lens cleaning kit, complete with lens cleaner and special tissues. For more portability, look for a lens cleaning pen that you can keep in your pocket.

- **Tripod**. It's very hard for a beginner to hold the camera steady while taking a shot, especially if you're using the zoom. To avoid possible frustration (and lots of blurry pictures), invest in a small tripod you can easily take with you, such as a table top (mini) tripod, or a monopod. For sheer ruggedness and stability, a large, heavy tripod is hard to beat. You may also want to purchase a remote shutter release cable or a wireless remote control so that you can take a picture without touching the camera.

- **External flash**. The best way to illuminate a scene indoors (or even outdoors on a cloudy day) is to add an extra flash. See the previous section for details on what to look for in a good flash.

- **LCD sunshade**. You won't use your digital camera for long before you run into a situation (such as full sun, outdoors) where the LCD screen is very difficult if not impossible to see. To solve this problem, shade the screen with an inexpensive sunshade designed to fit your specific camera. The sunshade is typically attached to the camera with Velcro strips, making it easy to remove when not needed.

- **Underwater housing**. Okay, maybe this isn't a true necessity, but when used properly, this waterproof housing protects your camera underwater up to 3 meters in depth, allowing you to take pictures at the beach, lake, or even in the ocean without damaging anything. Even if the housing only protects the camera during a sudden downpour, it might be worth the expense.

- **TV display device**. This accessory allows you to insert a memory card and browse through the card's images on your television screen or to display the photos on the card consecutively, in an instant slide show that appears on the device's monitor.

- **Lavaliere mic**. If you plan on taking short movies with your digital camera, purchase an inexpensive microphone, such as a lavaliere (clip-style) mic similar to the kind television reporters use. If you rely only on the microphone incorporated into your camera, the sound quality will be very poor because camera mics tend to pick up a lot of outside noise such as wind and street sounds as well.

TIP

You can make an inexpensive, lightweight tripod by mounting a piece of wood to a long length of metal tubing or PVC pipe.

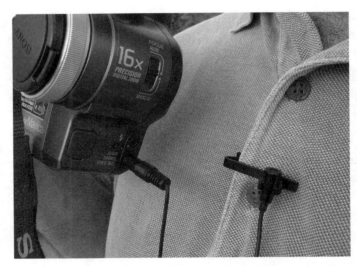

Use a lavaliere mic to capture sound when taking a movie or annotating images.

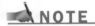

NOTE

Obviously, regardless of the printer you choose, there are things you can do using a graphics editor such as Photoshop Elements that will improve the quality of a printed photo. There are also some standard setup procedures you should complete, which improve your chances of printing a photo that looks similar to what you saw onscreen. See **85** **Ensure That What You See Is What You Get.**

Choosing a Printer for Digital Photography

If you plan on printing your digital photos at home, you'll need a printer designed and tested not only for color, but for photo paper. If you want to print a mix of photos and standard printing jobs such as letters and spreadsheets and want to save money, you can probably get away with the inkjet printer you already own. For best results with an ordinary inkjet printer, purchase photographic paper specifically designed for use with your printer. For example, purchase HP photo paper for use on an HP DeskJet 882C (a non-photo inkjet printer).

However, be aware that not all inkjet printers are capable of dealing with thicker, photo-quality paper, which you'll need to make your images proof quality. Even if the inkjet printer you own right now accepts photo paper, you might not like the result when you compare it to the print quality from an actual photo printer. That's because today's inkjet photo printers use six or seven colors of ink, including black, as opposed to the standard four colors you find with most inkjet printers. There are also dye-sublimation (dye-sub) photo printers available for a low cost, which produce superior photo prints, similar to professionally printed ones. With an inkjet photo printer, you don't have to buy the manufacturer's brand of photo paper to get good quality. So feel free to shop around, but be sure to purchase only high-quality photo paper. If

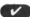

you go for a dye-sub printer, however, you'll want to compare not only quality but the price of consumables since you must purchase your paper and ink from the printer's manufacturer. I'll explain more about the differences between these two photo printer types in a moment; for now, let's talk features.

When shopping for a photo printer, be sure to do a test print from each of the models you're considering and compare them. It's amazing how many models you'll be able to eliminate with a few simple tests. Also, make a note of the print resolution (measured in dots per inch, or dpi)—the higher the resolution, the better the print quality. In addition, you might want to check whether the printer can produce borderless prints, if that's important to you. Other features to look for include the ability to print all images directly from a memory card while bypassing the computer, and *DPOF* support—the ability to print only preselected images (images you select using your camera's or printer's menu system). Also, when shopping, compare not only printer prices, but also the price of the matching ink cartridges and paper because that's where the real expense is. And yes, you do have to buy the ink brand that's specifically made for your printer—whether it's a photo or non-photo inkjet, or a dye-sub. However, as I mentioned earlier, you can purchase any brand of paper you want if you use a photo inkjet printer, so be sure to compare prices. If you use a plain inkjet or a dye-sub printer, you'll have to buy the manufacturer's brand of paper, but you can still shop around for the best price.

Inkjet printers are not your only choice now for home photo printing. Inexpensive (anywhere from $150 to $200 for a small 4"×6" printer to $450-$850 for a larger format 8.5"×11" printer), dye-sublimation (dye-sub) printers have entered the home market. Inkjet printers work by squirting ink onto the surface of the paper in a fine stream of dots, while dye-sub printers transfer ink by heating a multilayered ribbon made of plastic film and allowing the vaporized ink to diffuse onto specially coated paper. Varying colors and tones are achieved by precisely heating the ribbon. The ribbon contains three color layers: cyan, magenta, and yellow; each color is deposited in a separate pass. In the final pass, most dye-sub printers deposit a clear protective coating, which makes the final print as durable as a regular Kodak print. Dye-sub printers produce better quality photos because the ink is laid down in a continuous stream or tone, instead of a series of dots—thus, you avoid the graininess and dithering normally associated with home printing. In fact, you will be hard pressed to tell the difference between a professionally

KEY TERM

DPOF—(Digital Print Order Format) A system that allows you to browse and select a photo to print, choose the number of copies, and indicate whether to include date/time info on the resulting print, using your digital camera's menu system (assuming that your camera also supports DPOF). Some DPOF printers allow you to use the printer's menu system to make these same selections. After tagging the photos you want, you insert the memory card into a printer that also supports DPOF, and the printer prints just the selected photos.

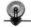 TIP

As an alternative to buying your own color photo printer, consider a do-it-yourself printing kiosk that allows you to insert your own disc and print your photos on high-quality photo paper. In addition, for occasional photo printing needs, the prices for uploading digital photos and having an online service such as Shutterfly print them is fairly reasonable.

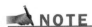

printed photo and a dye-sub photo printed at home. Also, some dye-sub printers allow you to print borderless prints, so that's another feature to look for.

Photos printed from standard inkjet printers using commonly available inks fade quite rapidly; only top-of-the-line inkjet photo printers use archival inks that are not subject to chemical degradation. Dye-sub photos, on the other hand, fade at about the same rate as professionally printed (chemically processed) photos because the inks infuse the paper with color, making the color more permanent. In addition, most dye-sub prints have a protective overcoat that prevents damage from UV rays. The downside in choosing a dye-sub printer (at least, right now) is that if you want to print larger format photos, they are more expensive (starting at $450). If you decide to print only smaller photos at home and leave the larger photos to professional printers, then a dye-sub printer is definitely worth a look because they are relatively fast (especially when connected to a computer rather than working in standalone mode), portable, and inexpensive (under $200). The special ink ribbons and papers you need will boost the cost though (but not over the cost of professional printing), so be sure to include those factors in the equation when comparing the ultimate cost of producing your own home photo prints.

Choosing a Scanner for Digital Photography

You don't need a scanner if all your photos are digital; however, if you want to organize and edit printed photos using Photoshop Album, you'll need some way of digitizing the prints. One method, of course, is to ask for a CD to be made when having your photos processed. The scanning quality of the images on these professionally produced discs is high, and it obviously saves you a lot of time. But you might find the price of having the CDs made for you a bit costly and might want to reserve this method only for rolls of film where you know you'll want to digitize every photo.

When shopping for a scanner, you'll find an amazing array of choices. The most important feature is a scanner's optical resolution, measured in dots per inch, or dpi. The higher the resolution, the better the scan, so look for about 1200 dpi × 2400 dpi as a minimum. Most scanners attempt to increase the resolution through software, but the results are typically less than satisfactory, so compare *optical* resolutions when shopping. The next factor to consider is speed, largely controlled by the type of computer connection the scanner uses. Fast connections include USB 2.0 and FireWire.

Some higher-end scanner models (starting at $400) include special features such as a film reader for scanning filmstrips and/or slides. Lower-cost scanners may offer a filmstrip reader as well, but unless the scanner uses at least a resolution of 2700 dpi, you won't be satisfied with the results you get.

Why Use Photoshop Album?

Photoshop Album is the perfect tool for organizing your digital photographs. Even if you don't own a digital camera, you have probably taken many hours to scan in printed photographs—time you don't want to lose by having something happen to the digital image files.

Not only can Photoshop Album help you get a handle on your digital images, it can also help you organize other media as well, such as digital video files and audio (sound) files. Even if you haven't created any digital video or audio files yourself, you've probably downloaded a few from the Internet or copied some from a friend's disc.

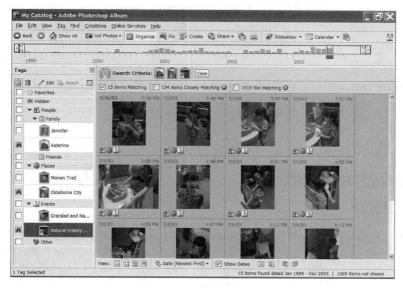

Photoshop Album helps you keep your media files organized.

With Photoshop Album, you can do the following:

- Import images from a digital camera or scanner.
- Organize digital images, video, and audio files.

 TIP

If you own a Nikon Coolpix 990, 950, or 880, you can buy a slide/film copying adapter, and use the camera to take positive or negative images of your 35mm film strips and slides. This nifty accessory costs about $60, so it's an inexpensive method for archiving your old photos.

 TIP

Although Photoshop Album allows you to apply minor corrections to your images, if you want to correct larger problems, you should invest in a full-fledged graphics editor such as Photoshop or Paint Shop Pro.

- Annotate images with personal audio comments or written captions and notes.

- Search for similar files, or a specific file, regardless of where that file is stored—on your hard disk, a CD-ROM, a DVD, or over your home network, stored on another computer.

- View an image, play a video, or listen to an audio file.

- Apply minor corrections to an image.

- Rotate or crop an image.

- Send an image to a graphics editor such as Adobe Photoshop, Paint Shop Pro, or Photoshop Elements for further editing.

- Protect your images by copying them onto a CD-ROM or DVD disc.

- Print a single image, a *portrait sheet*, or a *contact sheet*.

- Make *creations*, such as greeting cards, calendars, or books.

- Share images with special photo slideshows, digital eCards, a Web gallery designed for browsing images, a video CD of images you can play on a television, or by attaching images to an email message.

- Share images online using a photo-sharing service.

- Upload images to an online photo service for professional printing.

Become Familiar with Photoshop Album

By now you know that Photoshop Album can help you organize your digital images, video, and audio files. But you may not know *how* it does that. After you launch Photoshop Album for the first time, it has to make a list of your media files and their locations. For this simple process, you indicate the general location you want Photoshop Album to search and then let Photoshop Album compile its list. You'll learn the details of this procedure in **38** **Perform an Initial Scan for Media**. After compiling a list of media files on your hard disk, you'll want to

KEY TERMS

Portrait sheet—Multiple copies of the same photograph printed on a single sheet of paper, in a mix of photo sizes such as 8.5"×11", 5"×7", and wallet.

See Also

→ **38** Perform an Initial Scan for Media

→ **45** Back Up the Photoshop Album Catalog

→ **46** Create a New Catalog

→ **47** Copy Items onto CD-ROM or DVD

repeat this process from time to time to add new files to the list, such as those located on a CD-ROM, DVD, digital camera, or scanner.

After your media files (images, video, and audio) are listed in Photoshop Album, you begin organizing them by adding *tags*. After adding tags, you can quickly display a group of similar files, regardless of where they are stored—even if they are stored offline on a CD or DVD. For example, you might want to display all the photos of your dog so that you can pick out the best one for inclusion in a family photo album. After displaying a set of similar images, you can select a single image and display it full screen or make simple changes such as brightening, rotating, or cropping it. If you've located a favorite video or audio file, you can play it without leaving Photoshop Album. You can perform other image tasks as well, including printing, sharing, and creating cards and calendars.

You can add *captions* to your media files, making it easier to locate and identify them. Captions can be added as text to images, sound, and video files, and also as sound attachments (audio captions) to image files, bringing a new dimension to your media collection. For example, you might select a photo and add an audio description of the party or event at which it was taken. This audio could then be included in an eCard sent over the Internet, in a slideshow of photos, or in a video CD of images. Text captions appear under images included in Web galleries, photo albums, and slideshows, so it's well worth the extra time and effort to add them.

The list of media files that Photoshop Album compiles for you is called a *catalog*. If you share your computer with other members of your family, you can each create your own catalog of images and organize them as you like. This allows you the freedom of including only the media files you're interested in, in your own personal catalog. See **Create a New Catalog** for help. Because the catalog contains a list of each media file and its location, date, size, caption, tags, and other properties, it's important to create a backup copy of the catalog from time to time. The backup copy aids in data recovery, should something happen to the original catalog file. See **45** **Back Up the Photoshop Album Catalog**. As another protection against the loss of your original images, any changes you initiate from within Photoshop Album (whether you use the Photoshop Album editor or another graphics editor such as Photoshop to complete them) are automatically saved to a new image file.

KEY TERMS

Captions—A text or audio description of a media file.

Catalog—A collection of organized media files. Each member of your family can create his or her own unique collection (catalog) of files.

TIP

Backing up the catalog also protects your image, audio, and video files, so performing a backup from time to time is critical. If you're ready to offload your images, video, and audio files to a permanent location such as a CD-ROM or DVD, you can copy just those files to disc. See **47** **Copy Items onto CD-ROM or DVD**.

Photoshop Album is more than a great photo organizer, it's an editor too. Using Photoshop Album, you can make quick corrections to your images, such as lightening them and improving the color saturation. For more complex editing jobs, however, you'll want to use a good graphics editor such as Photoshop or Paint Shop Pro. To keep your catalog current, you must initiate any image changes from within Photoshop Album—by simply telling it to send the image over to your favorite graphics editor for editing as discussed in **95** **Fix a Photo Using Another Program**.

A Look at the Photoshop Album Work Area

TIP

If you don't want to show the **Quick Guide** each time you start Photoshop Album, you can turn off its **Show this window at startup** option.

When you start Photoshop Album, it displays the **Quick Guide**, a sort of jumping-off point for major tasks such as getting images into Photoshop Album, organizing them, and finding them later on. To remove the **Quick Guide** from the screen temporarily, click its **Close** button. You can always redisplay it by clicking the **Quick Guide to Photoshop Album** button located at the right end of the **Shortcuts bar**, which you'll see in a moment.

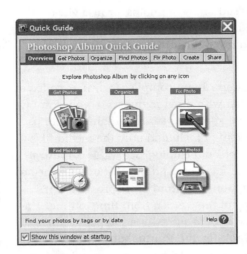

The **Quick Guide** provides quick access to major tasks.

NOTE

Photoshop Album recognizes only particular image file types (JPEG/JPG, TIFF/TIF, BMP, PNG, and GIF), so it can only import images in these file types. Photoshop Album also recognizes MP3 and WAV audio files, and AVI, MPEG, and MOV video files.

After performing some task with the **Quick Guide** or removing it from view, you'll see the Photoshop Album work area. If this is your first time starting the program, you should let Photoshop Album perform an

initial search for media files, as described in **38** **Perform an Initial Scan for Media**. After importing some media files, you're ready to familiarize yourself with the Photoshop Album work area.

In the work area you'll find the tools you need to organize and use your media files. At the top of the work area is the menu bar. Just like any other program, you click a menu to open it, and then click the menu command you want. Below the menu bar are the **Shortcuts** bar, **Timeline**, **Tags** pane, **Find** bar, **photo well**, and **Options** bar. Let's take a closer look at each of these features.

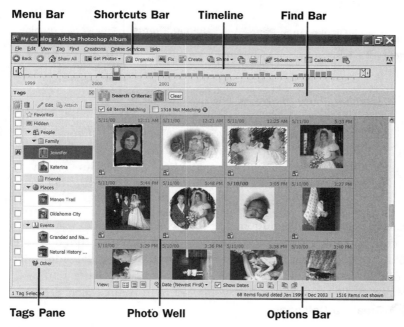

The Photoshop Album work area.

Shortcuts Bar

Below the menu bar, you'll find the **Shortcuts** bar—a toolbar of buttons for common commands such as searching and printing. Most of these buttons display an icon and a name, so you can easily identify the purpose of any button. For any button you're unsure of, simply move the mouse pointer over the button, and a tool tip appears, displaying a description for that button.

See Also

→ **78** Find Items with the Same Date

→ **100** Create a Calendar

→ **108** Create a Slideshow of Images

Some buttons on the **Shortcuts** bar require a bit more explanation than others. After you've searched for and displayed a group of similar images, you can redisplay a previously selected group of images by clicking **Back**. To return to the current display, click **Forward**. To redisplay all images in the catalog, click **Show All**.

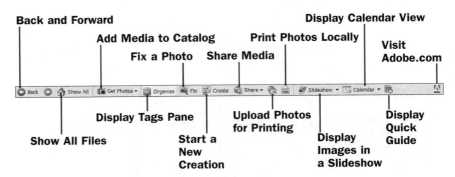

*The Photoshop Album **Shortcuts** bar.*

 TIP

The arrow on the **Slideshow** button in the **Shortcuts** bar tells you that it's really a menu; if you click the arrow, an additional command is displayed, **Slideshow Creation**, which allows you to create a slideshow that you can save and replay anytime you like. See **108** **Create a Slideshow of Images**.

By clicking the **Slideshow** button, you can view selected images in a kind of slideshow, which displays each image automatically, full screen, one after the other. The slideshow provides buttons that allow you to interrupt this automatic display, jumping ahead to the next image or returning to a previously displayed image.

By clicking the **Calendar** button, you can display a calendar. By clicking any date in the calendar, you can review images taken on that date, one by one. See **78** **Find Items with the Same Date**. The **Calendar** button also has a menu. Its other command allows you to create a printed calendar that features the images you select from your catalog. See **100** **Create a Calendar**.

Timeline

Under the **Shortcuts** bar, you'll find the **Timeline**. With it, you can quickly display images taken on a particular date or in a range of dates. You'll learn to use the **Timeline** in **79** **Find Items Within a Date Range**.

You can also get some quick information from the **Timeline**: Dates on which images were taken are represented by a bar on the Timeline graph; the more images for a particular date, the taller the bar. If the bar is purple, it indicates images that are currently hidden.

Tags Pane

The **Tags** pane displays the current list of tags, which you can attach to images to identify their content. When you see a binocular icon in front of a particular tag on the **Tags** pane, it indicates that only images with that tag are being displayed. To display all images again, click the **Show All** button on the **Shortcuts** bar. You'll learn how to attach tags to images in **64 Attach a Tag to an Item**.

Find Bar

By dragging tags onto the **Find** bar, you can display other images that have the same tag. You can also remove these restrictions quickly, redisplaying all images in the catalog. The **Find** bar also displays how many images match or closely match your criteria, and how many do not. See **74 Find Items with the Same Tag**.

Photo Well

Images, video, audio files, and creations matching the current search criteria are displayed in the **photo well**, typically in date order with the more recent files displayed first. You can change the order of display, arranging files in reverse date order, by folder location, by the batch in which they were imported into the catalog, or by color similarity. You can also change the size of the *thumbnails*.

Each file in the photo well is displayed with the date and time the file was originally created or scanned. Typically, items appear in reverse date order, with newly created or scanned images appearing at the top of the photo well. If you edit an image, the date it was modified is saved, but this creation date is not changed. This allows you to always display images grouped with other images taken that same day, whether you edit one of them or not. The date on which an item was imported into the catalog is also noted, so you can group items by import batch. You can modify these dates if you find they don't reflect what you expect; see **60 Change Image Date and Time**.

Selected files are surrounded by a yellow outline. You might select several images, for example, to include them in a slideshow you want to create. Icons appear with each file as well, indicating various things:

- Whether the file is stored locally or offline (on a CD, for example).

- Whether an audio caption is attached to the file.

NOTE

Actually, audio files are not initially displayed in the photo well at all, even if they are added to the catalog. To control which file types are displayed, select **View, Media Types**, select the types to display (such as **Photos** or **Audio**), and click **OK**.

KEY TERM

Thumbnail—A small version of an image generally appearing in a group of other small images, but just large enough so that you can easily distinguish it from the others.

- Whether the file is a video file.

- Any associated tags, such as a particular family member or event.

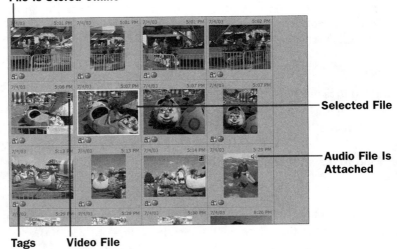

File Is Stored Offline

Selected File

Audio File Is Attached

Tags **Video File**

Icons in the photo well indicate various things.

Options Bar

See Also

→ 49 Change Thumbnail Size

→ 53 Sort Items

The buttons on the left end of the **Options** bar at the bottom of the work area help you control the display of images and other media files in the photo well. You'll learn more about these buttons in 49 **Change Thumbnail Size** and 53 **Sort Items**.

The buttons at the right end of the **Options** bar control the display of various screen elements, such as the **Properties** pane (with which you can change a file's properties, such as its caption) and the *Workspace*. You can also control the display of a file's date and time, tags, and other properties by turning on or off the **Show Dates** option; removing these informational elements from the photo well allows you to display more thumbnails onscreen. The two buttons on the far right of the **Options** bar allow you to quickly rotate an image right or left so that you can view it properly.

Thumbnail Size **Display File Properties** **Display Properties Pane**

Rotate Image to the Right

Sort Thumbnails **Display Workspace** **Rotate Image to the Left**

The Options bar.

Why Printing Isn't a One-Step Task

In using your computer to view and print images, you learn right away that no two devices ever worked so differently from one another as your monitor and your printer. You've probably come to expect your printer to render pretty much whatever you see on your screen in a reliable, representative, "close enough" format. With digital photos, however, the definition of "close enough" grows very narrow, and with good reason: The ways your monitor and your printer construct colors are almost complete opposites of one another.

Your monitor uses principles of *optics* to blend the color for each pixel in a digital photo. Optics is the science of light, in which color is created by mixing light of different wavelengths. The three primary colors of light are *red*, *green*, and *blue*. Your monitor adds various amounts of red, green, and blue light together to create other colors. This makes the science of optics an *additive process,* where colors are added to each other to create other colors. Shine a red and green flashlight on a single spot on the floor, you'll get yellow (your monitor uses something close to a cherry red and a lime green to create a sunny yellow).

Your color printer mixes colors following the rules of a science you're probably more familiar with: *pigment*, in which yellow is a primary ink color and not the product of red and green light. A color inkjet has as few as four, or as many as seven, different inks to work with. Affordable dye-sub printers typically have only one three-color ribbon. So rather than employing the optical process of *adding* light to attain the desired color, printing employs what's called a *subtractive* process. This theory works in precisely the opposite direction of optics—and even opposite of how artists are taught to mix paints. The subtractive process presumes that the purest light an object can reflect is white, so an object's color

See Also

→ **84** About Adobe Gamma

→ **85** Ensure That What You See Is What You Get

→ **87** Make Automatic Corrections

→ **94** Manually Adjust Color Saturation

NOTE

To create a white pixel, your monitor mixes all three colors in equal amounts: red, green, and blue. To get black, the monitor removes all three light sources from a pixel.

NOTE

Because your monitor mixes light to make colors, in its system red and green make *yellow*, green and blue make *cyan*, and red and blue make *magenta*. This might be a foreign concept for you, especially because it's so different from what you may have done as a child, where mixing yellow and blue make green, red and blue make purple, and so on. A color printer uses a color mixing system known as CMYK, where the three primary colors are cyan (the closest thing to blue in a transparent ink), magenta (a kind of red), and yellow.

NOTE

You'll learn more about these color profiles and how to install them in **84** About Adobe Gamma and **85** Ensure That What You See Is What You Get.

can be simulated by applying colored pigment to mask out, or subtract, just those hues that an object absorbs and does *not* reflect. During printing, magenta is applied to the color of an object not because the natural hue of that object is magenta or magenta-ish, but instead because the object appears to absorb—or not reflect—magenta light.

Theoretically, if your inkjet or dye-sub printer were to mix equal amounts of cyan, magenta, and yellow ink in a given area, they would cancel out all reflected light, and the product would be black. Dye-sub printers use a ribbon with only these three inks. However, because the cheaper inkjet inks tend to introduce certain impurities, the product of the three primary ink colors is actually a muddy brown. So inkjet printers must add a fourth pass, with black ink, to make darker portions bolder. Thus the name commonly given to the four-pigment process, CMYK (where the "K" stands for black). Recall from our earlier discussion of optics that cyan, magenta, and yellow just happen to be the three secondary hues in optics. This is the critical connection between optics and pigment, and this is why cyan, magenta, and yellow are the three basic inks used in process printing. Still, because the monitor and the printer use two different color models to create color, it's up to your program (in this case, Photoshop Album), to do the best job it can in translating between the monitor and the printer. Photoshop Album uses certain files called *color profiles* to help it do just that. Color profiles help to translate color information from your monitor's RGB color model to your printer's CMYK color model.

Microsoft Windows usually provides a color profile for translating optical shades to printed shades; when you installed your printer, the software it uses might have overridden that default color profile with one that's better suited to your printer. But it might not have done so. Adobe Gamma, a program that enables color profiling within Photoshop Album, will help you solve this problem.

2

Capturing Common Images and Movies

IN THIS CHAPTER:

Sure, most digital cameras offer you point-and-shoot ease. When you see something you like, just press the button to capture the image. The trouble is that digital cameras are even less sensitive to light than film cameras, so if you just point and shoot to capture an image, you may end up with a blurry, dim, uninteresting mess. If your desire is to capture the *best images* and not just *any image*, familiarize yourself with some basic photographic techniques and how to implement them on your digital camera. Even if you're pretty handy with a film camera, you've probably already noticed that there are some differences between using a film camera and a digital camera. In this chapter, you'll learn how to take a good picture or movie using your digital camera, and to deal with common obstacles such as a subject that's moving fast, located in the far distance, or hiding behind a fence or a pane of glass.

1 About Photography

See Also

→ **2** About Lighting

→ **3** About Getting Creative

TIP

Do not put batteries in your pocket unless they are enclosed in a plastic case; if the batteries come in contact with metal (keys, change, and the like) they will discharge and burn you.

TIP

If you use a card reader to transfer images to the computer, don't ask your computer to format a memory card for you because it may cause errors. Instead, format your memory card in the camera by selecting that option off the menu.

Because Photoshop Album can make only limited changes to your photos, you will benefit from taking good quality images from the outset. Even if you own a graphics editor such as Photoshop Elements, Photoshop, or Paint Shop Pro, learning a few things about what makes a more optically appealing photograph will save you time editing your images later on. In upcoming tasks, you'll learn the specifics needed to create prize-winning photographs. In the meanwhile, here are some simple things you should know:

- **Be prepared**. You can't take a picture if your camera's batteries are low, or if you're out of memory. Invest in some extra batteries and plenty of memory cards or sticks, and always keep them handy and ready to use. With ample backup power and storage on hand, you'll be more relaxed, so when you take a shot that you know isn't perfect, you can easily try again.

- **Don't skimp on quality**. Unless you're capturing an image for email or Web use *only*, always shoot at the highest resolution your camera allows. If you decide after the fact that a particular photo will make a nice 8"×10" print, you won't be able to get a quality result if you skimped on the resolution when taking the picture. In addition, if compression is a variable, select low or even none.

Low-resolution digital images are always much grainer than their higher-resolution cousins—a problem you cannot improve much,

even with the help of a graphics editor. So don't skimp on image resolution when taking photographs—you will always regret it.

- **Take lots of pictures**. The reason professional photographers can get that one really great shot is because they take far more than just one. This is especially true of candid moments, group photos, subjects in motion, or with less-than-perfect lighting conditions. Taking more than one photo also allows you to easily experiment with exposure and shutter speed settings, and maybe even a different lens (such as a wide-angle, telephoto, or fisheye lens). Later, you can choose the best image and discard the rest.

- **Study the light**. Locate the brightest and darkest areas of the scene you're capturing and determine how one affects the other. Is the sun shining right in your subject's face, causing them to squint and frown? Does the sunlight falling from behind put their face in shadow? Is your subject much brighter or darker than the background? There are ways to compensate for all these problems, and you'll learn them in upcoming tasks.

- **Get white right**. Whenever the lighting conditions change, *white balance* your camera. Typically, white balancing involves making a lighting choice from a menu or the mode button (such as indoors, outdoors, snow, cloudy day, nighttime, stage lighting, and so on). More sophisticated models enable you to select the white balance option, point it toward something white or near white, and white balance automatically, so that the temperature and quality of the light you capture are adjusted for the light in the scene you're shooting. Otherwise, flesh tones may look too blue or too orange. See **4** **White Balance the Camera**.

- **Don't "auto" everything**. Get involved in the picture-taking process. Use the flash to provide fill light even in the daytime, softening shadows on a subject's face. Understand the difference between the f-stop (*aperture*) and *shutter speed*, and how to use both to your advantage. See **2** **About Lighting**.

- **Throw the background out of focus**. Another way to bring out your subject is to blur the background behind it. This is easily accomplished by manipulating the shutter speed and aperture to create a small area that's in focus. See **2** **About Lighting** for more information.

By blurring the background, this unusual clematis bloom becomes the most important element in this photograph.

- **Get rid of the shakes.** Whenever you can, use a tripod. For most digital cameras, there's an interminable wait between the time you press the shutter release and the time the camera records the image. Holding a camera perfectly still during this waiting period can be almost impossible. Also, because electronic light detectors are less sensitive than film, shutter speeds are slower for digital cameras than they are for film cameras. So the brief period while the camera shutter is open renders it extremely susceptible to motion blur. So invest in a small pocket tripod to steady your camera and remove unnecessary blur, especially when you've zoomed in on a far away subject, or you are shooting in low-light conditions. Or, use your surroundings as a surrogate tripod.

- **Be careful of zoom.** Most digital cameras offer a digital zoom, where the camera artificially increases its maximum optical zoom factor by essentially cropping a region from the optical image and "magnifying" that same region. Digital zoomed images are grainy, even blocky, as a result. So if you want a quality photograph, don't zoom in past the natural optical zoom level of your digital camera's lens. Some digital cameras even give you the option of turning off the digital zoom so that you can't accidentally engage it.

- **Know the value of exposure.** A lot of cameras allow you to change the exposure value (plus or minus) to compensate for low light/bright light conditions. For example, you might be trying to take a nice picture of your child playing in the snow, but the camera sets the exposure automatically for the brightest object (the snow); as a result, your child's face is underexposed. The same situation happens when the sun is behind your subject and his or her face is in shadow, or the sun is in the picture when you're trying to capture the sunset. See **16** **Capture a Sunrise or Sunset**, **21** **Capture a Snowy or Sandy Scene**, and **22** **Capture Woods or Deep-Shadow Scenes**.

- **Be a fly on the wall.** If you want a great photograph of a friend or relative, become an observer. At get-togethers, blend into the background and discreetly take photos only when the moment is right. Your patience will be rewarded with a candid photo that captures people as they really are—beautiful and human. This trick works well with nature photographs of birds, butterflies, and squirrels at play. As a diver once put it, take pictures and leave only bubbles. See **37** **Photograph an Event**.

Framing the Shot

When deciding to take a picture, ask yourself these questions: What is the real *subject* of this photo? What is interesting about the scene the subject is in? What is it that you want to draw the viewer's attention to? What is the mood you want to convey? Frame the answers to those questions in your own field of vision, then substitute your eyes with your camera and shoot. If needed, move in closer to your subject to fill the frame, to draw more attention to the subject and create a stronger photograph.

After you've initially framed the subject, force yourself to notice the background—if it's busy, change your position or angle of view to eliminate distractions from behind your subject. Be on the lookout for vertical objects such as telephone poles, tree trunks, and signs, which may appear to pop out of your subject's head if you don't frame the image correctly. Text on billboards, store fronts, and signs is also distracting, so avoid including such items in a photo whenever possible. Avoid framing bright objects or lights, since they draw attention away from your subject.

 TIP

When photographing a child, kneel down and try to capture the world from her perspective. For a tall subject, turn the camera and shoot vertically, rather than horizontally, so that the subject can dominate the frame.

By changing my position and framing the eagle tightly, I was able to include the flag without including any part of the construction going on nearby.

KEY TERM

Parallax view—The representation of a scene provided by a camera's viewfinder, which is slightly askew of the lens. When framing close subjects, the angular difference between the parallax view and the lens view is exacerbated.

Most digital cameras come with an optical viewfinder, plus a larger LCD screen for both reviewing pictures and framing the scene you want to capture. When you're framing a picture using the viewfinder, you should be aware that the view of the scene you see is slightly askew from that of the camera lens. This problem is known as *parallax view*. The LCD's preview, however, comes directly from the lens, so it provides an accurate view of the actual image to be captured. If the subject is close to you, there's a chance that when you use the viewfinder to frame your shot, you may accidentally cut part of it off.

When considering where to place the subject in a photograph, think about the "negative space"—the empty space occupied by broad areas

of a single color and little detail. Negative spaces give the eye someplace to rest while considering the rest of the photo. When used cleverly, negative spaces can lead the eye around the image to the important elements of a photograph.

Obviously, there are no hard and fast rules for properly framing a subject, but many artists know that to create an interesting painting, you simply divide the canvas into thirds vertically and horizontally. The dividing lines intersect at four points on the canvas; these are your focal points—places where the eye is drawn naturally. By placing your subject on one of these four points—as opposed to the absolute center of the frame—you'll create a perfectly pleasing picture. This technique is known as the *rule of thirds*.

KEY TERM

Rule of thirds—A method of framing a subject in a photograph in which the subject is placed one-third of the distance vertically and horizontally from one corner.

Place Your Subject at One of These Intersections

This photo uses the "rule of thirds" to create an interesting composition.

A variant of the rule of thirds involves what's called the *golden mean*. By dividing the frame into right triangles of various sizes, you can achieve a balanced composition. Where the points of the triangles meet, a rectangle is formed whose width-to-height ratio is equal to pi—the Greek mathematician Euclid believed that this ratio represented "perfect proportions," and suggested it be used in architecture and artwork. If you place strong diagonal lines along the edges of these triangles, you'll help to guide the viewer's eye to the important elements of a composition.

KEY TERM

Golden mean—A method of framing a subject in which the frame is divided into three or four right-triangles, with the subject located within the largest triangle.

You can use the "golden mean" to compose an image.

TIP

If the perfect "frame" is not available, you can still liven up a picture of a distant mountain or other large feature by including something in the foreground and middle distances to add interest.

Providing Scale

If you want to take a picture of a large object such as a mountain or a building, it helps to include something in the foreground to give the object some scale. For example, you could include a tree branch or a person in the foreground, which not only provides some scale, but helps to frame the view.

Isolating the Subject

KEY TERM

Depth of field—The distance between the closest in-focus object to your camera and the furthest in-focus object away from your camera.

You can improve just about any photograph by isolating the subject from the other objects in the image. One way to do that is to use a small *depth of field*, or area of focus. By blurring everything behind the subject, the subject automatically becomes important because it's the only thing in focus. Portrait mode on your camera will give you this effect automatically. Another method you can use to isolate a subject is to exploit any contrast between it and its environment. For example, a

person walking along the beach, backlit by a rising sun and therefore very dark and in shadow, becomes instantly important because of the contrast between that person and the very light and sandy beach—even if that person is far away and fairly tiny.

Near objects such as the leaves in the top foreground lend a sense of scale to massive subjects such as this historic mansion, while also framing the view.

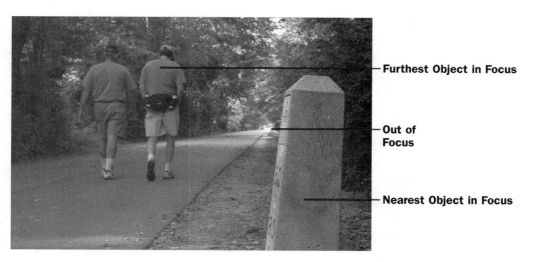

The depth of field includes only in-focus objects.

Image Sharpness

Sharpness can make or break a photograph, and it's one of the few things you can't correct with a graphics editing program (at least, not by much). As a result, getting a sharp photograph is pretty much determined by what you do when you take the picture. To make sure that your subject is in focus, press the shutter halfway and point directly at your subject. After the camera has focused, adjust the view to create a pleasing composition. Press the shutter the rest of the way to take the picture.

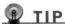 **TIP**

If you are using a large depth of field to capture a landscape, focus on an object one third of the distance between you and the horizon, rather than something in the middle of the frame. This allows objects in the foreground, middle distance, and horizon to remain in focus, rather than just middle-to-far objects.

The depth of field includes the in-focus area in front of and behind your subject. When your principal subject is one object within that field, it may not be necessary to keep everything else in focus. As you'll learn in the next section, you can control the depth of field by changing the aperture, or lens opening. But how else can you control it?

Obviously, you can take sharper pictures of fast-moving objects by using a faster shutter speed. The shutter speed is the speed at which the aperture opens and closes, letting in a precise amount of light. You might think, however, that to take a picture of a racehorse you have to use a very fast shutter speed. And you'd be right—assuming that you take the picture as the horse runs past you. However, if you take the picture as the horse moves directly toward you or away from you, the camera can use a slightly *slower* shutter speed, which results in a slightly smaller aperture and a larger depth of field. Rather than leave such things to chance, you might want to select the exact shutter speed yourself, to control the depth of field. If you shoot the horse coming at you down the track, and select a fast shutter speed, you'll get a fairly small depth of field. The horse remains sharp and in focus, while the blurrier background implies the horse's speed. Because human eyes tend to seek out sharp objects first, your subject will be the first thing they see, and the background will remain, well, just that—the *background*.

Sharpness is also controlled by the *focal length* of the lens you use to capture a moving object. If you zoom in to get a picture, you risk recording more blur; zoom out, and the object must move a greater distance during exposure before any blur is recorded. Likewise, your distance from a subject also plays a part in the resulting sharpness of a moving image—assuming that you don't change the zoom, if you move closer to a subject, you'll capture more blur than if you move farther away.

Most digital cameras give you a variety of methods you can use to adjust the focus when taking an image. Typically, the camera is set to

auto-focus, in which the camera adjusts the sharpness until the object in the center of the lens is in focus. If the subject is not located in the center of the frame, you can simply center the subject, press the shutter halfway, and then reframe the picture before pressing the shutter the rest of the way down to record the image. But auto-focus has trouble focusing in these circumstances:

- When there is low contrast in a scene, and therefore very little to distinguish the subject from its surroundings.

- When the subject is a whole lot brighter than its surroundings.

- When the subject is poorly illuminated and hard to make out.

- When the subject is moving fast.

- When there's something between you and the subject, such as the bars of a cage, a fence, or a screen.

Most cameras will beep at you, display a warning on the LCD or viewfinder, or turn on a warning light to let you know they are having trouble focusing. In such a case, if your camera offers a manual focus option, you can engage that option to find the focus for yourself, either by twisting the focus ring on the barrel of the lens, or selecting the distance between you and the subject from a menu.

The Side Effects of Zoom

If you decide to use your camera's zoom to capture a subject, there are several side effects you should be aware of:

- Remember the difference between the optical and digital zooms (as covered in Chapter 1), and use only optical zoom to achieve the best picture quality.

- Using optical zoom causes less light to enter the camera lens. As a consequence, the camera will automatically make the lens opening (the aperture) larger. If the subject is not well lit, however, you may not be able to capture the image properly, despite the larger aperture.

- As you'll learn in the next section, large apertures result in a small depth of field (the area that's in focus). As a result, when you zoom in on a far away subject, be careful that you actually get your subject in focus because you'll be working with a small depth of field.

KEY TERM

Auto-focus—A type of focusing method in which the camera automatically makes the object in the center of the frame perfectly sharp.

NOTE

Your camera's manual will tell you if manual focus is available, and how to engage it.

NOTE

On the front of the camera lens, you'll typically see a bunch of numbers such as f7.4–22.2mm and 1:2.8–4.9. The first set of numbers refers to the lens's focal length, or range of focus (see Chapter 1). The second set of numbers refers to the lens's maximum aperture in normal (f2.8) and zoom (f4.9) mode.

- Using a zoom affects your ability to produce a sharp image if the subject is moving. Zoom out or move back from a subject to make it harder for the camera to capture motion blur.

- Using a zoom also changes your perspective, compressing the apparent distance between objects. In other words, when you zoom in on a scene, objects will appear closer together than they actually are. The opposite occurs when you zoom out to a wide angle; near objects may seem further away from far objects than they actually are. Distant objects may seem *really* far away.

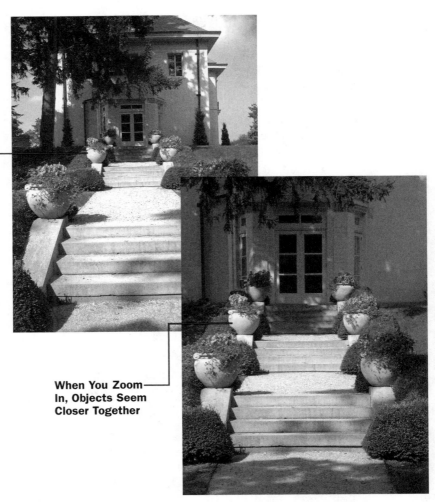

When You Zoom Out, Objects Seem Farther Apart

When You Zoom In, Objects Seem Closer Together

Zooming compresses the apparent distance between objects.

Final Thoughts

Digital photos mean digital storage media, so early on, you should develop a plan for managing your images. The simplest method for corralling your ever-growing horde is to import images from the camera directly into Photoshop Album, where you can immediately back them up onto CD-R or DVD. See **41** **Import Images from a Digital Camera**. After importing the images you've just taken, you can use Photoshop Album to print thumbnails of each image, select the best ones for printing or for use in a *creation*, and then as a final step, delete the rest from the hard disk to reclaim storage space. Images you keep in Photoshop Album can then be tagged and annotated for better organization. If you make any changes to an image using Photoshop Album, the image is automatically saved to a new file. Back up these edited images onto a separate CD-R or DVD. See **47** **Copy Items onto CD-ROM or DVD**.

2 About Lighting

Because photography is essentially the skillful capture of light, lighting is the single most important element in every image. Ironically, for most photographs, you will want to control the *available light* (perhaps supplementing it with *artificial light*) to produce an image *in which the light is the least most important element*. In other words, you will want to study the light in a scene, select the appropriate camera settings, and capture an image in which the *subject* is the most important part of the image and not the light source.

The most important aspects of lighting include its strength (is there enough light to capture an image?), its direction (where do the shadows fall, and do they obscure an important detail?), and its reflection (what light is being reflected back into the camera lens?). The light entering your camera's lens is determined by the reflection of light from objects directly in front of it. Too much light from a reflective object behind your subject can result in a washed-out, overexposed look.

Lighting can greatly affect the look of an image, making it seem natural (such as a candid shot taken outdoors using available light), or more formal (such as a well-lit studio portrait). You can add artificial light to a scene and still have it look natural, so as you select various lighting options, keep the ultimate look you're going for in mind. Before adding light to a scene, however, study what's there and take advantage of it—exploit the play of light and shadow whenever possible. For example, a

Before You Begin

✔ **1** About Photography

See Also

→ **23** Capture Fireworks

→ **25** Shoot an Indoor Portrait with On-Camera Flash

→ **27** Shoot a Formal Indoor Portrait

→ **28** Shoot an Outdoor Portrait

→ **34** Shoot a Nighttime Portrait

KEY TERMS

Available light—The light that naturally exists in a scene, such as sunlight, table lamps, and overhead fluorescents.

Artificial light—The light you add to a scene using an external flash or a reflector.

state capitol building can be made much more interesting by the setting sun glinting off its dome, or the noonday sun accentuating the dome's roundness by casting a deep shadow on one side. Both pictures are made better because of the existence of very light lights and very dark darks, rather than lots of medium, flat light.

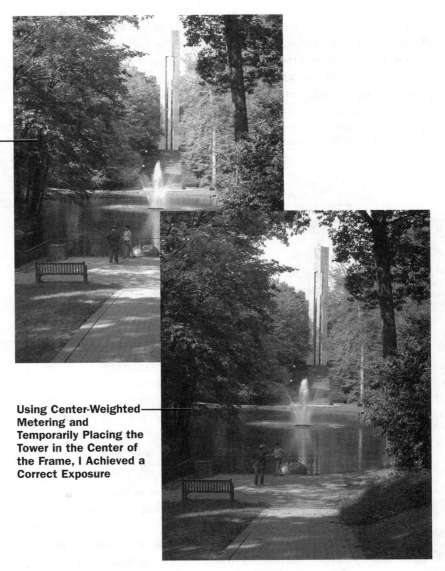

The Dominant Shade in This Scene Caused the Camera's Meter to Overexpose the Image

Using Center-Weighted Metering and Temporarily Placing the Tower in the Center of the Frame, I Achieved a Correct Exposure

Selecting the proper metering mode enabled me to get a proper exposure.

Highlight your subject by placing it on a contrasting background—for example, if the subject is a pair of white doves, they'll look more striking (and therefore, more interesting) if you shoot them against a dark background. Likewise, a dark silhouette is eye-catching when placed against a very light sky. Always, always watch the light.

Light that comes from behind a subject is called *backlight*. You can exploit backlight to your advantage, creating a silhouette that isolates and draws attention to your subject. Light from behind that also falls through translucent objects such as feathers, hair, sea shells, grass, leaves, and so on adds a glow which draws the eye.

The backlight behind this duck accentuates its form and makes the ripples in the water more dramatic.

Getting the Right Exposure

The amount of light used to capture an image is called the *exposure*. Typically, you'll set your camera to auto or program mode, in which the camera measures the amount of light in the scene and selects the appropriate exposure automatically. The exposure is determined by a combination of the f-stop (also called the aperture or lens opening) and shutter speed. In auto and program mode, the camera sets both the f-stop and shutter speed for you; in program mode, you can make adjustments such as exposure compensation, flash compensation, manual focus, and so on to the calculated exposure settings.

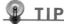 **TIP**

You'll find that early morning and late afternoon sun is much softer and more colorful than the harsh light at noon, so plan your photographic sessions for those times—especially if you want to photograph people, who look awful with dark noonday shadows accentuating their noses, chins, and the bags under their eyes.

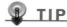 **TIP**

When shooting into backlight, add a lens hood to prevent lens flare and glare from the bright light.

 KEY TERM

Exposure—The amount of light used to capture an image; the exposure depends on the aperture and shutter speed settings.

NOTE

The smaller the f-stop number, the *larger* the aperture and the more light you record. F-stops typically include f2, f2.8, f4, f5.6, f8, f11, f16, f22, f32, and f64, although digital cameras only offer a limited number of f-stops such as f2.8 through f16. Most also offer "half-stop" increments such as f3.5.

KEY TERM

Aperture priority mode—A camera setting in which the user sets the desired aperture, and the camera selects the appropriate shutter speed.

One way to adjust the exposure manually is to change the f-stop or aperture. A large aperture such as f2 helps you capture images under low-light conditions because more light enters the lens through the large opening; a smaller aperture such as f16 is more appropriate for daylight conditions, when you don't need to let as much light in to capture the image. The largest aperture (f-stop) your camera uses is typically displayed on the front of the camera lens like this: 1:2.8–4.9, where 2.8 is the largest f-stop available in normal mode and 4.9 is the largest f-stop available in zoom mode. Moving from f2.8 to f2 (one f-stop) doubles the aperture opening.

When the camera is set to auto or programmed mode, the camera's meter determines the f-stop and shutter speed to use given a particular lighting condition. If you want to choose your own f-stop, switch to *aperture priority mode.* You'll most likely use this mode in situations where you want to also control the depth of field (as in portrait photography). To isolate a subject from its background (including other people who may be near by), use a shallow *depth of field*. To create a shallow depth of field, change to aperture priority mode and select a large aperture such as f4.

A shallow depth of field improves this candid portrait.

A wider depth of field might include not only a subject standing 3 feet away, but also her surroundings in the background 10 feet behind her. For example, you've finally made it to Paris and you'd like a shot of you and your friend standing in front of the Eiffel Tower. Because you need a

large depth of field to get you and your friend *and* the Eiffel Tower in focus, you should change to aperture priority mode and select a small aperture such as f11 or f16.

Shutter speeds on most digital cameras range from a slow 1 second to a fast 1/1000th second. Moving from a shutter speed of 1/60th second to 1/125th second doubles the speed at which the shutter opens and closes. A fast shutter speed such as 1/1000th second helps you catch the action; a slow shutter speed such as 1 second is perfect for motionless subjects. Sometimes you might want to choose a slightly slower shutter speed than normal to capture some blur with a fast-moving object; the blur will help the photo convey the speed at which the object is moving.

Using **shutter priority** mode, you can set the shutter speed to a particular value and let the camera select the appropriate aperture. Choose shutter priority mode in situations where capturing the action is the most important element of a scene. Most cameras also offer a **bulb mode** (timed-exposure mode) that's useful when capturing fireworks, the night-time sky, and other subjects under low-lighting conditions. Be careful about using bulb mode, however—exposures of longer than a second or so often result in added noise (graininess).

Proper exposure is the combination of a particular shutter speed and aperture, given the current lighting conditions. If the camera suggests an exposure of f11 at 1/125th second, you can increase the shutter speed by two stops to 1/500th second (to freeze a horse and rider, perhaps) and increase the aperture by two stops to f5.6, and achieve the same exposure.

Controlling Depth of Field

You can exploit this relationship between aperture and shutter speed to create the effect you want. If you are shooting in low-light conditions, for example, and you want a larger depth of field so that you capture not only the lovely bride but the crowd of well-wishers standing around her, you can combine a smaller aperture such as f11 (which creates a larger depth of field) with a slower shutter speed (for more light-capturing ability), and still get the shot.

Two other factors can jointly affect depth of field: the **focal length** of the lens and the camera-to-subject distance. For example, as you zoom in on a subject (zooming in creates a longer focal-length lens), you lose depth of field. Most photographs of professional models are taken this

NOTE

F-stop (aperture) and shutter speed are interrelated; when you set a large aperture, the camera compensates by selecting a fast shutter speed to prevent too much light from being recorded; the end result is a well-exposed image.

KEY TERMS

Shutter priority mode—A camera setting in which the user sets the desired shutter speed, and the camera selects the appropriate aperture.

Bulb mode—Otherwise known as timed exposure, bulb mode holds the shutter open for as long as you press the shutter release, allowing you to capture more of the available light. Light sources that move during exposure are seen as streaks of light.

 TIP

Keep in mind that as you slow the shutter speed, your ability to hold the camera still will diminish, so use a tripod in this situation.

way, with the photographer standing off a short distance and using a zoom lens to shorten the depth of field. The advantages here are twofold: By moving away, you create the illusion of privacy for your subject, and by shortening the depth of field, you blur the background and place the interest on the subject itself and not what's behind it. A shallow depth of field, however, requires a more precise focus, or the subject will appear less sharp. To get a greater depth of field, zoom out. In addition, as you move closer to a subject (shortening the camera-to-subject distance) and then adjust your lens to refocus on the subject, your depth of field becomes more shallow. To increase depth of field, move back from your subject and refocus.

Metering the Exposure

When you take an image in Auto mode, the camera determines the exposure, but how? It takes a measurement of the light within the frame and bases the aperture and shutter settings on that measurement to achieve a good exposure. A good exposure, in this case, is when the lights and the darks and all the tones in-between average out to a middle gray. How your digital camera normally takes its light measurement varies from camera to camera, but typically, *matrix metering* is used by default. In matrix metering (also known as evaluative light, multi-pattern, or digital ESP metering), the light from various zones is measured and compared to a library of typical compositions to create the best exposure. This allows the camera to take into account various factors such as actual focal point, subject distance, front and back lighting conditions, and so on. This metering method is good for most purposes, especially when there aren't any large very dark or very light areas in the scene.

Although the matrix metering system is pretty smart, it can't always come up with the correct exposure for every scene. In such a case, you'll want to switch to a different metering method such as *center-weighted metering*. With center-weighted metering, the light from the entire scene is measured and averaged together, with the light measurements from the center of the frame emphasized more than the measurements from the outer edges. This type of metering method is especially useful when your subject dominates the center of the frame, as in most portraits, and is much lighter or darker than the surrounding area. If your subject is not in the center of the frame, don't fret—simply center the subject in the frame, press the shutter release halfway, let the camera take its meter reading and adjust the focus, and then reframe the image, placing the subject where you want it and fully pressing the shutter to take the shot.

KEY TERMS

Matrix metering—Also known as multi-zone, multi-pattern, or evaluative metering. Light is measured within various zones and compared to typical compositions.

Center-weighted metering—Light is measured from the entire frame, with the light measurement from its center taking precedence.

With complex patterns of light and dark such as this landscape, matrix metering often works best at creating the proper exposure.

Spot metering limits the light metering to the very center of the frame (roughly 3% of the total area). Again, you can reframe the subject after pressing the shutter halfway and letting the camera take its measurement from the center of the frame. Although selecting the ideal spot to meter on is often difficult, you can use this metering method when the light around the subject differs greatly from the light falling on the subject (for example, the sun setting on a dark horizon, or a shaft of light cutting into a cavern). Use spot metering in situations where you might use center-weighted metering (such as a bright subject against a dark background), but want to meter a smaller area of the frame. This mode is also useful when taking photos of close subjects, where precise light metering is desirable. Some cameras offer a variation of this mode as well, linking the current focus area to the area to be metered, resulting in perhaps an even more precise exposure. For best results when using spot metering mode, keep the following in mind:

- Don't meter on the brightest object in the scene, or you'll get an underexposed image. Instead, meter just to one side of the lightest object. If the overall scene is important (as in a landscape), but the

lighting is tricky, meter on an object of light-medium value (not light, but not medium or dark).

- You might want to increase your chances in getting a good image by *bracketing the exposure*. This is especially important if you have spot metered on something that is not of medium value, such as a bright face. You can do this with most digital cameras by adjusting the exposure value plus or minus a particular amount. See the next section for more detail.

Some cameras offer a feature called AE Lock, in which you can lock in the exposure reading for a series of photographs. This is especially useful when creating a panorama from a sequence of images.

To get a proper exposure on a close subject under tricky lighting situations, change to spot metering and meter on the subject only.

Adjusting the Exposure Value

Most good digital cameras offer you the ability to adjust the exposure by small amounts, plus or minus. If you set the exposure value to +1, for example, you get the same effect as if you moved up one f-stop (to the next largest aperture setting) or if you decreased the shutter speed by half (increasing the exposure time). The effect of increasing the exposure value, therefore, is to increase the amount of light the camera records. Suppose that the camera metered the scene and decided on an exposure of f11 at 1/125th second. If you adjusted the exposure value to +1, it

would be the same as an exposure taken at f8 at 1/125th second or f11 at 1/60th second (see the chart below). You can also adjust the exposure downward, essentially underexposing the image.

Standard F-stops	Standard Shutter Speeds
f1.4 (large aperture)	1/500 (fast)
f2.0	1/250
f2.8	1/125
f4.0	1/60
f5.6	1/30
f8	1/15
f11	1/8
f16	1/4
f22	1/2
f32 (small aperture)	1 (slow)

Why play with the exposure value when you can change the aperture or shutter speed? First of all, adjusting the exposure value is fast and simple and makes the camera do most of the work, assessing the default exposure settings based on its meter readings. You can adjust the exposure value to compensate for complex metering situations, such as images with areas of high contrast or complex patterns of light and shade. Secondly, adjusting the exposure value allows you to essentially choose an aperture or shutter speed that might not be otherwise available to you. Finally, playing with the exposure value allows you to bracket the exposure through a series of images. To do that, you start by first taking the shot without adjustment, then adjusting the exposure value by +1/3, for example, and taking the same shot, then repeating this process with a +2/3 adjustment, and so on.

Here are some situations in which you might want to *increase* the exposure value, because not doing so would allow the meter to be fooled by the light conditions and unintentionally underexpose the photo:

- Large white or yellow areas that dominate the foreground or background

- At sunrise or sunset, when you have a bright central object and a darker landscape

- Images with high contrast

 TIP

Some cameras offer an auto-bracketing mode, which adjusts the exposure value for you automatically as you take a series of images (typically three or five).

- Snow scenes, beach scenes, or water scenes with lots of reflection and bright light

- When the subject has bright reflective areas, such as a piece of jewelry, a building with reflective windows, or a shiny metal baby cup

- Close-ups of bright subjects

- A subject that's standing in front of a very light background such as a white sky, sandy beach, or a snow-covered hill

TIP

If you are trying to capture an image that contains a lot of high contrast (very dark darks and very light lights), let the subject fill the frame as much as possible, then adjust the exposure for that subject. For example, if the subject is in a shadow area, increase the exposure by two stops (+2). If the subject is in the very light area, decrease the exposure two stops (–2). You can also try lightening the shadows with a flash, as explained in the upcoming section.

Here are some situations in which you might want to *decrease* the exposure value, because not doing so would allow the meter to be fooled by the light conditions and unintentionally overexpose the photo:

- Dark woods or forest scenes

- Large, dark objects dominating the frame, such as a large, black Labrador or a big, black train engine

- Large areas of shadow

- Subject standing in front of a dark background

- Dark, early morning or early evening landscapes

Adjusting ISO

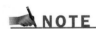

NOTE

How exactly do you increase the light sensitivity in a digital camera that doesn't use film? When you select a higher ISO setting on your digital camera, it simply boosts the signal coming from the CCD or CMOS chip (the light recorder). This boosts not just the light values but the dark ones as well, increasing the amount of noise.

When taking an image using a film camera, the exposure is determined by taking the sensitivity of the film into account. Film rated at ISO 100 is considered normal in terms of light sensitivity. Most digital cameras work in a mode that's equivalent to using ISO 100 film. As you may know, if you use a film with a higher ISO rating such as ISO 200 or ISO 400, its sensitivity to light is increased, and you don't have to worry as much about taking photos in low-light conditions. As a film's sensitivity is increased, however, so is the apparent film grain (dot pattern) in the resulting printed image. It happens that way in digital cameras as well.

If you increase the ISO rating for your camera (essentially changing the camera's apparent sensitivity to light), you can shoot in low-light conditions and capture images you might not have been able to otherwise, but the trade-off is added graininess in the resulting photo. For example, if you can't get a good image of your son at dusk, try increasing the ISO setting on your digital camera and reshooting. You may notice some additional graininess, but if you use the highest resolution on your

camera, you can compensate for this somewhat and you'll at least get the picture. With high-end digital cameras, you may not notice much graininess at all when you switch to a higher ISO setting, provided the light is not too low *and* you use the camera's highest resolution setting.

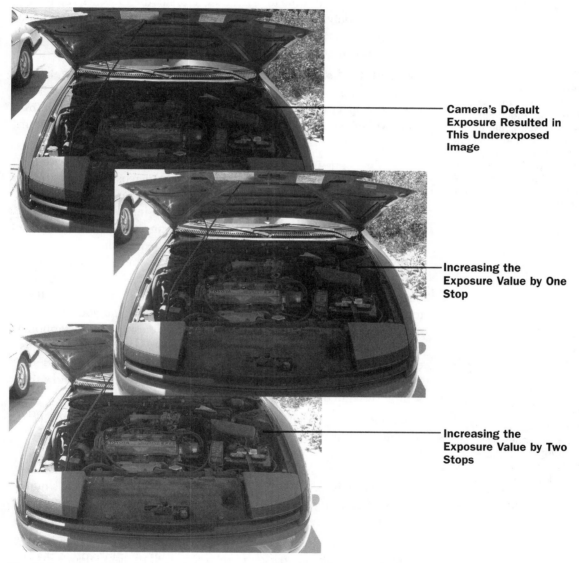

Camera's Default Exposure Resulted in This Underexposed Image

Increasing the Exposure Value by One Stop

Increasing the Exposure Value by Two Stops

The high contrast between the bright surroundings and the dark engine created an average exposure that left the engine too dark to show much detail. I compensated for this "average" by increasing the exposure value.

3 About Getting Creative

Before You Begin

✔ **1** About Photography

✔ **2** About Lighting

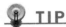 **TIP**

Tilting the horizon is an interesting effect. For example, you could tilt the camera and take a picture of your daughter peddling her new two-wheeler, playing the drums for a garage band, or doing tricks on her skateboard.

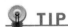 **TIP**

Slow the shutter speed to about 1/250th second to take a picture of a propeller-driven airplane or a helicopter in flight—you'll retain the motion of the propeller blades while still capturing a clear image of the aircraft itself. If you don't slow the shutter speed, the airplane or helicopter will look as if it is hung on a string, frozen in the air.

If you read the previous two tasks, you learned a lot about the "rules" of photography. Now that you have more confidence in your digital camera and yourself, it's time to learn how to break the rules. As you'll see, there are no rights or wrongs in photography, just good, interesting photographs and boring, poorly composed ones. In this section, I'll give you some ideas you can use to liven up your images.

Play with the horizon. When composing a landscape photograph, one thing you might want to play with is the horizon. If you place the horizon in the upper third of the frame, the objects on the ground or in the water will take on more importance. Place the horizon in the lower third of the frame, and the sky becomes more important.

Adjust the exposure. There are all sorts of reasons for playing with the exposure. For example, you might deliberately increase the ISO rating to add more grain, creating a gritty sense of realism or a vintage old-time look, depending on the subject. Underexpose an image (by changing to a smaller aperture or a faster shutter speed than the camera's meter suggests for the current lighting conditions), and create a dramatic silhouette of a building, statue, or piece of art. Skies are more dramatic when underexposed as well. Overexpose an image (by choosing a larger aperture or slower shutter speed) of candles, street lamps, or Christmas lights to create a vibrant glow. Decrease the shutter speed, and you can easily make your child's bicycle look as fast as a race car by introducing some blur. Shooting a waterfall with a slower shutter speed helps to retain its movement, rather than freezing the water with a fast shutter speed. Want to capture the feel of being in a rain or snowstorm? Just slow the shutter speed to about 1/60th second.

Add interest to a typical architectural photo by slowing the shutter speed and blurring the passersby. Use a super slow shutter speed to blur the headlights of cars as you take a photo of a beautiful California coastline at dusk. The lovely light patterns you'll capture will help define the barely visible coastline. Tired of the old vacation photo? Try slowing the shutter speed and zooming in on a subject just after you press the shutter release. The zoom will cause a slight blur that leads the eye right to your subject.

Don't forget that the aperture setting is the other half of the exposure formula. To isolate one person in a large crowd, try using a large aperture to create a small depth of field. Or choose a small aperture to create a depth of field large enough to photograph a long line of pies at the fair, all in perfect focus.

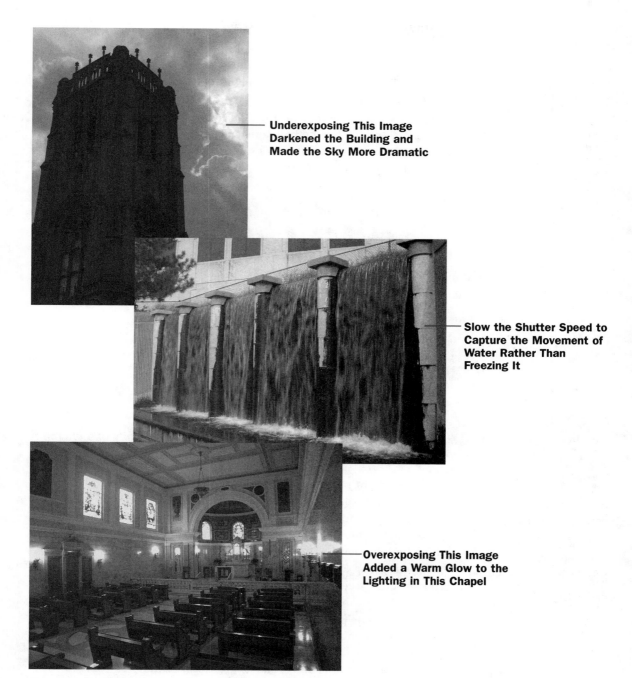

Underexposing This Image Darkened the Building and Made the Sky More Dramatic

Slow the Shutter Speed to Capture the Movement of Water Rather Than Freezing It

Overexposing This Image Added a Warm Glow to the Lighting in This Chapel

By playing with the shutter speed and aperture settings, these images were made more dramatic and memorable.

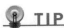

TIP

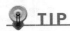

Take your own photo in a mirror. Stand near several dressing room mirrors and capture multiple reflections for a kind of kaleidoscope effect. Take a picture of someone wearing mirror sunglasses, and capture the surrounding scene through their "eyes."

Make use of nearby reflections. Reflections off metal, glass, or water can be used to make a photo more interesting. For example, instead of shooting a cabin by a lake, you can capture the cabin's *reflection* in the lake. Add your son's reflection as well, and you've got an unusual vacation photo. Don't worry if the water isn't perfectly still—a few ripples just might make the shot more artistic. Instead of shooting the band in the bleachers, capture the football game reflected in the tuba's large horn. Take a photo of the newlyweds or the church reflected by the limo's mirror or its highly polished surface.

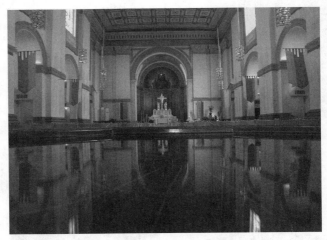

The water in this baptismal font reflects the cool serenity of a church in the late afternoon.

TIP

Play on the contrast between textures where possible. For example, the smoothness of an egg is more intriguing when contrasted against the rough texture of the grass in an Easter basket.

Play with light and shadow. Shadows, and the way in which light plays across a scene, can be used to add texture and drama to a photograph. For example, you could shoot your daughter walking to the school bus on her first day, backlit by the early morning sun, and casting a long shadow behind her. The shadow acts as a visual tool to lead the eye right up to the tiny, dark figure of a little girl on her big day. The shadow of a picket fence falling across a sidewalk or a beach umbrella's shadow falling on the sand can make an ordinary image seem extraordinary. Even the play of shadows across a face can make an outdoor portrait intriguing. Shadows give an object shape and texture. Move your position so that the light falls on one side of an object, and you'll draw out the shadows and make its texture more apparent.

The play of shadows across the sidewalk lends a tranquil air to this garden scene.

Change the angle. The angle at which you shoot your subject can be used to make even an ordinary photograph more memorable. Shoot your dad from a lower angle to make him look more powerful. Shoot a horse, dog, or even your flat bed truck from this same angle, and it'll seem majestic. Shoot down at a subject to make it seem less important or fragile. Hitchcock often changed to this point of view to remind the viewer that his stars were just ordinary human beings like us. Shoot from over someone's shoulder, and capture the subject and its environment. For example, if you shoot over your daughter's shoulder, you can capture her efforts in baiting a hook while also including the lake, the boat, and the pile of fish she's caught.

Create special effects with various lenses. Special lenses can help you capture a unique point of view. A wide-angle lens pointed down at a truck bed will make it seem longer. A wide-angle lens pointed up at a building will make it seem less tall. That's because with a wide-angle lens, close objects seem to grow, while far objects seem to shrink. Close objects also seem more far away. A zoom lens will get you right smack onto the action on the football field, but you can also use it with closer subjects to get a larger depth of field. For example, you could shoot your

 TIP

Want to make an armload of presents seem overwhelming? Just shoot downward, and the person carrying them will seem smaller while the stack of boxes will seem larger by comparison.

TIP

If you point a fisheye lens up or down, you can exaggerate its ultra-wide view. For example, point a fisheye lens down at a city skyline while standing at the top of a very tall building to capture the wide panorama.

son in a field of flowers from a few feet away, and capture the detail in every petal. Move back some distance and reshoot, and the flowers will be blurred. They will also appear to surround your son, because objects appear closer together when viewed through a long zoom. A full-frame fisheye lens can be fun; point one at a table of pottery at a local art show, and you can emphasize the pottery while also capturing the seller, the rest of the booth, and even the passersby.

Shooting from this angle makes this bell tower seem larger and more powerful.

4 White Balance the Camera

Before You Begin

✔ **2** About Lighting

See Also

→ **5** Take a Basic Picture

KEY TERM

White balance—To adjust the color balance of the camera to the current lighting conditions so that the colors in the resulting photo are "true."

Light comes in different color temperatures, measured on a Kelvin scale; incandescent light (which casts a yellow glow) is about 2500k, daylight on a sunny day (which is white) is about 5500k, a fluorescent light is about 6300k (and casts a slightly bluish light). Thus, if you take a picture of someone lit by a table lamp, with your camera set for Daylight white balance, their skin may look yellowish. Take a similar photo using the fluorescent lighting in your kitchen, and their skin will look greenish. Your digital camera can adjust its data input to account for color shifts caused by a changing light source, using a process known as *white-balancing*. Properly white-balancing the camera before you take a picture eliminates undesired color casts in the final image.

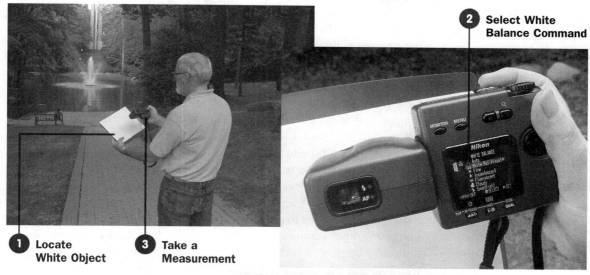

2 Select White
Balance Command

1 Locate
White Object

3 Take a
Measurement

 4 View the
Result

Original Image Is Too Blue

Natural Color Is Restored After White
Balancing the Camera

Some cameras typically reset the white-balance to Auto whenever you power them on. Others set the white-balance to Auto *only* when you change to Auto shooting mode, which means that they often retain the last white balance setting you choose for long periods of time. When the white balance is set to Auto, the camera automatically adjusts the white balance to match the current lighting conditions each time you take a

TIP

If conditions change after you white balance the camera (you move indoors or it starts to cloud up, for example), be sure to white balance the camera again.

shot. Even so, you may still see color shifts in your final images, especially when the lighting is mixed (bright sun and deep shade, or sunlight mixed with artificial light). To ensure the best color in all your images, white balance the camera every time you turn it on *and* whenever the light changes.

One method in which you can adjust the camera for differences in color temperature is to select the white-balance option from the camera's menu, and to choose a setting that matches the current lighting conditions from the submenu that appears, such as Tungsten (indoor), Daylight, Fluorescent, or Cloudy. The white balance setting you select remains in effect until you choose a different setting, select a scene mode from the Mode dial, turn on the flash, or turn off the camera. In situations when you want to give the camera more precise lighting information, most digital cameras allow you to white balance the camera manually by pressing a button and pointing the camera at something white. This is the method I'll show you in this task.

① Locate White Object

Locate a white object lit by the same light as your subject, or position a white card near the subject so that the card is lit by the same light as your subject.

② Select White-Balance Command

Open the camera's menu and select the white balance command. You should see a submenu of other choices. Select the command from this submenu that allows you to set the white balance manually—look for Custom, Measure, Hold, Manual, or a similar command.

If your camera does not allow you to manually white balance, simply select the most appropriate command from this submenu, such as Cloudy. Then skip step 3.

③ Take a Measurement

Point the camera at the card or other white object. If necessary, select the Set White Balance command (or something similar) from the camera's menu. Press Enter on the navipad to take a light measurement.

④ View the Result

The color in the first photo was bluish because I had white balanced the camera for Daylight, where it was expecting the bright light of a nice sunny day. The conditions, as you can see, were dense shade. I could have tried the white balance setting, Cloudy, but I decided to manually white balance instead since there were patches of bright sun mixed in with the dense shade. After white balancing, I was able to snap a nice photo of my brother, Mike.

5 Take a Basic Picture

Digital cameras are usually set up, right out of the box, to use Auto mode—a point-and-shoot mode that calculates the proper aperture, shutter speed, and flash output needed to capture the image. Even if you choose to use Auto mode, there are still some basic steps you should take to ensure a good result. In this task, you'll learn the steps to follow each time you take a picture—whether you want to manually adjust the exposure to suit the current lighting conditions or you choose to go automatic.

Before You Begin

✔ **1** About Photography
✔ **2** About Lighting
✔ **4** White Balance the Camera

See Also

→ **6** Take a Still Image with a Digital Camcorder

① Pre-visualize the Photo

What is it that you want to take a picture of? What moment do you want to capture—looking at the cake or blowing out the candles? Each moment requires its own camera settings. When you've decided what you want to take a picture of, get into position, and as you do, take note of the lighting conditions: Is it sunny, cloudy, or deep shade? If you're indoors, take note of the type of artificial lighting being used—is it incandescent or fluorescent? Can the subject be moved to take advantage of the available light? Will you have to use a flash or a large aperture to capture the scene?

② Set the Exposure

Select Auto mode on the Mode dial (which sets both the aperture and shutter for you) or choose Program Auto/Program AE or Manual to let the camera set the exposure but allow you to make adjustments such as white balancing, exposure compensation, matrix metering, and flash output. You can also set the exposure by selecting a particular scene mode, such as Landscape or Night Portrait. For more control, select *aperture preferred* or *shutter preferred* from the menu. If you're using aperture/shutter preferred, select the aperture or shutter speed desired.

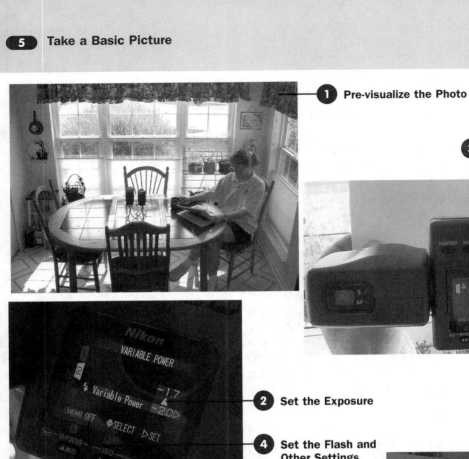

1 Pre-visualize the Photo

3 White Balance the Camera

2 Set the Exposure

4 Set the Flash and Other Settings

5 Support the Camera

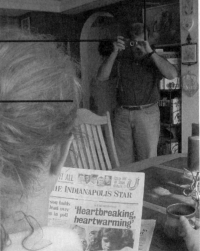

7 Take the Picture

6 Frame the Image and Prefocus

8 View the Result

3 White Balance the Camera

If you selected Auto in step 2, you will not be able to change the white balance. Instead, it will be set automatically by the camera. In mixed lighting conditions, it's best to select a white balance setting yourself, rather than letting the camera guess. If the lighting has changed since the last time you set it, set the white balance again as described in **4** White Balance the Camera.

4 Set the Flash and Other Settings

Normally, the on-camera flash will fire if the camera decides there isn't enough light available. Depending on the lighting situation and the result you are looking for, you may want to use the appropriate button or menu command to force the on-camera flash off, to force it on, to adjust its output, to allow an external flash to be used, or to switch to slow sync flash to capture some of the natural light after the flash has fired (see **23** Capture Fireworks and **34** Shoot a Nighttime Portrait). Make other changes as needed, such as switching to a different resolution or changing the ISO setting (you might not be able to make certain changes in particular scene modes).

5 Support the Camera

Support the camera from underneath horizontally with your left hand; support it vertically along the side with your right hand. Place your right index finger on the shutter release, and brace your right thumb on the camera's back. Be careful not to block the lens or the flash sensor. You can frame the view using the LCD, but using viewfinder instead (especially at slow shutter speeds) will allow your forehead to also support the camera.

6 Frame the Image and Prefocus

Zoom in or out as desired. Place your subject in the middle of the frame, within the AF (Auto Focus) frame, press the shutter release halfway down, and hold it there, as you allow the camera to focus and take a light reading on your subject. The camera will indicate that it has achieved focus with a steady (non-flashing) green light next to the viewfinder. It may also indicate focus by beeping or displaying an icon on the LCD monitor. If you can't get the camera to focus because you are too close to the subject, back up and try again.

TIP

If you have sunlight coming in from a window as well as some artificial light from a ceiling fixture, select the predominant light source from the White Balance menu or hold a white card up to the subject and manually white balance the camera using the white card.

NOTE

If people are included in the composition, you may want to turn on red-eye reduction if you are using a flash. Also, if you are using a special lens such as a wide-angle lens, you must tell the camera that a different lens is attached by selecting the appropriate menu command.

NOTE

The best camera support is a tripod. A small tabletop tripod can obviously be placed on a table or low wall, but it can also be braced against a vertical wall, or even against your chest to help you hold the camera steady.

 TIP

If the camera won't focus for other reasons—the subject is too reflective (metallic) or not reflective at all (dense fur), doesn't contrast well with the background, has no vertical lines, has no substance (such as smoke), is behind a window or a fence, or there is a high-contrast object near the subject in the frame but located at a different distance from you—try focusing on something roughly the same distance from you as your subject. See **12** **Shoot Through a Fence** for more information on this technique.

After achieving focus, and while still holding the shutter release halfway down, reframe the image as desired. Be sure to fill the frame with your subject, either by using the zoom or moving closer. Make a note of any background distractions, and reposition and reframe as needed.

7 Take the Picture

Draw a breath and let it out slowly as you squeeze the shutter gently. Do not stab at the shutter because this may cause camera shake. As you choose your moment, realize that there may be a small lag between when you press the shutter and when the camera takes the picture. Remember also that it takes awhile for the camera to save the image, so you won't be able to take another picture right away.

8 View the Result

View the image on the camera's LCD screen. Look for image sharpness, framing, brightness, and contrast. If desired, reshoot the image (after adjusting camera settings as needed). Here, I had mixed lighting conditions: bright sunlight behind an indoor subject. So I white balanced with a paper held close to the subject's face, adjusted the flash's power to act as a gentle fill, and changed to Program Auto mode so that I could shoot the picture using the camera's automatic exposure settings.

 6 Take a Still Image with a Digital Camcorder

See Also

→ **5** Take a Basic Picture

If you own a digital video camera, you're probably already aware that it has the capability of taking a still photo. If you're going to an event and you don't feel like lugging around a lot of equipment, leaving your still-frame camera behind may sound pretty tempting. Just keep in mind that a digital video camera is not designed specifically for taking still photos, and as a result, the quality in such photos is usually pretty low. In other words, the photos you take with your digital video camera may be good for email or Web usage, but not for "keepers" you might want to print later in a decent size.

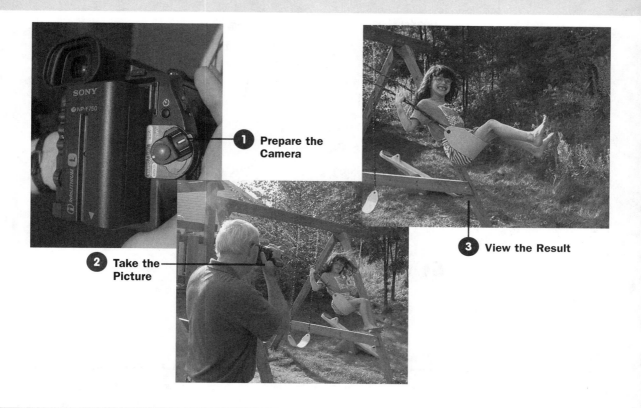

1 Prepare the Camera

2 Take the Picture

3 View the Result

The photo-taking process varies by digital video camera, but basically you activate still mode, press a shutter release button (one that's separate from the start/stop video button), and record the image. With some cameras, you might be able to do this while simultaneously recording a video; with other cameras, you'll have to pause or stop recording, change to still mode, and then take the picture. Typically, you have to be in fairly bright light to record still images unless your digital camcorder has a flash accessory for use with still image photography.

1 Prepare the Camera

White balance the video camera if you have not already done so. If your camera does not record still images onto the tape, be sure that the memory card is loaded. Select the photo resolution you

NOTE

Depending on your digital video camera, you might have to store digital photos directly to a memory card, instead of to the digital video tape.

TIP

Even if your video camera allows you to record an image to tape (with audio), you might not want to do that because the quality of such images is very low.

TIP

Some digital video cameras allow you to "grab" a still image from video as you are playing it back. See the camcorder manual for help.

want from the camera's menu system (use the highest resolution offered for best results). If you don't want to record the image to tape and your camera offers the option to record onto a memory card instead, change to Memory, Card, Still, or Photo mode. If you are recording the image to tape, set the recorder on Record or Pause mode.

② Take the Picture

Press the Photo, Still, Photo Shot, or similar shutter release button halfway to allow the camcorder to focus and adjust the exposure, then press the button the rest of the way to record the image. This shutter-release button is typically located near, but separate from, the video Record button.

③ View the Result

No need to miss that perfect shot just because you have only your camcorder with you.

7 Take a Short Digital Movie

See Also

→ **6** Take a Still Image with a Digital Camcorder

KEY TERMS

QuickTime—A popular cross-platform digital movie file format created by Apple. When you create a QuickTime movie using your digital camera, anyone with a QuickTime player (downloadable for free through the Internet) can view it.

Motion JPEG—A re-interpretation of the popular MPEG movie format, using the JPEG compression algorithm.

Many digital cameras allow you to record a short movie. Bear in mind, of course, that recording video is not your digital camera's main purpose, and as a result, the quality is not as good as you can get with a camcorder. Still, it's often handy to be able to record the action at an event, regardless of the quality. And it's certainly better than having to lug both your digital camera and your camcorder with you. Note that the length of the digital video you will be able to record using your camera is by necessity quite short (typically only a minute or less). Also, keep in mind that the camera's flash will not work during video recording, so there must be adequate light to record the video properly. The resulting digital video is usually saved in *QuickTime* format (a common video format used by most computers) or *Motion JPEG*.

Most digital cameras can record sound with your short movie, although some cannot, so keep that in mind when choosing what you'd like to record. If your camera supports sound recording, I recommend that you use a lavaliere microphone, equipped with a wind sock, for best sound quality. If you have to use the on-camera microphone, protect it from the wind by taping a piece of paper or a small card to the sides of your camera to block the wind.

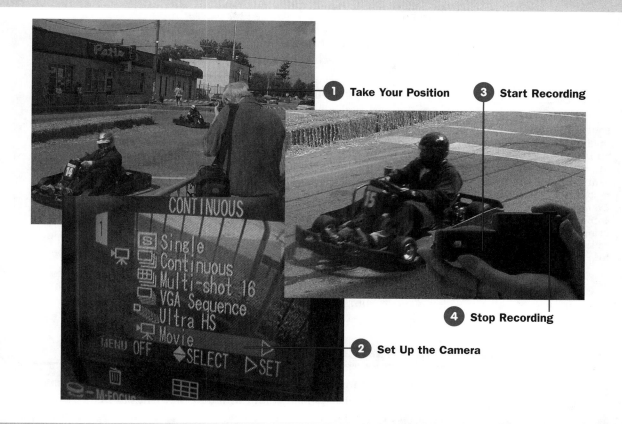

1. Take Your Position
3. Start Recording
4. Stop Recording
2. Set Up the Camera

CONTINUOUS

1
- Single
- Continuous
- Multi-shot 16
- VGA Sequence
- Ultra HS
- Movie

MENU OFF ◆SELECT ▷SET

① Take Your Position

Decide what you want to record, compose the shot, and get into position. You'll want to be ready to start before the action does.

② Set Up the Camera

Before recording the video, white balance the camera if needed (for some cameras, the *white balance* is set automatically as soon as you begin recording). Be sure that you have selected the appropriate video recording mode (NTSC for United States, Japan, and non-European countries or PAL for Europe) from the camera's menu system.

NOTE

Select other settings as desired, such as the resolution (which also determines the maximum length of the video you can record) and audio options (sound on or off).

Using the Mode dial or the camera's menu system, change to Movie or Video mode. A movie camera or similar icon appears on the LCD to indicate that you are now in video recording mode.

NOTE

If you choose to record sound with the video, you might not be able to zoom during the recording (recording sound might prevent the camera from also recording the zoom action). Even without sound, some cameras allow you to zoom using only the digital zoom, which you might have to turn on manually.

③ Start Recording

Zoom in or out as needed to properly frame the action. Keep in mind that you might not be able to change the zoom while recording. *Before the action starts*, press the shutter release to start recording. Some cameras require you to continue to hold down the shutter release while recording.

④ Stop Recording

After the scene has ended, release the button (if you've been holding it down) or press it again to stop recording. If you don't stop the recording yourself, the camera will stop it when the maximum recording time has elapsed. To watch the video, select playback mode from Mode dial.

8 Shoot a Fast-Moving Subject

Before You Begin

✔ **1** About Photography

NOTE

The quality of the images you capture using Burst or Continuous mode is often less than you get when you take the images one at a time. In addition, you may not be able to use the flash while in this mode. Still, in particular situations, you may find Burst/Continuous mode useful for capturing action photos.

Sometimes a subject just won't sit still for a photo, and you have to capture it "on the run." When dealing with a fast-moving subject (whether it's a race car, a dancer, or an uncooperative toddler), the most important element of your photo is sharpness. To control sharpness when taking a photo of a fast-moving subject, you increase the shutter speed, so you'll want to change to shutter-priority mode if your camera offers one. Even if you can't override your camera's shutter-speed selection, you'll learn some tricks in this task to help you capture your fast-moving subject successfully.

Some cameras have a Burst or Continuous mode, in which you can take a few images one right after the other. Using this type of mode may help you get the exact image you are looking for because it greatly reduces the lag time between photos. When shooting in this mode, the images are stored temporarily in the camera's memory. When memory is full, the camera stops for a short interval to record the images permanently.

❶ Pick Your Position

Consider whether you want to shoot as the subject is coming toward you, away from you, or as it passes, and pick your spot accordingly. Typically, you'll want to *pan with* the subject, so spread your feet and point the trailing foot in the direction the object is moving so that you will remain in balance after you twist.

If you are using a tripod, position its legs so that you won't trip over them as you twist. As you wait for the subject to approach, practice panning and adjust your body's balance and the tripod as needed.

❷ Set Shutter Speed

Change to *shutter priority mode* and select a shutter speed, or select a programmed mode such as Pan Focus, Sport, or Fast Shutter. If you are selecting the shutter speed yourself, then to freeze the subject and the background, select the fastest shutter speed your camera offers, such as 1/500th or 1/1000th second. To blur the background (and imply speed), reduce the shutter speed to 1/60th or even 1/30th second. Remember that taking a picture as a subject passes you requires a faster shutter speed than if you take the picture as the subject approaches or recedes from you.

❸ Pre-Focus the Camera

Press the shutter release halfway and point it at the spot where you intend to take your photo. This allows the camera to pre-focus and adjust its aperture setting as needed. Because the subject is probably not in the frame right now, focus on something roughly the same distance away, then reframe.

❹ Pan and Shoot

Point the camera to where the subject is coming from. Then pan with the subject as it passes, press the shutter release the rest of the way to take your picture, and continue to follow through. If you twist and shoot in one smooth motion without stopping, you'll reduce noticeable camera shake in the final image.

KEY TERM

Pan—To smoothly twist a camera along its horizontal axis so that a fast-moving subject is kept in the center of the camera frame, even as it moves past you.

TIP

If you are shooting a propeller-driven aircraft such as an old biplane or a helicopter in the air, shoot no faster than 1/250th second. You'll want to blur the blades of the aircraft or it will look as if it is hanging by a string. If you want to capture the feel of rain or snow as it is falling, shoot at 1/60th or 1/125th second, but no faster.

TIP

If you turn off the flash, the camera will take the picture just a bit faster after you press the shutter because it won't have to decide if a flash is needed.

1 Pick Your Position

3 Pre-Focus the Camera

2 Set Shutter Speed

4 Pan and Shoot

5 View the Result

5 View the Result

Check the image. If the subject is out of focus, try changing to Landscape mode, which automatically selects a large depth of field (with a small aperture and a fast shutter speed), and reshooting.

By selecting a shutter speed of about 1/60th of a second and panning as I shot this image, I kept the driver in sharp focus while blurring the background.

9 Shoot an Item You Want to Sell

Online auction sites abound, and if you have an item you want to sell, you'll need to take a photo of it. As you'll soon learn, you don't need a professional studio to take a picture that shows off your item's best features—just an observant and clever mind. One good place to start is to look at how professionals shoot advertisements of objects similar to the one you want to sell. For example, if you're trying to sell your car, look at car ads. What did the photographer use as a background? What kind of lighting, lens, and angle did the photographer choose?

Typically, to light the subject, you'll want to use as much natural daylight as possible, so either shoot outside in the morning or late afternoon, or near a south- or east-facing window indoors. You can then use your on-camera flash to fill in the shadows as needed. To focus attention on the object you want to sell, place it against a plain background that contrasts well with the item—you could place large items on a concrete or black tar driveway; you can place smaller items on a small table covered with a plain tablecloth, sheet, or blanket.

1 Set Up the Shot

Unless the object is really large, wait for a sunny day and then set up a card table inside your garage, near the door. This way you can use the bright, indirect light while minimizing harsh shadows. Cover the card table with a light or dark plain-colored tablecloth, sheet, or blanket and position your object. Consider adding a ruler or a penny to show the object's relative size. To ensure that you get the object in perfect focus, place your camera on a tripod no more than 6 inches above small items.

To soften any shadows and to bring out the detail in your object, lower the power of your on-camera's flash so that it can act as a fill. If your camera doesn't offer the option to reduce the flash output, you can also partially cover the flash with your finger or a white tissue to achieve roughly the same effect.

2 Adjust the Exposure

White balance the camera. Select the Slow Sync/Slow Shutter/Long Exp mode if your camera has one, or choose a large aperture and a slow shutter speed such as 1/15th second so that you can capture as much of the ambient light as possible. If necessary, change to Macro mode.

Before You Begin

✔ **2** About Lighting

See Also

➜ **10** Shoot a Highly Reflective Object

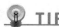 **TIP**

If the object is large, wait for a cloudy day or use the early/late afternoon sun to photograph it on a neutral background such as your driveway.

TIP

A ring flash (a flash that fits around the camera's lens in a ring) is useful in lighting products with diffuse light. If you plan to sell a lot of items through online auctions, you may want to purchase a ring flash (compatible with your camera) to help you easily light them without harsh shadows.

① **Set Up the Shot**

② **Adjust the Exposure**

③ **Take the Shot**

④ **View the Result**

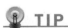 **TIP**

Be sure to take any detail shots you might need to show off your item's best features.

③ **Take the Shot**

Press the shutter release halfway to allow the camera to focus. Fill the frame with the object in a tight shot. Press the shutter release the rest of the way to record the image. You might want to use the self timer (if your camera has one) or a shutter release cord to help you avoid any possible blur and to increase object sharpness as you take the shot.

4 **View the Result**

To take the photo of the tape drive, I placed it on a TV tray, covered by a white laminated board left over from a home shelving project. Because the garage was well lit and I didn't want the flash to reflect off the drive's surface, I turned the flash off. I used a medium aperture (f8) and a medium shutter speed to capture the shot.

To take the photo of a baby's china set, I placed the item on a dark pillow case to create a nice contrast between it and the background. I had a friend hold one end of the pillow case up so that I would have a continuous background behind and below the item. I kept the same exposure settings but used my flash this time to illuminate the dark shadow inside the cup.

10 Shoot a Highly Reflective Object

Trying to take a good picture (whether for insurance purposes or because you want to sell it) of an object with a reflective surface is often difficult. That's because its surface reflects everything around it, including the flash, the camera, and you, the photographer. The trick to getting a good photograph is to surround the object with white so that it has nothing to reflect. Using a white tent also allows you to light the object with soft, diffuse light. You can easily create your own tent, as shown here, but if you plan on taking a lot of photos of a similar nature, you might prefer a specially built light cocoon or tent specifically designed for product photography, available at most camera stores or online.

Before You Begin

✔ **2** About Lighting

See Also

→ **9** Shoot an Item You Want to Sell

1 **Set Up Tent**

Place the object on a table, and cover the table with a white tablecloth or sheet. I happened to have a piece of white laminate left over from a home improvement project, so I used that. Next, I constructed a simple tent structure using a couple of flash stands, clothes pins, and a white sheet.

I placed the light tent outside to take advantage of the bright sun; if you use your tent indoors, you'll have to light it from both sides to create a diffuse light. You can use ordinary lamps (without lampshades) for that purpose, if they are bright enough.

TIP

If you don't happen to have to flash stands, substitute a coat rack, pole light, patio umbrella, microphone stand, bird feeder poles, or similar tall objects. You can also construct a light box by cutting large windows in a cardboard box and covering the inside and outside with white, translucent paper.

2 Adjust the Exposure

1 Set Up Tent

3 Take the Shot

Object Shot Without a
White Tent

4 View the Result

2 Adjust the Exposure

White balance the camera. Select the Slow Sync/Slow Shutter/Long
Exp mode if your camera has one, or choose a large aperture and
a slow shutter speed such as 1/15th second so that you can capture
as much of the ambient light as possible. If needed, change to
Macro mode.

❸ Take the Shot

Use clothes pins to wrap the tent material around the camera lens, creating a small hole through which you will shoot the photo. You don't want to give the object anything to reflect, so keep this hole small.

Press the shutter release halfway to allow the camera to focus. Fill the frame with the object in a tight shot. Slowly press the shutter release the rest of the way to record the image. You might want to use the self timer (if your camera has one) or a shutter release cord to help you avoid any possible blur and to increase object sharpness as you take the shot.

❹ View the Result

The first shot here shows what you get if you don't isolate the reflective item in a white tent—a reflection of the flash, the camera, the photographer, and the surrounding area. The second shot is much better—still clearly illuminated to show every detail of this baby cup, but minus the distracting reflections. To capture this image, I used a medium aperture (f8) and a medium shutter speed.

11 Shoot a Panorama

If a scene is too vast to capture in a single image, you can take several overlapping images instead and create a *panorama*. After taking a series of images, you can use Adobe Photoshop Elements or Jasc Paint Shop Pro Photo Album to stitch them together automatically. For more control, you can use Photoshop or Paint Shop Pro to manually combine the individual photos into a single wide image. If you take photos of the entire 360-degree view of an area, you can use a panorama program such as QuickTime VR Authoring Studio, Photovista Panorama, Ulead Cool 360, or Panoweaver to create a virtual reality, three-dimensional, 360-degree animated view.

Before You Begin

✔ **2** About Lighting

See Also

➜ **14** Shoot a Landscape

🔍 KEY TERM

Panorama—A series of overlapping pictures that are combined electronically into a single wide photo.

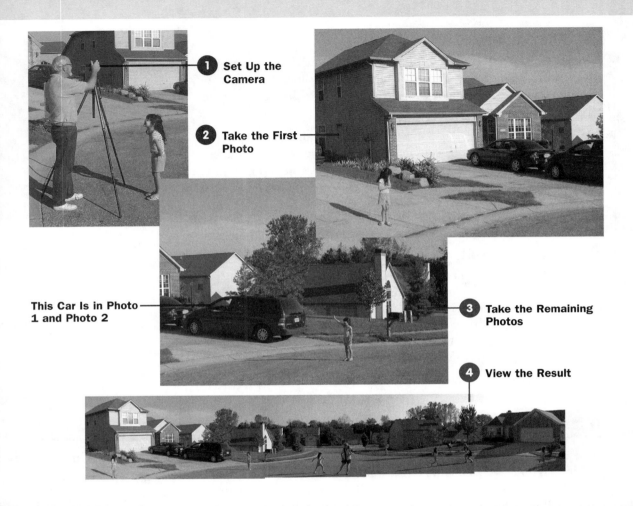

1 Set Up the Camera

2 Take the First Photo

This Car Is in Photo 1 and Photo 2

3 Take the Remaining Photos

4 View the Result

 TIP

When setting up the camera, try to find a location that will give you a series of interesting photographs, and not just a panorama. For example, at an air show, you could shoot the crowd, planes, runway, and so on. That way, you'll end up with usable individual photos *and* a panorama.

1 Set Up the Camera

Set the camera on a tripod and make sure that it is level with the horizon. White balance the camera and adjust the exposure. If your camera has a feature called Stitch Assist, Panorama, or AE Lock (auto exposure lock), turn it on. This feature allows you to use the same exposure values for each image in the series, giving the resulting panorama a more consistent look. For the same reason, if your camera has AF Lock (auto focus lock), use it to get a consistent depth of field.

② Take the First Photo

Point the camera at the furthest object on the left that you want to capture. Make a note of a significant feature you can include in the next shot, such as a particular tree, shrub, or building. Press the shutter release to record the first image.

③ Take the Remaining Photos

Frame the next image, being sure to include a dominant feature from the previous image. If possible, try to overlap the areas contained in the succeeding images by at least 30%. Press the shutter release to record the image. Repeat this step until you've captured all the images in the panorama.

④ View the Result

After using a graphics editor to stitch the individual images together, a super wide-angle view is created.

TIP

By including the same feature in adjacent images, the graphics editing software can more accurately blend the images together.

12 Shoot Through a Fence

Sometimes, barriers get in the way of the shot you want. For example, the monkeys at the zoo may have captured your attention, but because they are inside a large cage, you might find it difficult to get a clear shot. Although jamming the camera lens between the rails of a fence is a viable alternative to shooting through a fence, you might not be allowed to do so. For example, even though you've paid a lot of money for tickets to a big Nascar race, you probably won't be allowed close to the fence that surrounds the track for safety reasons. Does that mean you should just forget it and miss your shot? Not if you follow the steps illustrated here.

① Set Manual Focus

The hard part about shooting through a fence is getting the camera to focus not on the fence, but on the object beyond the fence. To do that, switch your camera to manual focus. You might be asked to focus on the object using the camera's focus ring, located around the lens; or to use the up/down indicators on the menu to focus; or to select the approximate distance to the subject from the menu.

Before You Begin

✔ **①** About Photography

See Also

→ **13** Shoot Through a Window

TIP

If your camera doesn't have a manual focus option, you can fool it by pressing the shutter release halfway down and pre-focusing on something roughly the same distance away as your subject, but *not* blocked by a fence. You can also try changing to Landscape mode, although the camera might still make the fence look sharp, especially if the fencing material is thick and prominent.

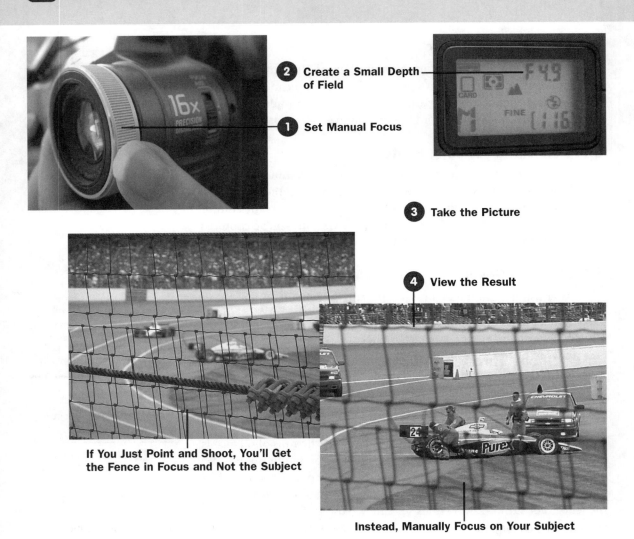

2 Create a Small Depth of Field

1 Set Manual Focus

3 Take the Picture

4 View the Result

If You Just Point and Shoot, You'll Get the Fence in Focus and Not the Subject

Instead, Manually Focus on Your Subject

2 Create a Small Depth of Field

You'll want to use a small *depth of field* so that only your subject is in focus, and not the fence in front of it. Change to *aperture priority mode* and select a large aperture such as f4 or f5.6, or simply use a long zoom lens, which also creates a small depth of field.

3 **Take the Picture**

Frame the shot and press the shutter release to record the image. Check the image to make sure that the subject is in focus, and reshoot if needed.

4 **View the Result**

I took this first shot right after an accident happened at the Indianapolis 500. When I noticed that the fence was in focus and not the car, I changed to manual focus and got the shot.

13 Shoot Through a Window

The object of your desire is just beyond reach, behind a tinted glass window full of reflections you don't want to take a picture of. So how do you capture a good image of the fish at an aquarium, a rare antiquity displayed under glass at a museum, or a comic window display at your favorite department store? Well, you'll have to use several photographic techniques to overcome all these obstacles, but it can be done, as you'll learn in this task.

Before You Begin

✔ **2** About Lighting

See Also

➔ **12** Shoot Through a Fence

1 **Set Manual Focus**

Unlike shooting through a fence, focusing on a subject behind glass may be not be a problem because you can typically place the lens right up against the glass to prevent the camera from focusing on the glass and not what's behind it. However, if the glass has an embedded safety grill or mesh, your camera might struggle to focus on your subject. In such a case, change to manual focus and use the camera's focus ring, manipulate the up/down indicators on the menu to focus, or select the appropriate distance to the subject from the camera's menu.

TIP

Selecting a large aperture such as f4 (which results in a small depth of field) can also help you focus on only the subject, and not what's in front (the glass or the reflections in the glass).

2 **Reduce Reflections**

Turn the flash off to prevent it from reflecting off the glass; if you must use a flash to capture the image, shoot at an angle to the glass so that you won't catch the glare. *Use only an external flash* and not the on-camera flash when shooting into an aquarium, or you'll capture the back scatter (floating sediment in the water).

2 Reduce Reflections

1 Set Manual Focus

4 Take the Picture

3 White Balance the Camera

Window Shows Reflections of Street Scenes

5 View the Result

A Polarizing Filter Removes the Reflections

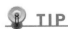 **TIP**

If you don't have a polarizing filter, you can reduce the glare caused by ambient light by increasing your shutter speed (to let in less light), or moving a friend nto a position that blocks the reflection.

If you have a polarizing filter, now is the time to use it. A polarizing filter prevents reflections from entering the camera's lens. Just attach the filter and twist it slowly until the glare is eliminated. Because a polarizing filter lets in less light, if you're in manual mode, increase your aperture setting to compensate. If you're in Auto mode, you don't have to do a thing because the camera will automatically adjust the exposure to account for the filter.

3 White Balance the Camera

Safety glass often has a blue tint, as does glass with an embedded mesh or screen. To remove this tint from the final image, white balance on something behind the glass that's white or neutral gray, or select a mode that matches the light source such as Tungsten or Cloudy (in the case of an aquarium).

4 Take the Picture

Place the camera lens against the glass if possible, and then press the shutter release to capture the image. View the result and reshoot if needed.

5 View the Result

I loved this comic dog in the window of a pet bakery, but when I tried to take a picture of it, I got an image full of reflections. Notice also that the reflections of the people standing behind me are in as sharp a focus as the dog. The solution, of course, was to add a polarizing filter. The glass was tinted slightly so I also had to white balance and manually focus.

3

Capturing Nature

IN THIS CHAPTER:

Opportunities for great photos abound in nature. There, you can find endless vistas, quiet pockets of solitude, and small discoveries. You will also find a variety of tough lighting conditions and other elements beyond your control. The keys to great nature photography are to always have your camera ready, to think about what you want to say with the picture, and to adjust camera settings or your position to deal with the ever-changing source of light. In this chapter, you'll learn how to meet the challenges thrown at you by Mother Nature, and to create photographs that remind you of why you stopped to look in the first place.

14 Shoot a Landscape

Before You Begin

✔ **2** About Lighting

See Also

→ **1** About Photography

→ **11** Shoot a Panorama

→ **21** Capture a Snowy or Sandy Scene

→ **22** Capture Woods or Deep-Shadow Scenes

TIP

If the lighting conditions don't meet your needs, and you'll be staying in the area for a while, plan to revisit the spot at a better time and take additional photos.

The most common mistake photographers make when taking a landscape photo is to simply point and shoot. For the eye to truly appreciate an immense view, you should include something in the foreground to provide some scale. This might be a massive old oak, a tree branch in flower, a person, horse, lighthouse, boat, or similar object. Landscape photos, like all good photographs, should follow the *rule of thirds* and divide the photographic canvas into one-third segments. For example, the sky might occupy the top one-third, and a mountain the bottom two-thirds.

Now, your first instinct when shooting a landscape photo might be to change to **Landscape** scene mode on your camera and just click away. That approach might get you an okay photograph, but not a great one. Because of the way **Landscape** mode works, you can't focus on the most important element in the landscape and let unimportant areas become slightly blurry. Instead, what **Landscape** mode gets you is a picture in which everything is in perfect focus—from your handsome husband to the distant hills. The result is a photo where every element screams, "Look at me!" and as a consequence, there is no central focus and therefore nothing to draw the viewer into the landscape. Instead of taking photos using **Landscape** mode, this task explains the settings you should choose to create that one-of-a-kind landscape photograph.

Before you shoot your landscape photo, consider what drew your eye to the scene. Determine the best vantage point for capturing that element and position yourself accordingly. As you choose where to stand and how to frame the picture, remember to include some foreground interest. Whenever possible, also pick an appropriate time of day for your landscape photo; generally speaking, early morning or late afternoon sun

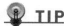

offers the best lighting for most landscapes. Also notice the direction from which the light is coming; if you're taking a picture of the wonderful fall foliage, you'll probably want the hills front lit for best color (the sun over your shoulder). If you're taking a picture of a beautiful stream running through a canyon, it may look better if the sun is coming at you and glinting off the water.

① White Balance

Set the *white balance* option on your camera to **Daylight/Sunlight**, or as in the case of my Nikon camera, **Fine**. (I have no idea why Nikon chose the word **Fine** to represent outdoor lighting, but there you go.)

Do not white balance manually when taking a photo of a sunset; first of all, the light shifts so much during a sunset that it's unlikely to do you much good. In addition, the colors of objects may look correct, but the extra warmth from the sunset will be removed (especially if you take a picture that does not include the sun). As a result, you'll end up with a photo that looks like it was taken at some other time of day, and not at sunset.

② Set Exposure

For most landscapes, you'll want to change to *aperture-priority mode* and select a small *aperture* such as f11 or f16 for a large *depth of field*. If the landscape serves more as a background to your subject, you'll want to use a large aperture such as f5 to create a small depth of field.

Choosing a metering system and using it appropriately is crucial to getting a correct *exposure* for your landscape photo. Your camera probably uses *matrix metering* by default, and that will probably work just fine for most landscape photos. If the subject is much lighter or darker than the background, you might want to switch to *center-weighted metering* or *spot metering*, then meter on a midtone element in your photo (by pressing the shutter release halfway down and placing that spot in the center of the frame). Assuming that you've changed to aperture priority as suggested here, when you meter a particular point in the landscape, the camera will use the aperture you've chosen and change the *shutter speed* to create an exposure that makes the object you metered roughly 18% gray in the final image. See **②** **About Lighting**.

💡 TIP

Using a polarizing filter (which reduces glare by bending the light) will add drama to an all-white sky that might otherwise spoil a perfect landscape. Adding a polarizing filter to the lens makes the white, drab sky as full of detail and drama—and as interesting—as the landscape below.

🔦 NOTE

Typically, whatever you meter on (whatever you point at when you press the shutter halfway to take a meter reading) will also be the point of focus, and therefore the sharpest element of the image. If that's not what you want, you must either set the focus manually, use the camera's **AE Lock** option to lock in the exposure so that you can take a second shot with the subject in focus (this assumes that your camera gives you the ability to lock in the current exposure using a menu command or button, and not the shutter release), or set a manual exposure using the aperture and shutter speed displayed during the meter reading as your guide.

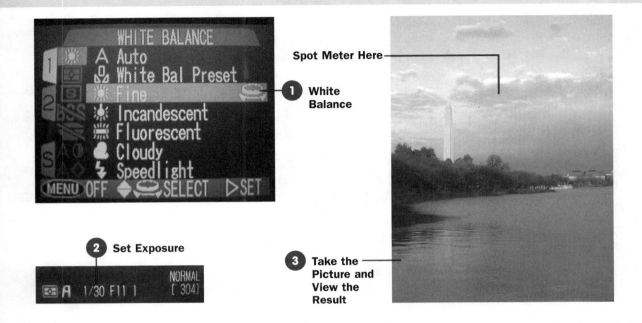

Spot Meter Here

1 White Balance

2 Set Exposure

3 Take the Picture and View the Result

KEY TERM

Exposure compensation—A method of adjusting an exposure by entering the amount of adjustment, such as +1 (which increases the exposure and lightens the image by one f-stop) or –1 (which darkens the image by one-f-stop).

If the lighting conditions are mixed (some light areas and some deep shade), then in addition to spot metering the landscape, you might want to *bracket the exposure* if your camera offers that option. Exposure bracketing forces the camera to automatically adjust its exposure by a small amount, as you take a series of around three to five photographs. If your camera doesn't have an exposure bracketing option, take a series of images manually, using slightly different *exposure compensations* chosen from the menu.

3 Take the Picture and View the Result

If you are taking the picture in the early morning or late afternoon, mount the camera on a tripod to keep it steady during the longer exposure required to capture the image in low light.

The eye naturally jumps to the lightest areas of an image first, so if the lightest element is not your subject, frame the image so that the light leads the viewer to your subject. Strong lines have this

same effect, so you can use lines (such as a road or a fence) to lead the eye to the most important elements of your photograph. Also remember the *rule of thirds* in positioning your subject and to add some foreground interest when composing the photo.

When you're ready to take the shot, press the shutter release halfway down and focus on your subject; if you're taking a general landscape photo without a dominant subject, focus one-third of the distance between you and the farthest object. Then, while still holding the shutter release partway down, reframe the picture and press the button the rest of the way to take the photograph. If possible, you may want to use a cable release, remote trigger, or the camera's self-timer to take the picture so that you can keep your hands off the camera and achieve sharp focus.

I was walking along the Tidal Basin near the Jefferson Memorial when I spotted this lovely view. It was early evening, and the sun was just starting to set, casting a rich glow on the Washington Monument. I loved the reflection, and included it in the photo for foreground interest. The trees, barely highlighted by the setting sun, created a nice contrast to the main subject, the Washington Monument. Off to the right, I included the Bureau of Engraving and Printing. To achieve a proper exposure, I spot metered on a light gray area of the big cloud behind the monument.

15 Capture a Distant Subject

Sometimes, your subject will not be close to you, and you have no other choice but to take its picture from far away. For example, you probably won't be able to climb that cliff to get closer to those eaglets, even if you wanted to. And it's unlikely that you can waltz onto the soccer field to grab that close-up of your daughter. So you'll have to use the camera's zoom feature to take the picture. One of your first considerations when using the zoom is quality. The *digital zoom* will get you closer than the camera's *optical zoom* can, but the digital zoom also gives you a lower quality, less sharp image. If you're only going to use the image on the Web or share it through email, using the digital zoom probably won't be a problem. If you want to print the image, you'll probably want higher quality and sharpness than the digital zoom will give you and you

Before You Begin

✔ 1 About Photography

✔ 2 About Lighting

NOTE

If you have to use the digital zoom, choose the highest *resolution* your camera offers so that you can compensate for its lower picture quality. This might not work in your situation because some cameras only let you select the medium resolution setting when engaging the digital zoom.

TIP

Photoshop Album also offers a sharpen option, although it's not as sophisticated as those in the higher-end applications and most likely does not provide the control you need to improve an image taken with a digital zoom.

TIP

Having a small depth of field is great for your zoomed photo because it will highlight your subject by blurring the background.

should use the optical zoom. On the other hand, if you can't get close enough with the optical zoom, using the digital zoom may be the only way you can capture the subject decently. Just know that if you print the image after capturing it with a digital zoom, the result may not be of very good quality, so you should limit yourself to printing in a fairly small size such as wallet photos or 3" × 5".

You might be able to artificially sharpen an image taken with a digital zoom (and thus, improve its apparent quality) by editing the image in a *graphics editor* such as Photoshop Elements or Paint Shop Pro.

1 White Balance

If you're taking a picture of a distant *outdoor* subject, set the *white balance* to **Daylight/Sunlight** (or as in the case of my Nikon camera, **Fine**); otherwise, select the appropriate white balance for the current lighting condition. For this image of newborn robins in their nest, I set my camera for **Cloudy** because where the nest was located, it was shady and cool. If I had used a **Daylight** white balance setting, the image would have been much more blue and the colors would not be correct.

2 Turn Off Flash

Turn off the camera's flash because it won't go far enough to help light the image.

3 Adjust the Exposure

You'll automatically get a small *depth of field* whenever you use a zoom lens, so you might as well change to Program Auto mode and let the camera select the appropriate *aperture* and *shutter speed*. If the camera has trouble focusing, however, change to manual focus or Landscape mode so that you can get a nice, sharp subject.

Typically, you'll want to change to *spot metering* or *center-weighted metering* and meter on the subject so that it is properly exposed, especially if your subject is the only light object in the scene. If the subject is the only dark object, you'll want more of an average exposure, so select *matrix metering* instead.

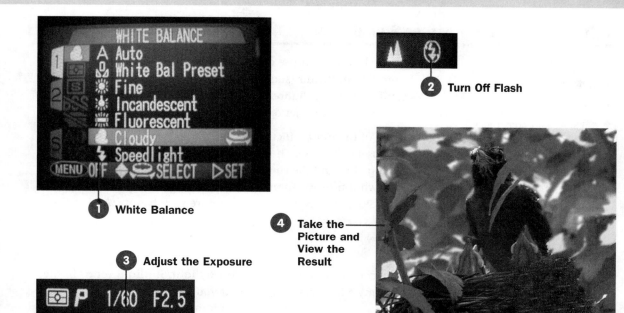

2 Turn Off Flash

1 White Balance

4 Take the Picture and View the Result

3 Adjust the Exposure

4 Take the Picture and View the Result

Place the camera on a tripod. Frame the shot, remembering to use the *rule of thirds* to place the subject off-center for more interest. Because you're using a zoom, any camera shake will be very noticeable in the final result, so use a cable release, remote trigger, or the camera's self-timer to take the image if possible.

I spotted some baby robins in a nest near my mother's house. Not wanting to disturb them, but still incredibly drawn to this image of motherhood, I quietly stood at the base of the tree and used my zoom lens to capture this photo of a mother robin feeding her hungry brood. I chose the **Cloudy** white balance option and used matrix metering (because the light was fairly even throughout the scene) to capture the image.

NOTE

For any type of long-distance shooting (photos that require a zoom), it's always best to use a tripod. If the thought of bringing a big tripod is inconvenient, consider a tabletop tripod instead. You can brace the tripod against a wall, table, ledge, or even yourself to produce a nice, sharp image.

CHAPTER 3: Capturing Nature

16 Capture a Sunrise or Sunset

Before You Begin

✔ **2** About Lighting

See Also

→ **1** About Photography

→ **29** Shoot a Backlit Portrait

→ **34** Shoot a Nighttime Portrait

Not every day brings a sunrise or sunset of particular note—but if there's a lot of humidity in the air (such as a warm, muggy summer's night), a storm's coming in, the pollution count is high, or if the wind is kicking up the sand in the desert, get ready for a beautiful display.

Probably one of the most difficult outdoor photographs to capture correctly is a sunset or sunrise. The sun at that time of day is much brighter than anything else, and the contrast between it and the surrounding landscape is what makes capturing such an image so difficult. Still, it's almost impossible to resist the urge to capture such beauty. And in this task, I'll show you how.

💡 TIP

Be sure to look behind you for alternative photos. The light from a sunrise or sunset often illuminates objects with a beautiful glow. Also, even after the sun has set or just before it rises, you will often get better nature shots because the subject is not competing with the sun.

① White Balance

Set the camera's *white balance* to **Daylight/Sunlight** (or as in the case of my Nikon camera, **Fine**). If your camera has a **Sunset** mode, turn it on because it may automatically select the white balance for you to something that adds a bit more warmth to the photo.

② Set Focus to Infinity

To keep the sun and the horizon in focus, change to **Landscape** mode, which causes everything in the frame to be in focus. If you are using the camera's **Sunset** mode, it may automatically switch to infinity focus.

③ Meter the Exposure

To create the proper *exposure*, select the **Sunset** scene mode if your camera has one. Otherwise, change to **Program Auto** mode, select *center-weighted* or *spot metering* from the camera's menu, press the shutter release partway down, and point the camera to a part of the sky, off to one side of the sun. The camera will take its light meter reading from that spot and select the appropriate exposure settings (*aperture* and *shutter speed*).

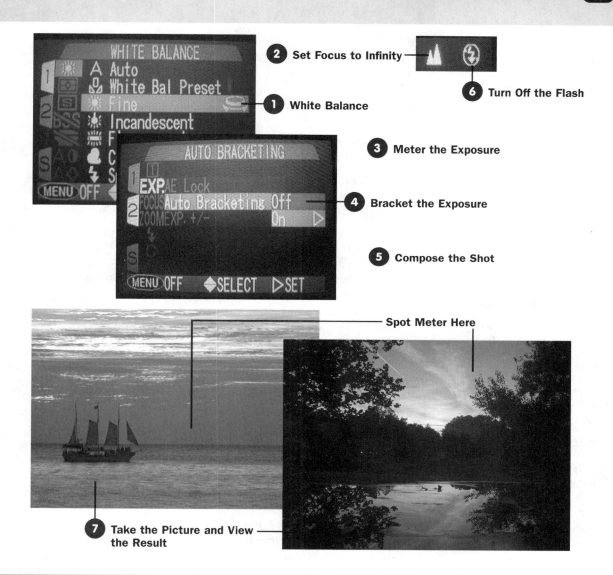

2 Set Focus to Infinity

6 Turn Off the Flash

1 White Balance

3 Meter the Exposure

4 Bracket the Exposure

5 Compose the Shot

Spot Meter Here

7 Take the Picture and View the Result

4 Bracket the Exposure

Because getting the exposure correct on a sunset or sunrise image is often difficult, you can increase your chances of getting it right by *bracketing the exposure* if possible. Select that option from the camera's menu, and as you take a series of pictures (typically from

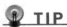

NOTE

In sunrise and sunset situations, you'll want to underexpose just a bit to enrich the colors and not fade them out. If you meter on a bright part of the sky (next to the sun), the camera will probably underexpose the image too much; you might want to compensate for that by selecting a small positive exposure compensation such as .5, 1, and so on.

TIP

If you use a zoom lens, the various elements of your sunset/sunrise landscape will be compressed or closer together. Use the zoom lens to create drama by bringing the sun right behind the other elements in the landscape. Using a zoom lens also makes the sun larger and more dominant.

NOTE

Don't take too long to frame your shot; you could burn out the camera's CCD if you point it at a bright object (such as the sun) for a long time.

three to five) the camera will automatically adjust the exposure for each image just a bit. If your camera doesn't offer this option, take a series of shots yourself, manually adjusting the exposure for each one by selecting different *exposure compensation* values from the menu.

5 Compose the Shot

With the shutter release still halfway down, compose your shot. Using the *rule of thirds*, you'll probably want to fill the upper two-thirds of the frame with sky (with a sunrise or sunset, that's typically where the "action" is), and the lower one-third with land or sea. When you have lots of foreground interest, use the opposite proportions (one-third sky, two-thirds land or sea). Like a regular landscape photo, you'll want to place some objects in the foreground to add interest. These objects will be backlit and silhouetted by the sun, but even so, the silhouette of your husband stowing the fishing gear after a great day out on the lake will add a lot to the photograph's story. If you want to capture the details in your husband's face *and* the sunset, see **29 Shoot a Backlit Portrait**. If there's nothing in particular to focus on, such as a boat, a tree, or a person, point to an area one-third of the distance from you to the furthest object.

6 Turn Off the Flash

You don't want the flash going off accidentally and illuminating any foreground objects, so turn the flash off.

7 Take the Picture and View the Result

Continue snapping away, manually adjusting the exposure values if necessary, until well after the sun has gone down. If you are capturing a sunrise, begin snapping before the sun comes up because the camera will have an easier job getting a decent exposure, and the sky will look just as brilliant.

This first image was taken during a recent trip to Hawaii, where glorious sunsets occur almost every evening. I was on a sunset cruise when I spotted another ship off the horizon. Backlit by the setting sun, the ship added interest to the photo. To get a proper exposure, I spot metered on the middle gray area of the sky.

The second image was taken out my mother's large dining room window. I liked how the setting sun was being reflected by the standing water on the flat roof of her garage in the foreground. I spot metered an area of the sky.

17 Take a Picture by Moonlight

The main problem with taking a picture when the moon is your main light source is the lack of decent light. Thus, you should try to take such pictures only when the moon is full or nearly so. Even so, you will have to take a longer exposure so that the camera can record what light there is. Whenever you take a long exposure with a digital camera, the resulting image will contain a lot of *noise*. Still, don't give up on such images, because they can often be made much more acceptable using a noise filter (a noise remover) in a graphics editing program such as Photoshop Elements or Paint Shop Pro. You can also reduce the amount of noise in the original image by making sure that you use the ISO 100 setting on your camera. Some cameras offer a noise-reduction setting as well; if yours does, now is the time to turn it on; otherwise, plan on printing the resulting image no larger than 4"×6" to reduce the noise.

You'll discover another problem if you decide to include the moon in your "image by moonlight": That problem is caused by the high contrast between the moon and the dark sky. If the camera exposes the image long enough to capture any detail, the moon's detail will be all washed out. You can overcome this problem by reshooting the image using a slightly faster *shutter speed*.

1 White Balance

Strange as it seems, you'll probably want to *white balance* your camera using its **Daylight/Sunlight** setting (or as in the case of my Nikon camera, **Fine**) to make sure that the resulting image is not too blue. If your camera has a **Night Scene**, **Night Landscape**, or **Twilight** mode, select that scene mode because it may automatically warm the image and brighten the colors.

If there is a lot of ambient light, for example, you're shooting a picture of a cityscape, the capitol dome lit up at night, or a brightly lit harbor, use a white balance setting that matches that light source, such as **Tungsten/Incandescent** or **Fluorescent**.

Before You Begin

✔ **2** About Lighting

See Also

→ **34** Shoot a Nighttime Portrait

 TIP

If you're looking for that professional look, then "cheat" like the pros do by taking one image of just the moon, and another of the scene without the moon in it. You can then combine the two images using a *graphics editor*, into a perfectly exposed, moonlit scene. You can also use this method of combining two images to create a larger, more beautiful moon in the final merged photograph.

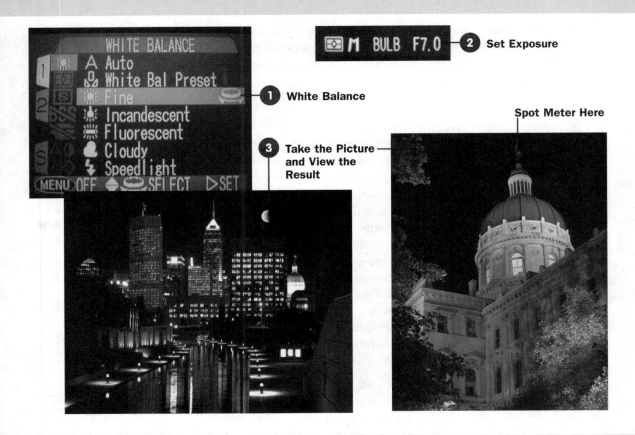

White Balance

Set Exposure

Spot Meter Here

Take the Picture and View the Result

TIP

You can make daylight look more like nightfall by turning it blue; movies are sometimes shot this way. To accomplish this trickery, select the **Tungsten/Incandescent** white balance option when the light source is bright sunlight.

2 Set Exposure

If your camera has a **Night Scene**, **Night Landscape**, or **Twilight** scene mode and you selected it in step 1, you won't have to set the *exposure* because these scene modes automatically select a longer exposure for you.

If your camera doesn't offer scene modes, select **Program Auto** mode. Choose *spot metering* or *center-weighted metering*, then press the shutter release halfway and point the camera at the ambient light source (such as the light on the capitol dome.)

If the overall scene is dark, and the ambient light sources are small (distant street lights or a few car lights), change to *bulb mode* or time mode as shown in the example. Choose a small *aperture* such as f8, and then control the exposure by holding the shutter release down for one to four seconds depending on the amount of light (less light requires a longer exposure). If your camera doesn't offer bulb mode and there's very little light around, try changing to *shutter-priority mode* and selecting the slowest *shutter speed* you can.

A night picture will often look okay when taken with a variety of exposures. So if you want, try both a long exposure (such as four seconds) and a shorter one (such as 1 second). The longer the exposure, the more ambient light you capture. You can turn lights in motion (such as car lights) into neon tubes by using a super-long exposure such as eight seconds.

❸ Take the Picture and View the Result

Because this will be a long exposure, place the camera on a tripod. You may want to use a cable release, remote trigger, or the camera's self-timer to reduce camera shake. If you've set the camera to bulb mode, you'll have to hold the shutter release down to keep the shutter open. With time mode, press the shutter release once to open the shutter and then again when you want to close the shutter. With both bulb and time mode, *you* control the length of the exposure.

If you are using **Program Auto** mode to capture the image, and the picture looks okay but a bit noisy, try changing to **Manual** mode and using a larger aperture and a slightly slower shutter speed. The shorter exposure time will cut down on the noise.

If you can't capture the image at all, try changing to a higher *ISO* such as 200, 400, or 800; doing so increases the camera's light sensitivity and its ability to capture images in low-light conditions. Using a higher ISO, however, increases the amount of noise, and often results in a loss of detail in the light areas. If you change the ISO, make sure that you white balance the camera again to prevent color shifts.

NOTE

Typically, whatever you meter on (whatever you point at when you press the shutter halfway to take a meter reading) will also be the point of focus, and therefore the sharpest element of the image. If that's not what you want, you must either set the focus manually, use AE Lock to lock in the exposure so that you can take a second shot with the subject in focus (assuming that your camera lets you lock in the current exposure using a menu command or button and not the shutter release), or set a manual exposure using the aperture and shutter speed displayed during the meter reading as your guide.

NOTE

If all you want to take is a picture of the moon itself, mount your camera on a tripod, point, and shoot using the **Program Auto** setting. Use the highest resolution you can so that you can crop the image later, making the moon larger in the final image. If you own a digital SLR, you can mount the camera to some types of telescopes using a T mount connector sold at most camera stores, and take advantage of its powerful lens.

The first image of the downtown skyline was taken on a clear October evening. I set the camera on bulb mode and exposed for two seconds to capture as much of the city light as possible. Although the photo was pretty terrific, the moon appeared very small (just a dot) in the final image and was red (as October moons tend to be). I wanted a larger moon, so I used Photoshop Elements to merge the skyline photo with a moon image I had shot in September. I adjusted the size of that moon to make it larger and more prominent in the final image.

The second image, of the Indiana state capitol building, does not include the moon although it was taken on a moonlit night (this image made a stronger statement without the moon fighting for attention). For this image, I spot metered on the middle gray area of the capitol dome.

18 Capture a Close-Up (Macro) Image

See Also

→ **9** Shoot an Item You Want to Sell

KEY TERM

Macro photography—Use of a short focal length lens to photograph objects that are extremely close.

The opposite of telephoto (zoom) photography, *macro photography* allows you to get really close to your subject. You might use macro photography to get a close-up picture of a flower, insect, or a piece of jewelry. The most important thing to remember in macro photography is to use the LCD monitor whenever possible when focusing on your subject. If you use the optical viewfinder to frame the picture, the subject may not appear where you want it to because of *parallax view*.

1 White Balance

When possible, select the best time of day for shooting your particular subject. For example, a white flower may look softer and more attractive when it's backlit than when the sun is facing it. After choosing the time of day, *white balance* the camera by selecting the appropriate setting (**Daylight** or **Indoor**, for example). You can also white balance using a white card held close to the subject.

2 Change to Macro Mode

Change to **Macro** mode (the tulip symbol on most cameras). Because you're getting in very close, any shaking of the camera will be noticeable, so set the camera on a tripod to minimize movement.

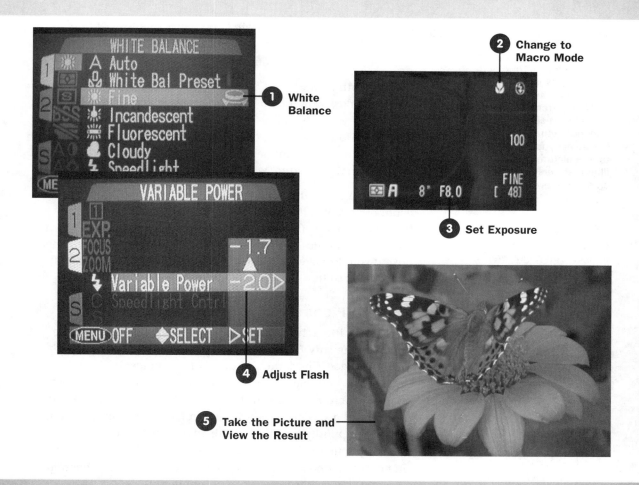

1 White Balance

2 Change to Macro Mode

3 Set Exposure

4 Adjust Flash

5 Take the Picture and View the Result

3 **Set Exposure**

Change to **Program Auto** mode. Change to *matrix metering*, point at the subject, and press the shutter release halfway to get an average exposure reading. If the object is much lighter or darker than the background, you can try *center-weighted metering* or *spot metering* instead.

If you need a larger *depth of field* than you normally get in **Macro** mode (because you want to make sure that the subject is in focus), keep the **Macro** option on, change to *aperture priority mode*, and select a medium-sized *aperture* such as f8.

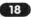
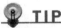**NOTE**

One problem with using an on-camera flash in macro photography is that, because a lot of flashes are offset from the camera lens, the on-camera flash may not actually illuminate the object you're trying to take a picture of, or it may illuminate only part of it, creating uneven lighting.

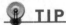 **TIP**

If you take a lot of macro images, you might want to invest in a *ring flash* designed to fit your camera. A ring flash is especially good for eliminating shadows and reflections in macro flash photography.

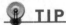 **TIP**

Macro lenses are available for most digital cameras, allowing you to magnify the subject and get even closer. Give them a try!

4 **Adjust Flash**

If it's cloudy outside but you don't need the flash, turn it off.

If you're using a flash and the subject is coming out overexposed, adjust the flash power by a negative amount to make it act as a fill flash. If you can't adjust the power of your flash, change to aperture-priority mode (if you're not already using it to create a larger depth of field) and select an even smaller aperture such as f11. The smaller aperture will let in less light.

If you want to use a flash but you also want to keep the small depth of field, you'll have to use an external flash further away from your subject. Turn off the on-camera flash; if you can't turn off the onboard flash because the camera won't fire the external flash if you do, cover the on-camera flash with a bit of electrical tape domed so that the light escapes out the top and bottom.

5 **Take the Picture and View the Result**

With the shutter release still held partway down, recompose the image if necessary. Then press the shutter the rest of the way to take the image. Check the sharpness of the image. If it's not perfectly sharp, you might want to manually focus on your subject because **Macro** mode uses a shallow depth of field that makes it tough to get a specific subject in perfect focus. You can also change to aperture priority mode as explained in step 3, and select the largest aperture offered to increase the depth of field (and your chances of getting a sharp image—especially if you are shooting an object that might move, such as a butterfly).

I was wandering through the gardens surrounding our local art museum and witnessed what seemed like hundreds of butterflies enjoying the floral bouquet. I changed to **Macro** mode, prefocused on a flower I noticed several butterflies visiting, and snapped this photo after a red admiral landed on the flower. It was a sunny day so I did not use my flash. Instead, I changed to aperture priority mode and selected a medium aperture so that I could get a slightly larger depth of field. These settings enabled me to get a sharp image of the butterfly, which seemed to be always in motion.

19 Photograph Zoo Animals

With the more natural environments favored by most zoos today, you can often get very realistic photographs of animals "in the wild." In fact, you'd be amazed how many nature photographers prefer to take pictures at the zoo, where the animals are more easily captured on film than they are when out in the savannah or the desert. When visiting a zoo, plan your trip to take advantage of feeding times because that's when the animals are most active. Typically, feeding time is very early or very late in the day. Visitor feeding opportunities also provide great photos because you can get much closer to the animals at these times.

Decide which animals you want to photograph the most, and visit those areas first. If the animals are sleeping or hiding, you can come back later in the day. Also, watch the direction of the sun when photographing the various animals—especially those with fur since you'll want enough light to provide more detail.

1 White Balance

- Select the appropriate *white balance*. For animals kept out of doors, choose **Daylight/Sunlight** (or in the case of my Nikon camera, **Fine**). If it's a cloudy day, if the animal you want to capture is resting in the shade, or if you're shooting into an aquarium, try **Cloudy/Overcast**.

 If you're shooting indoors through glass, white balance on something behind the glass that's white or medium gray, or try matching the light source with the **Fluorescent** or **Tungsten/Incandescent** setting.

2 Set Manual Focus

If the animal is behind a tall fence or a pane of glass, you may have trouble getting the camera to focus on it instead of the fence/window. If so, change to manual focus. Then use the camera's focus ring, located around the lens, or the up/down indicators on the menu to focus or select the approximate distance to the subject from the menu.

Before You Begin

✔ **1** About Photography

See Also

→ **12** Shoot Through a Fence

→ **13** Shoot Through a Window

NOTES

No photograph is worth your life. Do not taunt or tease the animals. Don't climb fences or go where you are not allowed. Obey the rules because the zookeepers put them there for a reason—even if you don't know what that reason might be.

Always review any regulations the zoo might have regarding the taking of pictures, especially flash pictures (which may be restricted in certain areas).

TIP

If your camera doesn't have a manual focus option, you can fool it by pressing the shutter release halfway down and prefocusing on something roughly the same distance away as your subject but *not* blocked by a fence/window. You can also try using Landscape mode and a large aperture, although the camera may still make the fence sharp if it is thick and prominent.

① White Balance

② Set Manual Focus

③ Turn Off the Flash

④ Create a Small Depth of Field

⑤ Take the Picture and View the Result

TIP

If you're shooting through glass, be sure to use a polarizing filter to remove any glare. Just attach the filter and twist it slowly until the glare is eliminated. When using a polarizing filter, increase the exposure by choosing a larger *aperture* or slower *shutter speed*.

③ Turn Off the Flash

Because most zoo animals are at some distance from the visitor's viewing platform, your flash will be of no use when taking their picture. However, if the animal is close, use a flash for fill and to add a catch light (glint) to its eyes. If the animal is close but behind glass, you can use the flash if necessary, but stand at an angle so that the flash doesn't reflect back into the lens. If you're shooting into an aquarium, use only an external flash because an on-camera flash will light up the back scatter (floating sediment) in the water.

4 **Create a Small Depth of Field**

You'll want to use a small *depth of field* to avoid putting the fence/window in focus. If the zoo enclosure is not visible in the camera frame, you might still want to use a small depth of field to put the animal in focus and blur the stuff behind it. To create a small depth of field, change to *aperture-priority mode* and select a large *aperture* such as f4 or f5.6, or simply use a long zoom lens, which automatically creates a small depth of field.

5 **Take the Picture and View the Result**

If you're using a zoom, place the camera on a tripod to eliminate camera shake. Also, use a cable release, remote control, or the camera's self-timer to trigger the shutter so that you don't accidentally shake the camera while taking the picture. If the animal is moving, and you're afraid that using a tripod will cause you to miss the shot, leave the tripod head unlocked a bit so that you can rotate it quickly and yet still steady your shot.

Compose the image, zooming in on your subject to eliminate distracting backgrounds, signs, fences, and other visitors. If you have to, move your position or raise or lower your angle to eliminate distractions. When composing the shot, you want the animal to fill the frame as much as possible, but be sure not to cut off legs or tails! Also, avoid shooting down at an animal; instead, shoot up toward it or at eye level for the best images. When you're ready, trigger the shutter release to record the image. Check the image to make sure that the subject is in focus, and reshoot if needed.

My local zoo offers hand-feeding opportunities for visitors, so I took advantage of that to create this memorable photo. After feeding the giraffe a few tasty tidbits of sweet potato, I posed with my daughter nearby, while the giraffe awaited its next morsel. My father-in-law snapped this close-up of the giraffe, with its long tongue extended for the next treat. He turned on his flash and used a large aperture to create a small depth of field that blurred the background.

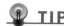 **TIP**

Consider purchasing a telephoto lens for use with your camera (if available); because the zoom power of a telephoto lens is much greater than that of the regular lens on your camera, the animals will appear closer and larger in the resulting images.

20 Photograph Birds

See Also

→ **12** Shoot Through a Fence

→ **13** Shoot Through a Window

 TIP

Birds are attracted by more than just food. They need water and a source of shelter. Trees and shrubs with thick branches offer great protection, so place the feeder near these shelters. Bring in a source of water, and you'll attract a wider variety of birds and create more opportunities for photographs at the same time.

 TIP

For more natural-looking photographs, place some branches or even a dead tree near the feeder or water source to act as an alternative perch and to attract a wider variety of birds such as woodpeckers and nuthatches. Limit the number of landing places on these extra perches to make it easier to prefocus; cut off branches that point toward or away from the camera because they are distracting. Place logs or large rocks with seed on the ground under the feeder to entice ground-feeding birds to stay awhile.

As anyone with a backyard bird feeder knows, our winged friends are fascinating creatures. You've probably already made a mental note as to the type of seed and suet that attracts particular species in your area and when those birds like to visit. Maybe you've even seen ducks, pigeons, squirrels, and chipmunks forage on the leftovers underneath the feeder—and sometimes *in* the feeder as well! After watching the antics that take place at the backyard feeder, it won't be long before you'll want to photograph them. In this task, I'll show you how.

1 **Position the Feeder**

Before you photograph the birds at your feeder, make sure that the feeder is positioned to take advantage of the light early or late in the day, when most birds feed. Place the feeder so that the sun will be coming from the side or from behind your camera for the best light. View the feeder at your planned shooting location and remove any distractions in the background, especially branches that may seem to pop out of a bird's head when they land on a perch to feed.

When considering feeder placement, calculate the maximum shooting distance you can achieve and still fill the frame. Locate the camera at this distance in a blind which will prevent you from accidentally frightening the birds away (if you don't plan on using a remote to trigger the camera). You can create your own blind using a cheap tent covered in leaves, branches, or camouflage material. You can also use your house, car, and even a cardboard box (as shown here) as a blind.

2 **Prep the Camera**

Prepare the camera with fresh batteries and a large memory stick. If you'll be triggering the shutter manually, move the camera into the blind (a car, house, tent, box, or similar hiding spot). Make sure that you and the camera are mostly out of view of the birds so that you don't frighten away your subjects. Set the camera up on a tripod because you'll be using a fast *shutter speed* in most cases.

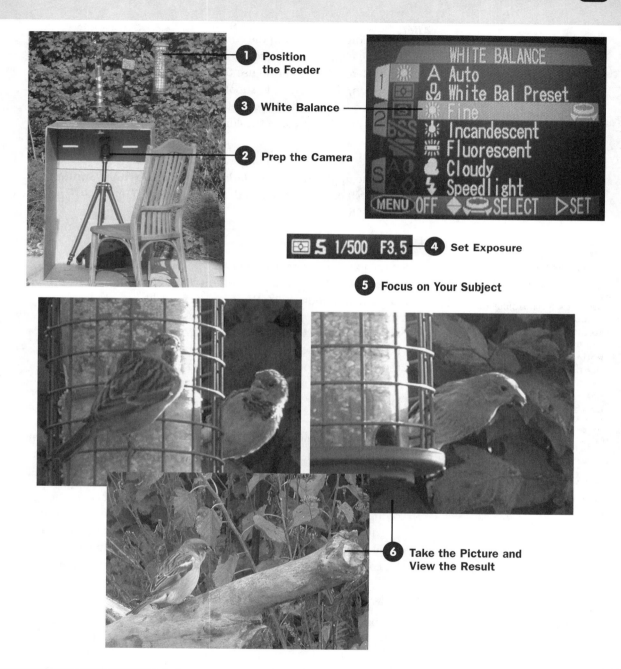

1 Position the Feeder

3 White Balance

2 Prep the Camera

WHITE BALANCE
A Auto
White Bal Preset
Fine
Incandescent
Fluorescent
Cloudy
Speedlight
MENU OFF SELECT SET

5 1/500 F3.5 — 4 Set Exposure

5 Focus on Your Subject

6 Take the Picture and View the Result

 TIP

If you want to capture birds in the wild, consider investing in a monopod, a one-legged "tripod" that's favored by hikers who are also nature photographers. A monopod will help you steady the camera while keeping you mobile.

 TIP

If the camera is close enough for the flash to do any good, force it on and use it as a fill. Adjust the amount of flash, if possible, so that it doesn't overwhelm the tiny birds and flatten out all detail; set the flash exposure compensation at –1 1/3 power. The flash will fill in shadows and provide detail.

If you plan on triggering the camera from some distance away, place the camera on a tripod and insert the remote control or long cable release. You can also use the camera's stop-motion or interval option, if it has one, to shoot images automatically, every few minutes or so. Use the AC adapter and plug the camera into an outdoor outlet to prepare the camera for a long session.

③ White Balance

Select the appropriate *white balance* such as **Daylight/Sunlight** (on my Nikon camera, this setting is called **Fine**), or **Cloudy/Overcast**.

④ Set Exposure

Set the exposure to match the lighting conditions when you plan to shoot. This is especially important if you're setting up the camera to shoot remotely. For the most part, you'll probably want to change to *shutter priority mode* and use a fast shutter speed because birds tend to move fairly fast. A fast shutter speed will give you a smaller *depth of field*, which is probably what you want to keep the bird in focus but blur the background.

⑤ Focus on Your Subject

Because you'll know where the birds are likely to land (the bird feeder, birdbath, or branches you've provided), you can prefocus by pressing the shutter release halfway and pointing the camera at a likely perch.

If you're using the camera remotely, make sure that there is enough contrast between the subject and the background so that the camera can focus automatically. If necessary, adjust either the camera or the feeder. Alternatively, if your camera has an Auto Focus Lock (AE Lock), you can use it to lock in the focus for a series of photos.

⑥ Take the Picture and View the Result

Compose the image, placing the bird off-center for more interest. If your camera uses 4 megapixels or more, you can frame the shot loosely and crop the image later on without appreciable loss in print quality. Otherwise, frame tightly to avoid cropping. Avoid shooting at an angle up or down from the subject; eye-level creates the most appealing images.

For these first two photos, I set up a simple cardboard box near the feeder and cut a hole in it for the camera. I didn't have to wait long because I planned my shooting session around "breakfast." I changed to shutter-priority mode and used a fast shutter speed, 1/500th second. The early morning sun cast a side light on the bird's feathers that really makes these photos worth the wait.

I wanted to see if a more comfortable blind would work as well, and so after adding some tree branches to the tableau, I took the third photo while sitting in the passenger seat of my car, parked in the driveway nearby. After sitting there for a surprisingly short period of time, the birds relaxed and came back to feed. I took the photo of this sparrow as it landed on a branch I had set up just for that purpose.

21 Capture a Snowy or Sandy Scene

The problem with capturing a snowy or sandy scene is obvious to the eyes—it's just too darn bright! As a result, your digital camera will underexpose the image, making the snow/sand the same light value as a middle gray. People will appear even darker, and important details will be lost.

So what's a photographer to do? Well, luckily you are not as silly as your camera's light meter, and you can manually compensate for what you already know will be a dark picture by doing any one of several things, as explained in this task.

① White Balance

Set the *white balance* to **Daylight/Sunlight** (or as in the case of my Nikon camera, **Fine**). If you are shooting at night, white balance on the snow or on a white card.

② Adjust the Exposure

If your camera has a **Snow** or **Snow/Sand** scene mode, select it because that mode will automatically balance the exposure for you. Otherwise, try using **Program Auto** mode and set the *exposure compensation* to +1 or +2. Alternatively, you can change to *aperture priority mode* and select an *aperture* one stop larger than the one that appears on the LCD monitor when you press the shutter release halfway down to take a meter reading. For example, if the camera suggests using f8, try f5.6 instead.

Before You Begin

✔ **1** About Photography
✔ **2** About Lighting

🔖 TIP

Heat isn't a problem for a digital camera, but the cold is. When you move outdoors, give condensation on the lens a minute to evaporate. Don't wipe the lens; just wait for it to clear. Keep some spare batteries in a warm pocket to use when the batteries already in the camera get so cold they won't function.

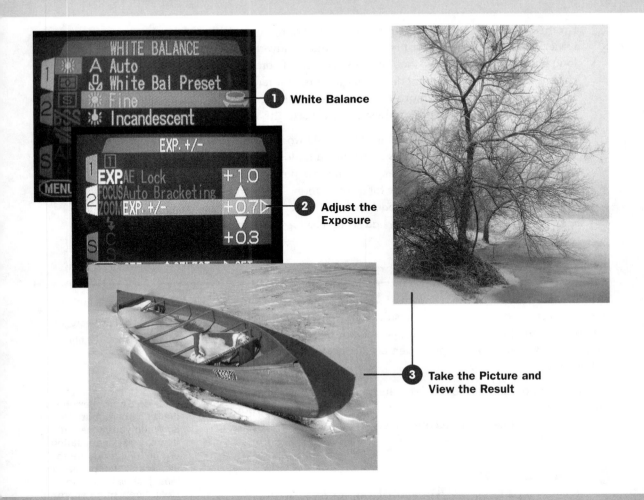

White Balance ①

Adjust the Exposure ②

Take the Picture and View the Result ③

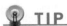

TIP

For a nighttime snow scene, select *shutter priority mode* and a slow *shutter speed*. Use a tripod and a cable release, remote control, or the camera's self-timer to minimize camera shake. Be sure to white balance off the snow.

If you are taking a picture of a person against the sand/snow, try changing to *center-weighted metering* or *spot metering*. Point the camera at the person's face and press the shutter release halfway to take an exposure reading.

Don't bother with the flash, even if you're tempted to use it to lighten shadow areas. First, the flash output is controlled by the size of the aperture, which in this brightly lit situation will be a very small one (such as f16). The output will be very low, and

given that your camera's flash is not terribly powerful to begin with, the effect will be minimal. And if you're outdoors in the cold, you won't want to waste your precious battery power on a futile effort.

3 Take the Picture and View the Result

Consider framing the image so that bright, colorful objects are included; they'll add interest to an all white/sandy scene. With snow, you can go the opposite route as well, framing the scene to eliminate colors, a technique that places more emphasis on the shapes and shadows in the photograph.

Frame the image and press the shutter release to take the picture. If you're shooting on a sunny beach, protect the camera by placing its strap around your neck so that you don't drop it in the sand accidentally. For some cameras, you can purchase plastic cases to protect your valuable toy from sand and water damage.

I took both of these images last year, while taking a walk by the lake near our home after a big snowstorm. I used *matrix metering*, but if I hadn't used exposure compensation of +1 on the image of the boat, the photo would have been very dark, and the snow would have been gray. The image of the tree standing its lonely vigil over the lake turned out pretty good without much exposure compensation, because the light and dark areas were fairly evenly dispersed throughout the image. I used matrix metering instead to get the correct exposure.

22 Capture Woods or Deep-Shadow Scenes

Capturing an image of a quiet wood is often difficult because the preponderance of dark objects will cause the camera to overexpose the image. The result is an image whose colors are much less saturated and a whole lot lighter than what you're seeing with your own eyes. If you instead try to capture an image of the woods when the sun is shining brightly through the forest canopy, the bright contrast can make it difficult for the camera to capture any detail. You'll probably get a better photograph if you simply wait for the sun to go behind a cloud.

Before You Begin

✔ **2** About Lighting

TIP

You can use the same general techniques explained in this task when photographing a dark subject, such as a black cat or a dark-brown dog.

NOTE

Typically, whatever you meter on (whatever you point at when you press the shutter halfway to take a meter reading) is also the point of focus, and therefore the sharpest element of the image. If you're metering off your palm, set the focus manually while still holding the shutter release halfway, use AE Lock to lock in the exposure so you can take a second shot with the subject in focus (assuming that your camera lets you lock in the current *exposure* using a menu command or button and not the shutter release), or set a manual exposure using the aperture and *shutter speed* displayed during the meter reading as your guide.

① White Balance

Set the *white balance* to **Cloudy/Overcast**. If your camera doesn't have one of these options, white balance manually using a white card.

② Adjust the Exposure

Set the *exposure compensation* to –1 or –2, and use **Program Auto** mode to get your shot. (The camera will calculate the appropriate *aperture* and *shutter speed* for you.)

If you do not get the results you desire, change to **Manual** mode and select an aperture one stop smaller than the one that appears on the LCD monitor when you press the shutter release halfway to take a meter reading. For example, if the camera displays f5.6 on the LCD monitor when you meter in **Program Auto** mode, try f8 instead. You can also use this method with a meter reading taken off your palm held in the same light as the most important element of the photograph.

If you are taking a picture of a person in the woods, try changing to *spot metering* or *centered-weighted metering*. Point the camera at the person's face (by walking up close to the person and pressing the shutter release halfway to take an exposure reading).

③ Set the Flash

If your subject lacks the detail you want, you can record some additional light by using the *slow synch* flash setting: **Slow Sync/Slow Shutter/Long Exp** or something similar.

If you're shooting a landscape or if the subject is too far away for the flash to reach, turn off the flash because it won't illuminate anything of importance and can mess up the exposure reading.

④ Take the Picture and View the Result

Because the camera will be using a slow shutter speed to capture what light it can, place the camera on a tripod. The first image was taken in the woods in a large city park. The sun was just beginning to set, and I liked the way it peeked through the trees. To get a proper exposure with the mixed lighting, I spot metered on the leaves and set the exposure compensation to –1.

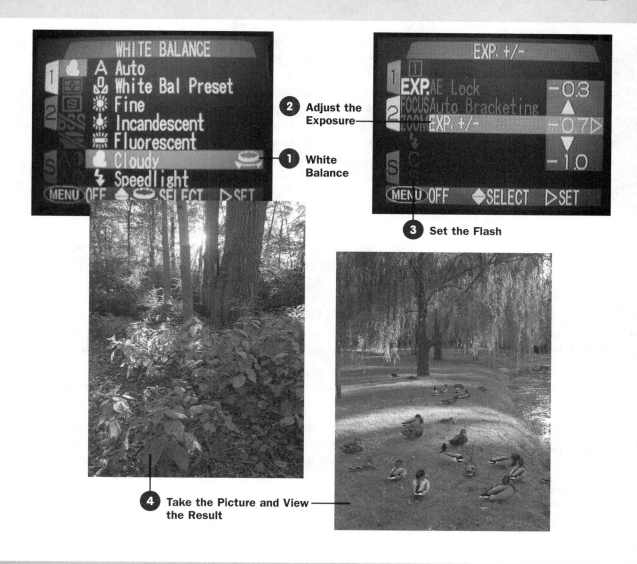

2 **Adjust the Exposure**

1 **White Balance**

3 **Set the Flash**

4 **Take the Picture and View the Result**

To get this second image, I had to take a lot of pictures. The lighting was tricky, and the ducks were skittish. But I was finally rewarded after about 10 minutes, when they got used to me and settled down. Here, I used matrix metering but zoomed in a bit so that the exposure was taken on an image that didn't include the sky; after metering and focusing, I recomposed the shot. I set the exposure compensation to −.7.

23 Capture Fireworks

TIP

You don't have to lug around a large tripod to the fireworks show—a tabletop tripod will do. If the tripod is too low to the ground, you can place it on a table, car roof, or fence.

NOTE

You might not want to use your camera's **Night Scene**, **Night Landscape**, or **Twilight** scene mode, because this mode typically uses a very small *depth of field* (large *aperture*) and sets the flash to fire. On the plus side, however, this mode often turns on "hot-spot reduction," a process that reduces hot spots in long exposures. If you're not sure what your camera does in this mode, try it and see.

It's hard to go to a fireworks show and not want to capture the beauty of the sparkling lights against the night sky. To create an outstanding photograph of fireworks, use a tripod and a slow *shutter speed*. Consider including foreground objects (such as monuments, trees, or people) to give the fireworks some scale and to balance the composition. Also use the highest *resolution* you can when shooting fireworks because the longer exposure times may create some noise in the final result.

1 Set White Balance

Set the *white balance* to **Daylight/Sunlight** (or as in the case of my Nikon camera, **Fine**). If your camera has a **Fireworks** scene mode, turn it on because this mode will automatically set the white balance and *exposure* for you and turn off the flash.

2 Turn Off the Flash

You probably don't want the flash going off while you're trying to capture the fireworks because the flash will only light up objects near you (such as people, or smoke from the fireworks) that you don't want to include. Turn off the flash so that it won't fire automatically.

However, if you want to include the people in the foreground to add some interest to your fireworks photo, force the flash. You can also try a longer shutter speed and no flash to capture the foreground objects using available light.

3 Select Bulb Mode

If your camera has a **Fireworks** scene mode, and you selected it in step 1, skip this step because that mode automatically creates a long exposure when you press the shutter release. Otherwise, select the **Bulb** or **Time** mode if your camera has one. **Bulb** mode keeps the shutter open as long as you press the shutter release. **Time** mode opens the shutter the first time you press the button and closes it only after you press the shutter release button again.

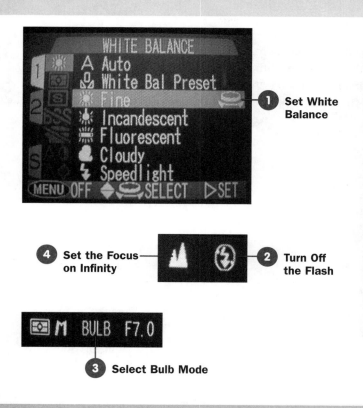

Set White Balance ①

④ **Set the Focus on Infinity**

② **Turn Off the Flash**

③ **Select Bulb Mode**

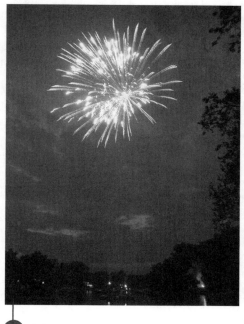

⑤ **Take the Picture and View the Result**

④ **Set the Focus on Infinity**

Change to **Landscape** mode so that everything's in focus.

⑤ **Take the Picture and View the Result**

Press the shutter release between explosions. If you're using **Bulb** mode, you'll need to hold the shutter release down until you are finished taking the shot. Leave the shutter open and capture two to three explosions. (If you leave the shutter open for a longer period of time, you'll capture more explosions but each will be much less colorful.) If you're using **Bulb** mode, release the shutter button; if you are using **Time** mode, press the shutter release again to close the shutter.

💡 TIP

If your camera does not offer a **Bulb** or **Time** mode, try using *shutter priority mode* and the slowest shutter speed available, such as eight seconds. You can also try using *aperture-priority mode* and the largest aperture available. Using either of these techniques, however, you won't be able to create multiple-explosion images.

 TIP

You can follow these same basic steps to capture lightning in a storm. Just keep in mind that your camera will be sitting on a very tall metal tripod and might attract lightning.

I took this shot last July, while watching a small riverside display from my sister's houseboat. The sun hadn't set completely yet, and I loved the soft colors of the setting sun, so I included them in the image. Using the **Bulb** setting, I was able to control the camera and get the exact exposure (about four seconds) I was looking for.

4

Shooting Great-Looking Portraits

IN THIS CHAPTER:

 TIP

If needed, reposition the subject so that the light source is not falling directly on the person's face and causing him to squint. To avoid distorting the face, use a telephoto lens to capture portraits whenever possible. Wide-angle and even normal 50mm lenses create a slight distortion in close objects such as a human face.

When you think of portrait photography, you may picture a professionally lit studio with glamorous backdrops and expensive equipment. Granted, having a studio is certainly a plus when it comes to creating the perfect portrait, but as you'll learn in this chapter, you can create some terrific portraits with just a digital camera and an *external flash* or two. The main thing you must remember when taking any portrait is that it's the eyes that tell the story. Thus, *always, always, always* make sure that the eyes are in focus, wide open, and squint free.

24 Shoot an Indoor Portrait with Available Light

See Also

→ **25** Shoot an Indoor Portrait with On-Camera Flash

→ **27** Shoot a Formal Indoor Portrait

 TIP

To avoid using a flash so that you can create warm portraits using only natural light, try a larger aperture or a slower shutter speed. Soften a flash by adjusting its output.

Generally speaking, the best photographs are shot using *available light*. The addition of a flash typically makes the subject look harsh and rough. Not a good idea when creating a portrait, where the goal is to capture your subject at her best. The only problem with using available light *indoors* is that there typically isn't much of it. In this task, I'll show you how to use what sunlight there is to your advantage, and how to supplement it with a soft, fill flash. If there simply isn't enough sunlight at your location indoors, you'll have to take the portrait using the flash as the main source of light. See **25** **Shoot an Indoor Portrait with On-Camera Flash** for help.

1 Position the Subject

Position the subject near a window or other outdoor light source. Here, I placed my niece near a brightly lit window covered with white sheer curtains that cast a perfect, diffused light on her. If you plan on using a fill flash, move the subject away from any walls directly behind him or her, so that the resulting shadow won't appear in the final image.

2 White Balance

If the available light is mostly sunshine, select **Cloudy/Overcast** or hold a white card up to the person's face and manually *white balance* on the card. If it's dark outside and you're shooting indoors using only artificial light such as a table lamp (and no flash other than a very soft fill flash), select a matching white balance such as **Tungsten**.

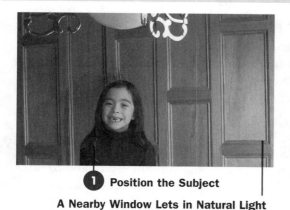

① **Position the Subject**

A Nearby Window Lets in Natural Light

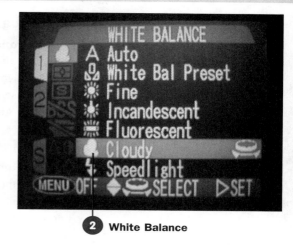

② **White Balance**

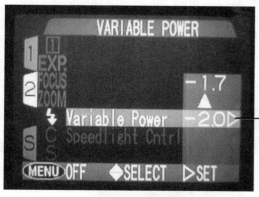

③ **Adjust the Flash**

⑤ **Take the Picture and View the Result**

④ **Select Automatic**

③ **Adjust the Flash**

Adjust the *flash exposure* compensation to –1 to –2 to create a fill flash. If you can't adjust the flash, diffuse it by placing several facial tissues over the flash.

If your camera has a *slow sync* flash setting such as **Slow Sync/Slow Shutter/Long** Exp or something similar, turn it on. This setting allows the camera to capture the ambient light after the flash goes off, creating a more natural-looking portrait.

NOTE

Even though you are using natural sunlight for your portrait, do not select the **Daylight** white balance setting. Sunlight streaming through a window indoors is not as warm and bright as outdoor sunlight, so use the **Cloudy** white balance setting instead.

⚲ TIP

If the room light is dim and the subject's pupils are large as a result, turn on your camera's red-eye reduction feature.

④ Select Program Auto

Select **Program Auto** mode, forcing the camera to choose the appropriate *shutter speed* and *aperture* to use with a flash and the amount of available light. Use this mode instead of automatic mode because it allows you to change the flash exposure, as described in step 3.

⑤ Take the Picture and View the Result

Mount the camera on a tripod so that you can get a sharp picture. Point the camera at the person's eyes, press the shutter release halfway to let the camera focus, and then recompose the shot. When the subject seems relaxed, press the shutter release the rest of the way to take the picture—but warn the subject beforehand not to move for a second or two after the flash goes off, because of the slow shutter. View the result and reshoot if needed.

The diffused sunlight, supplemented by a soft flash, provided the perfect lighting for this image of my niece. The wood paneling in the background added a warm glow. I used **Program Auto** mode, and the camera selected a large aperture and slightly slower shutter speed. I set my flash to provide a soft fill, and engaged the **Slow Sync** setting to capture the warm, natural light.

㉕ Shoot an Indoor Portrait with On-Camera Flash

Before You Begin

✔ ② About Lighting

See Also

→ ㉔ Shoot an Indoor Portrait with Available Light

→ ㉗ Shoot a Formal Indoor Portrait

Available light is always the best to use, regardless of the type of photograph you're taking. But it's especially important in portrait photography, where you want skin tones to look natural and not washed out by the flash. When there isn't enough available light (whether it's sunlight streaming through a window or a strong lamp light) to capture an image without a flash, you must take the picture using a mixture of *artificial light* and your on-camera flash—with the flash acting as the main source of light. Because your flash has one color temperature and an incandescent or fluorescent light source has another, you run the risk of getting a "color shift"—a picture whose colors simply don't look right. In this task, you'll learn how to make the best of what is potentially a bad picture-taking situation.

When using a flash, it's typically best to turn on the camera's red-eye reduction feature. However, in situations where the flash is weak

because of strong ambient light, the feature may not reduce all red eye. In such a case, you can use Photoshop Album to remove the red eye for you. See **90** **Remove Red Eye** for help. Also, be aware that most digital cameras fire the flash twice when you turn on red-eye reduction—in such a case, be sure to warn your subject so that he doesn't move until after the second flash.

❶ Position the Subject

Because you'll be using a flash to get this shot, move the subject away from any walls or tall objects such as bookcases or china cabinets so that the resulting shadows won't appear in the final image.

❷ White Balance

Select the **Electronic Flash/Speedlight** *white balance* setting. If your camera doesn't offer such a setting, select the **Daylight/Sunlight** white balance setting (because a flash is roughly the same color temperature as daylight, and you shouldn't see much of a color shift as a result of choosing the **Daylight** setting). When shooting under mixed lighting conditions (ambient and flash light) you might see a bit of a color shift in the portions of the image not lit by the flash—an orange/yellow color cast if the ambient light is tungsten or a blue color cast if the ambient light is fluorescent.

❸ Adjust the Flash

If you can, point the flash upward. If you can't adjust the flash position, diffuse it by placing several facial tissues over the flash. Turn on red-eye reduction only if you're sure the subject won't move, because this feature delays when the picture is recorded. Also, if your subject is near bright light, you won't have to use the red-eye reduction feature because the subject's pupils should be fairly small anyway.

If your camera has a *slow sync* flash setting such as **Slow Sync/Slow Shutter/Long Exp** or something similar, turn it on. This setting allows the camera to capture some ambient light after the flash goes off. If your camera offers a choice of slow sync flash settings, choose the one that also supports red-eye reduction.

TIP

You might be able to avoid using a flash if you increase the *ISO* setting on your camera; however, doing so will also increase the amount of noise (grain) in the final image. You can also try choosing a larger aperture or a slower shutter speed than your camera's meter suggests.

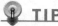

TIP

If you want more of an "available light" look rather than a direct flash portrait, purchase an 85B (for use with a dominant incandescent light source) or FL-D (for use with a fluorescent light source) Kodak gelatin filter and tape it over your flash. This filter will convert the temperature of the flash output to match the room light, warming the picture and preventing that "deer in the headlights" look. Choose **Incandescent** or **Fluorescent** as your white balance setting in such a case.

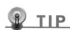

TIP

If you can't tilt your on-camera flash, avoid pointing it at any reflective surface (such as a mirror, glass window, or metal object). Otherwise, you'll catch the flash's reflection in your image. Instead of the regular on-camera flash, you can use a *ring flash* (a flash that rings the camera lens) to create a diffuse, no-shadow portrait look, popular in some model photography.

1. **Position the Subject**
2. **White Balance**
3. **Adjust the Flash**
4. **Adjust Exposure**
5. **Take the Picture and View the Result**

④ Adjust Exposure

Choose **Program Auto** mode so that the camera can select the *shutter speed* and *aperture* for you, while allowing you to select a white balance and the slow sync option. However, if your camera lacks a slow sync option, change to *shutter-priority mode* and select a slow shutter speed so that you can capture some available light.

⑤ Take the Picture and View the Result

Mount the camera on a tripod for sharpest results. Point the camera at the subject's eyes, press the shutter release halfway to let the camera focus, then recompose the shot. When the subject seems relaxed, press the shutter release the rest of the way to take the picture—but warn the subject beforehand not to move for a few seconds after the flash because of the slow shutter. View the result and reshoot if needed.

The room where this portrait was taken was fairly dark, despite the fact that the sun had not yet set. The only light was a small lamp on the dresser; by adding my on-camera flash and a slow sync shutter, I was able to light the image properly and capture the ambient light. Because the flash provided the main light for the portrait, I selected the **Electronic Flash/Speedlight** white balance setting. The flash was not strong enough to prevent red eye, even with red-eye reduction turned on, so I fixed that problem using Photoshop Album.

26 About Formal Portrait Photography

A formal portrait such as a family grouping for a holiday greeting card doesn't have to be stiff looking, but it does have to be properly lit. To create a formal portrait indoors, you'll have to use an *external flash* along with your on-camera flash to light it properly. You should be able to find a decent external flash for your camera for around $100. It's probably a good investment even if you don't plan on shooting that many formal portraits because an external flash is more powerful and (when diffused properly) more natural looking than your on-camera flash. Thus, if you purchase an external flash, you'll probably find yourself using it more often than the on-camera flash—to lighten shadows on a bright sunny day, to illuminate objects at dusk or after the sun has set, or to take casual portraits when there isn't enough available light.

External Flash Types and How They Work

There are two types of external flashes you can purchase: a *dedicated flash* or a *non-dedicated-flash*. A dedicated flash is connected directly to the camera, typically through a *hot shoe*. A dedicated flash adjusts its output based on the *exposure* information it receives directly from the

Before You Begin

✔ **2** About Lighting

See Also

→ **27** Shoot a Formal Indoor Portrait

🔍 KEY TERMS

External flash—A flash that's separate from the on-camera flash, and more powerful. External flashes come in two types: dedicated and non-dedicated.

Dedicated flash—A flash unit designed to be used with a specific camera.

Non-dedicated flash—A flash unit that can be used with any camera.

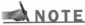
NOTE

Only a dedicated flash, designed specifically for use with your digital camera, should be directly connected to it. Connecting a non-dedicated flash to your camera may cause both the camera and the flash to short out.

KEY TERMS

First curtain sync—The flash is fired when the shutter opens, at the beginning of the exposure.

Second curtain sync—Also known as rear curtain sync. The flash is fired when the shutter starts to close, at the end of the exposure.

Flash exposure—The amount by which a particular flash will illuminate a subject under certain lighting conditions.

Slave flash—Also known as a non-dedicated or external flash, because it is not physically attached to the camera. With its attached slave unit, this type of flash can be made to go off automatically in sync with the on-camera flash.

Guide number—A measurement of a flash's output, based on the use of ISO 100 film.

camera, making it much easier for you to get a great looking photo without a lot of fiddling. A dedicated flash fires in sync with your on-camera flash automatically, and on some cameras, can be made to fire using *first curtain sync* or *second curtain sync*, allowing you to freeze the action when you want. If there's a dedicated flash available for your camera, spend the extra bucks to get it. Because a dedicated flash coordinates its output with the current camera settings, it will offset any extra cost by making your photos easier to capture. The only problem I can think of here is that only mid- to high-priced digital cameras support the use of a dedicated flash.

A non-dedicated flash can be used with any camera. Because it's not physically attached to the camera, you might want to purchase an L bracket so that you can hold the camera and flash together easily. You might have to set the output of a non-dedicated flash manually so that it doesn't overwhelm the subject when combined with the on-camera flash. Also, keep in mind that a non-dedicated flash can't coordinate its output with other camera settings you may have selected, such as *flash exposure* or **Night Portrait** mode. Thus, it's perhaps a little harder for a new photographer to get a perfect photo using a non-dedicated flash. With the addition of a *slave unit*, a non-dedicated flash can be made to fire automatically with the on-camera flash, so that's usually not a problem. You just need to make sure that you purchase a non-dedicated flash-slave unit combo that's designed to be used with a digital camera (unlike film cameras, digital cameras fire a pre-flash just before the regular on-camera flash is fired). Because a non-dedicated flash is not physically attached to your camera and must have a slave unit to fire in sync with the on-camera flash, this type of flash is often referred to as a *slave flash*.

You'll find more information in Chapter 1, "Start Here" about how to choose a good external flash and what accessories you might want to get with it. For now, let's concentrate on how a flash works, and what you might have to do to adjust it.

An external flash sends out an intense burst of light, timed with the maximum opening of the camera shutter so that the right amount of light is captured to illuminate the subject perfectly. The flash exposure is based on a combination of factors: the flash's *guide number*, the *aperture* you are using, and the flash-to-subject distance. The guide number relates to the power output of a particular flash; the higher this number, the more light a flash can emit in a single burst. To calculate the

aperture you should use to achieve a proper exposure, you take the guide number of the main flash and divide it by the flash-to-subject distance (in feet). More on this little calculation in a moment.

What you need to know about calculating flash exposure right now is that the result is unaffected by the *shutter speed* you select. If you were to use the same aperture you calculate using the formula, but a slower shutter speed, you would get a perfect flash exposure *and* also capture some of the available light. The other thing you need to know about flash exposure is that, if you use a dedicated flash and set your camera to just about any mode, you'll always get a perfect flash exposure because the camera will coordinate its aperture with the flash's output. However, if you use a dedicated flash and choose **Manual** mode, you'll have to perform the calculation to compute the appropriate aperture setting to use. Of course, if you are using a non-dedicated flash, you must perform this calculation every time to compute the proper aperture to use.

Using an External Flash for Casual Portraits

The trick to using a flash is to try to hide its presence so that you don't end up with unnatural-looking skin tones and artificially colored objects. If you're taking a casual portrait, start by first adjusting the flash head. You should bounce the flash's light off a white wall or low ceiling whenever possible, rather than point the flash directly at the subject. Bounced light is softer and more diffuse, and thus more natural than the harsh light of a flash aimed right at a subject. If there doesn't happen to be a white wall or ceiling nearby, you can bounce the flash with the help of an inexpensive accessory called a *flash reflector*, or diffuse it with a *flash diffuser*. The advantage in using a flash reflector to bounce flash light is that it's cheap (under $15), portable (most fold and then fit easily into a camera case), and easy to use. Simply tilt the flash head straight up, into the flash reflector's interior. A flash diffuser is equally inexpensive, portable, and easy to use: simply attach the diffuser (sometimes called a "soft box") directly onto the flash head. The light from the flash goes through the soft white window in the front of the diffuser, and is softened and diffused in turn.

Positioning an External Flash for a Formal Portrait

To create the proper lighting effect for a formal portrait, you'll need at least one external flash. A light stand (a pole that holds an external flash at a specific height) is very helpful in portrait photography,

NOTE

The flash exposure calculation is based on the assumption that you're using the flash at full power. You can manually adjust an external flash's output to less than full power if you want to use the flash as a fill—this is done through a camera menu for dedicated flashes or using a switch on the flash for non-dedicated ones.

KEY TERMS

Flash reflector— Inexpensive flash accessory that snaps around the head of an external flash, allowing you to bounce the flash light and soften its effect.

Flash diffuser—A soft box with a translucent front that snaps onto the flash head. The flash's light shines through this box, creating a diffuse, soft light.

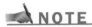

TIP

Placing the main flash just in front of the camera reduces any chance that it might cause lens flare.

NOTE

When you bounce the light off a wall or ceiling, the light will pick up the color of the surface off which it bounces, so bounce light only onto white walls and ceilings.

KEY TERM

Short lighting—Also known as Rembrandt lighting, it's a formal portrait lighting setup where the main flash illuminates the side of the subject's face farthest from the camera.

although you can achieve some fairly good lighting effects using an L bracket to hold the flash next to the camera (an inexpensive but very useful accessory, at around $15), or simply asking a friend to hold the flash for you.

So where do you position the external flash for a formal portrait session? As a starting point, I suggest placing the main flash on a light stand, to the right or left of the camera and just slightly in front of the lens, at a 45-degree angle to the subject. Diffuse this main flash by angling it off the ceiling, a white wall, or into a flash reflector. You can also use a flash diffuser, in which case, you want to point the light directly at the subject, and not up. Your camera's flash can then act as a fill light, softening the shadows caused by the external (main) flash. Because the power of your on-camera flash is slight compared to the main flash, you should set the on-camera flash at full power even though you want it to act as only a fill. If you have two external flashes, position them both on stands, at right angles to each other, at about 45 degrees from the subject. Designate one of these external flashes as the main flash, and diffuse it by bouncing it. The other external flash will act as the fill flash, so after bouncing it as well, adjust its output to use two to three stops less power.

Adjust the height of the main flash so that it's at an angle roughly 45 degrees above the person's head. Do a test shot and watch where the shadows fall. Also watch where the catch light appears—the reflection of the flash in the subject's eyes. This reflection tends to look best in either the 1 or 11 o'clock position, so adjust the height of the flash accordingly. Older people often look better with a slightly lower main flash (30 degrees above the head instead of 45) because this angle tends to reduce wrinkles.

For best results, have the subject face the camera at an angle, so that one side of the face is slightly closer and the near ear is fully visible, while the far ear is mostly hidden, but its tip is still visible. Of course, you may find other facial poses more complementary to your particular subject, so feel free to try them. You can achieve a variety of lighting effects depending on the exact location of the main flash in relationship to the subject's face. If you place the main flash so that it illuminates the side of the face furthest away from the camera, you'll create a distinctive triangular shadow on the cheek nearest the camera. This is called *short lighting*, and it's often used to slim a round face.

The following figure shows a lot of professional lighting accessories, such as a flash umbrella to bounce the light of the external flash light. You can of course, simply bounce the light up to the ceiling or into a flash reflector (an inexpensive, easily portable flash accessory). Behind the model, you'll see another accessory—a foldable portrait lighting background. In place of this, you can simply use a blank wall, plain curtain, or other non-busy background. You can even re-create this same effect by dyeing a white sheet with various colors. A second external flash was used to illuminate this background (which also eliminates dark shadows behind your subject). You can use a table lamp or portable flashlight to light up your background if the shadows falling on it seem too dark or if you like the effect.

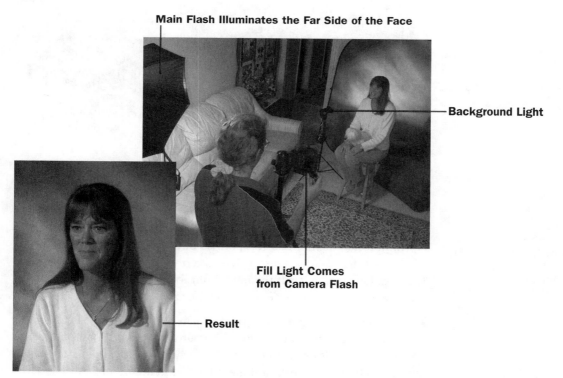

Main Flash Illuminates the Far Side of the Face

Background Light

Fill Light Comes from Camera Flash

Result

Short lighting creates a distinctive triangle shadow.

Another type of lighting effect is called *broad lighting*. Here, the main light is positioned so that it illuminates the side of the face nearest the camera. Although this type of lighting is flattering on oval faces, it may be a bit harsh depending on the amount of fill flash you add.

KEY TERM

Broad lighting—Formal portrait lighting setup where the main flash illuminates the side of the subject's face nearest the camera.

Main Flash Illuminates Near Side of Face

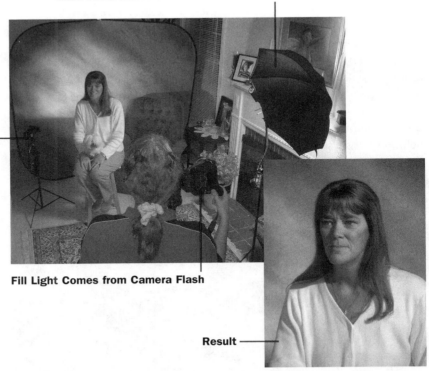

Background Light

Fill Light Comes from Camera Flash

Result

Broad lighting is good choice for a narrow, slim face.

KEY TERM

Butterfly lighting—Formal portrait lighting setup where the main flash is pointed directly at the subject, but slightly above the face, creating a distinctive butterfly shadow under the nose.

A type of lighting used often in glamour photography is called *butterfly lighting*. Here, the main light is pointed directly at the face, positioned at a height that creates a distinctive butterfly shadow under the nose. The trick here is to not put the main light too high, or you'll create large shadows in the eye sockets and on the upper lip.

After setting up the lights, your next task in portrait lighting is to determine the proper exposure. In flash photography, the flash output at time of exposure is determined by the aperture you use (the f-stop), the distance between the flash and the subject, and the main flash's total available output as measured by its guide number. To determine the correct aperture, take the guide number of your main flash and divide it by the distance (in feet) between that flash and your subject. Be sure to include any extra distance (such as up to the ceiling and down again) if

the flash is being bounced. If the guide number for your flash is 90, and you've placed the flash about 6 feet away, take 90 divided by 6 to get 15. Here, you'd use the nearest f-stop, f16, to take the shot.

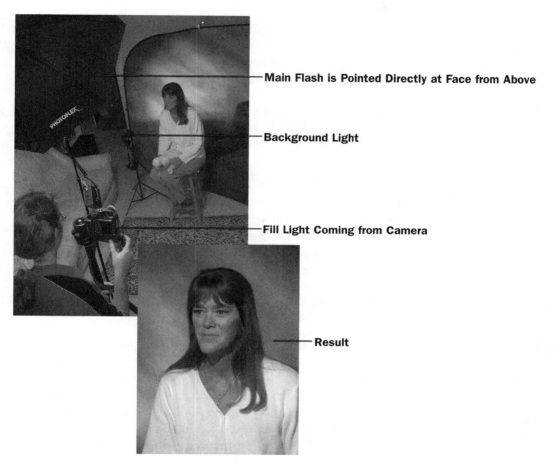

Main Flash is Pointed Directly at Face from Above

Background Light

Fill Light Coming from Camera

Result

Butterfly lighting is often used in glamour photography.

If you are using a dedicated flash and you set your camera to **Automatic** or **Program Auto** mode, the camera will determine the appropriate aperture and shutter speed. The flash will then adjust its output appropriately to create a proper exposure—so you don't need to perform any calculations. If there's a lot of ambient light and the resulting portrait shows a color shift, you'll want to change to

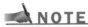

NOTE

With a dedicated flash, the flash exposure (output) is computed automatically based on the flash-to-subject distance, aperture, zoom, lens, and filter settings. However, if you are shooting in **Manual** mode or using a non-dedicated flash, you'll have to dial down the flash power manually if desired (by default, it fires at full power).

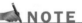

NOTE

Flash exposure is unaffected by shutter speed; it is instead determined by the aperture used and the flash-to-subject distance. What this means to you is that you can increase/decrease the amount of ambient light being recorded by adjusting the shutter speed. To record more ambient light, select a slower shutter speed or use a *slow sync* flash setting. This technique is very useful in night photography. See **34** Shoot a Nighttime Portrait.

shutter-priority mode, use the same aperture the camera was using in **Automatic** or **Program Auto** mode, and increase your shutter speed to prevent the ambient light from being recorded.

With a dedicated flash, the only time you'll have to calculate the aperture yourself is if you choose **Manual** mode or aperture-preferred mode. Using a non-dedicated flash, you'll have to control the flash exposure all the time, and the best way to do that is to calculate the appropriate aperture and use either **Manual** or aperture-preferred mode. To compute the aperture manually, take the guide number of the main flash and divide it by the distance from the flash to the subject (in feet). For example, if the main flash has a guide number of 100 and is positioned 10 feet away from the subject, take 100 divided by 10, which equals 10 (the aperture setting you would use). Cameras don't have an f-stop of 10, so you'd use the closest aperture, f11.

If the main flash is bounced onto the ceiling, take that extra distance into account with the formula: f-stop = .7 * (GN/(d1 +d2)). This formula also accounts for the loss of flash intensity when bouncing the flash this way. Suppose that the flash is 8 feet away from the subject, and the ceiling is 4 feet above the flash. Take 8 + 4 to get 12, then divide the guide number of 100 by 12, and get 8.33. Take that times .7 (which accounts for the loss of one f-stop of light) and get 5.83. So you could set the aperture at 5.6, the closest setting.

Using a higher ISO setting changes the aperture required to create a proper flash exposure, because a higher ISO is more sensitive to light. As you go from ISO 100 to 200, for example, you make the camera one f-stop more sensitive. So if you are using an ISO setting of 200, you can start by choosing an aperture one f-stop smaller than the one you calculated, and testing to see whether that setting produces a proper exposure. You can also adjust the flash exposure compensation by –1.

One last note: You might want to change to a different flash mode before taking the picture—some cameras allow you to fire just the external flash rather than use the on-camera flash. Some cameras also allow you to change to front or rear curtain sync, controlling the point during exposure at which the flash is fired.

27 Shoot a Formal Indoor Portrait

If you want to capture a formal-looking portrait such as a graduation, anniversary, or passport photo, you'll need an external flash and a light stand, ladder, or a helpful assistant to hold the flash at the right height and direction. You'll also need something that can act as a neutral background, such as a sheet or an uncluttered wall. A few objects might appear in the background, such as a fireplace or some potted plants, but keep the look simple and uncluttered—remember that the subject is the person you're trying to photograph, and not your pretty home. The way to get a nice-looking formal portrait is to light the subject completely using flash lighting, and yet achieve a natural-looking result. In this task, I'll show you how.

1 Position the Flashes

Position the subject on a stool, facing at an angle to the camera so that the subject's far ear is partially hidden. Position the flash(es) to achieve the lighting effect you want. In this situation, I chose to use only one external flash, supplementing it with the on-camera flash, which acted as a fill. I set up the main flash slightly in front and to the right of the camera. I placed the flash slightly above the subject's head and bounced it into a flash umbrella, creating a slight *butterfly-lighting* effect.

You can duplicate this setup by attaching your *external flash* to a light stand, ladder, or plant pole, or you can simply ask someone to hold the flash up for you. Because you probably don't have a flash umbrella, just tilt the flash head up and bounce the light off the ceiling. You can also bounce the flash into a *flash reflector*.

2 White Balance

Select a *white balance* setting such as **Electronic Flash/Speedlight** or **Daylight/Sunlight**.

Before You Begin

✔ **2** About Lighting

✔ **26** About Formal Portrait Photography

See Also

→ **28** Shoot an Outdoor Portrait

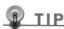 TIP

If you want to take a portrait of a young child, ask a volunteer to step in while you set up and test the lights so that the youngster won't get too fidgety come picture-taking time.

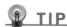 TIP

If you're taking a family portrait, visit portrait Web sites to gather creative ideas for arranging and photographing a group. For example, you might want all the family members to wear similarly colored outfits.

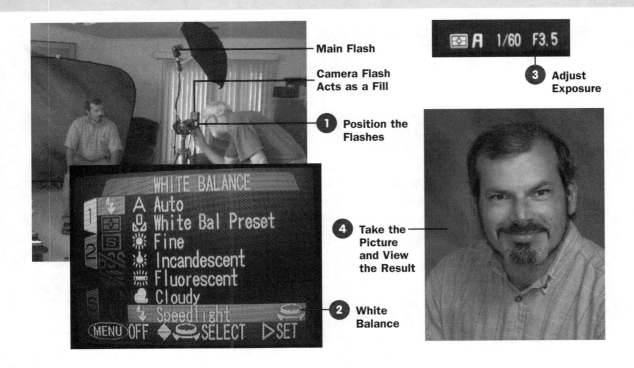

Main Flash

Camera Flash
Acts as a Fill

1 Position the
Flashes

3 Adjust
Exposure

4 Take the
Picture
and View
the Result

2 White
Balance

WHITE BALANCE
A Auto
White Bal Preset
Fine
Incandescent
Fluorescent
Cloudy
Speedlight
MENU OFF SELECT SET

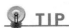 **TIP**

If you plan on taking a lot of formal portraits, you can invest in a flash meter, which will help you calculate the exact aperture required. Short of making that type of investment, set up the camera using the aperture you calculated, switch to a low *resolution*, and take a quick snapshot. Using a lower resolution reduces the time it takes for a photo to appear on the LCD monitor, which allows you to take a series of snapshots quickly as you make small adjustments to get the *exposure* right. Then change to high resolution to take the formal portrait.

3 Adjust Exposure

Change to *aperture priority* and select the *aperture* you calculated based on the main flash distance and *guide number* (see **26** **About Formal Portrait Photography**). When possible, favor a larger aperture over a smaller one to blur the background (and focus attention on the subject). The larger aperture also forces the camera to use a fast *shutter speed*, which limits the exposure of available light and reduces the risk of any color shift caused by mixed lighting sources (flash and incandescent, for example).

4 Take the Picture and View the Result

Mount the camera on a tripod so that you can get the sharpest results. Press the shutter release halfway, point the camera at the subject's eyes to let it focus, then recompose the shot. When the subject seems relaxed, press the shutter release the rest of the way to take the picture. View the result and reshoot if needed.

My husband wanted a casual portrait to use for his work, and with just one extra flash, I was able to grant his wish easily. I used a fairly large aperture—f3.5, and a medium shutter speed.

28 Shoot an Outdoor Portrait

Sunlight is often the most favorable lighting condition for a portrait because photographs using natural light show skin tones more accurately. Also, an outdoor background can lend a sense of casual friendliness to an otherwise formal pose. So it's not surprising that many photographers prefer to take portraits out-of-doors.

The main problem with taking a portrait outdoors is—ironically—the light. When shooting outdoors, you must examine the light carefully and choose a time and place where the light is not too harsh, or you'll emphasize every imperfection on your subject's face. Typically, early morning and late afternoon light is best, but you can shoot in the middle of the day if it's overcast or slightly shady where you are. (The east or north side of a house or large building often provides the kind of diffuse light needed to get a middle-of-the-day shot.) Even under very sunny conditions, you can soften shadows with a fill flash to lessen undesirable lighting, as this task will show. This technique (of using a flash to soften shadows caused by the harsh sun) is known as *synchro-sun*.

You can also diffuse harsh sunlight and remove shadows using a *diffuser*. You hold the diffuser between the light and your subject to remove harsh shadows caused by bright light. If the light is weak (as it often is around sunrise and sunset), you can lighten your subject's face by bouncing light back onto it using a *reflector*, which also softens any deep shadows. Reflectors come in many sizes and colors; typically a two-sided white/silver combo is best (because it does not change the color of the subject) although a gold reflector is useful when you want to add warmth to the reflected light. You should be able to find small portable diffusers and reflectors at reasonable prices from Photoflex Litediscs (**www.photoflex.com**), Visual Departures' Flexfill (**www.visualdepartures.com**), Adorama (**www.adorama.com**), and Westcott (**www.fjwestcott.com**). Note that the reflector I'm talking about here is a light reflector, a round piece of fabric that's used to reflect natural light onto a subject. This is not the same thing as a *flash reflector*, which is used to bounce the light of an external flash.

Before You Begin

✔ **1** About Photography
✔ **2** About Lighting

See Also

→ **29** Shoot a Backlit Portrait
→ **34** Shoot a Nighttime Portrait

⚲KEY TERMS

Synchro-sun—Using a soft flash to add fill light to an outdoor photograph to lighten shadows.

Diffuser—A semi-translucent panel that spreads and softens natural light falling on a subject.

Reflector—A round, lightweight, metallic fabric that reflects natural light back onto a subject, lightening shadows.

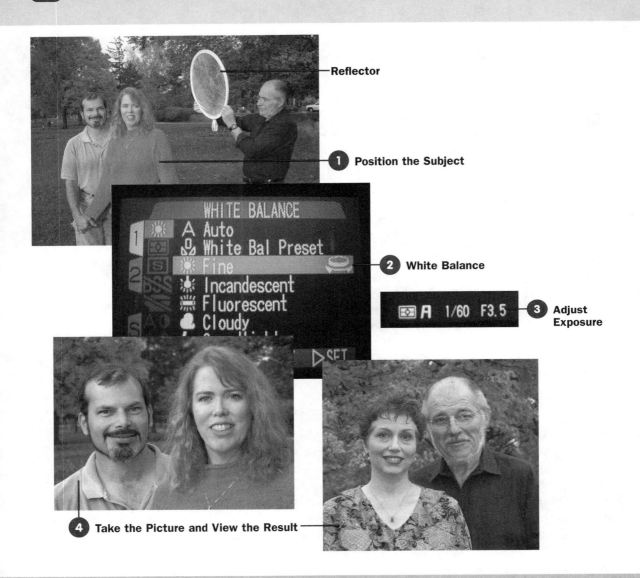

Reflector

1 **Position the Subject**

WHITE BALANCE
A Auto
White Bal Preset
Fine
Incandescent
Fluorescent
Cloudy

2 **White Balance**

A 1/60 F3.5

3 **Adjust Exposure**

4 **Take the Picture and View the Result**

1 Position the Subject

Position the subject so that the sun is not directly in his or her face; this arrangement prevents your subject from squinting. If needed, move to the eastern or northern side of a house or other building to block the harsh sun. Look for distractions in the background

(such as trees or poles coming out of the subject's head, bold or busy graphics, or signs) and reposition the subject or yourself as needed. If the subject's face is darkened by the sun coming from behind, see **29** **Shoot a Backlit Portrait** for help.

I waited until an hour before sunset for this portrait, and because the light was weak, I asked a friend to hold a silver reflector up to the couple's faces, to lighten the shadows and add a nice glow.

2 White Balance

Select **Daylight/Sunlight** as the *white balance* setting (on my Nikon camera, this setting is called **Fine**). If the subject is in the shade, select the **Cloudy/Overcast** setting.

3 Adjust Exposure

If your camera offers a **Portrait** scene mode, turn it on. Otherwise, choose *aperture priority* mode and select a large aperture such as f2.8 or f4. A large *aperture* gives you a small *depth of field* and blurs the background. This brings the focus of the photo onto the subject.

If the light is falling on only one side of the person's face, you might want to open up the aperture one *f-stop*. For example, if the camera's meter suggests that you use f4, change to f2.8 instead. You can do that by adjusting the *exposure compensation* to +1 or by manually selecting a larger aperture.

4 Take the Picture and View the Result

Mount the camera on a tripod for sharpest results. Point the camera at the subject's eyes, press the shutter release halfway to let the camera focus, then recompose the shot. When the subject seems relaxed, press the shutter release the rest of the way to take the picture. View the result and reshoot if needed.

The setting sun provided just enough light to create these charming outdoor portraits. Using a large aperture, I was able to blur the autumn leaves behind my subjects, creating the perfect background. I didn't use a fill flash, but for a few shots when the sun was just about to go down, I bounced light back on the subjects using a silver reflector held by a volunteer.

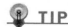

TIP

Need inspiration on where to shoot and how to pose your subjects? Look at the work of various professional photographers and use what you like to create your own unique portrait.

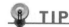

TIP

If you want to soften the shadows on the subject's face, turn on the flash (the **Forced Flash** option). This trick works, however, only if the subject is within flash distance. Because daylight is your main light source, be sure to adjust the *flash exposure* compensation to –1 or –2 to turn your on-camera flash into a fill light.

29 Shoot a Backlit Portrait

Before You Begin

✔ **2** About Lighting

See Also

→ **28** Shoot an Outdoor Portrait

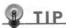

TIP

Be aware of lens flare (stray light entering the lens) when taking a backlit photograph; if needed, add a lens shade or use your hand to block the light and stop the flare.

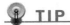

TIP

You can lighten your subject's face by turning on the flash (the **Forced Flash** setting). Adjust the flash exposure compensation to –1 or –2 to create a proper fill flash.

When the sun is positioned behind a subject, it provides a distinct advantage to the portrait photographer: Your subject's eyes are more likely to be wide open and free of squint. However, backlight also comes with a distinct disadvantage because it typically causes your camera to underexpose the subject while properly exposing the background. In this task, I'll show you how to deal with this tricky lighting situation.

❶ White Balance

Select **Daylight/Sunlight** as the *white balance* setting. On my Nikon, this setting is called **Fine**.

❷ Adjust Exposure

If your camera offers a **Backlight** scene mode, select it because that will automatically compensate for the camera's desire to underexpose such a picture. Otherwise, set the *exposure compensation* to +1 or +2.

If your camera doesn't offer a **Backlight** scene mode or exposure compensation, you can select *spot metering mode*, walk up close to your subject, and press the shutter release halfway to take an exposure reading from the subject's face. Using the *aperture* and *shutter speed* readings that appear on the *LCD monitor*, you can change to **Manual** mode and enter these settings manually to get a proper *exposure*.

❸ Take the Picture and View the Result

Mount the camera on a tripod for sharpest results. Point the camera at the subject's eyes, press the shutter release halfway to let the camera focus, and then recompose the shot. When the subject seems relaxed, press the shutter release the rest of the way to take the picture. View the result and reshoot if needed.

The sun setting behind our backs cast a nice glow around us, but unfortunately, it also put our faces in shadow. To fix that problem, I increased the exposure compensation by one and a half stops (1.5).

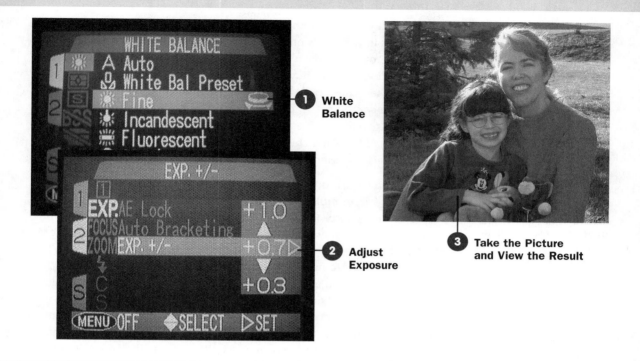

1 **White Balance**

2 **Adjust Exposure**

3 **Take the Picture and View the Result**

30 Capture an Infant's Portrait

Taking a picture of an infant is often a challenge because the child may not be able to hold her head up. When infants are 4 to 6 months of age, they can typically sit, hold up their heads, and smile—all the necessary ingredients for a very cute portrait. If your infant can't yet sit on his own, there are many tricks you can try to pose him naturally. For example, try propping him up in a car seat covered in a baby blanket. Laying her face up on a nice rug (a bearskin, if you want a traditional look) is another alternative; for a variation, place the infant on his side or belly with his head facing toward you. If the child can hold up her head but is unable to sit, you can try posing the infant on her belly, or lying across the top of a pillow covered in a soft blanket. The main problem you'll have in taking a portrait of an infant this age is preventing the baby's tendency to flop over. A Boppy—essentially a fabric-covered donut—may prove useful in propping up your baby for a portrait.

Before You Begin

✔ **1** About Photography

See Also

→ **31** Capture a Toddler's Portrait

Of course, if you include the parent in the portrait, there are any number of ways in which a small infant can be held with the neck properly supported. You can have a mother hold an infant close to her chest, or up to her face. You can have either parent lie on the floor, with the infant on their chest, both facing you. If you don't want to include the parent, you can have the father hold a small baby in his hand, with his arm outstretched. The size contrast between the father's hand and the baby's face will make a cherished photo. As in all situations regarding babies, especially handling, the utmost in care must be applied.

After a child can sit up, he can be photographed using various props such as stuffed animals, blocks, rattles, and the like. The infant can be seated on the floor or in a chair, surrounded by soft pillows. Because an infant of this age may also be teething, make sure that you have a soft cloth on hand for wiping the face. Also remember that a baby doesn't have to be awake to have her picture taken; a portrait of an infant sleeping is sweet and endearing. If you do want a picture of your child with his or her eyes wide open, then plan your picture-taking time for the child's normal period of activity. Have your camera, any props, and the outfit(s) you want to use all ready so that you can take advantage of that narrow window of wide-awake activity. Of course, there isn't any great need to pose an infant to get a memorable photograph; you can simply take a picture of your child doing perfectly ordinary things such as eating, being bathed, or exploring her new world.

TIP

You don't have to take a picture of the entire infant to get a treasured photograph. Tiny baby feet and hands make adorable photographs.

① White Balance

Because babies are so sensitive to the sun and changes in their environment, you'll probably want to take an infant's portrait indoors. After positioning or propping up the infant, select the appropriate *white balance* setting: **Tungsten**, **Daylight**, **Cloudy**, and so on.

NOTE

If you must use a non-bounced flash in infant photography, make sure that the flash is placed at least three feet away from the child to prevent damaging her tender eyes. You can then use your telephoto lens to fill the frame and still maintain a respectable distance. Also, turn on red-eye reduction if you use a non-bounced flash.

② Turn Off the Flash

Turn off the flash so that it doesn't hurt the infant's eyes, which are very sensitive. If you must use a flash, bounce it off a wall, into a *flash reflector* or a flash umbrella.

③ Select Automatic Mode

Because getting a good infant portrait is stressful enough, and because you won't be using a flash, make it easy on yourself and select **Automatic** exposure mode, which forces the camera to choose the appropriate shutter speed and aperture to use.

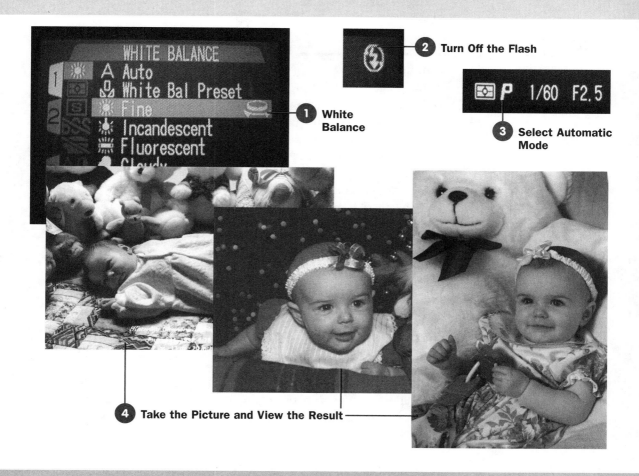

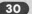 **2** Turn Off the Flash

1 White Balance

3 Select Automatic Mode

4 Take the Picture and View the Result

4 Take the Picture and View the Result

Mount the camera on a tripod so that you can get a sharp picture. Because infants are so small, you'll probably want to shoot at eye level and keep the background simple (such as a sheet) to make the child the focus of the photograph.

Point the camera at the infant's eyes, press the shutter release halfway to let the camera focus, and then recompose the shot. When the infant seems relaxed, press the shutter release the rest of the way to take the picture. View the result and reshoot if needed.

31 Capture a Toddler's Portrait

Before You Begin

✔ 1 About Photography

See Also

→ 32 Capture an Older Child's Portrait

TIP

A toddler's world is expanding and she is becoming more social. For a special picture, include your child's friends in the portrait.

Portraits of toddlers are often difficult to get because they are fascinated by their new mobility. Rather than posing a toddler, you may find it easier to capture a portrait "on the go." If you want more of a pose, try sitting your toddler down with a new toy and snap photos while he or she is busy exploring. Of course, as you are well aware by now, a toddler's attention span is notoriously short, so to stretch out this magic quiet time, have a supply of new objects to explore such as pots and pans, wooden spoons, books, balls, keys, and so on. Present each object one at a time to keep the photo from getting too cluttered. A large hat may occupy an infant for awhile because it is easy to use in peek-a-boo and it may even become part of the portrait, should the child choose to try it on.

① White Balance

Select the appropriate *white balance* setting: **Daylight**, **Tungsten**, **Cloudy**, and so on. The outdoor setting on my Nikon is named **Fine**.

② Set Exposure

Select **Portrait** scene mode if your camera has one. Otherwise, change to *aperture priority mode* and select a large *aperture* such as f4 to create a small *depth of field* and blur the background behind your subject.

If your toddler is on the go, do not select **Portrait** mode. Instead, change to *shutter priority mode* and select a fast *shutter speed*.

③ Take the Picture and View the Result

Mount the camera on a tripod if your toddler is engaged in an activity in which he or she will sit still. If your toddler is moving around a lot, you can still use a tripod, and simply pre-focus on a spot you know the toddler will return to. If you have to hold the camera in your hand while following the toddler around for a good shot, select a slightly slower shutter speed, pre-focus on a spot, and pull your elbows in to brace the camera.

Fill the frame with your subject as much as possible and press the shutter release the rest of the way to take the picture. View the result and reshoot if needed.

TIP

Although a toddler is usually not surprised by the peek-a-boo toy trick, you might be able to elicit a smile by blowing bubbles. You can also have the child say a word that ends in "y," such as *happy*, *turkey*, and so on to stretch the mouth into a soft smile.

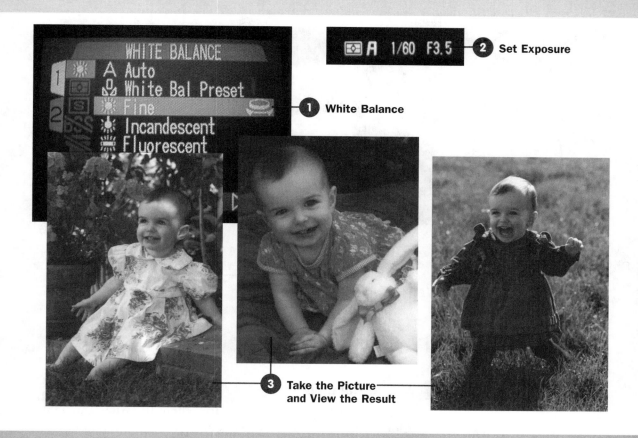

2 Set Exposure

A 1/60 F3.5

1 White Balance

WHITE BALANCE
A Auto
White Bal Preset
Fine
Incandescent
Fluorescent

3 Take the Picture and View the Result

32 Capture an Older Child's Portrait

The most difficult part of photographing an older child is getting her to smile naturally. By this age, they've had their pictures taken millions of times and are usually tired of it. Asking an older child to smile typically results in either a fake grin or an attitude. In such situations, it's best to let an older child act natural and forget posing. An older child might also relax more in his own space such as his bedroom or a favorite haunt. To distract the child, provide a familiar toy such as a basketball, book, car, or Frisbee so that he can concentrate on something other than the camera. You may even want to set the camera up on a tripod and use a remote to take the photo when the child seems relaxed.

Before You Begin

✔ **1** About Photography

See Also

→ **27** Shoot a Formal Indoor Portrait

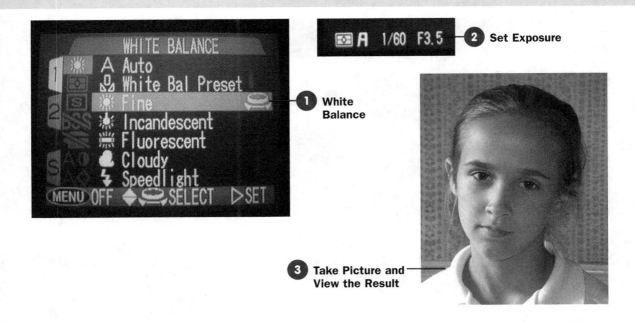

2 Set Exposure

1 White Balance

3 Take Picture and View the Result

 TIP

For something unique, let your older child borrow your camera and record his world. The result will give you lots of insight into what he considers important. You can also have an older child take a picture of a younger sibling.

1 White Balance

Select the appropriate *white balance* setting: **Tungsten**, **Daylight**, **Cloudy**, and so on. The outdoor setting on my Nikon is named **Fine**.

2 Set Exposure

Select **Portrait** scene mode if your camera has one. Otherwise, change to *aperture priority mode* and select a large *aperture* such as f4 to create a small *depth of field* and blur the background behind your subject.

3 Take the Picture and View the Result

Mount the camera on a tripod so that you can get a nice, sharp portrait. Point the camera at the subject's eyes, press the shutter release halfway to let the camera focus, and then recompose the shot. When the subject seems relaxed, press the shutter release the rest of the way to take the picture. View the result and reshoot if needed.

Seeing the moment and having my camera ready were the key factors in getting this portrait of my niece, Bridget, age 11. The sunlight from the window provided enough natural light, so no flash was used. I set up my camera and took several test shots before I asked her to sit for me. Right after this portrait, I got several shots of a young lady already bored with sitting for a portrait, so I'm glad I took the time necessary to get the exposure right before I brought her in. I actually did get one picture of her smiling, but frankly, this portrait seems more natural and mature, with her Mona Lisa almost-smile.

33 Capture a Pet's Portrait

Taking a picture of your pet can be similar to capturing a portrait of a toddler. Most pets—dogs, cats, hamsters, gerbils, rabbits, and so on—have minds of their own. This makes it unlikely your pet will sit still for a nice portrait. To increase your chances at getting a nice photograph, keep your camera handy and bring it out often. This will help your pet get used to the camera and its flash. Also, the shear volume of photos should increase the chances that one of them is a "keeper."

Like toddlers, most pets have very short attention spans and do not like to be restrained. To keep your pet entertained and in one spot, bring out a new toy, or one you reserve only for picture-taking time. Use a fairly fast shutter speed to capture your pet "on the go." You can also try pre-focusing on a spot and then simply waiting for the animal to step into the frame.

Before You Begin

✔ **1** About Photography

1 White Balance

Select the appropriate *white balance* setting: **Tungsten**, **Daylight**, **Cloudy**, and so on. The outdoor setting on my Nikon is named **Fine**.

2 Set Exposure

Select **Portrait** scene mode if your camera has one. Otherwise, change to *aperture priority mode* and select a large *aperture* such as f4 to create a small *depth of field* and blur the background behind your subject. A large aperture also results in a fast *shutter speed*, but if your pet is still blurred in your photographs, change to *shutter priority mode* and select an even faster shutter speed.

TIP

If you want a picture with more action, you can get a dog to lick its face if you rub bacon on its nose.

NOTE

If your pet has dark fur, you should use a fill flash, whether indoors or out. Force the flash on if necessary and adjust its output or diffuse it with a few facial tissues. Rather than using a flash, you can try adjusting the *exposure compensation* by **+1**.

2 Set Exposure

1 White Balance

3 Take the Picture and View the Result

TIP

The eyes are the key to a good portrait, so you might want to get down at your pet's eye level when taking its photograph.

3 Take the Picture and View the Result

Mount the camera on a tripod if your pet is engaged in an activity in which he or she will sit still. If your pet is moving around a lot, you can still use a tripod and simply pre-focus on a spot you know the pet will return to. If you have to hold the camera in your hand while following the pet around for a good shot, select a slightly faster shutter speed, pre-focus on a spot, and pull your elbows in to brace the camera.

Fill the frame with your subject as much as possible and then press the shutter release the rest of the way to take the picture. View the result and reshoot if needed. I followed my sister's dog, Angel, around for some time before she finally settled down for this casual portrait. Because Angel is not a very large dog, it was even more important that I get down to her level so that she could fill the frame. Because I have a Nikon 990 that twists, I didn't actually have to get down on the ground to shoot the image and still preview it in the *LCD monitor*—a nice camera feature to think about if you plan on shooting a lot of pets, babies, or other low-to-the-ground subjects.

34 Shoot a Nighttime Portrait

The main problem with trying to take someone's picture at night is that you'll have to use your flash and you'll probably end up with a "deer in the headlights" look. The subject will be well exposed, and the background will be almost black, lacking detail. To combat this problem, you can use a technique called *slow sync*, which lightens the background by capturing some of the ambient light.

❶ White Balance

Strange as it seems, you'll probably want to *white balance* your camera using its **Electronic Flash/Speedlight** or **Daylight/Sunlight** setting to make sure that the resulting image is not too blue. If your camera has a **Night Portrait** or **Twilight Portrait** scene mode, try this setting because it should automatically select a **Daylight** white balance for you.

If there is a lot of ambient light (for example, you're shooting a picture of someone in front of brightly lit buildings or monuments), *and* you can capture the image without a flash, use a white balance setting that matches that light source, such as **Tungsten/Incandescent** or **Fluorescent**. Otherwise, keep the white balance set at **Electronic Flash/Daylight**.

❷ Set Exposure and Flash

Select **Program Auto** mode and use *center-weighted* or *spot metering* on the most important element—for example, if you meter on the brightly lit building behind your subject, your subject might be slightly underexposed, but that's fairly accurate. If you meter on the subject, the building might appear too washed out, and because it'll be the lightest object in the frame, it might draw attention away from your subject.

If you are using a flash and your camera has a *slow sync* flash setting such as **Slow Sync/Slow Shutter/Long Exp** or something similar, turn it on. This setting will allow the camera to capture some of the ambient light after the flash goes off.

If your camera doesn't have a slow sync setting, change to *shutter-priority mode* and select a slow *shutter speed* so that you can record some of the ambient light. Using this method, make sure that you tell your subject not to move during the *exposure*.

Before You Begin

✔ **2** About Lighting

See Also

→ **17** Take a Picture by Moonlight

→ **28** Shoot an Outdoor Portrait

🔍 **KEY TERM**

Slow sync—Also known as synchronized flash or drag shutter, slow sync is a special flash setting in which the shutter is left open for a brief period after the flash goes off so that the camera can capture ambient light.

💡 **TIP**

With lots of ambient light and a flash, your photographs may experience a color shift. In such cases, use the appropriate Kodak gelatin filter (a filter that matches the ambient light source) and tape it over your flash. The filter will convert the temperature of the flash output to match the artificial light.

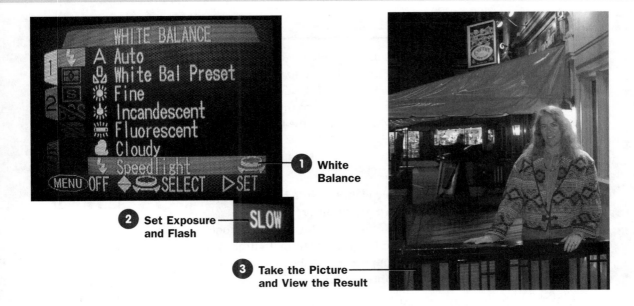

1 White Balance

2 Set Exposure and Flash

3 Take the Picture and View the Result

✎ NOTE

In low-light conditions, it's often difficult for a camera to properly focus. You might have to focus manually or change to the **Macro** setting to force the camera to focus on your subject (which is hopefully closer to the camera than the nearest bright object). You can also ask an assistant to shine a flashlight on your subject while the camera focuses and turn the flashlight off while you take the picture.

3 Take the Picture and View the Result

Because this will be a long exposure, place the camera on a tripod. You might want to use a cable release, remote trigger, or the camera's self-timer to reduce camera shake.

If you can't capture the image at all, try changing to a higher *ISO*; doing so increases the camera's light sensitivity and its ability to capture images in low-light conditions. Keep in mind that a higher ISO setting increases the amount of noise and often results in a loss of detail in the light areas. You can compensate for this a bit by selecting the highest *resolution* available. If you change the ISO, make sure that you white balance the camera again to prevent color shift.

This image was captured outside a restaurant in a quaint village near my home. Using the slow shutter enabled me to capture the ambient light from the various shops nearby.

35 Capture an On-Stage Performance

The problem with trying to take a picture of someone onstage during a live performance is that typically the performer is very well lit but much of the surrounding area is in darkness. This problem becomes even more acute in situations in which a spotlight is used. In addition, you'll probably have to use a zoom lens, which increases the chance for blur and lower resolution. On top of all this, your subject is moving onstage, and because you're seated in the audience, using a tripod is probably out of the question. Add all these elements up, and you have a very challenging photograph to capture. In this task, I'll show you some simple steps you can use to solve these problems and capture a memorable image.

① White Balance

Select **Tungsten/Incandescent** as the *white balance* option for the camera. You can also try manually white balancing the camera after zooming in on a white object onstage.

② Turn Off the Flash

The flash won't do you any good because its light won't reach the subject on-stage. Turn off the flash so that it won't bother the performers or the audience.

③ Set Exposure

Change to *shutter priority* mode and select a fast *shutter speed* so that you can freeze the action. *Matrix metering mode*, the default for most cameras, will work fine in situations where the entire stage is well lit; in situations where the subject is spotlighted, choose *spot metering mode* or *center-weighted metering mode* and meter on the subject.

④ Take the Picture and View the Result

Point the camera at the subject, press the shutter release halfway to let the camera focus, and then recompose the shot. Take the picture, view the result, and reshoot if needed.

Before You Begin

✔ **2** About Lighting

See Also

→ **37** Photograph an Event

 TIP

As a courtesy to the other audience members, turn off all camera sound effects (if possible). For example, most cameras let you turn off the sound they make after you take a photo.

 TIP

If you can lock in an exposure for a series of images (AE Lock), try using matrix metering when the stage is entirely lit and then lock in that exposure.

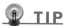 **TIP**

If the performer is wearing a dark costume, the subject might appear overexposed in the final image. If so, try changing the *exposure compensation* to –1 or –2.

1 White Balance

2 Turn Off the Flash

3 Set Exposure

4 Take the Picture and View the Result

I took this portrait at a luau during a recent visit to Hawaii. The sun had just set, but there was still some natural light left in the sky, which I managed to capture by metering for a correct exposure of the stage. To do that, I changed to center-weighted metering and zoomed in on the stage area while pressing the shutter release halfway. I then zoomed out a bit, recomposed, and took the picture. Even this small amount of natural light helped to add detail to the background which otherwise might have appeared as a black hole.

36 Shoot a Black-and-White Portrait

Before You Begin

✔ **2** About Lighting

When you're shooting an image in black and white, color is obviously not an important element. You should instead pay particular attention to *tone* (the lightness and darkness of a color). When you're setting up

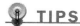

the portrait, take a moment to study the values in the scene and note how well they contrast. Squinting sometimes helps you concentrate more on the light and dark tones and less on color. What you're looking for here is a background that contrasts well with your subject's hair and clothing; it should be either considerably lighter or darker in tone.

Anytime you shoot in black and white, the effect is nostalgic. You can exploit this effect by having your subject wear an outfit with an old-time look, such as a simple button-down shirt and jeans. With children, keep the clothing soft and simple, such as a dress and pinafore.

① Position the Flashes

Position the subject on a stool, facing at an angle to the camera so that the subject's far ear is partially hidden. Position the flashes to achieve the lighting effect you want. I set up my main flash just to the left of the camera and slightly in front, at a 45-degree angle to the model.

You might have to use a background flash to separate a dark-haired person from the background. I had two external flashes with me, so I raised the second flash pretty high and tilted it to shine a bit on the background and on the back of my sister's hair, creating a nice accent. You could light the background using a table lamp with its shade removed; for an accent light, use a pole light or have an assistant shine a flashlight on the back of the subject's hair.

② White Balance

Select a *white balance* setting of **Electronic Flash** or if your camera doesn't have this option, **Daylight/Sunlight**.

③ Select Black and White

Select the **Black and White** photo effect option. This setting tells the camera to store the image in grayscale, and not in color. If your camera doesn't have this option, you can change an image to grayscale after the fact using a *graphics editor* such as Photoshop Elements or Paint Shop Pro.

TIPS

If it's a true nostalgic look you want, increase the image's graininess by increasing the *ISO* setting or by adding noise using a digital editing program such as Photoshop.

Black and White mode can be used to great effect in shooting character studies of someone's face, shooting a landscape with lots of high contrast, shooting a smoky or foggy landscape, and capturing the detail in architecture or statuary.

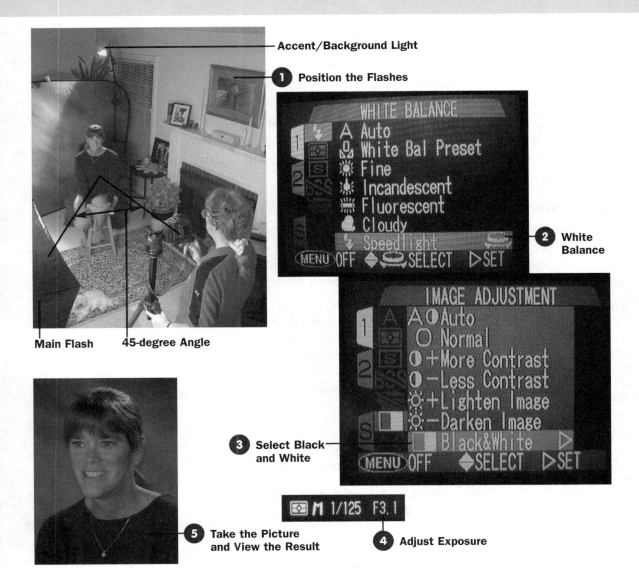

Accent/Background Light

1 Position the Flashes

WHITE BALANCE
A Auto
White Bal Preset
Fine
Incandescent
Fluorescent
Cloudy
Speedlight
MENU OFF ◆⬭SELECT ▷SET

2 White Balance

IMAGE ADJUSTMENT
A Auto
Normal
+More Contrast
-Less Contrast
+Lighten Image
-Darken Image
Black&White ▷
MENU OFF ◆SELECT ▷SET

Main Flash 45-degree Angle

3 Select Black and White

M 1/125 F3.1

5 Take the Picture and View the Result

4 Adjust Exposure

4 Adjust Exposure

Change to **Manual** mode and select the *aperture* you calculated based on the main flash-to-subject distance and flash's guide number (see **26** **About Formal Portrait Photography**). When

possible, favor a larger aperture over a smaller one because you'll blur the background (and focus attention on the subject). Select a fast *shutter speed* such as 1/60th of a second to limit the exposure of available light. (If you capture a lot of the available light along with the light from the flash, you'll see a color shift, so select a fast shutter speed to prevent that from happening.)

5 Take the Picture and View the Result

Mount the camera on a tripod so that you can get the sharpest results. Press the shutter release halfway, point the camera at the subject's eyes to let the camera focus, then recompose the shot. When the subject seems relaxed, press the shutter release the rest of the way to take the picture. View the result and reshoot if needed.

For this portrait of my sister, Pat, I set up an accent/background light above and behind her to highlight her hair and light the background. I positioned the main flash to the left of my camera and above her head, creating a *short lighting* effect. I used the on-camera flash as a soft fill light. After calculating the distance between the flash and the subject (I didn't need to add the distance up to the ceiling, since I was bouncing the flash into a flash umbrella), I choose an aperture of f3.1, and a shutter speed of 1/125th second.

 TIP

If you plan on taking a lot of formal portraits, invest in a flash meter, which will help you calculate the exact aperture required. Short of making that type of investment, select the aperture you calculated based on the formula given earlier, switch to a low *resolution*, and take a quick snapshot. Using a lower resolution reduces the time it takes for a photo to appear on the *LCD monitor*, which allows you to quickly make small adjustments to the exposure. Then change to high resolution to take the formal portrait.

37 Photograph an Event

Probably the number-one reason amateur photographers take pictures is to record some kind of special event—a birthday, anniversary, reunion, parade, festival, convention, or other one-time happening. Before you lug your camera to the next event, make a plan so that you can get great-looking shots. For example, ask yourself what you want to do with the resulting photos. If you're planning on printing them, you'll need to use the highest *resolution* possible; if you simply want to share them with friends and relatives using email, you can go with a much lower resolution and capture more images on a single memory stick. If you are planning on creating a photo CD, make sure that you get a good cover shot—one that tells enough of the story to make the purpose of the CD obvious and yet still leaves room for text for the cover if desired. You might recycle some of the images for thank-you cards, t-shirt transfers, magnets, or even a scrapbook, so make out your laundry list of needed images before you go to the event.

Before You Begin

✔ **1** About Photography
✔ **2** About Lighting

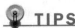 **TIP**

If the event is a public one such as a NASCAR race, get credentials if possible by writing the public relations office and asking for a press pass. The press pass will allow you to move more freely and cover the event more thoroughly.

 TIPS

If you want to mingle while covering an event such as a family birthday, set up your camera on a tripod and leave it on. The camera will automatically reduce its power usage when you're not using it. When it looks like a good shot is coming up, you can quickly jump behind the camera and capture the image. Better yet, with a remote control, you can snap images without getting near the camera and no one will be the wiser.

Remember to shoot a mixture of shots of various focal lengths (zoomed in and zoomed out) and orientations (both horizontal and vertical shots). A good variety of shots will aid in spicing up a photo album or photo CD and keep the images from looking predictable in their layout.

When you arrive at the event, wander around and look for locations that will get you the shots on your list. Take a few sample shots to test for exposure, sharpness, and framing. The idea is to tell the full story of the event—the beginning, middle, and end. For example, you might want to take a picture of the limousine on your way into the church for a wedding, as well as the church itself. At a birthday party, take pictures of the cake and the party decorations—both inside and out. At the family Christmas party, take a picture of the Christmas tree, the buffet, and the presents. Then capture images as the event is going on and as it winds down. If you blend into the background, you can often capture candid images of people conversing, thinking, or simply enjoying the experience.

1 **Set Up Camera**

Get to the event early so that you can prepare and get a good spot from which to take your photographs. Anticipate where the majority of the action will take place and choose your spot accordingly. Have your equipment ready—batteries charged, lots of memory sticks, and a tripod if you think you'll need one. Be familiar with your camera so that you're not groping for the controls or missing the action.

Be sure to **white balance** the camera before you begin shooting, basing your choice on the main light source, such as **Tungsten**, **Daylight**, or **Electronic Flash**. Take a few test shots and change the *exposure* settings (*aperture*, *shutter speed*) as desired.

If your camera has an **AE Lock** (automatic exposure lock) feature where you can lock in the exposure settings for a series of images, you might want to turn it on so that the settings you select don't change with every photo. Of course, if you're moving around a lot and the lighting changes frequently, you won't want to engage the **AE Lock** feature.

2 **Take Establishing Shots**

On your way into the event, capture images that establish where you are—the church, the family farm, the outside of the auditorium, and so on. Get candid shots of people arriving, getting ready for the event, and so on.

1 Set Up Camera

2 Take Establishing Shots

3 Pick a Spot and Take Remaining Shots

The Tour of Hope with Lance Armstrong came to town recently, and I wanted to take pictures of the event. Before the event started, I captured the excitement of the waiting crowd, the tour bus outside, and a poster announcing the event. Each of these images tells the beginning of the story and sets the scene. I might choose the bus image, for example, as the first image in a slideshow.

3 Pick a Spot and Take Remaining Shots

If the event is a public one, you probably won't be able to move after the event begins, but you can still get a nice variety of images. When shooting, use various focal lengths to capture close-ups of the main people at the event, overall shots of the crowd and the surrounding area, and so on.

During the Tour of Hope event, I couldn't move around so I took the remaining shots from my seat. I made sure to vary the shots, capturing a few that included the crowd, a bicycling demonstration, and the stage. I also took some close-ups of Lance, Dr. Einhorn (who pioneered the treatment that cured him), and Reggie Miller of the Indiana Pacers. After the event was over, I captured a few shots of the crowd leaving Conseco Fieldhouse, sharing their stories of cancer survival, and posing by the tour bus.

PART II

Importing and Viewing Items

IN THIS PART:

5

Importing Items into Photoshop Album

IN THIS CHAPTER:

Up to this point, this book has concentrated on the skills you need to take great-looking digital photographs. By now you have probably accumulated quite a collection of images, and that's where Photoshop Album comes in. With Photoshop Album, you can organize your images quickly and easily locate them later. At the heart of Photoshop Album is its *catalog*—in the catalog, you can organize all your images, regardless of their location, into whatever categories you choose. For example, if you want to organize all the photos of your son into one folder, you can, even if those photos are stored in various locations on the hard disk and on several CDs or DVDs. Of course, to keep Photoshop Album running smoothly, you must keep its catalog in order, so in this chapter you'll learn not only how to add images to the catalog, but to remove them when needed, to update the catalog when an image's location has changed, and to back up the catalog listing periodically. If several people use a single computer, you can create multiple catalogs, each with its own way of organizing the same (or even different) images. Finally, you'll learn how to back up the images themselves onto CD-ROM or DVD—a good practice that ensures that your photos are protected should something happen to the originals.

38 Perform an Initial Scan for Media

See Also

→ **39** Import Media from a Folder

→ **40** Import Media from a CD-ROM or DVD

→ **41** Import Images from a Digital Camera

→ **42** Import a Scanned Image

When you start Photoshop Album for the first time, it will search the hard disk for media files—images, music, and movies. When it finds a media file, Photoshop Album makes a note of its name, file type, and location. After the scan, you select the folders containing the media files you want to catalog, ignoring any folders with media files you don't often use. For example, Microsoft Office comes with lots of clip art files; although they are media files, you probably don't want to add them to your Photoshop Album catalog because you typically will not use these clip art files outside of Microsoft Office.

The media files contained in the folders you select are then added to the catalog listing. Imported media files can then be organized into whatever categories you choose. If you create more images, sound files, or movies after this initial scan, you can go back into Photoshop Album and perform similar steps to add these new media files to the catalog. See **39** **Import Media from a Folder**, **40** **Import Media from a CD-ROM or DVD**, **41** **Import Images from a Digital Camera**, and

42 **Import a Scanned Image** for help in adding any new images you acquire after performing an initial scan as described in this task.

If you already have photos organized in Adobe PhotoDeluxe, you can import them directly by selecting **File, Get Photos, PhotoDeluxe Album**. Select **Search PhotoDeluxe User Folders** and click **Start**. Select the albums you want to import and then click **Import Album**. If your images are stored in Adobe ActiveShare, you can import them as well; just select **File, Get Photos, ActiveShare Albums** and click **Search**. Select the albums to import and click **Import Album**.

1 **Click Get Photos**

After starting Photoshop Album, the *Quick Guide* appears. (If it doesn't, click the **Quick Guide** button on the **Shortcuts** bar—located just under the menu bar, at the top of the Photoshop Album window—to display it.) Click the **Get Photos** icon on the **Overview** tab to initiate the importing process.

2 **Click Search Drive**

On the **Get Photos** tab, click the **Search Drive** icon to initiate a search for media files on your hard disk.

3 **Select Location**

From the **Look In** drop-down list, select the location you want to search. To search your entire computer, select **All Hard Disks**. To search only the main drive, select **C Drive**. It's recommended that you select one of these two options for the initial scan; however, if you want to import just your digital photos, they are most likely already stored somewhere in the **My Documents** folder, so you can select that option. You can also select **Browse** and choose a specific folder if you want to really limit the search.

4 **Set Options and Click Search**

By default, Photoshop Album does not search the computer's system folders or any folders for programs you've installed, but you can turn the **Exclude System and Program Folders** option off and search there anyway if you like.

NOTE

This task assumes you have media files on your computer ready to import. If you haven't copied images from your digital camera to your computer yet, you can import them into Photoshop Album directly from the camera or card reader. See **41** **Import Images from a Digital Camera**.

KEY TERM

Quick Guide—The window that appears automatically whenever you start Photoshop Album; use the Quick Guide to initiate common tasks such as importing media files into the catalog.

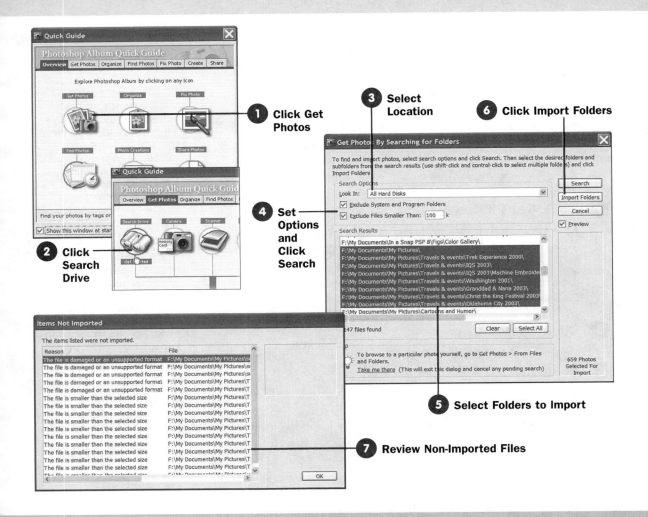

1. **Click Get Photos**
2. **Click Search Drive**
3. **Select Location**
4. **Set Options and Click Search**
5. **Select Folders to Import**
6. **Click Import Folders**
7. **Review Non-Imported Files**

Also, by default, Photoshop Album does not look for files smaller than 100KB, under the assumption that smaller files are unlikely to be of high quality. You can turn the **Exclude Files Smaller Than 100k** option off, or modify the value as desired to include smaller files in the search. You might need to do this, for example, if you take a lot of low-quality photos that you want to store in the catalog.

After changing any options, click **Search** to begin the initial scan. Depending on the location you selected to search, the scan may take a while.

5 **Select Folders to Import**

After the scan is complete, a list of folders that contain media files is displayed in the **Search Results** frame. Select the folders whose contents you want to list in the catalog by either pressing **Ctrl** and clicking each folder or pressing **Shift** and clicking the first and last folder in a group. Selected folders are highlighted in blue. If you want to import all the media files from the folders listed, click **Select All**.

6 **Click Import Folders**

After selecting the folders you want to import, click the **Import Folders** button. The **Getting Photos** dialog box appears, displaying each photo as it's added to the catalog. You can click **Stop** if you want to interrupt the importing process for some reason; only photos already imported at that point will appear in the catalog.

7 **Review Non-Imported Files**

After the import process is complete, the **Items Not Imported** dialog box appears; it lists any files that were not imported. (This dialog box will not appear if all the files were imported correctly.) For example, a file might be smaller than the limit specified, in an unsupported format, or already in the catalog. After reviewing the list, click **OK**. Photoshop Album might display a reminder telling you that the only images being displayed right now are those you have just imported; click **OK** to dismiss this warning box.

TIP

If you're not sure why a specific folder was included in the list, you can click it to display its contents in the column to the right of the **Search Results** frame. You can't select specific files within a folder, but this way you can at least preview what you're importing by choosing a particular folder from the **Search Results** list.

TIP

After the scan, Photoshop Album displays in the photo well only those media files you just imported. To redisplay all the images in the catalog, click the **Show All** button on the **Shortcuts bar**.

39 **Import Media from a Folder**

After you import an initial set of media files by following the steps outlined in **38** **Perform an Initial Scan for Media**, you can import additional media files whenever you like. Suppose that you've scanned photos from a recent vacation and have placed those scans on the hard disk. With Photoshop Album, you don't have to organize digital photos and scans on the hard disk into special folders. You can scan the photos and place them with other image files in the **My Pictures** folder, or you can create a special **Vacations** or **Scans** folder to hold the scanned photos. To view and organize those photos using Photoshop Album, you must import the files into the catalog. Importing does nothing to the files themselves; the process simply adds the files' names, file types, and

Before You Begin

✔ **38** Perform an Initial Scan for Media

See Also

→ **40** Import Media from a CD-ROM or DVD

→ **41** Import Images from a Digital Camera

→ **42** Import a Scanned Image

TIP

To get a few photos into the catalog quickly, drag and drop them. You can drag an image currently displayed in a *graphics editor* such as Photoshop Elements, or from the file listing in **My Computer**. Just drag the image and drop it into the photo well in Photoshop Album to add that image to the catalog.

locations to the catalog. You can then organize the media listing in the catalog however you like, and display or edit the actual images themselves by selecting them from the catalog.

① Click Get Photos, From Files and Folders

Click the **Get Photos** button on the **Shortcuts** bar, and then select **From Files and Folders** from the list that appears. You can also choose **File, Get Photos, From Files and Folders** from the menu.

If you've just started Photoshop Album, you can click the **Get Photos** icon on the **Overview** tab in the *Quick Guide*, and then click the **File Folders** icon to get started.

② Select Location

From the **Look In** drop-down list, select the location of the folder that contains the images you want to import. For example, if the files are located on the main drive, select **Local Disk (C)**.

③ Select Folder

Select the folder whose contents you want to import. For example, if you chose **Local Drive (C)** from the **Look In** list, you can double-click the **My Documents** folder to display its contents, and then double-click the **My Pictures** folder to select only that subfolder. If you want to import the contents of any subfolders of the selected folder (for example, if you have several subfolders within the **My Pictures** folder and you want to scan all of them), enable the **Get Photos from Subfolders** check box. You can select multiple folders by pressing **Ctrl** and clicking each one.

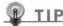

TIP

You don't have to import all the images in a folder; if you double-click the folder and display its contents, you can select just the images you want to import by pressing **Ctrl** and clicking each image file.

For my scan, I navigated to the **My Documents** folder, then double-clicked the **My Pictures** icon to display its contents. I then clicked the **Nature** folder icon to select just that folder for scanning. I enabled the **Get Photos from Subfolders** option to include any subfolders within the **Nature** folder in the scan.

④ Click Get Photos

Click **Get Photos** to begin the importing process. The **Getting Photos** dialog box appears, displaying each photo as it's added to the catalog. You can click **Stop** if you want to interrupt the importing process for some reason; only photos already imported at that point will appear in the catalog.

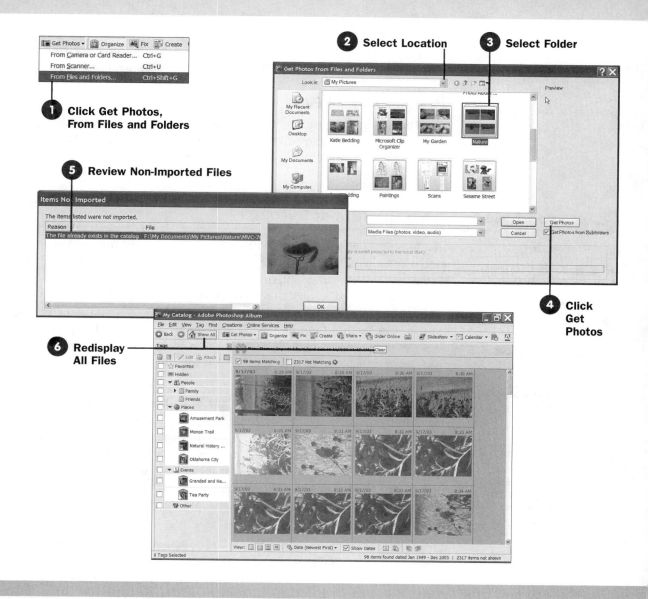

2 Select Location

3 Select Folder

Get Photos ▾ | Organize | Fix | Create
From Camera or Card Reader... Ctrl+G
From Scanner... Ctrl+U
From Files and Folders... Ctrl+Shift+G

1 Click Get Photos,
From Files and Folders

5 Review Non-Imported Files

4 Click
Get
Photos

6 Redisplay
All Files

5 Review Non-Imported Files

After the import process is complete, the **Items Not Imported** dialog box may appear; it lists any files that were not imported. For example, a file might be smaller than the limit specified, in an unsupported format, or already in the catalog. After reviewing the

list, click **OK**. Photoshop Album might display a reminder telling you that the only images being displayed right now are those you have just imported; click **OK** to dismiss this warning box.

6 Redisplay All Files

The files you've just imported are the only ones displayed in the photo well; to display all files in the catalog, click the **Clear** button on the **Find** bar. You can also click the **Show All** button on the **Shortcuts** bar.

40 Import Media from a CD-ROM or DVD

Before You Begin

✔ **38** Perform an Initial Scan for Media

See Also

→ **39** Import Media from a Folder

→ **41** Import Images from a Digital Camera

→ **42** Import a Scanned Image

(K)EY TERM

Offline—Images in the Photoshop Album catalog that are stored on a CD-ROM or DVD and not copied to the hard disk.

After importing images into Photoshop Album for the first time and creating a catalog as described in **38** **Perform an Initial Scan for Media**, you might want to import additional images as you create them. If the images are stored on CD-ROM or DVD, you can copy them to the hard disk at the same time you add them to the catalog, or you can continue to store them *offline*, on the CD-ROM or DVD. For example, perhaps you took a roll of photos using your film camera and had them processed, printed, and copied to a CD. You can use this task to import those photos into Photoshop Album.

If you choose to store images offline, a low-*resolution* copy of the image is kept in the catalog so that you can still view offline images and organize them as you like. However, if you attempt to perform some task that requires the actual image (such as adjusting the contrast or creating a greeting card), you'll be asked if you want to use the low-resolution copy or the offline file (which is typically of much higher quality). If you choose to use the offline file, you'll be prompted to insert the CD-ROM or DVD on which the image file is stored.

When you add images to the catalog that are stored offline, you'll be prompted to create a reference name. This name is used later on whenever you're prompted to insert the CD-ROM or DVD on which the image is stored. (The name helps you insert the correct CD-ROM or DVD.) So it's a good idea to create easily identifiable reference names that you also write on the disc or its jewel case.

2 Select Drive

3 Select Folder

1 Click Get Photos, From Files and Folders

4 Set Offline Option

7 Redisplay All Files

5 Click Get Photos

6 Review Non-Imported Files

Indicates Images Stored Offline

❶ Click Get Photos, From Files and Folders

Click the **Get Photos** button on the **Shortcuts** bar and then select **From Files and Folders** from the list that appears. You can also choose **File, Get Photos, From Files and Folders** from the menu.

 TIP

If you've just started Photoshop Album, you can click the **Get Photos** icon in the **Quick Guide**, and then click the **CD** icon instead of following steps 1 and 2.

 TIP

You don't have to import all the images in a folder; if you double-click the folder and display its contents, you can select just the images you want to import by pressing **Ctrl** and clicking each image.

❷ Select Drive

From the **Look In** drop-down list, select the CD-ROM or DVD drive that contains the images you want to add to the catalog.

❸ Select Folder

Select the folder whose contents you want to import. If the CD or DVD doesn't contain any folders, you can skip this step.

If you want to import the contents of any subfolders of the selected folder, select the **Get Photos from Subfolders** check box. You can select multiple folders by pressing **Ctrl** and clicking each one.

❹ Set Offline Option

If you want to keep the images offline (that is, you want to keep only low-resolution images in the catalog and leave the larger original images on the CD or DVD), select the **Keep Original Offline** check box and type a name for the disc in the **Optional Reference Note for Disc** box. If you do not select the **Keep Original Offline** check box, Photoshop Album will copy the files from the CD or DVD to the hard disk.

❺ Click Get Photos

Click **Get Photos** to begin the importing process. The **Getting Photos** dialog box appears, displaying each photo as it's added to the catalog. You can click **Stop** if you want to interrupt the importing process for some reason; only photos already imported at that point will appear in the catalog.

❻ Review Non-Imported Files

After the import process is complete, the **Items Not Imported** dialog box may appear; it lists any files that were not imported. For example, a file might be smaller than the limit specified, in an unsupported format, or already in the catalog. After reviewing the list, click **OK**. Photoshop Album might display a reminder telling you that the only images being displayed right now are those you have just imported; click **OK** to dismiss this warning box.

7 **Redisplay All Files**

The files you've just imported are displayed in the photo well. If you kept the images offline, a small CD icon appears in the upper-left corner of each small *thumbnail*. To display all files in the catalog rather than just the images you've imported, click the **Clear** button on the **Find** bar. You can also click the **Show All** button on the **Shortcuts** bar.

41 Import Images from a Digital Camera

You can import images directly from a digital camera and add them to the Photoshop Album catalog. The method you use to do that, however, varies as much as digital cameras vary from one another. For a great many cameras, when you connect them to your computer using a SCSI or FireWire cable, Windows automatically detects the camera, reads its memory stick, and displays the contents in a new drive window within **My Computer**. For example, your computer might have only one hard disk—drive C—but when you connect your digital camera, Windows presents you with a window that displays all the files on "drive D," which is really the memory stick inside your camera. At that point, you might be able to select the drive from the **Get Photos from Camera or Card Reader** dialog box as described here, but if the virtual drive is not listed, you may be forced to manually copy the images to your hard disk, and then follow the steps outlined in **39** **Import Media from a Folder** to add the images to the catalog.

This same process typically occurs if you use a memory stick reader. When you take the memory stick out of the camera, insert it into the reader, and connect the reader to your computer using a cable, Windows will treat the contents of the memory stick as a virtual (pretend) drive D or other drive letter. In the case of a card reader, however, you can always follow the steps outlined here and select the virtual drive from the **Get Photos from Camera or Card Reader** dialog box as described in this task.

If a virtual drive is not created when you connect your camera to the computer, you must use the driver that came with the camera to read its memory stick. Photoshop Album can use this driver to read the memory stick directly, copy the images to the hard disk for you, and then import the images into the catalog. You must make sure that the camera driver has been properly installed; see your camera documentation and the disk that came with it for help.

Before You Begin

✔ **38** Perform an Initial Scan for Media

See Also

→ **39** Import Media from a Folder

→ **40** Import Media from a CD-ROM or DVD

→ **42** Import a Scanned Image

① Click Get Photos, From Camera or Card Reader

After connecting the camera to the computer, click the **Get Photos** button on the **Shortcuts** bar and select **From Camera or Card Reader** from the list that appears. You can also choose **File, Get Photos, From Camera or Card Reader** from the menu. If you've just started Photoshop Album, you can click the **Get Photos** icon in the *Quick Guide*, and then click the **Camera** icon to display the **Get Photos from Camera or Card Reader** dialog box.

NOTE

Some cameras, when they are connected and Photoshop Album is running, cause the **Get Photos from Camera or Card Reader** dialog box to automatically display. In such a case, skip step 1.

② Select Device

From the **Camera** drop-down list, select your camera or card reader from the devices listed.

③ Set Options

Images copied to the computer using the **Get Photos from Camera or Card Reader** dialog box are automatically placed in the **My Documents\My Pictures\Adobe\Digital Camera Photos** folder. Enable the **Create Subfolder Using Date/Time of Import** check box if you want to create a new subfolder for the images you are importing. The new folder will use a name based on the current date and time.

If you want Photoshop Album to automatically delete images from the memory stick after they are copied to the hard disk, enable the **Delete Photos on Camera or Memory Card after Import** check box.

Enable the **Import All Photos** check box if you want to import all the images on the memory stick. (You might not be able to select this option with certain cameras and card readers.) If this option is available and you don't enable it, a dialog box appears from which you can select individual images to import.

TIP

You can change the camera preferences, such as the default folder in which images are stored, using the **Preferences** dialog box. Select **Edit, Preferences** from the Photoshop Album main menu and then click **Camera or Card Reader**.

NOTE

For some cameras, when you click **OK** in step 4, Photoshop Album launches the camera software. If that happens, you'll have to use the camera software to copy the images to the hard disk and then follow the steps in **39** Import Media from a Folder to import them into the catalog.

④ Click OK

Click **OK** to begin the importing process. The **Getting Photos** dialog box appears, displaying each photo as it's added to the catalog. You can click **Stop** if you want to interrupt the importing process for some reason; only photos already imported at that point will appear in the catalog.

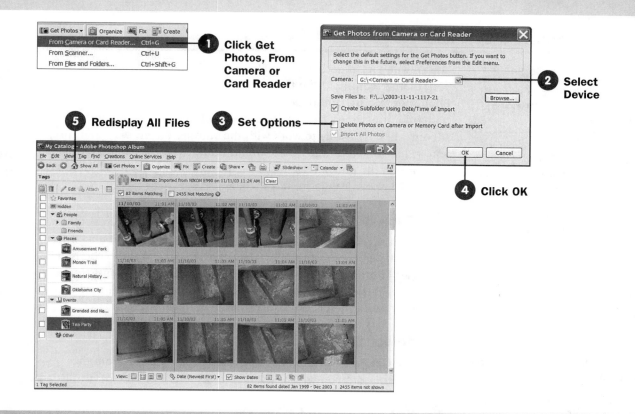

① Click Get Photos, From Camera or Card Reader

② Select Device

⑤ Redisplay All Files

③ Set Options

④ Click OK

⑤ Redisplay All Files

You might see a dialog box listing images that were not imported; typically the only reason this happens when importing images directly from a camera or card reader is that the images have already been imported. If you see the **Items Not Imported** dialog box, make a note of the images that were not imported and click **OK** to continue.

Next, Photoshop Album might display a reminder telling you that the only images being displayed right now are those you have just imported; click **OK** to dismiss this warning box.

Even if the warning box does not appear, the files you've just imported are the only ones displayed in the photo well; to display all files in the catalog, click the **Clear** button on the **Find** bar. You can also click the **Show All** button on the **Shortcuts** bar.

42 Import a Scanned Image

Before You Begin

✔ **38** Perform an Initial
 Scan for Media

See Also

→ **39** Import Media from
 a Folder

→ **40** Import Media from
 a CD-ROM or DVD

→ **41** Import Images
 from a Digital
 Camera

You can import images into the Photoshop Album catalog directly from your digital scanner. Using the driver that came with your scanner, Photoshop Album can talk directly to it, enabling you to begin the scanning and importing process with one click. In rare cases, Photoshop Album will not be able to work with the scanner driver; in such a case, you will need to scan the photo in manually, save it to the hard disk, then import the image into the catalog by following the steps outlined in **39** **Import Media from a Folder**.

① Click Get Photos, From Scanner

Click the **Get Photos** button on the **Shortcuts** bar and then select **From Scanner** from the list that appears. You can also choose **File, Get Photos, From Scanner** from the menu. If you've just started Photoshop Album, you can click the **Get Photos** icon in the *Quick Guide* and then click the **Scanner** icon to get started.

TIP

To change the default scanning options normally displayed in the **Get Photos from Scanner** dialog box, choose **Edit, Preferences**. Select **Scanner** from the list on the left, select the default options you want to use (such as the folder in which scans are normally saved), and click **OK**.

② Select Scanner

The **Get Photos from Scanner** dialog box appears. From the **Scanner** drop-down list, select your scanner from the devices listed.

③ Set Options and Click OK

Scanned images are normally saved to the **My Documents\My Pictures\Adobe\Scanned Photos** folder, but if you prefer to store the scanned image in some other folder, click the **Browse** button and select that location.

From the **Save As** drop-down list, choose the file format you want to use. If you choose **TIFF** or **PNG**, you'll get a higher quality image and a much larger file. If you select **JPEG**, you can adjust the **Quality** slider and affect the resulting file size (lower-quality images result in smaller files).

After setting the options for the scan, click **OK**.

Click Get Photos, From Scanner

2 Select Scanner

3 Set Options and Click OK

4 Set Scanning Options

5 Redisplay All Files

4 Set Scanning Options

The scanning program starts and displays the options available to your scanner. Adjust the options as desired and click **Scan** (for more information on these options, see your scanner manual). The dialog box shown here is the default Windows XP scanning program; the dialog box you see might look different than this one.

After the image is scanned, the **Getting Photos** dialog box appears, and the image is automatically imported into Photoshop Album.

 TIP

Scanned images are marked with a date that matches the date on which they were imported into Photoshop Album. To change the date to the date on which the photo was taken, see **60 Change Image Date and Time.**

5 Redisplay All Files

The scanned image is the only one displayed in the photo well; to display all the files in the catalog, click the **Clear** button on the **Find** bar. You can also click the **Show All** button on the **Shortcuts** bar.

43 Remove an Item from the Catalog

Before You Begin

✔ **38** Perform an Initial Scan for Media

 TIP

If you want to delete a group of related items (such as all the images of your pet fish), use the **Find bar** to display them first. (See **73** About Finding Items.) Then press **Ctrl+A** or choose **Edit, Select All** to quickly select all the displayed images. If the catalog is sorted by batch or folder, you can click the gray bar above a group to select all the items in that group.

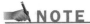**NOTE**

You can also select an item and simply press the **Delete** key to remove it from the catalog.

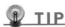 **TIP**

If you deleted an item you didn't want to remove from the catalog, you can immediately choose **Edit, Undo Delete Selected Items from Catalog** to return that item to the catalog. If you deleted the item from the hard disk, it's restored to the hard disk as well.

To make Photoshop Album useful, its catalog must list all the images you want to work with. In earlier tasks in this chapter, you learned how to import the images you want. After an image is displayed in the catalog, you can make changes to it or incorporate it into a *creation* such as a calendar or *slideshow*. If the catalog lists an image you no longer want to work with, you can remove that image just as easily as you imported it. You can also use this task to remove unwanted audio and movie files from the catalog.

Remember that the catalog is simply a *listing* of files, not the files themselves. Removing an item from the catalog does not actually remove the file from the hard disk, unless you specifically tell Photoshop Album that you want to do that.

1 Select Item(s) to Remove

Press **Ctrl** and click each item in the photo well that you want to remove. Selected items appear with a yellow outline.

2 Select Delete Command

Choose **Edit, Delete from Catalog**. If you selected multiple items, choose **Edit, Delete Selected Items from Catalog** instead.

3 Confirm Deletion and Click OK

The **Confirm Deletion from Catalog** dialog box appears. If you want to remove the actual item(s) from the hard disk as well as from the catalog, enable the **Also delete selected item(s) from the hard disk** check box. Click **OK**.

4 View the Result

The selected item is removed from the catalog and is no longer displayed in the photo well.

1 **Select Item(s) to Remove**

2 **Select Delete Command**

3 **Confirm Deletion and Click OK**

4 **View the Result**

44 **"Reimport" Moved Files**

As you are probably well aware by now, the Photoshop Album catalog is not a collection of media files, but rather a listing of those files and their various locations on your hard disks, CDs, and DVDs. Because Photoshop Album does not store the actual media files, it is unaware of any file maintenance activities you perform on the files outside of the program. If, for example, you move a file from one folder into another, Photoshop Album assumes that the file has simply disappeared. Similar problems arise if you rename or delete a file outside of Photoshop Album. To properly rename a file, make the change within Photoshop Album as described in **56** **Rename an Image**. To delete a file from the Photoshop Album catalog and from the hard disk, see **43** **Remove an Item from the Catalog.**

Before You Begin

✔ **38** Perform an Initial Scan for Media

If you find that you have accidentally moved a file using **My Computer** and not Photoshop Album, you must update the catalog by following the steps in this task. If you have renamed a file outside of Photoshop Album, you'll have to import the file again and remove the original item from the catalog. If you have deleted an item from the hard disk, you can remove it from the catalog manually.

TIP

If you've moved a lot of files, you can reconnect them in one step by selecting **File, Reconnect All Missing Files**. A listing of missing files appears on the right side of the **Reconnect Missing Files** dialog box. Select as many files as you like, choose the folder in which they are located, and click **Reconnect**.

1 Select Missing File

When an image in the catalog is no longer connected to the actual file, a missing file icon appears on top of the image in the photo well. The image also appears faint and pinkish—visual cues that let you know something is wrong. Click the image to select it.

2 Choose Edit, Reconnect Missing File

Choose **Edit, Reconnect Missing File** from the menu. You can also double-click the image in the photo well. The **Reconnect Missing Files** dialog box appears.

3 Locate Actual File

In the **Reconnect Missing Files** dialog box, the original location and *thumbnail* of the missing image appears on the left. From the **Look In** drop-down list on the right side of the dialog box, navigate to the folder in which the file is now located. Select the file from those listed on the right. Its thumbnail appears on the bottom right of the dialog box so that you can verify that it is indeed the missing file.

4 Click Reconnect

Click the **Reconnect** button to update the file's location in the catalog.

5 Click Close

You can reconnect additional files while the **Reconnect Missing Files** dialog box is open; just repeat steps 3 and 4. When you're through reconnecting files, click **Close**.

6 View the Result

After the file's new location is updated in the catalog, its thumbnail appears as normal in the photo well and the missing file icon is removed.

1 Select Missing File

Missing File Icon

2 Choose Edit, Reconnect Missing File

3 Locate Actual File

4 Click Reconnect

5 Click Close

6 View the Result

CHAPTER 5: Importing Items into Photoshop Album

175

45 Back Up the Photoshop Album Catalog

See Also

→ **46** Create a New Catalog

→ **47** Copy Items onto CD-ROM or DVD

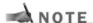

EY TERM

Properties—Information associated with each media file, such as its creation date, modification date, tags, audio or text captions, or notes.

NOTE

You should make sure that all your image files are properly listed in the catalog before you back it up. If needed, click **Reconnect** in the **Missing Files Check Before Backup** dialog box and see **44** "Reimport" Moved Files for help. If you don't want to be reminded of this step, select the **Don't Show Again** option and click **Continue**.

After you've imported lots of images into the Photoshop Album *catalog* and have used its features to organize your images, you won't want to risk losing your hard work. True, the catalog does not contain the images themselves, so if something were to happen to the catalog, you wouldn't lose any photographs. What you would lose, however, are the *properties* of each image, such as the various categories to which an image is associated, plus any *audio captions* or text notes. You would also lose your creations, and organizational information, such as an item's location, file size, file type, and thumbnail. If something happened to the catalog (but your media files were still okay), you could always reimport all your media files and then retag, annotate, and caption them, but that would be a lot of work. In the ideal world, you should back up *both* the Photoshop Album catalog *and* your media files onto CD, DVD, or another drive in case something happens to your media files or the catalog. Lucky for you, Photoshop Album provides an easy method for you to do both in one simple process.

① Choose File, Backup

Choose **File, Backup** from the menu bar. The **Missing Files Check Before Backup** dialog box might appear; use it to reconnect any moved files before you back up (see the Note for more information). Click **OK** to close this dialog box and continue.

② Choose Backup Drive

The **Backup** dialog box appears. To back up your data onto CD or DVD, select the **Burn onto a CD or DVD Disc** option. If necessary, select the specific drive you want to use from the list.

To back up your data onto a different hard disk or a removable disk drive, select the **Specify Backup Drive** option and choose a drive from the list.

③ Select Backup Type and Click OK

To back up the entire catalog and all your media files, select **Full Backup**. To make an incremental backup that contains just the changes and new media files added to the catalog since the last backup, select **Incremental Backup**. Click **OK**.

1 **Choose File, Backup**

2 **Choose Backup Drive**

3 **Select Backup Type and Click OK**

4 **Complete the Backup**

4 Complete the Backup

Another **Backup** dialog box appears; type a name for the backup in the **Backup Set Name** text box and click **OK**.

If you are backing up the data onto a CD or DVD, insert that disc when prompted and click **OK**. You'll see a dialog box telling you how many discs you'll need to complete the backup. Click **Yes** to continue and then follow the onscreen instructions.

If you are backing up the data onto another drive, a dialog box appears from which you can select a folder in which to store the backup files.

If you are performing an incremental backup, you must first insert the original backup disc. If necessary, you'll be prompted to insert an additional disc on which to store the incremental backup.

When the backup is complete, be sure to label any removable discs with the date and time of the backup.

If something occurs to the catalog later on (such as a power surge that damages the file), you'll be prompted to recover the file—a process that fixes the damage. Simply choose **File, Catalog** from the menu to display the **Catalog** dialog box. Click the **Recover** button, and then click **OK** to proceed. If the catalog file is so badly damaged that it can't be repaired using this method, or if you want to return to an earlier version of the catalog at some later date, you can restore that version. Just choose **File, Restore** from the menu, locate the backup file, and click **Restore**.

NOTE

This process backs up the currently displayed catalog only. If you are using more than one catalog (for example, if each family member has their own catalog file, as described in **46 Create a New Catalog**), you must first open the catalog you want to back up (by choosing **File, Catalog**) and then repeat steps 1 through 4 to back up that catalog.

46 Create a New Catalog

Before You Begin

✔ **38** Perform an Initial Scan for Media

See Also

→ **45** Back Up the Photoshop Album Catalog

✎ NOTE

There's an important limitation to using multiple catalogs that you should consider before creating them. You can view the contents of only one catalog at a time. Therefore, you cannot copy or move media files and their *tags* from one catalog to another. Nor can you perform a search that includes multiple catalogs.

💡 TIP

If you want to create a new catalog based on an existing catalog (with the same images and tags), select **File, Catalog**. In the **Catalog** dialog box, click **Save As**. Select a location in which to place the copy of the catalog, type a name for the copy in the **File name** text box, and click **Save**.

When you started Photoshop Album for the first time and imported some media files by following the steps in **38** **Perform an Initial Scan for Media**, a *catalog* was automatically created for you. If more than one person uses your computer, however, you might want to create a unique catalog for each person to use. Creating separate catalogs lets each user organize and keep track of only the images that are important to her. In this task, you'll learn how to create new catalogs and how to switch from one catalog to the other.

1 Choose File, Catalog

Choose **File**, **Catalog** from the menu bar. The **Catalog** dialog box appears.

2 Click New

By default, Photoshop Album adds some music files into each new catalog. If you don't want these audio files, disable the **Import free music into all new catalogs** check box. Click the **New** button. The **New Catalog** dialog box appears.

3 Enter a Name

The original catalog uses the filename **My Catalog.psa**. Type a different name for the new catalog in the **File name** text box. If desired, change the storage location of the catalog by browsing for a different folder in the **Save in** drop-down list.

4 Click Save

Click **Save** to create the catalog. The contents of the new, empty catalog are displayed in the photo well. To add images to the new catalog, see **38** **Perform an Initial Scan for Media** for help.

To switch from catalog to catalog, choose **File, Catalog** from the menu. Click **Open**, navigate to the folder in which the catalog you want to open is stored (if you saved the catalog in some folder other than the default **Catalogs** folder), select the catalog you want to open and click **Open** again.

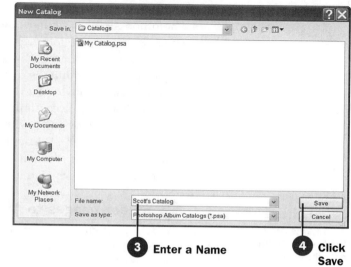

① **Choose File, Catalog**

② **Click New**

③ **Enter a Name**

④ **Click Save**

47 Copy Items onto CD-ROM or DVD

In **45** **Back Up the Photoshop Album Catalog**, you learned how to protect both your media files and the information in the *catalog* by backing it up onto disc. That way, if something goes wrong and Photoshop Album cannot open the catalog file or if one of the image, audio, or movie files is damaged, you can restore the needed file from the backup disc.

You can protect just the media files if you like by following the steps in this task. Here, you'll learn how to copy just the items in a catalog (and not the catalog itself) to a CD-ROM or DVD. Copying the media files to a CD or DVD is a great way to back up just those files and not the catalog, and it's also a convenient way to share particular images, audio, and movie files with friends or family.

See Also

→ **45** Back Up the Photoshop Album Catalog

→ **108** Create a Slideshow of Images

→ **109** Create a Video CD

During the process of creating the CD or DVD, you can instruct Photoshop Album to change the status of the items to *offline*. If you choose this option, Photoshop Album copies the files from your hard disc to the CD or DVD, creates low-*resolution* copies of any image files for display purposes within the photo well, and then removes the files from the hard disk. Archiving files in this manner frees up hard disk space and yet allows you to continue to view and work with those images, audio files, and movie files within Photoshop Album. Offline images are marked with a small CD icon; if you attempt to edit one of these images or to use any offline media file in a *creation*, you'll be prompted to insert the disc onto which the original copies were transferred.

💡 TIP

If no items are selected, Photoshop Album archives only those items currently displayed in the photo well. Rather than selecting individual items to archive, you can use the **Find** bar to display just the items you want. See **73** About Finding Items for more help.

1 Select Images to Archive

Only the currently displayed items are archived, so if the items you want to archive are the only ones displayed, skip this step.

If you want to archive (copy) only particular displayed media files to the disc, select them first. You can select a contiguous group of items by pressing **Shift**, clicking the first item in the group, and then clicking the last item. To select non-contiguous items, press **Ctrl** and click each *thumbnail*. If the catalog is sorted by batch or folder, you can click the gray bar above a group to select all the items in that group. (See **53** Sort Items for more information.)

2 Choose File, Archive

Choose **File**, **Archive** from the menu bar. The **Archive** dialog box appears.

3 Name the Archive

Type a name (up to 70 characters) for the archive file in the **Archive Set Name** text box. Use a name that will remind you later on which items the archive contains. I wanted to archive images taken during a 2003 visit by Granddad and Nana, so I typed **G&N Visit 08-03**.

📝 NOTE

You can archive items only to a CD-ROM or a DVD, not to the hard disk.

4 Select Drive

From the list of drive options, select the CD-ROM or DVD drive to which you want to copy the media files.

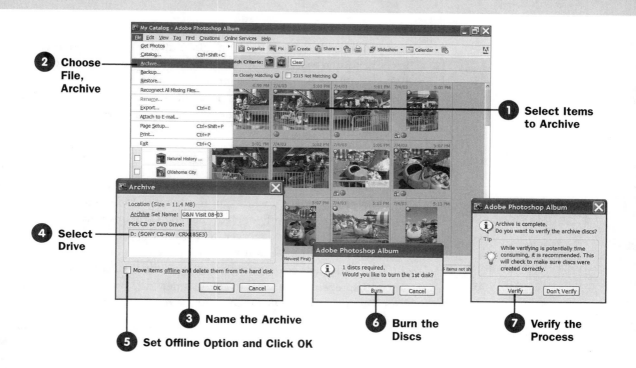

2 Choose File, Archive

1 Select Items to Archive

4 Select Drive

3 Name the Archive

5 Set Offline Option and Click OK

6 Burn the Discs

7 Verify the Process

5 Set Offline Option and Click OK

If you want to move the items offline (that is, if you want to copy the media files from the hard disk to the CD or DVD and then remove the files from your hard disk), select the **Move items offline and delete them from the hard disk** check box. If you deselect this check box, you will copy the media files to the CD or DVD but leave them on the hard disk. Click **OK**. If items are being moved offline, you'll be asked to confirm that decision; click **Yes** to continue.

6 Burn the Discs

If you haven't already inserted a CD or DVD disc, you'll be prompted to do so. Click **OK** to continue.

Photoshop Album then takes a moment to calculate how many discs you'll need and displays that information in the next dialog box. Click **Burn** to initiate the archive process. After a disc is completed, you'll see a reminder to label the disc properly. Click **OK** to continue. If an additional disc is needed to archive the files, you'll be prompted to insert additional discs until the archive procedure is complete.

7 Verify the Process

A message appears asking whether you want to verify the archive disc. This process takes a while, but it also guarantees that the discs were created properly and can be read (which is time well spent if you later have to recover items from the archive discs). Click **Verify** to continue. At the end of the verification process, you'll be told whether everything is okay. If the verification detects any errors, repeat these steps to create a new archive using new discs. Otherwise, click **OK** to return to the main Photoshop Album window.

6

Viewing and Sorting Items

IN THIS CHAPTER:

After importing images into a *catalog*, you can begin to work with them in Photoshop Album. Several tasks you perform have nothing to do with editing an image or creating anything, but simply reviewing what you've got. In this chapter, you'll learn how to review images one at a time in an automated *slideshow*, adjust the size of the *thumbnails*, play an *audio caption* you might have added to an image, play audio and video files you've imported, sort images, and update an image's thumbnail if it ever gets out of sync with the actual contents of the image file.

48 View Images in a Slideshow

Before You Begin

✔ **38** Perform an Initial Scan for Media

See Also

→ **108** Create a Slideshow of Images

KEY TERM

Slideshow—A creation that presents a series of images, full-screen, in a controllable manner. Background music and animated transitions between images may be included in a slideshow.

TIP

If you want to select a group of related items (such as all the images of your pet fish), use the **Find bar** to display them first. (See **73** About Finding Items.) Then press **Ctrl+A** or choose **Edit, Select All** to quickly select the displayed images. If the catalog is sorted by batch or folder, you can click the gray bar above a group to select all the items in that group.

A *slideshow* in Photoshop Album is a very sophisticated, self-contained package that features a sequence of pictures, displayed on pretty backgrounds or within decorative frames, perhaps with a musical accompaniment and fancy transitions between images, with special controls you can use to direct the action. Because a slideshow is a *creation*, after creating it, you can do many things with the slideshow, including playing it in Photoshop Album, sending it to someone as an email attachment, publishing it to a Web site, or saving it onto a CD.

In **108** **Create a Slideshow of Images**, you'll learn how to produce one of these slideshow packages. In this task, you'll learn how to quickly select a group of images and view them in full-screen mode with a fading transition between them—but without the fancy background music, graphic backgrounds, or frames you might choose in a full-blown slideshow. You might do this to preview how a group of images might look together before you create a full-blown slideshow suitable for publication. You might also perform this task to quickly treat some guests to an instant slideshow of images taken during the party they're currently attending.

❶ Select Photos in Sequence

In the photo well, click the photos you want to include in the instant slideshow, in the order in which you want to see them. To select multiple photos, click the first photo, then hold down the **Ctrl** key as you click the others. To select a series of photos from the well in the sequence they currently appear there (left-to-right, top-to-bottom), click the first photo in the series, and hold **Shift** as you click the final photo in the series.

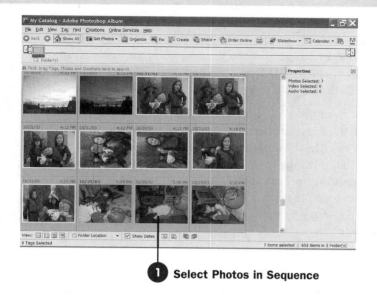

Photos Selected: 7
Video Selected: 0
Audio Selected: 0

① Select Photos in Sequence

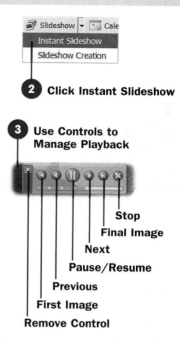

② Click Instant Slideshow

③ Use Controls to Manage Playback

Stop
Final Image
Next
Pause/Resume
Previous
First Image
Remove Control

The **Properties** pane, if displayed, will display the number of photos you've selected thus far (but not the order in which you've selected them, unfortunately).

② **Click Instant Slideshow**

On the **Shortcuts** bar, click the down arrow on the **Slideshow** button; from the menu that appears, select **Instant Slideshow**.

③ **Use Controls to Manage Playback**

The screen immediately goes black, and the first image you selected appears. If you've added a text *caption* to the photo (see **58 Add a Text Caption**), it appears at the bottom of the image. Photos appear automatically, one after another. If you do nothing but watch, each image fades in gradually, replacing the previous image, until the whole sequence is played and you're returned to the main Photoshop Album window.

✐ NOTE

An instant slideshow is not something you can save or publish or give to friends and relatives. To produce a complete slideshow package that you can give away freely and easily, see **108 Create a Slideshow of Images**.

However, with the control device displayed in the upper-right corner of the screen, you can direct the playback of the slideshow more precisely. The strip along the bottom of this control represents the progress of the slideshow from beginning to end; the gaps in the middle of this strip represent transitions between photos.

Click the **Next** button to immediately skip to the next photo in the set. Click the **Previous** button to return to the previous photo in the set. Click **Final Image** to skip forward to the final photo in the set. Click **First Image** to fall back to the first photo in the set. Click the **Pause/Resume** button to pause the slideshow, and then click it again when you're ready to resume. Click the **Stop** button to stop the slideshow at any time and return to the main Photoshop Album window.

 TIP

Click the **Remove Control** button to remove the control device from view. To bring it back, just move the mouse.

 Change Thumbnail Size

Before You Begin

✔ **38** Perform an Initial Scan for Media

By default, Photoshop Album displays the items in its active *catalog* (photos, movies, *slideshows*, and other presentations) in reduced sizes. Each of these miniature media files is called a *thumbnail*, which is a name borrowed from the realm of professional photography. There, *contact sheets* are often printed separately for each developed roll of film, containing miniatures of each print on the roll. These contact sheets were often used by the photographer for cataloging purposes. The size of each miniature on the contact sheet was usually just larger than an actual thumbnail, hence the name.

You can adjust the size of Photoshop Album's thumbnails to suit the task at hand. By default, the photo well displays thumbnails in medium size.

 TIP

If the **Options** bar is not visible, you can also change from one thumbnail size to another by selecting the size you want from the **View, Size** menu.

❶ Display Small Thumbnails

To display images in a small thumbnail size so there are more of them displayed onscreen at one time, click the **Small Thumbnail** button on the **Options** bar.

❷ Or Display Medium Thumbnails

To display images in a medium size, click the **Medium Thumbnail** button on the **Options** bar. This view is how images normally appear in Photoshop Album.

1 Display Small Thumbnails

2 Or Display Medium Thumbnails

3 Or Display Large Thumbnails

Click to Display Previous Image

Click to Display Next Image

4 Or Display a Single Photo

3 Or Display Large Thumbnails

To display images in a large size, click the **Large Thumbnail** button on the **Options** bar.

4 Or Display a Single Photo

To display images one at a time in the largest size possible, click the **Single Photo** button on the **Options** bar. You can then scroll from one image to another using the left and right arrow buttons displayed under the image.

50 Play an Audio Caption Attached to an Image

See Also

→ **51** Play an Audio File
→ **58** Add a Text Caption
→ **59** Record an Audio Caption

KEY TERM

Audio Caption—A short bit of recorded audio associated with an image file. Recording an audio caption enables you to describe that image using your own words.

NOTE

To remove an audio caption from a photo, in the **Media Player** window for the audio caption, choose **Edit, Clear**. This command does not delete the audio file— just removes its association with the photo.

TIP

See **51** Play an Audio File for information about the other controls in the **Media Player** window. With them, you can pause the playback, skip to the end, or stop the playback whenever you like.

Photoshop Album can keep track of any *caption* you might add to any photo in your *catalog*. The presence of such a caption on an image doesn't alter its file in any way—the caption simply helps to describe the image or the events surrounding the image in a more thorough way. Usually, you enter a caption by typing it in as text; but if your feelings about a photo are best expressed from your own voice, you can record an *audio caption* using your computer's microphone, and have Photoshop Album associate that audio track with an image. In **59** **Record an Audio Caption**, you learn how to produce the audio caption yourself; here, you'll see how to play a caption after it's been recorded.

1 Double-click Image to Change to Single Photo View

When a photo has an audio caption associated with it, a speaker icon appears in the upper-right corner of its *thumbnail* in the photo well. If you like, you can quickly display all images that have an audio caption by choosing **Find, By Media Type, Items with Audio Captions** from the menu.

Double-click the image thumbnail to change to **Single Photo** view if needed.

2 Click Play Associated Audio

Beneath the photo, to the right of the **Caption** box, is a speaker button. Click this **Play Associated Audio** button to display the **Media Player** window.

3 Click Play

Click the **Play** button at the bottom of the **Media Player** window to listen to the audio caption. The audio plays to the end; you can replay the audio by clicking **Play** again. When you're through, click the **Close** button on the **Media Player** window to remove it.

Speaker Icon

1 Double-click Image to Change to Single Photo View

3 Click Play

2 Click Play Associated Audio

51 Play an Audio File

Although it isn't obvious from the title *Photoshop* Album, this application can also organize other multimedia files, such as audio and video files. If you didn't import your audio or video files into the *catalog* when you performed the initial scan for media, see **39** **Import Media from a Folder** for help in adding them now. Photoshop Album recognizes audio files in **.WAV** format (produced by Windows's Sound Recorder and other applications that use your microphone) and **.MP3** format (used in recording high-fidelity stereo tracks). You can use Photoshop Album to organize audio clips of your son reading his favorite book or musical clips of your favorite band.

My catalog includes not just pictures of my daughter at various ages, but also recordings of her singing or talking. If your Photoshop Album collection is similar, there's no reason you can't organize both types of files together. In other words, you can keep your toddler photos in the

Before You Begin

✓ **39** Import Media from a Folder

See Also

→ **50** Play an Audio Caption Attached to an Image

→ **52** View a Video

→ **59** Record an Audio Caption

→ **75** Find Items of the Same File Type

NOTE

Although Photoshop Album recognizes particular audio files and can play them, you can't use the program to create audio files, with the exception of brief audio annotations which are then associated with particular images, as described in **59** Record an Audio Caption. To listen to an *audio caption*, see **50** Play an Audio Caption Attached to an Image.

TIP

To display audio files all the time, choose **View, Media Types**. In the **Items Shown** dialog box, enable the **Audio** check box and click **OK**.

same folder with your toddler audio tracks if you want to, and look and listen to these files within Photoshop Album whenever you like. You can keep your musical files in a completely different folder or in several folders (organized by artist, for example); after importing the audio files into Photoshop Album, you can play the music files the same way you play any audio clip.

① Display Audio Files

By default, Photoshop Album does not display audio files in the photo well. This is probably what you want because you cannot edit audio files in Photoshop Album, only play them. To display your audio files temporarily so that you can play one or two, select **Find, By Media Type, Audio**. The photo well displays all your audio files.

② Double-click Audio File

Photoshop Album represents audio files in the catalog with a blue horn icon, which serves as the file's *thumbnail*. In the photo well, double-click the icon for the audio file you want to play. The Photoshop Album **Media Player** appears.

③ Click Play

Click the **Play** button at the bottom of the player to begin playback. The audio plays to the end; you can replay the audio by clicking **Play** again.

④ Use Controls to Manage Playback

You can control the playback of the audio file using the controls located below the horn icon in the **Media Player**. Just below the icon is a **Current Position** slider bar, which indicates the current location of the playback relative to the entire file. Slide this bar forward or back to jump forward or backward in the audio file. For example, you might drag this bar to the right to play something at the end of the audio file.

Click **Rewind** to set the slider to the beginning of the file. Click **Play** to hear the file from the point at which the **Current Position** slider is set; click **Pause** to stop playback temporarily. Click **Stop** to end playback and reset the slider to the beginning of the file. Click **Fast Forward** to set the slider to the very end of the file.

1 Display Audio Files

2 Double-click Audio File

3 Click Play

4 Use Controls to Manage Playback

Rewind

Play/Pause

Stop

Fast Forward

Current Position

Volume

At the bottom of the **Media Player** window is a volume slider, with which you can adjust the playback volume. Setting this volume to maximum plays back the sound at the volume you've currently set for the rest of your Windows environment. In other words, the playback volume does not adjust Windows's master volume, but rather, your listening volume in relation to the Windows current maximum.

When you're through, click the **Close** button on the **Media Player** window to remove it.

TIP

If you've already set the Media Player volume control to maximum and you want the sound louder, adjust the volume control in Windows.

52 **View a Video**

Before You Begin

✔ **39** Import Media from a Folder

See Also

→ **51** Play an Audio File

→ **75** Find Items of the Same File Type

TIP

You can create an image from a video file by clipping out a single frame. Photoshop Elements can perform this task, as can many other *graphics editors*, but not Photoshop Album.

TIP

You can drag the border of the player to make the video window bigger, but the playback might seem more grainy as a result.

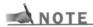

NOTE

The same **Media Player** controls used to control the playback of audio files are used to play video files. See **51** **Play an Audio File** for information about those controls.

Because many new digital cameras are actually digital *video* cameras (or can at least double as video cameras in a pinch), Photoshop Album contains tools that enable you to organize digital video files along with your photos and audio tracks. The supported video formats include AVI (a common Windows format), MPG (a common format for movies that is used by most digital cameras), and MOV (QuickTime format). Thus, you can use Photoshop Album to organize your home videos and short movie files you download from the Web. If you haven't imported your video files into the *catalog*, see **39** **Import Media from a Folder** for help.

You aren't limited to simply viewing videos you may import into Photoshop Album. You can also incorporate brief video clips into various *creations* such as *slideshows*, video CDs, and eCards. However, playback quality in these creations might not be as smooth as when you use a dedicated video playback program such as Windows Media Player or ZoomPlayer.

① Display Video Files

Photoshop Album displays video files side by side with images and creations. The first frame of a video is used as its *thumbnail*, and a movie icon appears in the upper-right corner of the thumbnail to distinguish it from photos and other types of files.

One way to locate a specific video file for playback is to temporarily display only video files in the photo well. Select **File, By Media Type, Video**. Your video files appear in the photo well.

② Double-click the File's Thumbnail

In the photo well, double-click the thumbnail for the video file you want to play. The Photoshop Album **Media Player** appears.

③ Click Play

Click the **Play** button to begin playback. The movie plays to the end and then stops. Click the **Close** button to close the **Media Player** and return to the main Photoshop Album window.

Display Video Files 1

Movie Icon

3 Click Play

2 Double-click the File's Thumbnail

53 Sort Items

The *thumbnails* that appear in the photo well are laid out in some kind of order, from left to right, then top to bottom. By default, the newest photo in the well appears in the upper-left corner. You can change this sort order very easily, and you may find yourself re-sorting the *catalog* quite often, especially when you're working to organize and make better sense of several hundred or more digital images, movies, and audio files freshly imported from your camera.

Photoshop Album does not sort its thumbnails in the photo well by filename. Filenames, in fact, don't play very important roles in Photoshop Album, mainly because the names given to images by your camera tend to be non-informational to you (for instance, DSC00425.JPG), and the information you want to associate with them is generally difficult to compact into the space of a filename anyway. This is why Photoshop Album provides more informational tools for organizing media, such as *tags*—which are covered in **62 About Organizing Items**.

Before You Begin

✔ **38** Perform an Initial Scan for Media

See Also

→ **60** Change Image Date and Time

→ **62** About Organizing Items

→ **80** Find Images with Similar Color

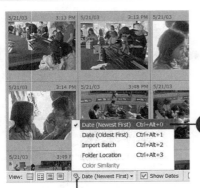

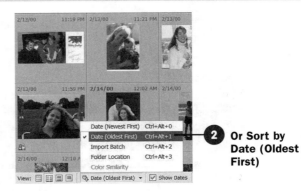

Photo Well Arrangement Button

1 Sort by Date (Newest First)

2 Or Sort by Date (Oldest First)

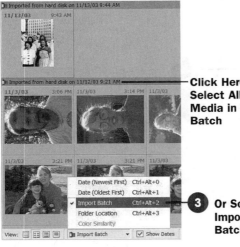

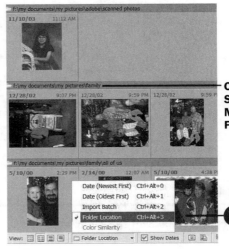

Click Here to Select All Media in This Batch

Click Here to Select All Media in This Folder

3 Or Sort by Import Batch

4 Or Sort by Location

TIP

You can also sort items by selecting the appropriate command from the **View, Arrangement** menu.

1 Sort by Date (Newest First)

Click the **Photo Well Arrangement** button on the **Options** bar, and select **Date (Newest First)** from the menu. This option arranges items by *file date*, with newer images and other media appearing at the top. This is how items are normally arranged in the photo well.

② Or Sort by Date (Oldest First)

Click the **Photo Well Arrangement** button on the **Options** bar and select **Date (Oldest First)** from the menu. This option arranges items within the photo well in reverse date order, with older items appearing near the top.

③ Or Sort by Import Batch

Click the **Photo Well Arrangement** button on the **Options** bar and select **Import Batch** from the menu. This option arranges items into subgroups, each of which contains batches of photos, audio, and video files you added to the well at the same time. The most recently imported items appear in a group at the top of the photo well. Within each subgroup, however, the oldest items appear first (the items with the oldest file date).

④ Or Sort by Location

Click the **Photo Well Arrangement** button on the **Options** bar and select **Folder Location** from the menu. This option arranges items into subgroups, each of which contains items located within the same folder on a hard disk, CD-ROM, or DVD.

NOTE

The **Color Similarity** sort order is never available as a choice in the **Photo Well Arrangement** menu. Instead, this option, when checkmarked, indicates that you have followed other steps to display images that contain similar colors, as described in **80** Find Images with Similar Color.

54 Update an Image in the Catalog

Photoshop Album is *not* a full-featured *graphics editor*, so you may choose from time to time to make changes to an image using Photoshop, Photoshop Elements, Paint Shop Pro, or a similar program. When you edit an image using another graphics application, you should open the program from within Photoshop Album (see **95** Fix a Photo Using Another Program for instructions), so that Photoshop Album can make a note that the image has changed.

If you forget and launch a graphics editor the old-fashioned way (through the **Start** menu), and make changes to an image in the Photoshop Album *catalog*, Photoshop Album won't "know" you've edited the image. After you've edited and corrected the image, and re-saved its file over the original file, Photoshop Album won't know that it needs to update its records, and the *thumbnail* in the photo well will not reflect your recent changes. To correct this situation, you have to tell Photoshop Album that you've changed the image so that it can update the thumbnail to accurately reflect the current version of the image.

Before You Begin

✔ **39** Import Media from a Folder

See Also

→ **44** "Reimport" Moved Files

→ **95** Fix a Photo Using Another Program

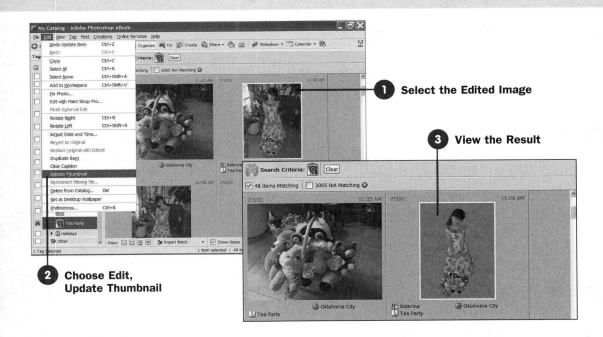

1 Select the Edited Image

3 View the Result

 2 Choose Edit, Update Thumbnail

1 Select the Edited Image

In the photo well, click the old thumbnail for the image you've just completed editing. Photoshop Album will highlight that thumbnail with a yellow border.

2 Choose Edit, Update Thumbnail

Choose **Edit, Update Thumbnail** from the menu bar. In a moment, Photoshop Album will update the thumbnail image to reflect your most recent changes to the photo file.

3 View the Result

As you can see here, the image thumbnail has changed to display the most recent version of the image. I liked this image of my daughter, dressed up for a tea party at a local restaurant, but the background was too busy. So I opened the image in Photoshop Elements, removed the background, and replaced it with bright pink, one of her favorite colors. After updating the thumbnail, the newly edited image appears in the photo well.

PART III

Organizing, Finding and Fixing Images

IN THIS PART:

7

Changing Image Properties

KEY TERM

Metadata—Tells you the specific camera, camera settings, and *resolution* used to take the image. This *EXIF* data may also be used by your printer to print an image more accurately. Also tells you the history of changes to the image, and the tags associated with the image.

An image's *properties* include data that describe the image, such as its filename and location, the date and time the image was created or changed, its textual *caption* or *audio caption*, and any notes attached to the image. The properties also include *tags* and a listing of any *creations* that use the image. On the **Properties** pane, you can also view the *metadata* associated with an image. In this chapter, you'll learn how to display the **Properties** pane and use it to make changes to an image such as renaming it, adding a text or audio caption, changing the date and time associated with an image, and attaching a note.

55 About the Properties Pane

See Also

→ **1** About Photography
→ **56** Rename an Image
→ **58** Add a Text Caption
→ **59** Record an Audio Caption
→ **60** Change Image Date and Time
→ **61** Attach a Note to an Item

NOTE

Photoshop Album can associate up to three dates with an image—the date it was shot or scanned (the file date), the date the image was last changed (the modified date), and the date the image was imported into the catalog (the import date). You can view the file date by displaying it above each item in the photo well; to view the other dates, you must display the **Properties** pane.

The **Properties** pane lists the various *properties* of an image (its name, location, *tags*, *captions*, notes, *metadata*, and so on). It isn't normally displayed within the work area, but you can quickly display the **Properties** pane by clicking the **Show or Hide Properties** button on the **Options** bar, or by pressing **Alt+Enter**. The **Properties** pane appears to the right of the **photo well** and displays the properties of the currently selected image, such as its *file date* (the date the image was shot or scanned). If you select more than one media file, the **Properties** pane displays the number of images, audio, and video files you've selected. If you choose not to display the **Properties** pane, you can still display the file date and time by selecting the **Show Dates** option on the **Option** bar. The file date and time then appear above each item in the photo well.

Using the **Properties** pane, you can perform many file maintenance tasks such as renaming a file. If you own a digital camera, you'll find yourself performing this task a lot because digital cameras assign generic names to image files, such as **DSCN0500.JPG**. If you want to rename several image files in one step, you can use the **Rename** command as described in **57** **Rename a Group of Images**.

Of course, you can do more than just rename a file using the **Properties** pane. You can also create a text or *audio caption* that describes the image, or enter a note that provides even more information about the image, perhaps describing the event or the conditions under which the image was taken. The **Properties** pane is also useful in learning more about a file, such as when it was created, and when you imported it into Photoshop Album. You might want to know the import date if you're comparing the image to a different copy stored in another location.

Selected Image

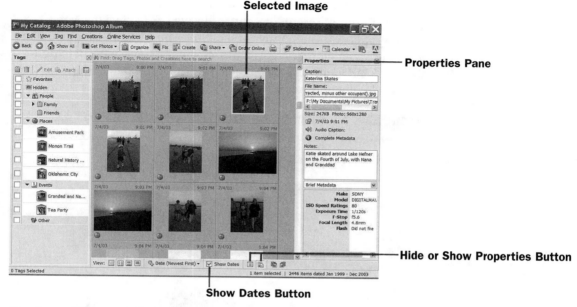

Properties Pane

Hide or Show Properties Button

Show Dates Button

*The **Properties** pane displays the properties of the selected image.*

As you can tell from the preceding figure, the **Properties** pane is divided into several sections. The **Caption** or title of the image appears first, followed by its **File Name** and location. Next, you'll see the date and time the image was created (the image's file date), followed by a button that allows you to play the audio caption (if any). After the **Notes** section (where you can enter any kind of notation you like), you'll see the **Metadata** section.

Metadata contains data about an image such as its change history and the *tags* you've associated with it. The metadata also includes the *EXIF* data, which is data that comes from the digital camera with which an image was taken. The EXIF (Exchangeable Image File) data typically tells you things such as the f-stop, shutter speed, *resolution*, flash level, and other settings used to record that specific image. This data is extremely valuable in faithfully displaying the image onscreen and also printing it without shifts in color or contrast.

On the **Properties** pane, you can review the metadata as you like. Use the drop-down list in the **Metadata** section to select the type of metadata you want to see: the basic stuff (**Brief Metadata**), change and import dates (**History**), and the various categories to which the media file

belongs (**Tags**). If you want to view all the metadata in a single window, click the **Complete Metadata** button (located just above the **Notes** box in the **Properties** pane). When you do, the **Complete Metadata** dialog box appears as shown here. Use the scroll bar to review the data and then click **OK** to dismiss the dialog box and return to the main Photoshop Album window.

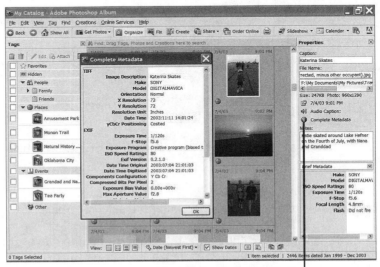

Complete Metadata Button

*You can display all metadata associated with the current image by opening the **Complete Metadata** dialog box.*

56 Rename an Image

Before You Begin

✔ **55** About the Properties Pane

See Also

→ **57** Rename a Group of Images

→ **76** Find Items with Similar Filenames

You don't have to worry so much about filenames when working with a group of images in Photoshop Album because you can easily locate an image by looking at its *thumbnail* or by searching for various *tags* associated with it. Still, outside of Photoshop Album, the filenames that digital cameras provide, such as **DSC1014.TIF**, don't provide much help when you're trying to decide whether a particular image is the one you want to use. When necessary, you can rename any media file quickly and easily, right within the Photoshop Album window. This task shows you what you need to know. If you want to rename a group of similar images, see **57** **Rename a Group of Images** for help.

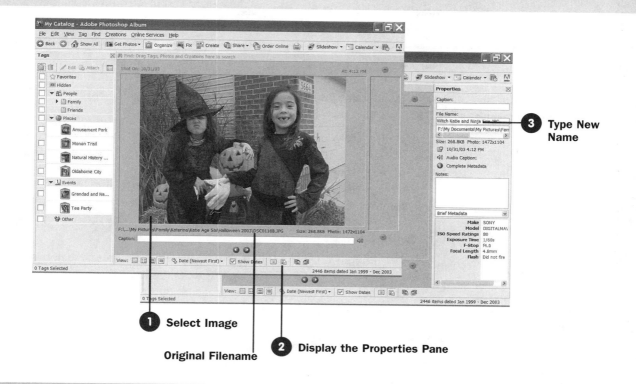

3 Type New Name

1 Select Image

Original Filename

2 Display the Properties Pane

1 Select Image

Select the image you want to rename by clicking it in the photo well. The selected image appears with a yellow border, unless you are displaying only a single photo.

2 Display the Properties Pane

If it's not already open, display the **Properties** pane by clicking the **Show or Hide Properties** button on the **Options** bar.

3 Type New Name

Select the old filename in the **File Name** text box on the **Properties** pane. Type a new filename; you don't have to type the *extension*, such as **.JPG**. Press **Enter**; Photoshop Album adds the file extension to the filename for you.

NOTE

If you want, you can return a file to its old filename by choosing **Edit, Undo Modify Metadata or File(s)** immediately after renaming a file.

KEY TERM

Extension—The last part of a filename, appearing after the period. An extension typically consists of only three letters such as TIF, JPG, or GIF, and it identifies the file type.

57 Rename a Group of Images

See Also

→ **56** Rename an Image

→ **76** Find Images with Similar Filenames

Realistically, you won't find yourself renaming a single file often. Instead, you'll typically want to rename an entire group of digital images newly imported into Photoshop Album. In this task, you'll learn how to rename a group of images in a single step.

When renaming a collection of images, you're asked to enter a common base name such as **Alex's Birthday**. To this group name, Photoshop Album adds a numerical suffix such as **-01** and **-02**. When the renaming procedure is complete, the files you select will have names such as **Alex's Birthday-01** and **Alex's Birthday-02**.

💡 TIP

If you want to select a group of related items (such as all the images of your pet fish), use the **Find bar** to display them first. (See **73** **About Finding Items**.) Then press **Ctrl+A** or choose **Edit, Select All** to quickly select the displayed images. If the catalog is sorted by batch or folder, you can click the gray bar above a group to select all the items in that group.

❶ Select Images

In the photo well, select the images you want to rename. To select contiguous images, press **Shift**, click the first image, then click the last image in the group. To select noncontiguous images, press **Ctrl** and click each one. Selected files appear with a yellow border.

❷ Select File, Rename

Choose **File, Rename** from the menu bar. The **Rename** dialog box appears.

❸ Type Base Name and Click OK

Type the common part of the group name in the **Common Base Name** box. Click **OK**, and Photoshop Album renames the selected images using the common name you entered, plus a numerical suffix.

❹ View the Result

After renaming a group of images of my daughter painting her Halloween pumpkin, I switched to **Single Photo** view to verify the new filenames. As you can see here, Photoshop Album used the base name I supplied and added a number to each image's name to create a unique filename. This particular image was number 30 in the group of images, so its name became **Painting a Halloween Pumpkin-30.jpg**.

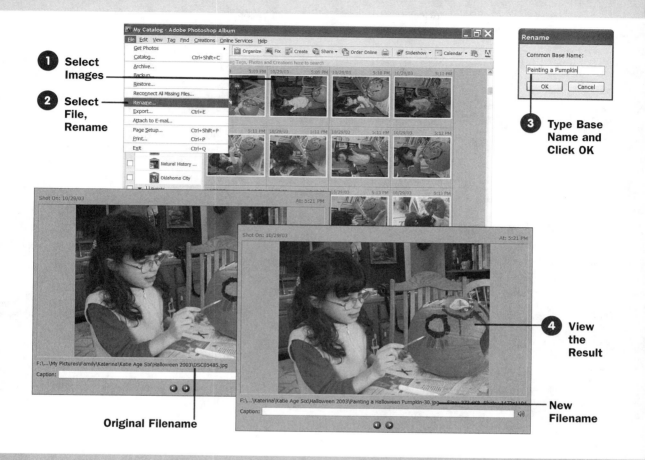

1 Select Images

2 Select File, Rename

3 Type Base Name and Click OK

4 View the Result

Original Filename

New Filename

58 Add a Text Caption

With a text *caption*, you can provide a title for your works of art (a.k.a. photographs). The caption appears in the photo well if you are displaying images using the **Single Photo** view. Captions also appear in the **Properties** pane whenever it is displayed. Although having a caption appear beneath a photo while you're reviewing images in Photoshop Album may be fun, there is a serious purpose to all this work. After you've entered captions for your images, the captions can be made to appear in various *creations*, such as a *slideshow*, album, video CD, calendar, eCard, photo book, Web Photo Gallery, or Atmosphere 3D Gallery. See **96** **About Creations** for more information.

Before You Begin

✔ **55** About the Properties Pane

See Also

→ **59** Record an Audio Caption

→ **61** Attach a Note to an Item

→ **77** Find Items with the Same Caption or Note

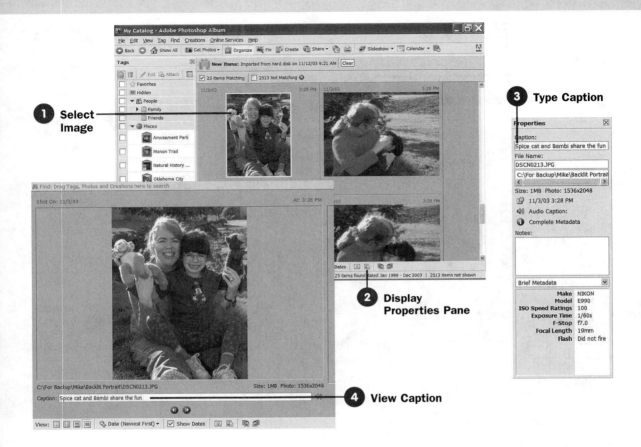

1 Select Image

3 Type Caption

2 Display Properties Pane

4 View Caption

TIP

When searching for a particular image, you can search for text contained in its filename, caption, or note. So adding captions also helps you locate images.

1 Select Image

In the photo well, click the image to which you want to add a caption. The selected image appears with a yellow border around it.

2 Display Properties Pane

If it's not already open, click the **Show or Hide Properties** button on the **Options** bar to display the **Properties** pane.

3 Type Caption

On the **Properties** pane, click in the **Caption** box and type your caption, such as **Benita at Yellowstone Park, July 2003** or **We**

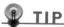

watched the rain under the protection of a large maple tree. Your caption is limited to 63 characters, including spaces, so keep it short. Longer descriptions can be added to the **Notes** section; see **61** **Attach a Note to an Item**.

4 View Caption

To view the caption, change to **Single Photo** view by double-clicking the image in the photo well or by clicking the **Single Photo** button on the **Options** bar.

As you can see, you can also enter captions when an image is displayed in **Single Photo** view. Just double-click an image to display it in **Single Photo** view. Then type a caption in the **Caption** box under the image.

TIP

To remove captions, select the images whose captions you want to remove and choose **Edit, Clear Caption** or **Edit, Clear Captions of Selected Items**. You can also delete the text from the **Caption** box in the **Properties** pane or in **Single Photo** view to remove the caption for an individual image.

59 Record an Audio Caption

Information about an image doesn't have to be stored as text; it can be stored instead as audio, in an *audio caption* attached to an image. After an audio caption has been attached to an image, you can click the special audio caption icon that appears on its *thumbnail* to listen to its contents (see **50** **Play an Audio Caption Attached to an Image**).

If you copy images onto a disc as described in **47** **Copy Items onto a CD-ROM or DVD**, any audio captions attached to those images are copied as well. If you give the resulting disc to a friend or relative, that person can play the audio file (it's stored in **.WAV** format) using a compatible audio program and listen to any comments you may have had about the images. In addition, if you use an image with an audio caption in a *slideshow* or eCard *creation*, you can include the audio caption as well.

Before You Begin

✔ **55** About the Properties Pane

See Also

→ **50** Play an Audio Caption Attached to an Image

→ **58** Add a Text Caption

NOTE

To record an audio caption, your computer must be equipped with a microphone.

1 Select Image

In the photo well, click the image to which you want to add a caption. The selected image appears with a yellow border around it (unless the image is displayed in **Single Photo** view).

2 Display Properties Pane

If it's not already open, click the **Show or Hide Properties** button on the **Options** bar to display the **Properties** pane.

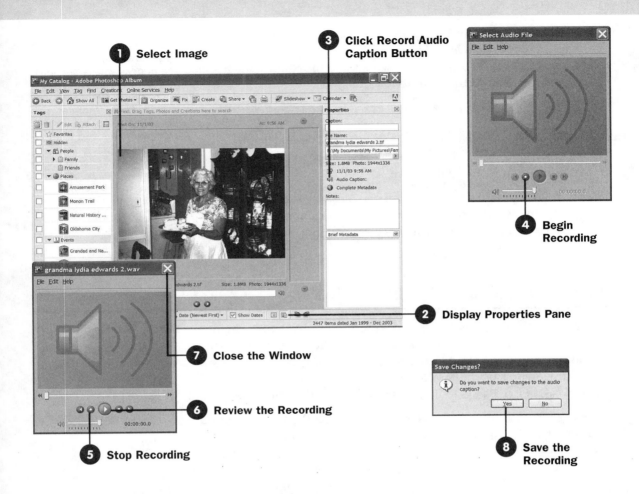

1 Select Image

3 Click Record Audio Caption Button

4 Begin Recording

2 Display Properties Pane

7 Close the Window

6 Review the Recording

5 Stop Recording

8 Save the Recording

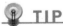 **TIP**

You can attach an existing audio file in **.MP3** or **.WAV** format to the selected image, rather than recording one now. Just choose **File, Browse** in the **Select Audio File** dialog box, select the audio file you want to use, and click **OK**.

3 **Click Record Audio Caption Button**

Click the **Record Audio Caption** button (located below the image *file date* and time) on the **Properties** pane. The **Select Audio File** dialog box appears.

4 **Begin Recording**

When you're ready to begin recording, click the **Record** button. Speak into the microphone.

5 Stop Recording

When you are done recording your audio annotation, click the **Record** button again to stop the recording. The file is immediately saved in **.WAV** format (in the **\My Pictures\Adobe\Audio Captions** folder), using the image's filename as the base. The filename appears on the title bar of the **Media Player**, and the Media Player's controls become active. In this example, my annotation was saved to the file named **grandma lydia edwards 2.wav** because the image I selected for annotation was called **grandma lydia edwards 2.tif**.

This audio filename, by the way, will not change if you later change the image filename, but the audio file *will* remain associated with that image so you'll still be able to play it.

6 Review the Recording

Click the **Play** button and listen to the recording. If you don't like what you've recorded, you can't really edit it, but you can record something else entirely by repeating steps 4, 5, and 6.

7 Close the Window

When you're satisfied with the recording, click the **Close** button to close the **Media Player** window.

8 Save the Recording

Photoshop Album displays a prompt asking whether you want to save the recording; click **Yes.** Photoshop Album attaches the recording to the image.

60 Change Image Date and Time

Several dates are associated with each image: the *import date*, the *file date*, and the *modified date*. The import date tells you the date and time the item was imported (added) into the *catalog*. The file date tells you when an image was created or scanned. The modified date indicates the last time an image was changed—rotated, brightened, saturated, and so on. The modified date is the same as the file date until you change the image by adjusting its characteristics using either the

💡 TIP

For help in using the other buttons in the **Media Player** window, see **51** **Play an Audio File.**

✎ NOTE

After an audio caption is attached to an image, a special icon (a sound horn) appears on the image's thumbnail in the photo well; to listen to the audio caption or to remove it, see **50** **Play an Audio Caption Attached to an Image.**

Before You Begin

✔ **55** About the Properties Pane

See Also

→ **78** Find Items with the Same Date

→ **79** Find Items Within a Date Range

Photoshop Album editor or a graphics editor such as Photoshop Elements or Paint Shop Pro, which you launch from within Photoshop Album. At that time, the modified date will change, but the file date will remain the same. You can see all three dates—the import date, modified date, and file date—on the **Properties** pane when the **History** list is displayed.

The file date, by the way, also appears above the image in the photo well, provided that the **Show Dates** option on the **Options** bar is selected. In **Single Photo** view, this date is labeled **Shot On**, even though the image may have been scanned and not shot using a digital camera. In any case, sometimes the file date is simply wrong and must be manually adjusted. For example, you might have taken a picture with your digital camera while on vacation in another time zone, and the date and time recorded were based on your home time, and not local time. Not that a difference of a few hours should matter much, but for record-keeping purposes, *it might matter to you*—especially if the difference between the two time zones (the vacation spot and your home) results in a different date.

Most often, the reason you'll want to manually change the file date is with a scanned image. With a scanned photo, the date and time assigned to the resulting file is based on when the image was scanned, not when the photograph itself was taken. This means that, for most scanned photos in the catalog, the file date will not tell you when the image was taken. So if you know when the photograph was actually shot, you can follow the steps in this task to adjust the file date accordingly.

① Select Image

In the photo well, click the image whose date you want to change. The selected image appears with a yellow border around it (unless you're working in **Single Photo** view).

② Display Properties Pane

If it's not already displayed, click the **Show or Hide Properties** button on the **Options** bar to display the **Properties** pane.

③ Click Adjust Date and Time Button

Click the **Adjust Date and Time** button, located to the left of the date and time on the **Properties** pane. The **Adjust Date and Time** dialog box appears.

④ Select Change Option and Click OK

To change the file date and time to anything you like, select the **Change to a specified date and time** option. To change the file date so that it matches the current modified date, select the **Change to match file date and time** option. To adjust the time portion only by a few hours or so, select the **Shift by set number of hours (time zone adjust)** option. After selecting the option you want to use to change the file date, click **OK**.

⑤ Enter New Date or Time and Click OK

If you selected the **Change to match file date and time** option, the file date is changed immediately to match the modified date and you're returned to the Photoshop Album main window.

If you selected the **Change to a specified date and time** option in step 4, the **Set Date and Time** dialog box appears. Enter a **Year**, **Month**, and **Day**. If you don't know the actual date on which a photo was taken, and you'd rather list it as unknown, select **????** from the **Year** list. Click **Known** and enter the time as well; if you don't know the actual time the photo was taken or you don't want to bother with it, select **Unknown**. Click **OK**.

If you selected the **Shift by set number of hours (time zone adjust)** option in step 4, the **Time Zone Adjust** dialog box appears. Select either **Ahead** or **Back** to indicate the direction in which you want the time adjusted, and then enter the number of **Hours** to adjust the time of the photograph. Click **OK**.

⑥ View the Result

Photoshop Album immediately adjusts the file date and time based on your choices and displays that new date/time in the photo well. Here, the file date for this photo of my daughter, taken just after her first birthday, has been changed to a date that coincides with when the photo was taken and not when it was scanned.

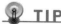
TIP

You can change several images to the same date and time by selecting them and then either clicking the date and time above one of the *thumbnails* or choosing **Edit, Adjust Date and Time of Selected Items**. To make it easy to select several similar images, use the **Find** bar to display just those images. See **73** **About Finding Items**.

1 Select Image

3 Click Adjust Date and Time Button

4 Select Change Option and Click OK

5 Enter New Date or Time and Click OK

2 Display Properties Pane

New File Date

6 View the Result

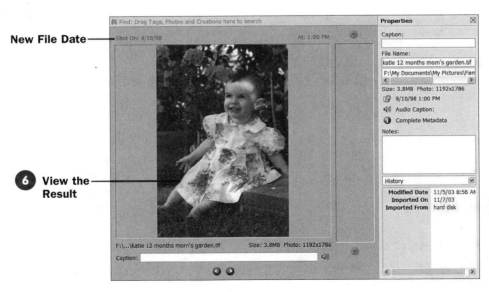

61 Attach a Note to an Item

As you begin collecting images in Photoshop Album, adding *tags* and descriptive *captions*, there may come a time when you want to add something more to tell the full story about a photo. For example, perhaps you've scanned in a photo of your grandfather, sitting in his fishing boat. You've added several tags, such as **fishing** and **grandfather**, to group the image with similar ones. You've also added a caption to the image that tells the viewer **Grandpa Joe, fishing, 1925**. But what you'd really like to preserve are the memories you have of this photo and when it was taken—and that's where notes come in.

Using the **Notes** section of the **Properties** pane, you can annotate an image with a detailed description of its contents, when it was taken, and the events surrounding the photograph. Here, you could write about how **Grandpa Joe loved fishing, which he did every Sunday afternoon, on Lake Hefner, two miles from his home.** You might even include other details such as the name of his boat, the kinds of fish he used to catch, and whether or not he made his own lures. Although these notes are visible only on the Photoshop Album **Properties** pane, your children and their grandchildren will surely appreciate the extra time and effort you've made in recording the family history.

Before You Begin

✔ **55** About the Properties Pane

See Also

→ **58** Add a Text Caption

→ **59** Record an Audio Caption

→ **77** Find Items with the Same Caption or Note

1 Select Image

In the photo well, click the image you want to annotate. The selected image appears with a yellow border around it (unless you are in **Single Photo** view).

2 Display Properties Pane

If it's not already open, click the **Show or Hide Properties** button on the **Options** bar to display the **Properties** pane.

3 Type Note

Click in the **Notes** box of the **Properties** pane and type your note.

After entering the note, you can close the **Properties** pane if you no longer want it visible by clicking the **Show or Hide Properties** pane button on the **Options** bar again. However, to view the note at a later time, you must redisplay the **Properties** pane.

 NOTE

A note is limited in length to 1,023 characters, including spaces.

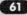

1 Select Image

2 Display Properties Pane

3 Type Note

8

Organizing Items

IN THIS CHAPTER:

KEY TERM

Tag—A category that describes a group of images. For example, you could create a tag called **Nikki**, and use it to group the photos of your cat into one collection.

The main reason for importing images, audio files, and movies into Photoshop Album is to organize them, and that's what this chapter is all about. You group similar media files together, such as similar images by adding the same *tag*. You can tag any item in the *catalog*, typically identifying the content of the file with the tag you choose. For example, you might add the **John** tag to several audio files, movie files, and image files that contain your son, John.

After tagging your image files, you'll probably begin to edit them. Editing images creates additional organizational challenges for Photoshop Album. Although you'll learn how to edit images in Chapter 10, "Fixing Images," in this chapter, you'll learn how to undo your edits and revert back to the original image. You'll also learn how to replace original images with your newly edited ones, a process that can reduce the size of your catalog immensely. And if you use your images in other programs such as PowerPoint or Word, you may want to copy or export those images. In this chapter, you'll learn how.

62 About Organizing Items

See Also

→ **53** Sort Items

→ **64** Attach a Tag to an Item

→ **74** Find Items with the Same Tag

→ **78** Find Items with the Same Date

→ **79** Find Items Within a Date Range

Photoshop Album provides many different ways to sort, display, and organize the items in your *catalog*. For example, in **53** **Sort Items**, you learned how to change the view in the photo well so that items are sorted in the order in which you want them to appear, such as grouped by import batch. You can also use this method to sort and group items by *file date* or their location on a hard disk, CD-ROM, or DVD. The advantage of this method of organization is that you don't have to do anything to an item (other than import it) to have that item appear in the proper sort order within the catalog.

Although you can also use the technique explained in **53** **Sort Items** to arrange items by file date, you might prefer a method that actually limits the display so that only those items created on a particular day or within a particular range of dates are displayed. One way to do this is to use the **Calendar**, as described in **78** **Find Items with the Same Date**. With the **Calendar**, you can quickly view all the images and other items created on a particular day (all items with the same file date). If you're looking for Halloween photos of your daughter, for example, it's easy to display the **Calendar** and simply click **October 31st**. The arrow buttons allow you to quickly scroll through just the images and other items created on the selected day.

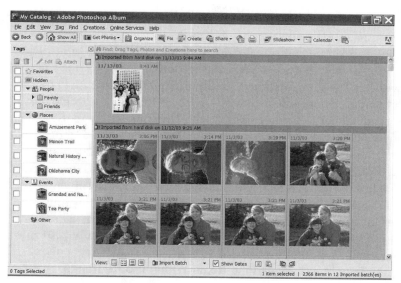

Items imported at the same time can be grouped together in the photo well.

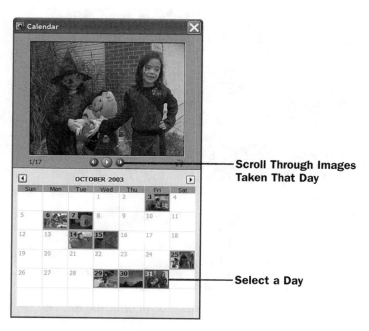

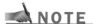— Scroll Through Images Taken That Day

— Select a Day

*The **Calendar** limits the number of items displayed to a particular date.*

NOTE

You can also use text *captions* and notes to organize images and other items. For example, if you add a text caption to an image that says, **Ramone takes a dive**, you can search for the word *dive* and locate the image. You can search the notes attached to images and other items as well. See **77** Find Items with the Same Caption or Note.

The **Calendar**'s great, but the selected images and other items are displayed in its window and not the photo well, which means that you can't increase an image's size if needed. To limit the display of media files in the photo well (where you can show an image in a large size if needed), you use the **Timeline**. You can also use the **Timeline** to quickly scroll to a particular set of media files, without limiting the display of items at all. Either way you employ it, the **Timeline** is easy to use. After displaying it, just click anywhere on the **Timeline** to jump to that set of images and items. For example, you might click **April 2002** to jump directly to the images taken on your birthday last year, plus any items you might have created that day. (Like the **Calendar**, the **Timeline** looks for items with the same file date.) If you want to display only the images taken during the latter half of 2001 (and items created during that same period), you can drag the endpoint markers to **July 2001** and **December 2001** to limit the **Timeline** range. You'll learn more about using the **Timeline** in **79** **Find Items Within a Date Range**.

Endpoint Markers

Range of Displayed Items—

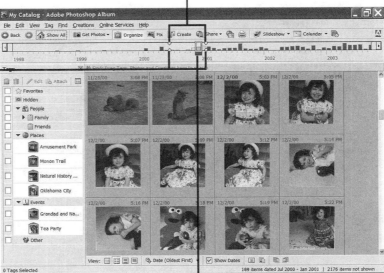

Click to Scroll to Matching Items

*Use the **Timeline** to scroll within the catalog or to limit the display.*

Although the **Calendar** and **Timeline** are useful tools, they depend on an item's file date being correct. As discussed in **60** **Change Image Date and Time**, an image's file date might be wrong simply because you

scanned it in three months after it was actually taken. In other words, an image's file date might be **10/16/03** because that's when you scanned it in, rather than because that's the actual date the image was taken. So relying on the **Calendar** and **Timeline** to help you organize images and other items in the catalog is not enough. And searching for an image based on its filename (see **76** **Find Items with Similar Filenames**) may not help because digital images use generic filenames such as **DSC00203.TIF**. Renaming files is a fairly simple process, as shown in **56** **Rename an Image** and **57** **Rename a Group of Images**, but it is tedious work. So, what is the simplest and easiest method to organize your growing pile of images and other catalog items? The answer, of course, is *tags*, which just happen to be the subject of this chapter.

How Tags Work

With tags, you can group similar items together quickly and easily. You start by creating a tag that describes an item's group. For example, you might create a tag called **Holidays** and then assign that tag to all your Fourth of July, Thanksgiving, Christmas, and other holiday images. Tags assigned to an item appear as small icons beneath an item's *thumbnail* in the catalog. In **Single Photo** views, you'll see not only the tag icon (which uses a photo that you think best represents all items in that category), but the tag's description as well. In **Large Thumbnail** or **Medium Thumbnail** view, you won't see specific tag icons, but the category icons (icons that represent the category to which a tag belongs, such as **People**). In **Large Thumbnail** view, you'll also see each tag's description. In the **Small Thumbnail** view, you won't see specific tag or category icons, but only a generic tag icon that tells you some kind of tag or tags have been assigned to the image.

If you need to work in a view that displays an item's tags in a way that makes it hard for you to decipher what they mean, you have two options. You can simply move the mouse pointer over whatever icon is displayed; a list of the assigned icons appears. You can also display the **Properties** pane, and look for the names of the assigned tags in the metafile section (see **55** **About the Properties Pane**).

Now, if you were to create a **Holiday** tag as I suggested earlier, and assign it to several images, you could quickly display just your holiday images using the steps shown in **74** **Find Items with the Same Tag**. Being able to control the catalog display is one of the powerful results of using tags to organize your catalog items.

NOTE

Tags do not appear on thumbnails in the photo well if you do not also display file dates. To display dates, turn on the **Show Dates** option on the **Options** bar.

Tags Pane Tags Appear as Icons on Thumbnails

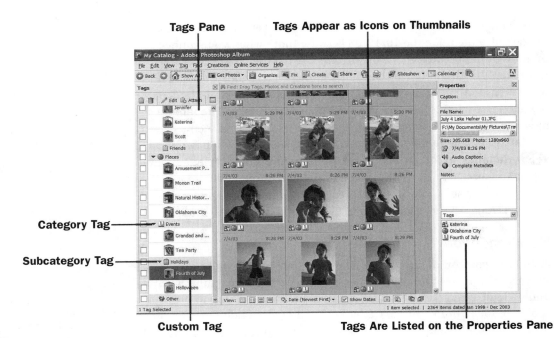

Category Tag

Subcategory Tag

Custom Tag Tags Are Listed on the Properties Pane

Tags help you organize your images.

Available tags are displayed on the **Tags** pane, located on the left side of the Photoshop Album window. By default, tags consist of five main categories: **Favorites**, **People**, **Places**, **Events**, and **Other**. Under the **People** category, you'll find two subcategories waiting for you—**Family** and **Friends**. You can use these existing category (**People**) and subcategory tags (**Friends**) to organize your media files, or you can create new tags.

By the way, Photoshop Album provides one more additional category, called **Hidden**, that you can use to temporarily hide media files you don't use very often. This allows you to keep items in the catalog, but to also keep the catalog uncluttered with images and other media files you don't use often. See **82** **Hide Items You Don't Generally Use**.

When creating a new tag, you can place it under any category and subcategory—for example, you could create a tag for your son and place it in the **People**, **Family** category. You can create tags under any of the other categories or subcategories as well; for example under **Places**, you could create a **Chicago** tag to organize photos of your visits to friends and relatives in Chicago. Tags don't have to be that specific, however; you could just as easily create a tag for **Museums** or **Parks** if you spend

NOTE

The **Tags** pane is normally displayed, but if it isn't for some reason, you can display it quickly by clicking the **Organize** button on the **Shortcuts** bar. You can also choose **View, Tags** from the menu to display the **Tags** pane.

a lot of time in those places. Tags in the **Events** category can also be specific (**Family Reunion 2003**) or generic (**Holidays**). Just create tags that relate *in your mind* to a specific collection of media files. That way, you'll be able to later find that same group of items by simply using the tag you created. As you can see, I created several tags for my collection—one for each member of my immediate family, organized under the **Family** category. I added several places we visit often to the **Places** category, such as amusement parks and the Monon Trail (a walking and riding trail that runs through my city). In the **Event** category, I've listed a few events, although I'm sure I'll add more as I expand my collection. One is generic (**Granddad and Nana Visit**), the other specific (**Tea Party**). I found that I had a lot of holiday photos, so I created my own category (**Holidays**), with several subcategory tags (**Christmas, Fourth of July**, and so on). As I add to the catalog, I invent new tags to help me organize the files. As I work with Photoshop Album, I reorganize the tags as needed, eliminating those that just don't seem to work after all.

You can create additional subcategories as well. For example, under the **People, Friends** category, you could create the subcategories **College, Work**, and **Other**. You could then apply the **College** tag to any media file containing a college cohort. You'll learn how to create subcategories and tags in **63 Create a Tag**. When creating tags, don't create a tag for every little thing. You should instead create several general tags, and then, by associating multiple tags with specific items, narrow down broad groups. For example, you might create a tag for your friend, **Juanita**. If you also have a tag called **Vacation**, you could assign both the **Juanita** and **Vacation** tags to several images, and use them together to display photos of your friend and you on vacation together. You could also use the **Vacation** tag, however, to group photos of your family on vacation. By assigning those images the additional tag, **Family**, you could quickly display your family on vacation in Florida without wading through the additional photos of Juanita.

Changing the Tags Pane Display

To display the **Tags** pane at any time, click the **Organize** button on the **Shortcuts** bar, or choose **View, Tags** from the menu. If a tag you want to use is out of view, use the scrollbar on the right side of the **Tags** pane to scroll through the list. You can shorten the list by temporarily hiding particular categories. Just click the down arrow to the left of a category name to hide any subcategories and tags it contains. To expand a category and display its tags, click the right arrow to the left of the category

 NOTE

If you create a tag under the **People, Family** category, Photoshop Album will automatically create a tag for you as well. In other words, if you choose to create a tag for your son, **Lucas**, under the **Family** subcategory (instead of simply assigning the **Family** tag to all the images of your son), then Photoshop Album will automatically create a tag for *you*. In my case, it automatically created a **Jennifer** tag.

TIP

If you use a category tag to display a selected group of media files (as described in **74 Find Items with the Same Tag**), all items associated with a subcategory or a tag under that category also display. For example, if you select the **People** category for display, all items tagged with the **Family** or **Friends** subcategory tag, as well as any items tagged with custom tags under that heading, display.

The check boxes that appear in front of each tag in the **Tags** pane are used to tell Photoshop Album which items you want to display. See **74** **Find Items with the Same Tag**.

name. You can quickly expand the entire tag listing by selecting **Tag, Expand All** from the menu. To collapse the listing and show only the main categories, select **Tag, Collapse All** instead.

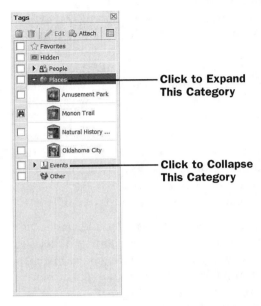

Expand or collapse categories to control the tag listing.

Normally, tags appear in the listing with both a name and a medium-sized photo icon as shown in the figure. Each tag is displayed on its own row, which can make for an awfully long tag listing if you happen to use more than just a few tags. You can change this display so that the tag icons are larger and easier to see, with two tags displayed on each row. The display can also be changed to a small icon format in which the generic tag icon is used, rather than the photo icon—an option that makes the listing much smaller.

To change the tag list view, click the **Tag Viewing Options** button on the **Tags** pane. In the **Tag Options** dialog box that opens, select the option you want. If you select the **Alphabetical Order** option under the **Small** or **Medium Icon** view, the tags are listed in alphabetical order, and the categories and subcategories are displayed at the bottom of the list.

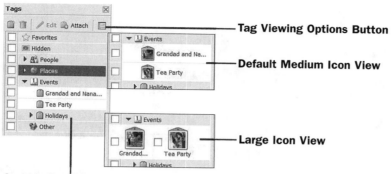

Tag Viewing Options Button

Default Medium Icon View

Large Icon View

Generic Small Icon View

The various tag views.

NOTE

Tips on how to use tags appear at the bottom of the **Tags** pane, in a **Tips** pane. To close the **Tips** pane, click its **Close** button. To redisplay it, choose **Help, Reset Tag Tips** from the menu.

63 Create a Tag

Although Photoshop Album provides you with a few category and sub-category *tags* to start out with, you may quickly come to the conclusion that they simply aren't enough, and you'll want to create some of your own. You can place the tags you create into any existing category or subcategory. You must assign the new tag a name, and add any descriptive notes in the text box provided. New tags use a generic icon with no picture (even if you're looking at the **Tags** pane in **Medium** or **Large Icon** view). The first time you assign the new tag to a photo however, that photo is used as the icon for the tag. Assigning a photo to the tag icon helps the icon act as a better visible reference for you when assigning tags to various items in the catalog. In addition, you'll see the tag photo icons assigned to an item if the item is displayed in **Single** view. However, you can reassign the photo being used as a tag's icon whenever you like; see **67** **Change a Tag's Icon**. You can make other changes to a tag after the fact: see **68** **Change a Tag's Category, Name, or Note**.

Before You Begin

✔ **62** About Organizing Items

See Also

→ **64** Attach a Tag to an Item

→ **67** Change a Tag's Icon

→ **68** Change a Tag's Category, Name, or Note

TIP

You can't create categories, but to create a new subcategory, select **Tag, New Sub-Category** from the menu. In the dialog box that appears, type a name for the new subcategory in the **Sub-Category Name** box, select a **Category** under which to place it, and click **OK**.

1 Click Create New Tag Button

Click the **Create New Tag** button on the **Tags** pane. You can also select **Tag, New Tag** from the menu bar if the **Tags** pane is not visible. The **Tag Editor** dialog box appears.

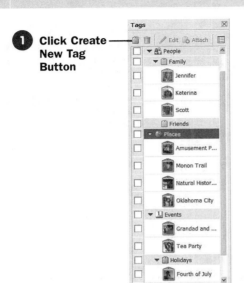

1 Click Create New Tag Button

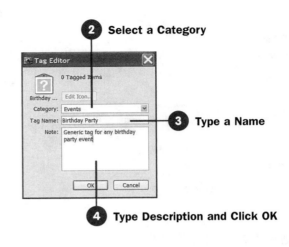

2 Select a Category

3 Type a Name

4 Type Description and Click OK

TIP

To add a tag to a specific category quickly, right-click that category (or subcategory) in the **Tags** pane and select **Create New Tag** from the context menu. The category/subcategory you selected will automatically appear in the **Category** box in the **Tag Editor** dialog box.

NOTE

If you decide at a later date that you want to remove a tag you've created from the **Tags** pane, see **66** Delete a Tag from the Tags Pane.

2 Select a Category

Open the **Category** drop-down list and select the category or sub-category to which you want to assign this new tag.

3 Type a Name

Type a name for the new tag in the **Tag Name** box. The name can include spaces if you like, but you are limited to 63 characters.

4 Type Description and Click OK

Click in the **Notes** box and type a description of the tag if desired. This note appears only when you select a tag and display the **Tag Editor** dialog box, so it's of limited use. Click **OK** to create the tag. The tag appears on the **Tags** pane underneath the category you selected. The tag is ready to be assigned to any item you want. See **64** Attach a Tag to an Item.

64 Attach a Tag to an Item

To organize your media files into logical groups such as vacation photos, photos of the family dog, audio files of your daughter, movies of friends, and so on, assign *tags* to them. After a tag has been associated with your media files, you can search for items with a particular tag and display them onscreen. For example, if you have a tag called **Hattie**, you could use it to instantly display photos of your pet Scottie dog. You can also organize audio and video clips that you've imported into the *catalog* by assigning tags to them as well.

If you've recently created a tag (see **63** **Create a Tag**), then the tag does not yet have a photo icon. When you assign the new tag to a photo, it will take that photo for use as its icon. If you assign a new tag to a group of items, the tag will use the first photo in that group as its icon. So when assigning a new tag for the first time, you'll want to be selective and choose a photo that represents that category well.

There are two special tags you should be aware of: **Favorites** and **Hidden**. Use the **Favorites** tag to mark favorite image, audio, and video files for quick retrieval. Most likely, you'll use the **Favorites** tag in combination with other tags; for example, if you attach the **Favorites** tag to an image that also uses the **Vacation** tag, you can locate your favorite vacation photos in a jiffy. The **Hidden** tag is used to temporarily hide items in the photo well; see **82** **Hide Items You Don't Generally Use**.

1 Select Items

Press **Shift** and click the first item in the group you want to tag and then click the last item in the group. Alternatively, press **Ctrl** and click each item you want. If items are grouped by folder or import batch, you can click the gray bar above a group to select all its items.

2 Select Tags

In the **Tags** pane, press **Ctrl** and click each tag you want to assign to the selected items.

Before You Begin

✔ **62** About Organizing Items

✔ **63** Create a Tag

See Also

→ **65** Remove a Tag from an Item

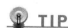 **TIP**

If you forget and assign a new tag to any old photo and later decide that a different photo is more representative of the group, you can change a tag's photo icon. See **67** Change a Tag's Icon.

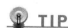 **TIP**

You can attach a single tag to selected items quickly by choosing **Tag**, **Attach Tag** from the menu and then selecting the category and tag you want from the submenu that appears.

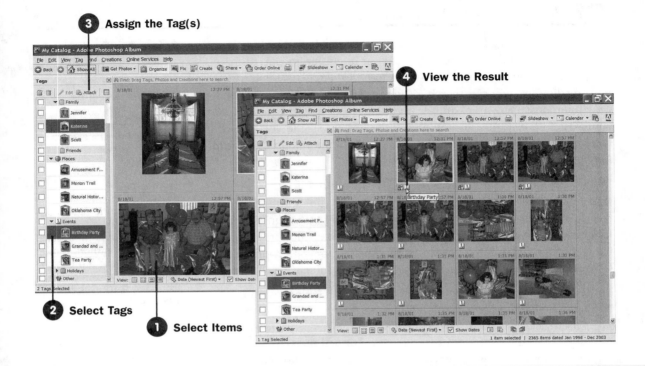

3 Assign the Tag(s)

4 View the Result

2 Select Tags

1 Select Items

3 Assign the Tag(s)

Drag the selected tag(s) onto any one of the selected items and then drop the tags on the item. If you don't like dragging, you can simply click the **Attach** button at the top of the **Tags** pane.

NOTE

If you've accidentally associated a tag with an item, and you feel that the tag doesn't really apply, you can remove it. See **65** Remove a Tag from an Item.

4 View the Result

If you're assigning a new tag to an image for the first time, that image will be used as the tag's photo icon which appears on the **Tags** pane.

The tags you assigned appear as icons underneath the selected items. If the descriptions for the tags attached to an image are not visible in the current view (for example, if you've switched to **Medium Thumbnail** view as shown here), move the mouse pointer over the icon to make the tag's description appear.

65 Remove a Tag from an Item

If you accidentally attach a *tag* to the wrong item, or if you decide later on that a tag simply doesn't go with the media file you assigned it to, you can remove the tag easily. Often, I'll select a group of images and other items, apply a series of tags that reflect the majority of them, and then I'll use these steps to remove the tags that don't apply to specific items. Removing a tag doesn't injure the item in any way; removing the tag simply enables you to exclude the item from searches that include that tag. You can remove only one tag at a time, but you can remove the same tag from multiple items if you like.

Before You Begin

✔ **64** Attach a Tag to an Item

See Also

➔ **66** Delete a Tag from the Tags Pane

① Select Items

Press **Shift** and click the first item in the group whose tag you want to remove, and then click the last item. Alternatively, press **Ctrl** and click each item you want. If items are grouped by folder or import batch, you can click the gray bar above a group to select all its items.

TIP

To quickly display items with a particular tag so that you can remove the tag, see **74** **Find Items with the Same Tag.**

② Select Tag, Remove Tags from Selected Items

Choose **Tag, Remove Tags from Selected Items** from the menu bar. A submenu appears listing the tag categories; select the appropriate category. From the next menu that appears, select the specific tag you want to remove.

③ View the Result

The tag you selected is removed, and no longer appears on the chosen items in the photo well. Here, I selected a series of images of my daughter fishing with Granddad. I then applied the **Granddad/Nana**, **Katerina**, **Oklahoma City**, and **Fishing** tags. Then I selected those images in which Granddad did not appear, and removed the **Granddad/Nana** tag from those images. Removing this single tag did not affect the other tags already assigned to the images; as you can see here, the other tags were left in place.

TIP

You can remove a tag from a single item by right-clicking the tag in the **Medium Thumbnail**, **Large Thumbnail**, or **Single Photo** view, and selecting **Remove XX tag**, where **XX** is the tag name. In **Small Thumbnail** view, right-click the generic tag icon and select **Remove Tag** from the context menu, then select the actual tag to remove from the submenu that appears.

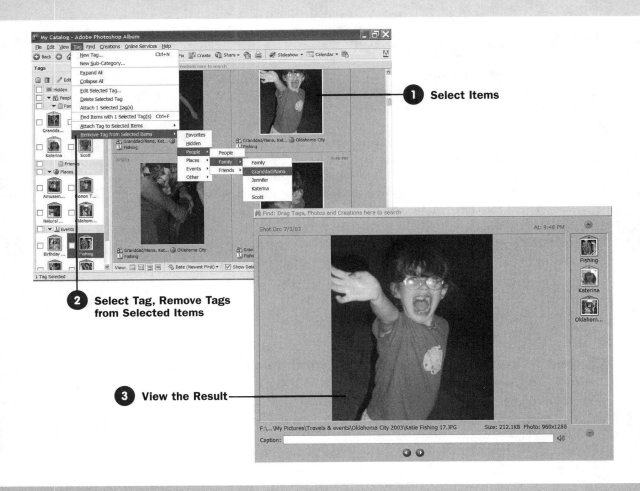

① **Select Items**

② **Select Tag, Remove Tags from Selected Items**

③ **View the Result**

66 Delete a Tag from the Tags Pane

Before You Begin

✔ **62** About Organizing Items

See Also

→ **65** Remove a Tag from an Item

The *tags* you've created appear in the **Tags** pane, organized under the category/subcategory to which they belong. Occasionally, after creating a tag, you'll realize that its purpose overlaps other tags, and that it simply isn't needed.

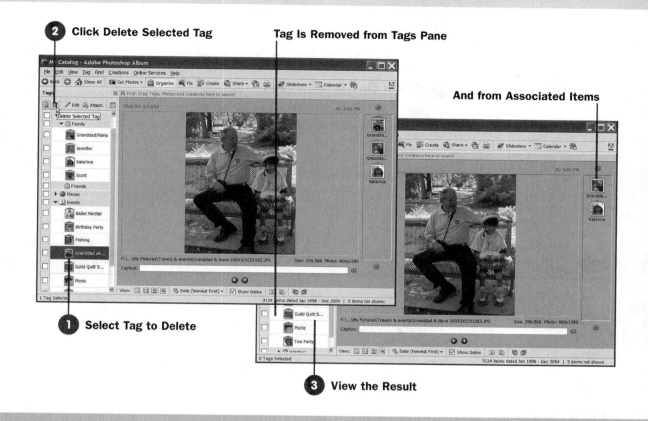

2 Click Delete Selected Tag

Tag Is Removed from Tags Pane

And from Associated Items

1 Select Tag to Delete

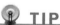

3 View the Result

When I first started using Photoshop Album, I imported several photos from a recent visit by Granddad and Nana, and so I created a **Granddad and Nana Visit** tag, intending to use it to mark photos taken when they came to visit us or when we went to visit them. I hadn't yet created a **People** tag for Granddad or Nana, but when I finally got around to doing that later on, I realized I didn't need the **Granddad and Nana Visit** tag. If I wanted to view pictures of our trip to the zoo with Granddad and Nana, I could search for items with the tags **Zoo** and **Granddad/Nana** and not include the **Visit** tag. If you happen to create a tag that you later on decide you don't need, follow these steps to remove the tag you no longer intend to use from the **Tags** pane.

After a tag is deleted from the **Tags** pane, its name and icon no longer appear on the **Tags** pane. Also, the tag is automatically removed from any items that might have been using it; the items themselves are not deleted.

TIP

To remove an unwanted category you've created, right-click it in the **Tags** pane and select **Delete XX sub-category** (where **XX** is the category or subcategory name). Click **OK** to confirm the deletion. You can't, by the way, remove any of the standard categories Photoshop Album came with (**Favorites**, **Hidden**, **People**, **Family**, **Friends**, **Places**, **Events**, and **Other**).

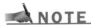

① **Select Tag to Delete**

In the **Tags** pane, click the tag you no longer need.

② **Click Delete Selected Tag**

Click the **Delete Selected Tag** button located at the top of the **Tags** pane. You can also choose **Tag, Delete Selected Tag** from the menu. You'll be asked to confirm the deletion; click **OK** to continue.

③ **View the Result**

The selected tag is removed from the **Tags** pane and from any associated items.

67 Change a Tag's Icon

Before You Begin

✔ **63** Create a Tag

See Also

→ **62** About Organizing Items

→ **66** Delete a Tag from the Tags Pane

→ **68** Change a Tag's Category, Name, or Note

The first time you assign a new *tag* to an image, that image is used as the tag's icon in the **Tags** pane. Choose carefully when making this initial assignment; by selecting a meaningful image to act as the tag's icon, you might find it easier to locate the icon on the **Tags** pane when you decide to assign it to other items later on. In addition, remember that the photo appears on the tag icon when an item is displayed in **Single Photo** view, enabling you to quickly identify its purpose.

Regardless of how careful you are, you might discover an image later on that better exemplifies the meaning of the tag. If that happens, follow the steps in this task to select a different image to act as a tag's icon.

① **Select Tag**

In the **Tags** pane, click the tag you want to change. The selected tag is highlighted.

② **Click Edit**

Click the **Edit Selected Tag** button located at the top of the **Tags** pane. The **Tag Editor** dialog box appears.

③ **Click Edit Icon**

Click the **Edit Icon** button in the **Tag Editor** dialog box. The **Tag Icon Editor** dialog box appears.

2 Click Edit

3 Click Edit Icon

1 Select Tag

7 Click OK

4 Click Find

5 Select Photo and Click OK

6 Make Adjustments and Click OK

4 Click Find

Click the **Find** button in the **Tag Icon Editor** dialog box. All the items currently associated with the selected tag appear in a separate **Select Icon for Tag** dialog box.

5 Select Photo and Click OK

In the **Select Icon for Tag** dialog box, select the photo you want to use as the tag's icon by clicking it. Click **OK** to close the **Select Icon for Tag** dialog box. You're returned to the **Tag Icon Editor** dialog box.

NOTE

The number of images using the selected tag appears just below the image in the **Tag Icon Editor** dialog box. Instead of clicking **Find**, you can click the left and right arrows on either side of the **Find** button to scroll through each matching image and select the one you want.

6 Make Adjustments and Click OK

You can use only a selected portion of the image as the icon if you like. Just drag the corner of the white cropping border to adjust the size of the area that will be used as the icon. Click in the middle of the cropping border and drag to adjust its position on the image. When you're through, click **OK** to close the **Tag Icon Editor** dialog box.

7 Click OK

You're returned to the **Tag Editor** dialog box. Click **OK** again to close the dialog box and complete the selection of the new tag icon. The cropped portion of the image you've selected appears as the tag's new icon in the **Tags** pane.

68 Change a Tag's Category, Name, or Note

Before You Begin

✔ **63** Create a Tag

See Also

→ **67** Change a Tag's Icon

As you learned in **63** **Create a Tag**, when you create a new *tag* for organizing items, you give that tag a name and select the category or subcategory to which you want it assigned. You're also given a chance to add a description (a note) to help you better understand the tag's purpose at a later date. In the computer world, things are rarely permanent, and tags are no exception. If they don't prove as helpful as you might have thought, you can change a tag's name, category, and description at any time by following the steps in this task.

1 Select Tag

In the **Tags** pane, click the tag you want to change. The selected tag is highlighted.

TIP

If you want to create a new category for the selected tag, choose **New Sub-Category** from the **Category** list. Type a name in the **Sub-Category Name** box, select a category from the **Category** list, and click **OK**.

2 Click Edit

Click the **Edit** button located at the top of the **Tags** pane. The **Tag Editor** dialog box appears.

3 Select Category

In the **Tag Editor** dialog box, you should change only the things that are wrong. If you want, open the **Category** list and select a different category to which you want the tag to belong.

2 Click Edit

1 Select Tag

3 Select Category

6 View the Result

4 Type Name

5 Type Note and Click OK

4 Type Name

If you want, select the tag's name in the **Tag Name** box and type a replacement name.

5 Type Note and Click OK

If you want, type a replacement description in the **Note** box, or simply edit the existing description. When you're through making changes, click **OK**.

6 View the Result

The tag's name, category, and note are changed immediately, and those changes appear in the **Tags** pane.

I originally had a **Natural History Museum** tag that I used to tag images from a visit to a museum in Oklahoma. I was about to create another tag for a different museum when I realized that we didn't get to that many museums, so I didn't really need tags for each different museum. Instead of creating a new tag for each

 NOTE

Want to delete a category you no longer need? Just right-click the category in the **Tags** pane and select **Delete XX sub-category** (where **XX** is the category's name). Click **OK** to confirm the deletion.

museum we might visit, I could instead create a single **Museum** tag. Then, by assigning a city tag when needed, I'd be able to quickly locate the images I wanted. For example, if I wanted to locate the Natural History Museum images again, I could search for images with the tags **Museum** and **Oklahoma City**. After making the appropriate changes to the **Natural History Museum** tag, I deleted the old **Museum** category I had created earlier and kept only the **Museum** tag, relocated to the **Places** category.

 69 Revert Back to an Original Image

Before You Begin

✔ **86** About Fix Photo

See Also

→ **95** Fix a Photo Using Another Program

 NOTE

When you edit an image using Photoshop Album, Photoshop Album automatically creates a new file for you, called *originalname_edited* (where *originalname* is replaced with the actual name of the original file). This new file automatically replaces the original file in the catalog. The steps in this task simply remove the edited file from the hard disk and the catalog and replace it with a *thumbnail* of the original file.

TIP

You can display a related group of images quickly if you need to revert them all to their original appearance. See **74** Find Items with the Same Tag.

Despite their convenience, digital cameras do not always capture an image exactly the way you want it to appear. For example, a digital image might appear too dark or lack contrast. Even if you capture perfect images on film (and there's certainly no guarantee of that), they must still be scanned into the computer before you can use them in Photoshop Album. During the scanning process, your images might become too dark or lose contrast. The result is that you'll find yourself wanting to make little tweaks to the images in the *catalog* from time to time. In Chapter 10, "Fixing Images," you'll learn everything you need to know about how to fix images using the tools in Photoshop Album or your preferred *graphics editor*. However, if those changes don't work out the way you wanted, you can reverse them at any time, following the steps in this task.

1 Select Edited Images

Select a single edited image by clicking it in the photo well. To select multiple images, press **Shift** and click the first edited image in the group, and then click the last image. Alternatively, press **Ctrl** and click each image you want. If edited images are grouped by folder or import batch, you can click the gray bar above a group to select all its images.

2 Select Edit, Revert

If you selected only one edited image, choose **Edit, Revert to Original** from the menu. If you selected multiple edited images, choose **Edit, Revert Selected Photos** instead. A warning box might appear, reminding you that you are about to undo changes to the file. If so, click **OK** to confirm that you want Photoshop Album to restore the original file to the catalog.

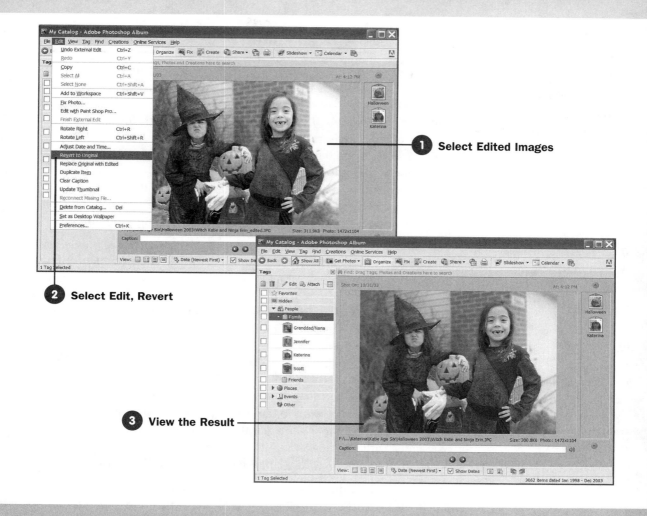

1 Select Edited Images

2 Select Edit, Revert

3 View the Result

3 View the Result

I used Photoshop Album to change the brightness and contrast of this Halloween image (see **91** **Manually Adjust Brightness and Contrast**) that I later decided to undo. The edited file appears in the first figure (you can tell the image has been edited by looking at its filename, which is visible in **Single Photo** view). After I selected the **Revert to Original** command, the original file appeared in the catalog. The edited file was completely removed, both from the catalog and from the hard disk.

70 Replace an Original Image with an Edited One

Before You Begin

✔ **86** About Fix Photo

See Also

→ **95** Fix a Photo Using Another Program

When you edit an image using Photoshop Album, or initiate the editing process with a *graphics editor* such as Photoshop Elements from within Photoshop Album, the program automatically creates a new file for you, called *originalname*_edited (where *originalname* is replaced by the image's original filename). For example, if you started editing a file called **Soccer 01.jpg**, Photoshop Album automatically creates a copy file called **Soccer 01_edited.jpg** and saves your changes to that file. This means that you now have two files on the hard disk: the original file and the edited copy. The edited copy, by the way, replaces the original in the *catalog* so that you see only one image in Photoshop Album.

I should remind you that a copy of the original file is created only if you initiate the editing process from within Photoshop Album, which you should do whether you want to use the Photoshop Album editor or some other graphics editor to make those changes. See **86** **About Fix Photo** and **95** **Fix a Photo Using Another Program** for more information. If for some reason you make changes to an image using a graphics editor without starting that editor from within Photoshop Album, the changes are most likely saved to the original file, and you won't have a copy file. In such a case, you will not have to perform this task because only one file will be on the hard disk—the original—and you certainly will not want to remove it. You will have a different problem, however; the image shown in the catalog won't reflect the changes you made without Photoshop Album's knowledge, so you'll have to update the catalog. See **54** **Update an Image in the Catalog**.

If you've made changes to an image the way you should (by initiating those changes from within Photoshop Album), you'll have two files on the hard disk—the original and the edited copy. From a file management standpoint, it may be a good idea to eventually get rid of the original file. Doing so will save you room on the hard disk. And it may also prevent you from accidentally selecting the wrong image for use in other programs such as a graphics editor, presentation program, or a greeting card creator. If you've edited an image and then decide that you like the edits and are sure that you no longer need the original file, perform the steps in this task to remove the original and free up hard disk space.

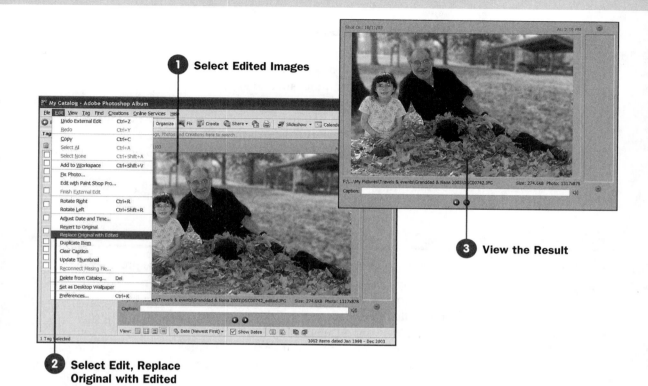

1 Select Edited Images

3 View the Result

2 Select Edit, Replace Original with Edited

1 **Select Edited Images**

Select a single edited image by clicking it in the photo well. To select multiple images, press **Shift** and click the first edited image in the group, and then click the last image. Alternatively, press **Ctrl** and click each image you want. If edited images are grouped by folder or import batch, you can click the gray bar above a group to select all its images.

2 **Select Edit, Replace Original with Edited**

If you selected only one edited image, choose **Edit, Replace Original with Edited** from the menu. If you selected multiple edited images, choose **Edit, Replace Selected Originals with Edited** instead. A warning box may appear, reminding you that you are about to delete the original files. If so, click **OK** to continue.

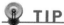 **TIP**

You can display a related group of images quickly if you want to locate several edited images so that you can remove their original files. See **74** Find Items with the Same Tag.

3 **View the Result**

I had made some minor changes to this photo of my daughter and her Granddad playing in the fall leaves, and decided that I liked the changes and therefore no longer needed the original file. So I selected the edited copy (you can tell an image is edited by looking at its filename in **Single Photo** view, as shown in the first figure), and used the **Edit, Replace Original with Edited** command to delete the original. As you can see in the second figure, Photoshop Album deleted the original file, and then renamed the edited file with the original filename, removing the _**edited** part.

71 Duplicate an Image for Editing

See Also

→ **47** Copy Items onto CD-ROM or DVD

→ **86** About Fix Photo

→ **95** Fix a Photo Using Another Program

NOTE

Tags, captions, and notes associated with the original image are automatically copied to the duplicate image as well.

When you edit an image using Photoshop Album, the program automatically creates a copy of the original file and then performs the edits on the copy. This organization keeps your original file safe from disastrous edits. This same process occurs if you launch a *graphics editor* such as Photoshop Elements from within Photoshop Album: Again, a copy of the original file is automatically created, and the edits are performed on the copy. The original image, by the way, is no longer displayed in the *catalog*—just the edited image. This keeps the catalog smaller and more organized, since the theory is that the catalog should contain only the images you want to use. The hard disk, however, contains both the original *and* the edited versions of the image, until you remove the original file permanently, as described in **70** Replace an Original Image with an Edited One.

But what if you have several different changes you want to make to an image and are not sure in advance which ones you might keep, if any? If you want, you can manually create additional copies of an image so that you can edit each copy in a different way. When you duplicate an image in this manner, both the original and the duplicate appear in the catalog. In addition, both images are stored as separate files on the hard disk. The original image retains its filename, while the duplicate is named *originalname*-copy (where *originalname* is replaced with the image's original filename). Because this procedure increases the size of the catalog and uses extra disk space, you'll only want to follow the steps in this task when you want to store multiple edited copies of the same image.

1 Select Image

3 View the Result

Edited with Fix Photo

Edited with Photoshop Elements

2 Create Duplicate

1 Select Image

Select the image you want to duplicate by clicking it in the photo well.

2 Create Duplicate

Choose **Edit, Duplicate Item** from the menu. The duplicate image appears next to the original image in the catalog, and a duplicate file appears on the hard disk. The filename for the duplicate is changed to *originalname*-copy (where *originalname* is the actual filename of the image). The two files are not linked, so changes you make to one are not reflected in the other. You can treat them as two totally separate images in the catalog.

NOTE

If the image you selected is an edited image, then *two duplicates* are made—a copy of the original image, and a copy of the edited one for a total of four files.

3 View the Result

Because this photo didn't need much editing, I wasn't sure whether the editor in Photoshop Album or Photoshop Elements would produce the best results. I duplicated the image and made changes to each one using a different editor. The results are close, but I think I prefer the image on the right, edited with Photoshop Elements.

72 Export Images for Use in Another Program

See Also

→ **47** Copy Items onto CD-ROM or DVD

→ **95** Fix a Photo Using Another Program

NOTE

If you're copying an image from Photoshop Album so that you can edit it using a *graphics editor*, you must follow a different procedure. See **95** Fix a Photo Using Another Program.

TIP

You can display a related group of images quickly if you need to export them. See **74** Find Items with the Same Tag.

Images imported into the Photoshop Album *catalog* can be easily sorted, tagged, and edited. They can also be used in any of the wonderful *creations* offered by the program, such as a calendar, eCard, or *slideshow*. But your images are not stuck in Photoshop Album; they can be used in other programs as desired, such as a word processor, spreadsheet, presentation, Web page designer, greeting card designer, publishing, or other program. In this manner, you can use each program to its best advantage.

For example, if you're assembling a family newsletter using Microsoft Publisher, you can quickly locate the images you need using Photoshop Album's powerful catalog, and lay them out with text and other graphic elements using Publisher's superior layout controls.

To get an image from Photoshop Album's catalog into any other program, you can use tools you're already familiar with: the **Copy** and **Paste** commands or the drag-and-drop technique. The result is an exact copy of the image as it appears in the catalog—the exact same size, file type, and quality. If you want to exercise a bit more control over the images you're exporting into another program, follow the steps in this task.

1 Select Images

Select a single image by clicking it in the **photo well**. To select multiple images, press **Shift** and click the first image in the group, and then click the last image. Alternatively, press **Ctrl** and click each image you want. If images are grouped by folder or import batch, you can click the gray bar above a group to select all its images.

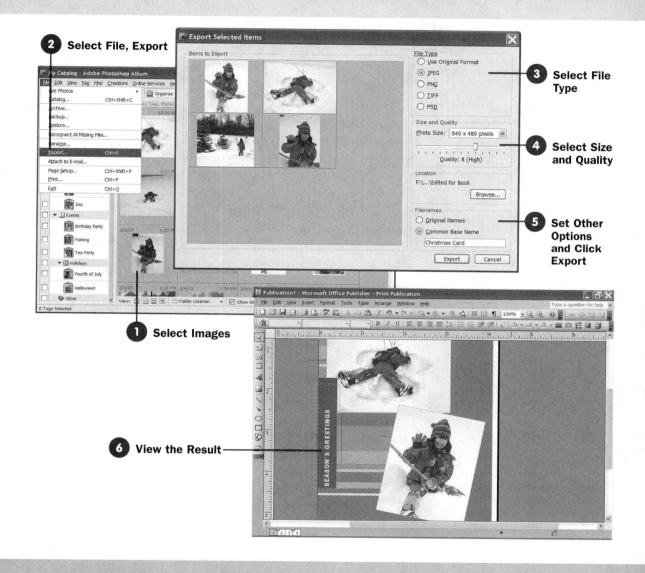

② Select File, Export

③ Select File Type

④ Select Size and Quality

⑤ Set Other Options and Click Export

① Select Images

⑥ View the Result

② Select File, Export

Choose **File, Export** from the menu. The **Export Selected Items** dialog box appears.

NOTE

If you want to use the images on the Web, choose **JPEG** or **PNG** from the **File Type** list. Choose **TIFF** to retain the best quality. If you plan on using the images in a Photoshop or Photoshop Elements-compatible program, choose **PSD** format.

NOTE

Resizing an image may result in a loss of image quality, especially if you're trying to make the image *larger* than it was.

③ Select File Type

Select the file type you want to use from those listed in the **File Type** area. Be sure to select a file type that's compatible with the program in which you intend to use the images.

If you just want to keep the files in their original format and not convert them to some other image format, select **Use Original Format** from the list. If you choose **Use Original Format**, skip steps 4 and 5.

④ Select Size and Quality

Open the **Photo Size** drop-down list and select a size for the images. The size you select is applied to all the selected images.

If you chose the **JPEG** file type in step 3, you can adjust the **Quality** of the exported image(s) by dragging the slider left or right. Reducing quality saves space, but may result in a fuzzy, less detailed image. However, if you're going to be using the image on the Web or other onscreen applications, or in a small size within a printed document, you can typically lower the quality and still achieve good results; the loss of detail simply won't be noticed.

⑤ Set Other Options and Click Export

Normally, exported files are placed in the **My Pictures** folder. To place them in a different folder, click **Browse** and select the folder you want to use.

Exported files retain their original filenames; if you've resized or adjusted the quality of the images, you might want to use new names for the modified images. If so, select the **Common Base Name** option and type a name to use. Each image then uses this name plus a number, such as **Fall Leaves 01** and **Fall Leaves 02**.

Click **Export** to export the images to the specified folder. You'll see a message telling you the images were successfully exported; click **OK**.

⑥ View the Result

To use the exported files, open your application and import them in the usual manner. You'll find the images in the folder you selected in step 5. Here, I used Microsoft Publisher and some of the exported files to create a quick Christmas card.

9

Locating Items

IN THIS CHAPTER:

You'll know your digital photos, audio files, and movies are truly and properly organized when you're able to quickly locate any photo without struggling to recall its exact filename or the folder you saved it in. If you had to organize photographs with Windows alone, you'd probably create an organized system of folders, and then attempt to save each photo in an appropriate folder. This limited method of organization quickly leads to all sorts of problems. Suppose that you have a photo of your two kids seated with their granddad and uncle beneath the Christmas tree. Do you file the image in the **Christmas** folder? Or in the **Kids**, **Granddad**, or **Uncle** folder? Or do you place multiple copies of the image in several folders, wasting disk space?

With Photoshop Album, you don't have to depend on a series of Windows folders to help you organize your media files. As you learned in **64** **Attach a Tag to an Item**, you can assign various categories, or *tags*, to an item, enabling you to locate it in multiple ways. For example, you could assign the **Christmas**, **Granddad**, **Uncle**, and **Kids** tags to the holiday snapshot, and locate it later on by searching for items with that unique combination of tags. Because you're using Photoshop Album to organize images and other media files, you can store all of them in the **My Pictures** folder if you like, rather than creating separate folders for various groups. You can even store media files *offline*, on CD-ROMs or DVDs. Photoshop Album doesn't care where files are located; it can organize them all easily.

By the way, tags aren't the only things you can use to locate an image or other file, as you'll discover in this chapter. You can also search for media files based on *file date*, filename, *caption*, note, color range, and other criteria. With Photoshop Album and a little bit of work initially tagging and captioning items, you can locate any one or any group of photos, audio files, or movies with the people you want, in the scene you want, at the time you want, without any fuss or difficulty.

73 About Finding Items

Before You Begin

✔ **62** About Organizing Items

If you take full advantage of the power and potential of digital photography, before very long, your Photoshop Album *catalog* will be filled with *thousands* of photographs. You might have also imported a lot of audio and movie files into the catalog. You should feel good about that. You don't have to store all those thousands of media files on your hard drive *unless you want to*. You can choose to offload your media files onto

CD-R or writeable DVD media, and *still* include those **offline** items in your Photoshop Album catalog. So even if you collect volumes of optical discs full of your photos, audio files, and movies (and with discs so inexpensive, why not?), finding a handful or just one item the moment you need it can be a simple and non-distracting process. When an item in your catalog isn't on your computer, Photoshop Album tells you which disc to insert in your optical drive.

Just because your catalog may have countless rows of **thumbnails** does not mean that it is less manageable, or that your media files are more difficult to find than when you had only a few dozen thumbnails to contend with. After each image file is imported, the catalog automatically begins tracking that image's filename, location, **file date**, and file type, along with the Exchangeable Image File (*EXIF*) data that your camera/scanner stored in the file when the image was shot or scanned. If you import an audio or movie file, its filename, location, file date, and file type are also tracked. So without doing any work other than importing a media file, you can locate an item immediately if you know any of the file data.

The true organizational magic begins when you associate any number of tags to the items in the catalog. The tags enable you to keep track of what's important about a particular item—for instance, whether your subjects are posed or shot candidly in a particular photo, indoors or outdoors. You can add notes and captions to your catalog items, making it even easier to locate a particular media file when needed. See **58** **Add a Text Caption**, **61** **Attach a Note to an Item**, and **64** **Attach a Tag to an Item** for more information.

If you make any changes to a digital image file *and* you start the editing process through Photoshop Album, then the program will keep track of *when* these changes occurred. This is true whether you use the Photoshop Album editor to make the changes or some other *graphics editor* such as Photoshop Elements. This makes it possible for you to search for "whatever that family photo was that I edited in Photoshop Elements last month." If you include a photo in a greeting card or a *slideshow*, Photoshop Album will keep track of that fact as well, allowing you to search for just the images or other media files used in *creations*. (See **81** **Find Items You've Used in Creations**.)

Because Photoshop Album keeps track of so much, finding the file you want is simple. For example, by adding a tag to the **Find** bar, you can display only the photos, audio, and movie files with that tag. You can

TIP

Because your catalog contains a list of all your media files, *tags*, notes, *captions*, and other organizational information such as offline disc location, you wouldn't want to ever lose it. So protect your catalog by backing it up from time to time. This process also backs up your actual media files. See **45** **Back Up the Photoshop Album Catalog**.

KEY TERM

EXIF (Exchangeable Image File)—Data that tells a printer or monitor how to properly print or display an image. This data typically includes the *resolution*, color gamut (range), image size, compression, shutter speed, f-stop, and other camera settings.

NOTE

EXIF data such as image resolution will not be saved in a scanned image if you use Microsoft Office Document Imaging to perform the scan. It's best to use the software that came with the scanner. In addition, some scanners may not be capable of recording EXIF data—see the scanner documentation.

add multiple tags to the **Find** bar and see just the items with all the tags, just one of them, or none of them, depending on other options you choose. See **74** **Find Items with the Same Tag**.

Find Bar **Timeline**

Tags Pane

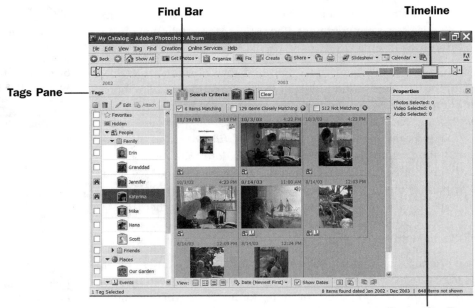

Properties Pane

After tagging images and other files, you can easily locate media files with similar characteristics, such as images that include your wife and daughter.

Here are some of the other types of searches made possible by Photoshop Album:

- You can quickly display only audio files or home movies. See **75** **Find Items of the Same File Type**.

- You can have the catalog show only those photos, audio, or movie files that were shot or created on a particular day, or during a particular *range* of time—say, the last weekend of October. See **78** **Find Items with the Same Date** and **79** **Find Items Within a Date Range**.

- If you wrote a caption or description (note) about an image, and you remember just a single key word or phrase from that description (for instance, *Walt Disney World* or *wedding reception*), you can

retrieve the photo based on that text alone. See **77** **Find Items with the Same Caption or Note**.

- If you used Photoshop Album to email a photo to someone in particular, you can retrieve that photo using the email address as criteria. Just select **Find, By History, Items Emailed to**.

- If you received a photo through an online sharing service supported by Photoshop Album (such as Shutterfly), you can retrieve that photo using the name of the sender as criteria. Just select **Find, By History, Items Received from**. To view items you uploaded for sharing, select **Find, By History, Items Shared Online**. If you ordered prints from Shutterfly, select **Find, By History, Items Ordered Online** to view them.

- If you used Photoshop Album to print a photo and you remember the date on which you printed it, you can have Photoshop Album retrieve the photo for you. Just select **Find, By History, Items Printed on**.

The **By History** submenu allows you to search for items in other ways as well. For example, you can quickly display items imported in the same batch or exported to some other application.

- If you can find a photo in the catalog that looks pretty similar to the image you're actually looking for, but you know it's not the one you want, you can have Photoshop Album retrieve all photos in the catalog that have a similar disposition of colors. Perhaps, for instance, you've found a picture of your spouse wearing the same sweater as she is wearing in the photo you want. There's a chance that Photoshop Album could retrieve similarly lit photos where your spouse is wearing that sweater. See **80** **Find Images with Similar Color**.

Understand the Find Bar

Just above the photo well in the Photoshop Album window is a long bar marked with a binoculars icon. It's called the **Find** bar. You don't have to worry about displaying the **Find** bar, even if you're not currently searching for particular items, because it's always there. Whenever you have a search in progress, however, the **Find** bar shows you the different criteria—the tags, notes, or captions you're searching for—that each item in the well currently matches. If you're searching for items with

NOTE

You cannot mix and match different types of searches. For example, if the **Find** bar contains one or more tags, and you want to search for items you emailed to someone or that you included in a slideshow, Photoshop Album clears the current search by tags and processes your search by email or slideshow request as a new search.

NOTE

Whenever the **Find** bar displays some tag icons or other search criteria, some type of filtering is going on. For you, this means that not all your media files are currently visible—instead, only those items matching the criteria shown on the **Find** bar are currently displayed.

certain tags, those tags appear in the **Find** bar. If you're looking for the photos you used in a particular slideshow, the **Find** bar reads **Used in** along with the name of that slideshow. If you're looking for only those items to which you've attached audio captions (see **59** **Record an Audio Caption** for how to accomplish that goal), the **Find** bar reads **Items with Audio Captions**.

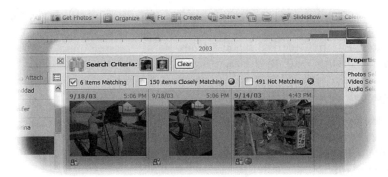

*The **Find** bar shows you the criteria for the currently displayed items.*

One exception to this functionality deals with when you're searching for photos or other media files created during a particular period of time. In that case, the **Timeline** at the top of the window narrows itself to represent the range of time you've chosen, and the **Find** bar displays no search criteria at all. See **79** **Find Items Within a Date Range** to learn how such a search works.

TIP

You can review the results of a previous search by clicking the **Back** button on the **Shortcuts** bar. You can return to the current search by clicking the **Forward** button.

You can add criteria to the **Find** bar to narrow a search. For example, you can start with one tag such as **Birthday** and then add another tag such as **Ramona** to display only Ramona's birthday photos, audio, and movie files. If you mean to start a new search, and there's already a search in progress, you'll have to clear the **Find** bar of its current criteria. To do that, just click the **Clear** button on the **Find** bar. Clicking **Clear** also resets the photo well so that all items in the catalog are displayed.

When there's an active search in progress, the **Find** bar displays the number of matches and non-matches. After you perform a search, the matching items are displayed in the photo well, and a check mark appears next to the **Items Matching** box on the **Find** bar. To also show those items that *do not match* the criteria in the **Find** bar, select the **Not Matching** check box. With both boxes selected, the photo well will show

all the items in the catalog, but will adorn the non-matches with the red **X** icon shown on the **Find** bar. Matches won't have this icon.

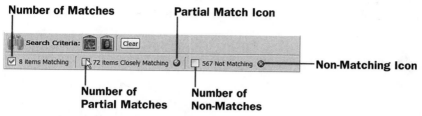

*You can control the display of matches, non-matches, and partial matches using the **Find** bar.*

To have the photo well show only items that do *not* match the search criteria, you must *uncheck* the **Items Matching** check box and check only the **Not Matching** check box. After you do this, all the items in the photo well feature the red **X** icon. You could use the **Items Not Matching** option, for example, to help you search for photos that *do not include* your son.

In a situation where there's more than one tag in the **Find** bar, only items with *all* the selected tags attached are displayed. You can, if you want, display items that have at least one of the tags but not all of them by selecting only the **Items Closely Matching** check box. Items that meet this special condition are adorned with a blue check mark icon, like the one shown in the example. You can have the photo well show items that are both partial *and* complete matches by checking both the **Items Matching** and **Items Closely Matching** check boxes in the **Find** bar and by leaving the **Not Matching** check box unchecked.

 TIP

If you always want to display both matching and closely matching items when you conduct a new search, choose **Edit, Preferences** and select the **General** tab. Select the **Show Closely Matching Sets for Searches** option and click **OK**.

74 Find Items with the Same Tag

The payoff of tags is that you can find specific items quickly and easily. There are several different methods you can use to tell Photoshop Album which tags are attached to the items you're looking for. After Photoshop Album knows the tags you're interested in, it searches the catalog for items that have those tags attached and displays them in the photo well.

When selecting a tag to use in searching for a particular set of media files, keep in mind that if you select a category or subcategory tag, you automatically include all the tags within that category or subcategory as

Before You Begin

✔ **64** Attach a Tag to an Item

✔ **73** About Finding Items

NOTE

You'll have to display the **Tags** pane to complete this task. If it's not currently showing, select **View**, **Tags** from the menu bar to display it.

well. Although these extra tags won't appear on the **Find** bar, they are included by implication. For example, if you place the **Events** tag on the **Find** bar, then items tagged with the **Events** category tag *plus* any items tagged with a specific **Events** tag such as **Family Reunion** or **Fourth of July** will also appear in the photo well.

① Drag the Tag to the Find Bar

One method for displaying specific items is to drag the applicable tags to the **Find** bar. In the **Tags** pane, open the applicable category and subcategory to locate the tag associated with the items you wish to locate. Click the right-arrow beside a category/subcategory name to open it. For example, if you want to search for photos or movies containing a certain person, or audio files of a particular person's voice, click the right arrow in front of the **People** category to display its tags.

Point to the tag you want. Your mouse pointer changes to a hand. Click and drag the chosen tag to the **Find** bar (which lights up a bit), and then release the mouse button to drop the tag. In a moment, the **Find** bar displays the tag next to the words **Search Criteria**. To narrow the display, drag and drop additional tags on the **Find** bar. Only items that match *all the tags* are shown in the photo well.

NOTE

You can display closely matching or non-matching items by choosing those options on the **Find** bar. For example, to display items that use any one of the tags but not all of them, select the **Items Closely Matching** check box in the **Find** bar.

② Or Click the Tag to Search For

Another method for displaying tagged items is to select particular tags from the list in the **Tags** pane. In the **Tags** pane, click the white box to the left of the tag you want your items to match, *or* double-click the tag itself. A binoculars icon appears in the box, and the tag appears in the **Find** bar. At that point, only items with the selected tag appear in the photo well. To search for items that have multiple tags, simply click the box in front of additional tags to add those tags to the search criteria.

NOTE

Selecting a tag from the menu bar resets the search in progress, so you can't combine tags into a single search using the method discussed in step 3.

③ Or Select the Tag from the Menu Bar

There's a final method you can use to display a particular group of tagged items. In the menu bar, choose **Find**, **Items Tagged with**, then select through the menus of categories and subcategories until you locate and select your tag. The tag you selected appears with a binoculars icon in the **Tags** pane and as an icon on the **Find** bar. Only items with that tag appear in the photo well.

TIP

To quickly display items that do not yet have any tags associated with them, select **Find**, **Untagged Items**.

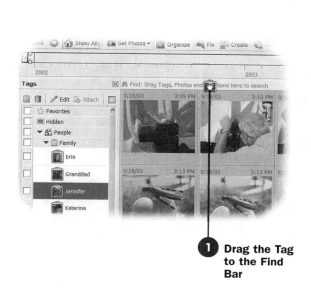

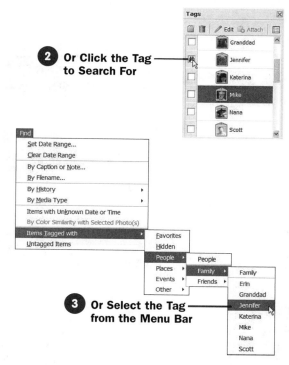

2 Or Click the Tag to Search For

1 Drag the Tag to the Find Bar

3 Or Select the Tag from the Menu Bar

75 Find Items of the Same File Type

The three types of files you can import into the photo well are digital or scanned photos (of course), video files, and audio files. There are several file formats for each type, which Windows distinguishes using a file-name *extension* such as **.JPG** or **.JPEG** for images using the Joint Photographic Experts Group format or **.WAV** for audio files using WAVE format.

Photoshop Album is not concerned with file *formats*, only the *types* of media the files contain. In this task, you learn how to display items in the *catalog* based on their media type—audio files for example. If you want to locate items by file type (such as JPG, GIF, or TIFF), search for that part of their filename (for example, search for items with **JPG** or **JPEG** as part of their filename as explained in **76** **Find Items with Similar Filenames**).

Before You Begin

✔ **62** About Organizing Items

✔ **73** About Finding Items

See Also

→ **59** Record an Audio Caption

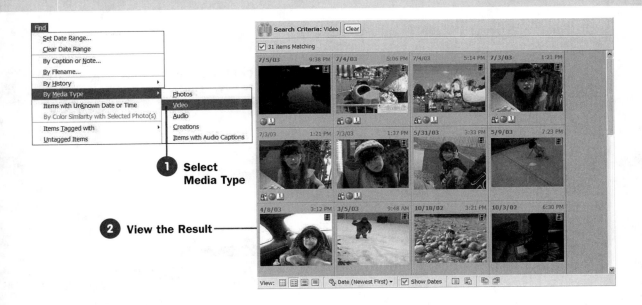

Select Media Type

View the Result

<div>

NOTE

By default, the photo well does not show *thumbnails* representing audio tracks, although audio tracks can be imported. To show audio tracks as blue speaker icons along with all your other image and movie thumbnails, select **View, Media Types**; from the dialog box that opens, check the **Audio** check box and click **OK**.

</div>

Photoshop Album also includes in its catalog items you create using the program, such as *slideshows* and greeting cards. When you need to, you can have the photo well show only your *creations* (slideshows, photo albums, eCards, and so on). Of course, the entire creation won't be displayed in the photo well (because most creations contain multiple pages), but the first page of each creation appears as the thumbnail. You can also search for items (regardless of media type) that have an *audio caption* attached to them. You might do this, for example, to review the images you've annotated with audio.

① Select Media Type

From the menu bar, choose **Find, By Media Type**. From the submenu that appears, select the type of item you want to display: **Photos, Video, Audio,** or **Creations** (items you've created in Photoshop Album). To have the photo well show items of any media type that have audio captions attached to them, select **Items with Audio Captions**.

If you select **Audio** from the **By Media Type** submenu, and audio files are not currently displayed in the photo well, you'll see a warning box telling you that, for the purposes of this search only, audio files will be displayed. Click **OK** to continue. When you clear the search results, the audio files will no longer be included in the display unless you've changed your viewing options as explained in the margin note.

② View the Result

Here, I selected **Video** from the **By Media Type** submenu. The photo well displays only the video files in my catalog. Notice the small movie icon in the upper-right corner of each thumbnail. Notice also that the **Find** bar displays the words, **Search Criteria: Video**, which let you know that only video files are currently displayed.

To play a particular video, double-click the thumbnail. See **52** **View a Video** for help.

TIP

To redisplay all files, click the **Clear** button on the **Find** bar.

76 Find Items with Similar Filenames

If you know something about the filename of the media file or set of files you're looking for, but you're not quite sure of the actual filename, you might still be able to locate the file. Photoshop Album can run a search for partial matches of any entry of text. If the filename of an item in the *catalog* contains the characters in this text entry (in uppercase or lowercase characters), in the sequence you entered those characters, the photo well will display the *thumbnail* for that image.

For example, if you know that an image has the word *spring* in its name, you can search for the text **spring** and get a list of items that contain that text, such as **Spring 2003-01**, **Jim's springer spaniel**, **Katie's spring recital**, and so on.

① Choose Find, By Filename

Select **Find, By Filename** from the menu bar. The **Find by Filename** dialog box appears.

Before You Begin

✔ **62** About Organizing Items

✔ **73** About Finding Items

NOTE

You can also search for letters in the filename *extension*. For example, to locate all files saved in TIFF format, enter the search text **tif**, which will match images that use either the **.TIFF** or **.TIF** extension.

1 Choose Find, By Filename

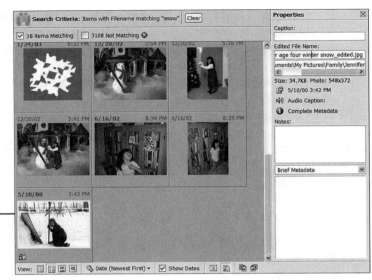

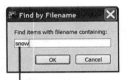

3 View the Result

2 Enter Search Text and Click OK

2 Enter Search Text and Click OK

Type the portion of the filename you know in the **Find items with filename containing** box. For example, type **jan** to search for files such as **January Snow**, **Jan's new car**, and **janyce 02**. The text you enter here is not case sensitive, nor does it have to be a complete word. If you typed **Erin**, for example, files whose names include **Katerina** are considered matches because the word *Katerina* contains the characters *erin*. Click **OK**.

3 View the Result

In a moment, the photo well displays only those items whose filenames include the text you entered *somewhere* in the filename or file extension. Here, I typed the word **snow** in the text box, and Photoshop Album displayed several photos, videos, and audio files whose names contained those letters. I got quite a variety of items as a result of my search, including a scan of a snowflake my daughter made, several photos from a Christmas card with a snowy scene, and an old photo of me building a snow fort. Notice that the **Find** bar displays the search criteria.

✎ NOTE

Do not type wildcard search characters such as a question mark or an asterisk in the **Find items with file-name containing** box. These characters are treated as a literal part of the search text. For example, the search text **ba*** will match only those filenames that include the characters **ba***. Because filenames can't actually include an asterisk or a question mark, such a search will return no matches.

77 Find Items with the Same Caption or Note

Ideally, the best way to ensure that items are easily located by category is to use *tags* and to search for items using those tags. However, tags might not tell the whole story about an image. Every photo in the Photoshop Album *catalog* can be annotated by way of its own note, which is a textual notation of up to 1,023 characters. (See **61** **Attach a Note to an Item** for instructions.) Notes for a photo appear in the **Properties** pane and can consist of any extra description that helps you recall the subject matter. If your catalog contains scans of printed photos bound in albums, for instance, you could use Photoshop Album's notes to store the identity and location of the album to which each scanned photo belongs.

Cataloged media files can also contain *captions*, which can be made to appear under each image or movie in a *slideshow* or other *creation*. If using tags to search for the items you need is not working for some reason, you can have Photoshop Album search for any passage or bit of text you may have used in a caption or note.

1 Choose Find, By Caption or Note

Select **Find, By Caption or Note** from the menu bar. The **Find by Caption or Note** dialog box appears.

2 Enter Text to Search For

Type the known portion of the caption or note you want to search for in the **Find items with caption or note** box. Photoshop Album will search *both* captions and notes for this text.

3 Choose How Matches Are Determined and Click OK

Select the **Match only the beginning of words in Captions or Notes** option to make Photoshop Album search for the text you enter at the *beginning* of words only. For example, the search text **Erin** will not match the word *Katerina*.

To search for matches throughout all characters (and not just those at the beginning of words), select the **Match any part of any word in Captions and Notes** option. With this option selected, the search text **Erin** does match the word *Katerina*. Click **OK** to begin the search process.

Before You Begin

✔ **73** About Finding Items

See Also

→ **58** Add a Text Caption

→ **61** Attach a Note to an Item

✎ NOTE

Photoshop Album searches *both* captions and notes for matches to the text you supply. You cannot instruct the program to search through only one or the other.

✎ NOTE

The search is not case sensitive, so don't worry about that when entering the search text.

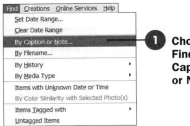

1 Choose Find, By Caption or Note

2 Enter Text to Search For

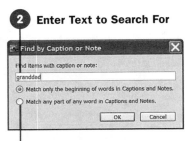

3 Choose How Matches Are Determined and Click OK

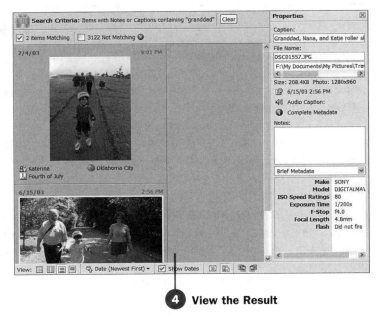

4 View the Result

4 **View the Result**

In a moment, the photo well displays only those items that match the search criteria. I needed to locate an image of my daughter skating at a park one day while we were visiting her granddad. The image had apparently been tagged only with her tag and not Granddad's (as I discovered after a search using his tag didn't produce the results I wanted, and a search using her tag alone resulted in too large a listing to browse through). So I searched the notes and captions for any item that contained the word *granddad* and came up with two matches, including the photo I was looking for.

78 Find Items with the Same Date

The designers of Photoshop Album realized that a day's worth of photographs, movies, and audio files represents a chronicle of an important time in your life. So rather than make the search for media created on the same day into a dull and lifeless process, Photoshop Album offers you a functional **Calendar**. Using the **Calendar**, you can leaf through the important days of your life month by month and have each day's items leap out at you in a dramatic photographic *slideshow*. Specifically, you'll see each image and the first frame of each video for the selected day, displayed in the **Calendar** pane. If audio files are currently being displayed in the photo well, their thumbnails also appear.

Calendar view not only helps you locate the media files you created on a particular day, but to recall the events in your life in the context in which you remember having looked forward to them: a monthly calendar. Summer vacation, family weddings, Christmas...at one time, you planned for these days by looking at a calendar, so why not use a calendar-style control to help you recall and cherish those moments?

① **Switch to Calendar View**

From the menu bar, select **View**, **Calendar**. The **Calendar** appears.

② **Locate Desired Month**

The month that appears first in **Calendar** view is the one during which the currently selected item in the photo well was taken or created. If this isn't the month you're looking for, click the **Previous Month** or **Next Month** button to page to the month you do want to review.

③ **Click Desired Day**

Every day for which the *catalog* contains items is marked with the earliest item created that day. The day you're looking for should be marked with a photo or other thumbnail, although it may not represent the precise item you want. Click that day. The selected day is highlighted in blue.

Before You Begin

✔ **62** About Organizing Items

✔ **73** About Finding Items

See Also

→ **53** Sort Items

→ **60** Change Image Date and Time

→ **79** Find Items Within a Date Range

NOTE

Calendar view is best used when you want to review a group of media created on the same day. To quickly display a larger group of media created within a specific date range, see **79** Find Items Within a Date Range.

TIP

You can select a month quickly by clicking the month name, and then choosing a month from the list that appears. You can select a different year by clicking the year number and choosing a year from the list.

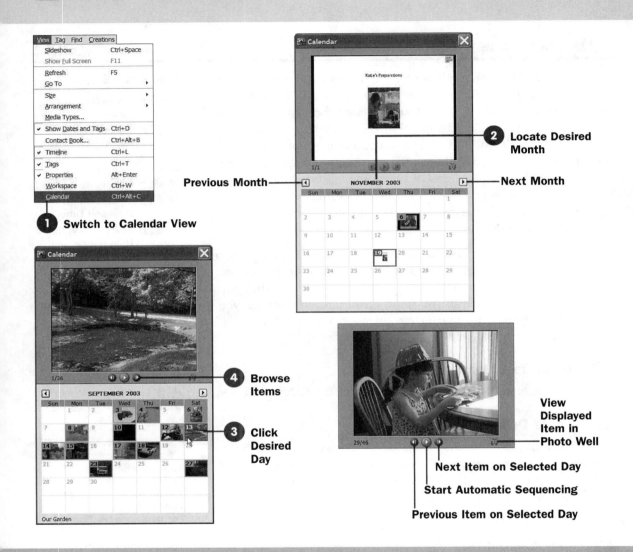

1 Switch to Calendar View

2 Locate Desired Month

Previous Month

Next Month

3 Click Desired Day

4 Browse Items

View Displayed Item in Photo Well

Next Item on Selected Day

Start Automatic Sequencing

Previous Item on Selected Day

The date that **Calendar** uses to display items in groups is the date on which the item was created (its *file date*), not the *import date* or *modified date*. To arrange items by import date, see **53** **Sort Items**. To locate items you modified, search for the text **edit** in the filename, as explained in **76** **Find Items with Similar Filenames**.

4 **Browse Items**

After you select a day, the thumbnail for the first item created that day is displayed in the top **Calendar** pane. For videos, the first frame of the movie appears; for audio files (if they are currently displayed in the photo well which they normally are not), the generic audio icon appears along with the name of the audio file). Under this pane on the left is a pair of numbers: The right number is the total count of items in the catalog created or shot that day, and the left number is the number of the item you're viewing now. At the very bottom of the **Calendar** window on the left are the names of the *tags* associated with the first item for that day.

Below the item in the top **Calendar** pane are controls you can use to browse the photos and other items for that day. Click the **Start Automatic Sequencing** arrow button to display the entire sequence of items, one at a time, in the top pane. Each item is displayed for about a second and a half. If the item is a video, only the first frame is shown; if the item is an audio file, only the audio icon is shown. When all the items for that day have been displayed, the slideshow begins again automatically. Click this same button (now called **Pause Automatic Sequencing**) to temporarily stop this playback. Click the button again to restart the slideshow.

Click the **Previous Item on Selected Day** arrow button to see the next earliest item in the sequence, or to cycle back to the final item if you're looking at the first one. Click the **Next Item on Selected Day** arrow button to see the next item in the sequence or to cycle back to the beginning if you're looking at the final item.

Click the **View displayed item in photo well** icon (the binoculars) to have Photoshop Album highlight the currently displayed item in its present position in the photo well. You might do this if you used the **Calendar** to locate and image you wanted to edit. After the item is selected in the photo well, you're free to make changes to the photo as desired. This action, by the way, does not close the **Calendar** view, so you'll either have to close it manually (if you're done using the **Calendar**), or drag it out of the way so that you can see the photo well.

Click the close box on the **Calendar** view window to return to the main Photoshop Album window.

NOTE

If an item's date was changed to **Unknown** (as explained in **60** **Change Image Date and Time**), it will not appear in the **Calendar**. To display items whose date or time was manually changed to **Unknown**, choose **Find, Items with Unknown Date and Time**.

79 Find Items Within a Date Range

79 Find Items Within a Date Range

Before You Begin

✔ **62** About Organizing Items

✔ **73** About Finding Items

See Also

➜ **53** Sort Items

➜ **60** Change Image Date and Time

➜ **78** Find Items with the Same Date

In **62** **About Organizing Items**, you learned about the **Timeline**, which is a graph that appears above the photo well. On the graph are bars representing how many items in the *catalog* originated in various months. Specifically, this is the number of items whose *file dates* (not *import date* or *modified date*) fall within that month. You can see which month represents the largest bounty of media files by looking for the tallest bar on the **Timeline**. By clicking a bar, you can instantly jump to that month of items in the catalog. Notice that the **Timeline** does not limit the display of items when you click a particular bar; however, the **Timeline** can be used to display only those items that fall within a particular date range if you like.

At either end of the **Timeline** are scroll arrows; use these arrows to scroll through the years. The **Timeline** has "margins," which resemble the margins on a ruler in a word processing program. Initially, these margin markers appear at the ends of the **Timeline**, next to the scroll arrows. By dragging these margin markers inward, you can narrow the valid portion of the **Timeline**, and thus limit the number of items displayed in the photo well (only items whose file dates fall between the dates represented by the margin markers on the **Timeline** are displayed in the photo well).

Despite appearances, the margins on the **Timeline** are not precise. You can set them to the beginning or the end of a month, but no place in between. To display items that fall on precise days within a month or months, you use a dialog box that restricts the photo well to showing items created between any two specific days. This method is explained in this task.

💡 TIP

You can narrow an existing search to display only items that fall between particular dates. Suppose that you've used the **Find** bar to display a set of items that match two or three *tags*. You can use the margins in the **Timeline** or the **Set Date Range** dialog box to further limit the results shown in the photo well to only those items that match the tags *and* that were created within a specific date range.

1 **Choose Find, Set Date Range**

From the menu bar, select **Find, Set Date Range**. The **Set Date Range** dialog box opens.

2 **Set Start Date**

Set the **Start Date** by typing the **Year** and selecting the **Month** and **Day** from the drop-down lists.

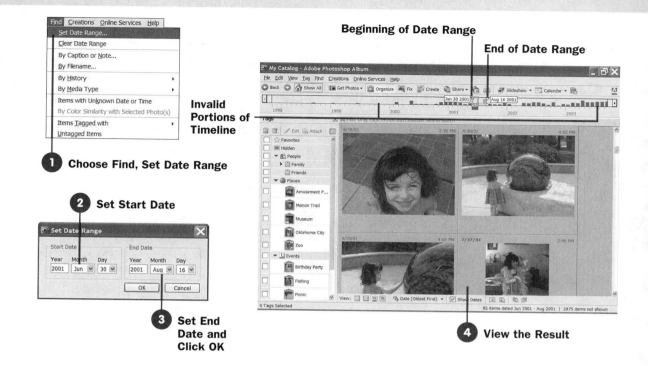

Beginning of Date Range

End of Date Range

Invalid Portions of Timeline

1 Choose Find, Set Date Range

2 Set Start Date

3 Set End Date and Click OK

4 View the Result

3 **Set End Date and Click OK**

Set the **End Date** by typing the **Year** and selecting the **Month** and **Day** from the drop-down lists. Click **OK** to display only items that have file dates between and including these two dates.

4 **View the Result**

In a moment, the photo well displays only items created during the range you selected. The margin markers on the **Timeline** are also adjusted. ToolTips appear next to the margin markers, displaying the start and end dates you selected. Notice also that the invalid part of the **Timeline** appears grayed out and that the valid area is in full color.

NOTE

To reset the **Timeline** so that all items in the catalog are displayed, select **Find, Clear Date Range**.

80 Find Images with Similar Color

Before You Begin

✔ **73** About Finding Items

When you take more than one photo of an event or a group of people, at or about the same time, the content of those images is generally very similar. Photoshop Album can't see the content of an image; it can't look at a photograph, determine the lines and contours of what's depicted in it, and draw any conclusions about what's there. Photoshop Album can, however, detect similarities in color (including brightness and intensity), and present you with a series of images that may contain similar content.

Suppose that you took several photos of your kids standing in front of the Eiffel Tower. The sky, background, and your children's hair, skin, clothing and so on would all look the same in every shot. Even if the photos were taken each year when you visit Paris, chances are they would still contain a similar range of colors. By selecting one of those images and then asking Photoshop Album to locate others of similar color, Photoshop Album can quickly compile a collection of Paris memories.

> ### NOTE
>
> You can select only photos, not *creations* made with Photoshop Album. And you obviously can't select audio files or videos, despite the fact that a "photo" is used as its thumbnail.

It's entirely possible that Photoshop Album will find other photos with surprisingly similar colors without those photos having any real *contextual* relationship to one another. Your search could result in images of your kids and the Eiffel Tower along with one or two shots of your golden retriever walking in front of a cast iron gate. Don't let this deter you from trying to search for an image based on color. The power of this type of search is to enable you to locate photos with similar content, even if those images were taken years apart, are stored in different places, and use dissimilar filenames, *captions*, notes, and *tags*.

❶ Select Sample Images

In the photo well, select the images whose color content is similar to that of the other images you're looking for. You can select multiple sample images, which might produce a more accurate color sample to search for and increase the odds that you'll locate other similar, related images.

> ### TIP
>
> To locate a few related images so that you can search for others that use similar colors, use the **Find** bar, as explained in **73** About Finding Items.

❷ Choose Find, By Color Similarity

From the menu bar, select **Find, By Color Similarity with Selected Photo(s)**. In a moment, the photo well displays images whose color and brightness resemble that of the original image or images. The **Find** bar displays *thumbnails* of the original photos, and those thumbnails also appear at the top of the photo well.

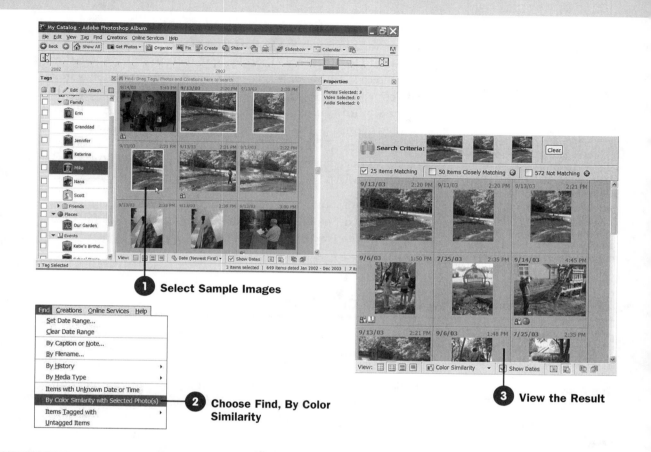

1 Select Sample Images

2 Choose Find, By Color Similarity

3 View the Result

3 View the Result

The photo well arranges items in descending order of assessed similarity. This means that the images with the greatest similarity appear at the top of the photo well, with images of lesser degrees of similarity appearing lower in the list. A number of other images in the *catalog* may have moderate or passing similarity. To see these additional images, select the **Items Closely Matching** check box on the **Find** bar. These moderate matches are marked with a blue check mark dot in the upper-right corner of their thumbnails.

TIP

When you use more than one sample photo in a search for images with similar colors, try to limit yourself to *very similar* images for best results. If for example, one sample is a brightly lit portrait and the other is a very dimly lit portrait of the same person, Photoshop Album may return images whose colors are all over the map, including medium-hued images and photos that aren't even portraits and do not include your subject.

The **Photo Well Arrangement** button on the **Options** bar (which you learned to use in **53** **Sort Items**) will display the **Color Similarity** label when you sort by similar colors (most of the time, this choice is unavailable—it's grayed out). You might notice that you can't select the other sort options while you're viewing your **Color Similarity** search results; what this means is that you won't be able to arrange the results of your color search in date order, for example. You can, however, use the **Timeline** to limit the file dates of the displayed items. See **79** **Find Items Within a Date Range**.

Remember that after a search such as this, only matching items are displayed. To redisplay all items in the catalog, click the **Clear** button on the **Find** bar.

81 Find Items You've Used in Creations

Before You Begin

✔ **73** About Finding Items

See Also

→ **75** Find Items of the Same File Type

→ **96** About Creations

TIP

If you want to display a listing of all your creations in the photo well, see **75** **Find Items of the Same File Type**.

NOTE

If you want to find items used in a Web Photo Gallery or an Atmosphere 3D Gallery, select that command from the **By History** menu instead.

Whenever you use a digital photo in a *slideshow*, greeting card, calendar, or other *creation*, Photoshop Album remembers which photos and other items you used. However, Photoshop Album doesn't display that information in the photo well; instead, it simply displays a thumbnail of the first item you used in the creation. If you want to recall which items you used in making a particular creation (so that you can use them in a different, but similar creation, for example), you can have Photoshop Album display those items for you.

1 **Choose Find, By History, Items Used in Creations**

From the menu bar, select **Find, By History, Items Used in Creations**. The **Select one or more creations** dialog box appears.

2 **Choose Creations and Click OK**

In the **Select one or more creations** dialog box, select the creation (album, slideshow, greeting card, and so on) for which you want to view items. You can choose more than one creation, or select all the creations in this list. Click **OK**.

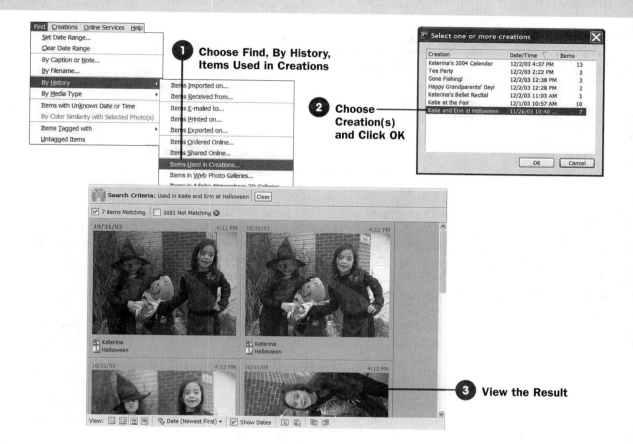

1 Choose Find, By History, Items Used in Creations

2 Choose Creation(s) and Click OK

3 View the Result

3 View the Result

In a moment, the items you used in the selected creations appear in the photo well, arranged in the currently chosen sort order; *items are not grouped by creation.*

You can easily modify these instructions to pull up a list of items that you've *never* used in a creation. You might do this, for example, if you were creating a new calendar for each set of grandparents and wanted to make sure that you didn't use any photos you'd used in previous creations (gifts created for them). From the list in the **Select one or more creations** dialog box, choose all the creations that appear. After the results appear in the photo well, select only the **Not Matching** check box on the **Find** bar.

82 **Hide Items You Don't Generally Use**

Before You Begin

✔ **62** About Organizing Items

✔ **64** Attach a Tag to an Item

✔ **73** About Finding Items

NOTE

Audio files are not normally displayed in the photo well, so you won't need to perform this task to hide them. See **75** Find Items of the Same File Type.

Here's something you may be wondering: Why go through all the trouble of adding items to a *catalog*, along with other items that may be used later in albums or *slideshows*, if you're only going to *hide them*? Well, not every digital image or movie you may ever want to keep track of or use in a presentation is so important that you need to see it and thumb through it every day. Removing such items from the catalog keeps the catalog leaner and meaner, easier to load and to scroll through.

For example, take a shot of a closed stage curtain. It's not a terribly important image. If you lost it, you wouldn't shed any tears. But you might want to use a closed stage curtain photo sometime as an opening shot in a slideshow, so it's certainly worth keeping the catalog. Suppose that you have some not-so-great photos of a relative in which the person is blinking or frowning. You probably don't want to forget that you have the photo, but yet it's unlikely you'll use it for anything. Ditto for "the world's most boring videos." Bottom line: You don't need such items cluttering up the photo well, but you do want to keep them in the catalog.

You can "hide" a less-important item by giving it the **Hidden** *tag*. Photoshop Album treats this tag differently than the others. After assigning the **Hidden** tag to an image or other item, that item is no longer displayed in the photo well. However, the item still belongs to the catalog, and you can see it when you need to.

1 Apply the Hidden Tag

TIP

To quickly display related items so that you can apply the **Hidden** tag to them, use the **Find** bar. See **73** About Finding Items for help.

In the photo well, select the items you want to hide from general view. Drag the **Hidden** tag from the **Tags** pane to the selected items in the photo well or click the white box next to the entry for the **Hidden** tag in the **Tags** pane to assign the tag to the selected items.

2 View the Hidden Icon on Selected Images

NOTE

Simply scrolling through the photo well does not remove the hidden items from view.

A closed-eye icon appears on the items you just tagged, and they are still visible, as you can see from the example. These newly tagged items won't actually become hidden until after the next change you make to the contents of the photo well. For example, if you re-sort the photo well or import new items, the hidden items are removed from display.

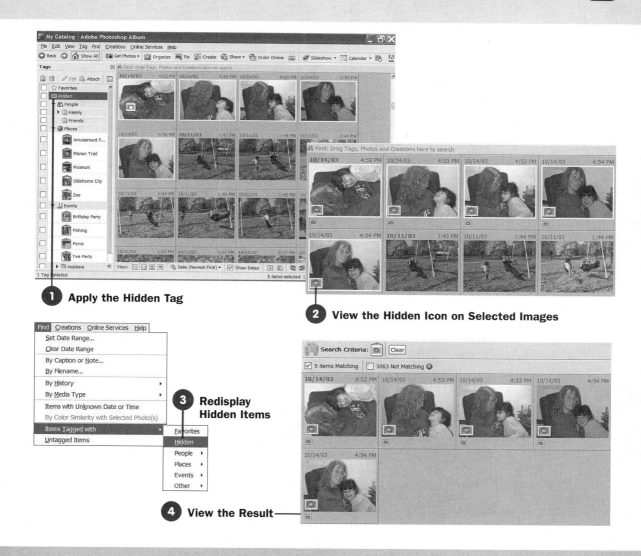

① **Apply the Hidden Tag**

② **View the Hidden Icon on Selected Images**

③ **Redisplay Hidden Items**

④ **View the Result**

③ Redisplay Hidden Items

To see all the items you normally keep hidden in the photo well, select **Find, Items Tagged with, Hidden**.

④ View the Result

Only items marked with the **Hidden** tag are displayed in the photo well. Each item appears with the closed-eye icon, and the **Find** bar indicates that only items tagged with the **Hidden** tag are currently being viewed. To redisplay all items in the catalog, click the **Clear** button.

10

Fixing Images

IN THIS CHAPTER:

Despite sharing a prominent brand name with the premier application of its genre, Photoshop Album is not a full-featured *graphics editor*. It does not do "touch-up" repairs, specifically because Photoshop Album cannot make changes to a *part* of an image. However, Photoshop Album does give you some convenient resources with which you can make some fast alterations to the appearance of an entire image, such as tuning its brightness and compensating for over-*saturation*. Having these features present saves you from having to launch a major graphics editor such as Photoshop or Photoshop Elements, although Photoshop Album does give you a way to launch such an application when the editing job you need to perform is beyond Photoshop Album's purview. (See **95** **Fix a Photo Using Another Program**.)

83 About Color Management

🔍 KEY TERMS

Gamut—A complete palette comprised of all the individual colors that can be reproduced by a device. Your monitor and your printer each have separate gamuts, and sometimes, colors within them may match closely but not precisely.

Color management—The process of coordinating the color gamut of your monitor with that of your scanner and printer so that the same colors are represented throughout.

What you see onscreen when you view an image is often very different from what you get when you print an image on paper. Not only do your monitor, printer, and even your scanner use different methods to render color images, but each device works with its own separate range of possible colors (also called a *gamut*). What this means is that, when representing an image onscreen, your monitor may display a grayish red for an area of an image, which is not reproducible by your printer as *an exact match*. The printer, in such a case, simply substitutes a close match to the grayish red from similar colors in its gamut. So when printed, you get an image that's close to what it looked like onscreen, but not exactly. The best way you can deal with this messy situation is to create an environment that simulates onscreen (as nearly as possible) what an image will look like when it's finally printed. To do that, you use *color management*.

Why Manage Colors?

One of the tasks of color management is to match the gamut of colors your monitor uses with the gamut of colors your printer is capable of reproducing, so that, in the best of all worlds, what you see onscreen as a "pale shade of greenish-blue" approximates that shade when printed. Perhaps you won't remember the exact shade of pink used to paint the side of a roller coaster your kid took a ride on at an amusement park two years ago, so if your printer gets that shade a bit wrong, it won't bother you. But you do know the shade of pink in your kid's cheeks when he's singing with delight, and if your monitor or printer gets that shade wrong, you know the entire picture is wrong.

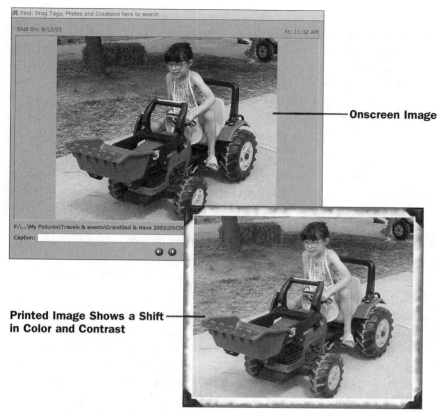

Onscreen Image

Printed Image Shows a Shift in Color and Contrast

When what you see onscreen is not what you get when an image is printed, you need color management.

Microsoft Windows has the unenviable task of translating colors from one device to another. For Windows to have a clue how to go about this task, it requires specific ICM (Image Color Management) profiles for the devices involved—commonly called *ICC color profiles*. All devices that use color should have one of these profiles installed (your monitor, printer, and scanner). Typically, the profile is located on the manufacturer's disc, and you install it at the time you install the device driver and other software. In the absence of an ICC color profile for a device (if you haven't installed one for your printer, for example, or you simply couldn't find one on a disc or at the manufacturer's Web site), Windows uses its own color gamut instead, and relies on your video card and your program (in this case, Photoshop Album) to decide what to do with Windows's choices.

NOTE

The way a monitor composes color and the way a printer composes color are entirely different. This makes translating colors between devices an extremely difficult—and imperfect—process. Imagine any color in your mind. If you "asked" your monitor to make that color "greener," it would become brighter. If you asked your printer to make it "greener," it would become *darker*. That's because your monitor uses light to represent colors, and your printer uses ink.

KEY TERM

ICC color profiles—Also known as ICM profiles, these files help Windows translate colors between two devices, such as the monitor and printer, so that they match up as much as possible.

NOTE

Adobe Gamma creates an ICC color profile of its own, using information provided by the video card through Windows. The resulting profile is what Photoshop Album uses to represent colors onscreen. You'll learn how to make adjustments to the choices Adobe Gamma makes in **85** **Ensure That What You See Is What You Get.**

If you want the **Adobe Gamma** profile to be used by other programs, make that selection from the **Color Management** tab of your video driver: double-click the **Display** icon in the **Control Panel**, click the **Advanced** button on the **Settings** tab, click the **Color Management** tab, and select the **Adobe Gamma** profile.

NOTE

In optics, white is comprised of red, green, and blue; in printing, white is produced by neither red, green, nor blue but by the shade of paper you're using.

NOTE

As explained in **55** **About the Properties Pane,** you can view the EXIF data for an image, along with other *metadata* such as the *modified date*, by displaying the **Complete Metadata** dialog box.

When your monitor has an ICC color profile installed, Windows adjusts its own primary colors toward how the profile says your monitor produces those colors. You'll see those adjustments in Photoshop Album, Photoshop Elements, Photoshop, Paint Shop Pro, every other program in Windows, and Windows itself. When you have not yet installed a color profile for your monitor, the video card takes over the job of trying to represent colors on the screen with accuracy. Photoshop Album takes this one step further by making minor adjustments to these colors with some help from a program called Adobe Gamma.

Digital cameras do not have color profiles associated with them. Instead, each of the image files produced by a modern digital camera includes information about how the camera perceived its color gamut *at the time it took the picture.* This is why proper photographic practices, including *white balancing,* are so important: When white looks the way it should *for your camera,* a calibrated monitor will precisely re-create that shade of white so that you won't make color adjustments to photos that may not really need them.

Photoshop Album can interpret how your digital camera perceives color by making use of information the camera attaches to its image files. This information is stored under a standard adopted by all major camera manufacturers (and some scanner manufacturers) called Exchangeable Image File Format (EXIF). *EXIF* data helps the program determine where the camera's interpretation of "pure" red, green, and blue (the optical primary colors) are located on a theoretical chart of all visible colors. Photoshop Album can compare these coordinates to where its own "pure" primary colors are located on the same theoretical chart. After the program knows how to adjust these three pure colors, it can mathematically determine how to adjust *all the other colors* so that it displays onscreen what your camera saw when the image was recorded. The EXIF data is in turn used by most photo printers when an image is printed, so again, you get a pretty good printout of what the camera saw when the photo was taken.

Problems with PIM Printers and Photoshop Album

Some printers do not interpret EXIF data. Instead, they rely on Windows to provide them with a standard set of colors to use when printing an image that has EXIF data. This set of colors, by the way, has been

re-interpreted at least once by the imaging program (such as Photoshop Album) that imported the image file from the camera. This system is pretty good, but Epson has decided to do it one better.

Photoshop Album displays the EXIF data attached to one of the images in its catalog.

Recently, Epson has engineered a system for its inkjet and photo printers so that they are given the EXIF data for an image directly, by way of a bypass driver. Epson calls its system Print Image Management (PIM), and it enables its printers to see with a high degree of accuracy (albeit through two translators) what a PIM-enabled digital camera saw when it recorded an image. This way, "black" in the digital image (which optically is comprised of no red, green, or blue whatsoever) translates into "black" on the printed page (which, for pigment, generally involves a mixture of black ink with equal parts of cyan, magenta, and yellow inks). Essentially, PIM—and its successor, PIM II—are systems for ensuring that both the Epson printer and the PIM-enabled digital camera interpret color and present EXIF data in the same way.

When PIM is involved, the color management scheme changes. Software called the "PIM plug-in" *bypasses* Windows color management *and the ICC color profile*, presenting EXIF data from an image directly to Adobe Photoshop or Photoshop Elements. Photoshop Album interprets EXIF data in its own way, and does not use the PIM or PIM II plug-in. As a result, according to Adobe, images with EXIF data (images taken by a

NOTE

The status of the PIM coalition changes often; as a result, other printer brands (such as Canon) may be PIM enabled, and result in a situation similar to the one described here. Consult your printer's documentation to learn whether it is PIM-enabled, then decide on a plan of action based on whether or not you use a PIM-enabled graphics editor to modify images stored in the Photoshop Album catalog.

digital camera and saved in a format such as JPG that retains the EXIF data) that are edited in Photoshop or Photoshop Elements may appear strangely tinted after being imported into Photoshop Album, and the strange tint may carry over if Photoshop Album is used to print the image or to make *creations* (such as greeting cards) that use the image.

Adobe recognizes this problem and offers two possible solutions: One is a second add-on module to Photoshop or Photoshop Elements that completely strips the EXIF data from the image file before it's resaved—in effect, nullifying the benefit of having a PIM-enabled digital camera and printer. This solution may introduce another problem, in that you might make adjustments to an image displayed correctly in Photoshop or Photoshop Elements using PIM, save the changes, and then because the EXIF data is removed and PIM is nullified, experience a strange color shift when you open the image again or print it.

Adobe's second solution is for you to use its Adobe Gamma utility (explained in detail in **85** **Ensure That What You See Is What You Get**) to recalibrate your monitor to use a standardized color profile called sRGB, which I'll cover in detail later. Indeed, this solution might clear up the strange tinting problem with regard to the Photoshop/Photoshop Elements-edited images that appear in Photoshop Album. However, *if* it solves that problem, most likely *everything else on your monitor will appear strangely tinted*, including your Windows desktop, your word processor, your email program, and your Web browser.

So what's the final solution if you have a PIM-enabled printer and you want to use it to print digital camera images you need to edit? Well, you might decide to use only the Photoshop Album **Fix Photo** feature (explained in **86** **About Fix Photo**) to correct an EXIF image rather than relying on Photoshop Elements or Photoshop. Or you might decide to edit the images in Photoshop/Photoshop Elements anyway, live with the tinting effect when they are viewed in the catalog, and print them using only the program that changed them (Photoshop Elements or Photoshop). If you have an EXIF image edited by Photoshop Elements or Photoshop that you want to use in a Photoshop Album creation, you might want to create a copy that you "fix" using the **Fix Photo** feature so that when the image is printed by Photoshop Album, it looks right. In such a case, the ICC color profiles that were bypassed by the PIM plug-in come back into play. Note that you still need a perfectly calibrated

NOTE

The situation described here involves any EXIF image edited by any PIM-enabled graphics editor, such as Photoshop, Photoshop Elements, or Paint Shop Pro, and subsequently printed from Photoshop Album to a PIM-enabled printer.

NOTE

Because Photoshop Album does not support PIM, you can also run into a similar problem (of images not appearing in the catalog as they will look when printed) if you import a digital camera's images directly from its memory card through a PIM-enabled printer. (In other words, the memory card is inserted in the printer and images are imported to the computer through the printer.) To bypass this problem, import digital camera images using a card reader and not through a PIM printer.

monitor to fix the photo so that it will look okay when printed (as you learn to do in **85** **Ensure That What You See Is What You Get**).

84 About Adobe Gamma

Keeping your monitor calibrated is the best way for you to reduce the likelihood that what you see when viewing an image inside Photoshop Album becomes something other than what you print. You should calibrate your monitor (as explained in **85** **Ensure That What You See Is What You Get**) at least twice per year, plus every time you replace your video card or update your video drivers. To calibrate your monitor properly, you must gauge which colors look right—and that is determined by *your own eyes* as you step through the process. Monitor calibration affects not just Photoshop Album but everything you see and use in Windows, and especially your imaging applications.

Adobe has given you a tool for calibrating your monitor called Adobe Gamma. You'll learn how to use Adobe Gamma in **85** **Ensure That What You See Is What You Get**. Before you jump to that task, however, there are some technical terms you must understand to complete the steps, and the first one is called *monitor chromaticity*. Now don't stop breathing—although it sounds complicated, monitor chromaticity is fairly easy to understand.

Monitor Chromaticity and You

The easiest way for you to use Adobe Gamma to calibrate your monitor so that colors look "right" is for the tool to have at least some starting point with regard to where "right" *should be*. That starting point is your monitor's chromaticity, or its definition of pure red, pure green, and pure blue. Windows uses these definitions to adjust its display. Your monitor's *ICC color profile* contains its chromaticity settings. If plotted on a chart, the chromaticity settings (the settings for pure red, green, and blue) define the three points of a triangle, which if placed on a chart depicting all colors in the visible spectrum, defines your monitor's *gamut*, or specific range of displayable colors.

Before You Begin

✔ **83** About Color Management

See Also

→ **85** Ensure That What You See Is What You Get

NOTE

Proper calibration of color on your screen has a direct effect on how sharp your text looks in your word processor. How do colors affect contrast? Windows uses an anti-aliasing technique to make black letters look smooth on a white background. It's an optical illusion that involves "lacing" the stair-stepped notches in curves and diagonal lines with blue and orange dots (optical opposites) so that your mind actually blanks the notches out. If your monitor isn't calibrated, these colored dots become more evident, enhancing an illusion of *low* contrast rather than one of *high* contrast.

KEY TERM

Monitor chromaticity—A particular monitor's definition of pure red, green, and blue. A monitor's chromaticity is stored in the monitor's ICC color profile.

Visible Spectrum——

Chromaticity Settings for——
Pure Red, Green, and Blue

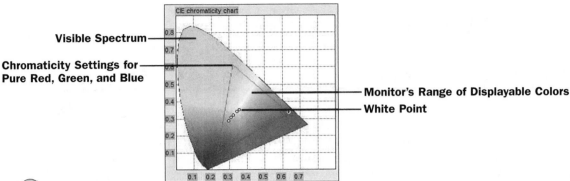

——Monitor's Range of Displayable Colors
——White Point

A monitor's chromaticity chart based on its ICC color profile, as produced by a program called ICC Inspector.

KEY TERM

White point—A representation on a chromaticity chart of the hue produced by a monitor when it is instructed to show pure white. A CRT produces white by aiming its red, green, and blue electron guns at the same point, at full intensity. On an LCD monitor, white is produced by transparency. For accuracy, the white point is often expressed in terms of the *temperature* of the light—a measure of the actual heat it produces. Adobe Gamma lets you set the basic white point in degrees Kelvin, although you can also express it in coordinates if you have them.

NOTE

Because white is produced on a CRT by red, green, and blue put together, the chromaticity of those three points directly affects the white point. But on an LCD, white is produced by red, green, and blue *taken away*. So the white point there depends only on the wavelength of light produced by the fluorescent source behind the LCD screen.

In addition, a monitor's ICC color profile also contains a value that describes its **white point**. Just like white paint, the definition of "pure white" on your monitor may actually look like anything from a cool white to a warm white—calibrating the monitor helps you adjust this definition so that what you see when the monitor displays "pure white" is a neutral white color and not a blue white or a yellow white. On a chromaticity chart, the white point is always somewhere in the middle of the triangle that defines your monitor's gamut, but not necessarily in the geometric center.

You cannot change the chromaticity of your monitor. It's a reflection of the state of the hardware. But by entering the correct chromaticity settings into Adobe Gamma (either by loading the appropriate ICC color profile, or by making selections manually), you can change what Windows "thinks" the chromaticity should be, which in turn, changes how Windows adjusts its own output colors for your monitor. Windows makes its own reds brighter, for instance, when it ascertains that your monitor's reds are generally dimmer than normal.

You can run into several problems when attempting to enter the correct chromaticity and white point settings in Adobe Gamma. For example, perhaps you can't locate your monitor's ICC color profile, either on a disc or on the Internet. The sad truth is that a lot of manufacturers simply don't provide them. Even if you do have your monitor's ICC color profile installed, as a monitor ages, these settings can be a little off, so there are still adjustments you need to make.

In the absence of an ICC color profile, Windows sets the chromaticity to *something*. This something may or may not result in colors that look right to you. Also, when you install a new video card or update its driver, the video card may reset your monitor's chromaticity to something else. The driver might also install an ICC color profile, even though that ICC color profile might not pertain to—or even work well with—your monitor. So even if you find that an ICC color profile has already been installed, if it's not the specific profile for your monitor (if it's named for your video card and not the monitor), it might not produce the most accurate colors. But in some circumstances—especially if your monitor is more than a few years old—the driver's choice of profiles might be *better* than the monitor's native ICC color profile. In any case, you can use Adobe Gamma to adjust the display to correct any problems with these initial settings.

In Adobe Gamma, the chromaticity setting is called **Phosphors**, but it still represents the x/y coordinates on a color chart pinpointing the purest red, green, and blue your monitor can produce. Your ICC color profile contains the chromaticity settings for your monitor; thankfully, when you install the profile, the coordinates are entered automatically. When you don't have an ICC color profile, or the profile has been created by your video driver and is not producing the best results, what should you do?

What you do depends on how wrong you think the monitor's colors are (in other words, how far off an image appears onscreen from its printed version). Here are some rules you can apply for using Adobe Gamma to determine—in the absence of any recommendations from your manufacturer—whether your current chromaticity settings are the right ones:

- When your color is more than just a tiny bit off, but not completely wrong, *and* if you know for certain that your CRT is a Trinitron—especially if it was manufactured by Sony, but also if your manufacturer licenses Sony's technology—select **Trinitron** for your chromaticity setting.

- If your CRT is not a Trinitron, try the sRGB setting, which Adobe Gamma calls **EBU/ITU**. In **Wizard** mode, you can test your **Before** and **After** settings against one another to see whether the results look right to you. Of all the possibilities, **EBU/ITU** is the most likely to yield acceptable results.

NOTE

Although Adobe Gamma allows you to, you should never attempt to guess at the chromaticity settings by manually entering a string of numbers.

TIP

In some cases—especially if your monitor is more than a few years old—the **EBU/ITU** (sRGB) chromaticity setting might look somewhat better than even your monitor's own designated profile settings. You do not risk damage to your monitor if you use chromaticity settings other than those specified by the manufacturer. But for the sake of image quality, do not override the ICC color profile unless the results look preferable to your own eyes.

- If the **EBU/ITU** setting doesn't result in true colors, and neither your monitor manufacturer nor the Internet can help you locate your chromaticity settings, your best course of action is to cancel Adobe Gamma, start over, and make gamma and white point adjustments to your video driver's chromaticity settings. In the Windows **Control Panel**, double-click the **Display** icon. Click the **Settings** tab and then click the **Advanced** button. Click the tab for your video driver (such as GeForce or nVIDIA) and adjust the gamma and white point settings as desired.

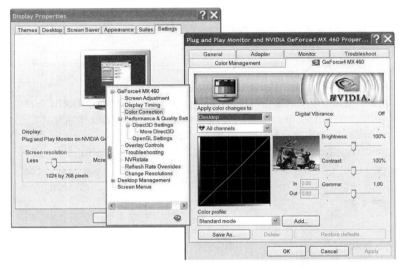

The monitor calibration panel supplied with a recent version of nVIDIA's ForceWare video card driver. Use this panel to manually calibrate a monitor if Adobe Gamma does not solve the problem.

TIP

If you decide to adjust the color correction settings of your video driver, make sure that you do it after making whatever changes you want to make to the ICC color profile using Adobe Gamma. Because the video driver's color corrections are applied over top of whatever the ICC color profile is telling the monitor to display, you'll want to make video driver adjustments last.

If, no matter what happens, the color on your monitor always looks wrong, consider upgrading your video card driver software. Whatever your card's manufacturer may be, check its manual to see who produces its internal video chipset (most likely, nVIDIA or ATI). You can also look for the chip name on the video card, or try looking in the **Properties** dialog box for your monitor, which will contain a tab for the video card: Double-click the **Display** icon in the **Control Panel**, click **Advanced** on the **Settings** tab, click the tab for your video card, and look for a logo for nVIDIA or ATI. After determining who makes the chipset for your video card, go to that manufacturer's Web site and download its latest "benchmark" drivers. These drivers use the latest technology and are generally

updated far more frequently than the brand-specific drivers for your video card. They are probably better drivers than what you're using now anyway, and they will probably reset your chromaticity settings to sRGB specifications, or something at least remotely pleasing. Even so, you can tweak the results of using this new driver by changing the color correction settings of the video driver as explained earlier.

The True Meaning of Gamma

Another term you must be familiar with before using Adobe Gamma to calibrate your monitor is *gamma*. Because a monitor's gamma affects the brightness of images displayed on that monitor, you'll also find this term used a lot in *graphics editors* such as Photoshop and Photoshop Elements. Because a monitor does not respond in a linear fashion to changes in brightness in an image (its response looks more like a sharp curve), by properly adjusting the gamma value on your monitor (the point where its luminance curve begins to bend), you can create a near 1:1 relationship between the tonal values in an image and their brightness onscreen. In other words, when the monitor gamma is set correctly, the brightness and contrast of the *midtones* within an image will also appear correct.

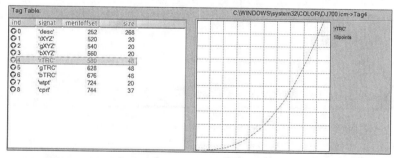

A plot of the rate at which a monitor increases the intensity of its red color channel to produce a range of colors from dark red to light red, as produced by the program ICC Inspector.

White on your monitor is really composed of three colors (red, green, and blue) at full intensity. The luminance curve for each color channel is not exactly the same; to properly calibrate a monitor, you must adjust the gamma for each color channel individually. In Adobe Gamma, you adjust these gamma points by sight. Luckily, because of the way this is accomplished, *you can actually be color blind* and still make the proper

NOTE

Software manufacturers don't make this very clear, but for any one monitor setup, you may actually have to deal with *three* different sets of gamma curves—one each for red, green, and blue. Windows has a basic curve of its own, whose gamma point is set at 2.20. Adobe Gamma lets you adjust this starting value and also set gamma variations that pertain to the three color channels individually. Your video card driver may include a *separate* gamma setting that pertains to color correction for your monitor; it does not affect the choices you make in Adobe Gamma or the values saved in the resulting profile. The video card gamma is simply an additional adjustment to the profile *result*, so typically this gamma is left at a neutral setting of 1.0 so it does not affect color management.

choices. Adobe Gamma presents you with red, green, and blue squares. Each square is framed with a region of thin horizontal stripes, alternating between full color intensity and black. In the center is a block of color that is plotted at what Windows considers "half intensity." As you squint at each square (so that you're looking at it fuzzy rather than in focus), you adjust a slider to minimize the distinction you see between the striped region and the solid center. If you consider "half intensity" to be a blend of "full intensity" and black, squinting provides you with a reasonable specimen of how half intensity should appear. (If you're color blind and can't see red, green, or blue, you can still compare the striped shade you do see with the solid shade.)

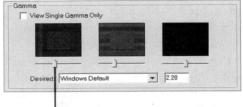

Adjust the Slider So That the Inner Square Is Similar in Value to the Outer Frame

In Adobe Gamma, you adjust the gamma of each color channel using these three squares.

85 Ensure That What You See Is What You Get

Before You Begin

✔ **83** About Color Management

✔ **84** About Adobe Gamma

See Also

→ **117** Print Images

To ensure that what you see onscreen when viewing an image is what you get after printing that image on paper, you must properly calibrate your monitor. When you use **Adobe Gamma** for monitor calibration, you rely on your own eyes as the best gauge for what looks right. First, your monitor should be warm and stabilized so that colors and contrast don't appear washed out. For best results, leave your monitor running and active (that is, not in standby mode) for at least 30 minutes before running Adobe Gamma. When you're ready to begin, turn off the interior lights in your computer's office, or at least as far down as possible.

Adobe Gamma has two operating modes. The **Wizard** mode leads you by the hand, step by step, with each option presented in its own individual panel. The **Control Panel** mode displays all options in a single

window, without description. This task shows you how to use the **Control Panel** mode to make your selections and to save them in a new *ICC color profile*.

① Change to 32-Bit Color

Before beginning this task, install the ICM color profiles for your monitor and printer (if available). You can find them on the disc that came with the hardware or on the manufacturer's Web site. Save the files to the **Windows\System\Color** folder for Windows 98, 98SE, or Me; save it to the **Windows\System32\Color** folder for Windows NT, 2000, or XP.

Right-click the Windows Desktop and choose **Properties** from the context menu to display the **Display Properties** dialog box. Click the **Settings** tab. Open the **Color quality** drop-down list and choose **Highest (32 bit)**. If this option isn't available, it's because your system does not have enough video memory to support it; in that case choose the highest setting you can. Click **OK**.

② Load a Test Picture

You won't be able to tell whether the settings you're about to make are "right" unless you have a real-world test pattern whose colors you're familiar with. In the Photoshop Album photo well, locate an image you've already printed out, so that you can compare its onscreen version with its printed version as you work. In the photo well, double-click that image to display it in **Single Photo** view.

③ Launch Adobe Gamma

After it's installed, the **Adobe Gamma** tool is located in the **Control Panel**. Click the **Start** menu, select **Control Panel**, and double-click the **Adobe Gamma** icon to start the program.

If prompted, select the **Control Panel Mode** option and click **Next**. The **Adobe Gamma** dialog box appears.

④ Load the Monitor's Profile

If an ICC color profile for your monitor has been installed on your computer, load it now. Click **Load**, then locate the file and click **Open**. You'll probably find the profile in the **Windows\system32\spool\drivers\color** or **\Windows\system32\COLOR** folder. The

NOTE

Has Adobe Gamma already been installed on your computer? Check your Windows **Control Panel** for **Adobe Gamma**. If it's not there, install Adobe Gamma by copying the **Adobe Gamma.cpl** file from the **\Adobe Gamma** folder of the Photoshop Album CD-ROM to the **\Windows\System** folder (for Windows 98, 98SE, and Me) or the **\Windows\System32** folder (for Windows NT, 2000, and XP). You can then launch the program from the **Control Panel**.

TIP

If you've enabled any color correction features in your video card driver (for example, nVIDIA's **Digital Vibrance** option), be sure to disengage those features or reset them to their defaults before beginning monitor calibration with Adobe Gamma. You should make any video driver adjustments (if needed) *after* creating an Adobe Gamma profile.

file uses the *extension* **.ICM**, and its filename probably contains your monitor's model number. Adobe Gamma immediately applies those settings to your monitor. Although they may already be the optimal settings, you should test each setting to be sure.

TIP

You might be able to determine whether a particular profile was designed for use with your monitor by right-clicking the file and choosing **Properties**.

If you don't have an ICC color profile for your monitor already loaded on your computer (because you couldn't find one), then Adobe Gamma has to start from scratch rather than allowing you to adjust the profile settings. In any case, after you're done here, Adobe Gamma will create a separate monitor profile for you. So that you can easily switch between this profile and the existing profile (in case you ever want to return to your original settings), enter a unique name for the profile in the **Description** box. Preferably, include the model number of your monitor.

⑤ Set Basic Chromaticity

If you have a monitor profile installed, the **Phosphors** list shows the **Custom** option, which means that Adobe Gamma is reading the profile and loading the *monitor chromaticity* settings. Skip to step 6.

If you do not have monitor profile installed, use the guidelines presented in **84** **About Adobe Gamma** to determine the selection you should make from the **Phosphors** list.

NOTE

The white bar in the **Brightness and Contrast** pane is there to make the test fair. It's easier to distinguish dark gray from black when they're alone; it's harder when they're adjacent to white.

⑥ Set Brightness and Contrast

The sample black and white bars in the **Brightness and Contrast** pane are presented as test patterns for your monitor. If you look closely, you'll notice that the black bar is actually made up of jet black and very dark gray boxes, alternating with one another. If you don't notice this, you will after you complete this section of the calibration.

Use the physical controls on your monitor (not on Adobe Gamma) to set your **contrast** to 100%, or as high as it will register. Next, set the **brightness** control on your monitor to as *low* a setting as possible where you can still distinguish the very dark gray blocks from the black ones. The moment they become indistinguishable, you're too low.

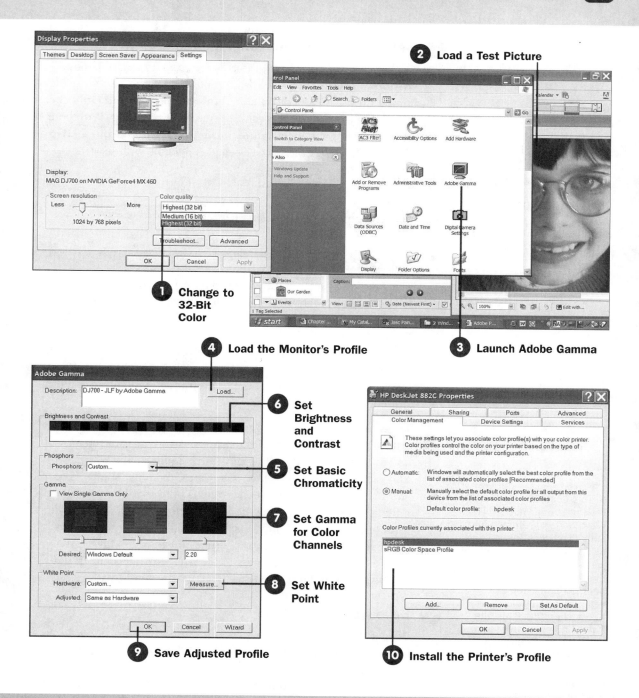

2 **Load a Test Picture**

1 **Change to 32-Bit Color**

4 **Load the Monitor's Profile**

3 **Launch Adobe Gamma**

6 **Set Brightness and Contrast**

5 **Set Basic Chromaticity**

7 **Set Gamma for Color Channels**

8 **Set White Point**

9 **Save Adjusted Profile**

10 **Install the Printer's Profile**

7 Set Gamma for Color Channels

In the **Gamma** pane, from the **Desired** drop-down list, choose **Windows Default**. This is always a good starting point for achieving best results. Then disable the **View Single Gamma Only** check box to see the test squares for all three color channels. With your eyes squinting, for each square, move the slider until the solid block in the center blends as closely as possible with its striped frame.

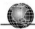

WEB RESOURCE

A series of charts you might find helpful in verifying your gamma adjustments.

www.photoscientia.co.uk/Gamma.htm

8 Set White Point

The **Adjusted** list normally shows the setting, **Same as Hardware**. In the unlikely event that your monitor's manufacturer has presented you with color chart data for its *white point*, in the **White Point** pane choose **Custom** from the **Adjusted** drop-down list. In the dialog box that appears, enter the white-point coordinates and click **OK**. If your manufacturer has specified the white point in terms of temperature, select the appropriate temperature from the **Adjusted** list. Continue to step 9.

To test and set the white point for yourself, click the **Measure** button. In the directions panel that opens, click **OK**. Your screen will go black, and then you'll see three gray squares. The warmer of these shades *in terms of temperature* (thus, the bluer shade) is on the left; the cooler shade (the redder one) is on the right. Study the middle shade carefully. Use the left and right arrow keys to rotate through the shades of gray, until the middle square appears as *unbiased* or as neutral as possible (not bluish, not reddish). When you've found that shade, press **Enter**. The **Hardware** list in the **Adobe Gamma** dialog box now displays the word **Custom**.

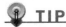

TIP

At this point, all your Adobe programs and most of your Windows programs should start displaying images using the settings you've just saved in the new profile. The notable exception here is Paint Shop Pro, which must be told to use the new profile. From the Paint Shop Pro menu bar, choose **File, Preferences, Color Management**, then click **Enable Color Management** and select the **Monitor Profile** from those listed.

9 Save Adjusted Profile

Repeat steps 6 through 8 as necessary until your test image looks as true to real-world color as possible. When you're ready to save your settings, click **OK**. The **Save As** dialog box appears. In the **File name** text box, enter a unique name for the ICC color profile you've just created. Click **Save**.

10 Install the Printer's Profile

Click the Windows **Start** button and choose **Printers and Faxes** or open the **Control Panel** and double-click the **Printers and Faxes** icon. Right-click the printer icon and choose **Properties**. In the **Properties** dialog box that opens, click the **Color Management** tab.

Select the **Manual** option. A list of profiles associated with your printer appears. Select the profile that matches your printer and click **Set As Default**.

If the list is empty, click **Add**. The **Add Profile Association** dialog box appears. Select the ICC color profile supplied by your printer manufacturer—you should find it in the **\Windows\system32\spool\drivers\color** or **\Windows\system32\COLOR** folder that automatically opens. If no such profile is available, either on your driver installation disc or from the manufacturer's Web site, search this folder for a file named **sRGB Color Space Profile** and, if present, select it. Click **Add**. Make sure that the new profile is selected and click **Set As Default**.

Click **OK** to install the printer profile.

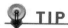

TIP

To test your new profiles and the monitor calibration, print your test image and compare it to what you see onscreen. The result should be fairly close to a true match.

86 About Fix Photo

The most common changes you'll want to make to a newly imported image are likely to be the sort of color, contrast, and brightness alterations that affect the *entire* photo. Photoshop Album has a readily available feature for making these global adjustments called **Fix Photo**. As its name implies, the purpose of this feature is not to fix some *part* of a photo, or to add some other graphics or text to a photo, or to make some embellishments to it that render it fantastic or psychedelic. The changes **Fix Photo** makes apply to the entire photo (with the exception of the **Red Eye Removal** option which, thankfully, removes the red and not the eye).

See Also

→ **87** Make Automatic Corrections

→ **91** Manually Adjust Brightness and Contrast

→ **92** Lighten Dark, Backlit Subjects

→ **93** Darken Overexposed Subjects

→ **94** Manually Adjust Color Saturation

→ **95** Fix a Photo Using Another Program

TIP

To make changes to a portion of an image—for example, to darken only the background—you must use a *graphics editor* such as Photoshop Elements or Photoshop.

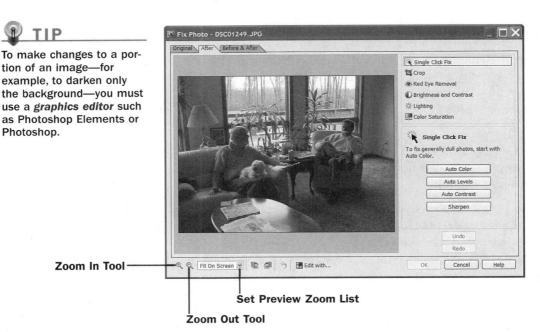

Zoom In Tool

Set Preview Zoom List

Zoom Out Tool

*The **Fix Photo** window lets you make general changes to an entire image.*

You can use **Fix Photo** to fix the following problems with an image:

- When the scene is either brighter or darker in the photograph than you remember it in reality.

- When only the darkest darks are too dark or the brightest brights are too bright.

- When the photo is either more or less colorful than you recall for the actual scene.

- When there are areas along the extremities of the photo that you don't want to include in the final image.

- When objects that are supposed to be in focus tend to blend into the background.

- When a photo is tipped sideways (by virtue of your having turned the camera when shooting it), and you want to rotate it so that it can be viewed properly.

When you see an image that needs fixing, launch **Fix Photo** by clicking that image in the photo well and then clicking the **Fix** button on the **Shortcuts** bar. This action brings up the **Fix Photo** dialog box where you make your changes. You can also double-click an image while displaying it in **Single Photo** view to bring up the **Fix Photo** dialog box.

The **Fix Photo** dialog box is initially divided into three tabs. **Original** lets you see what you started out with, while **After** is where you can review your changes as you work. On the **Before & After** tab, you can directly compare the original photo to the fixed version side by side.

When you decide to keep your changes, *the original image is not overwritten or deleted.* Your changes are automatically made to a separate copy of the image file, with the suffix **_edited** added to the filename, as in **Snowy day 01_edited**. The original file no longer appears in the *catalog*, but it still exists on the hard disk. If you use **Fix Photo** to re-fix the edited image, the **Fix Photo** dialog box will show four tabs: the original, unedited photo appears on the **Original** tab, the edited image under the **Before** tab, and the newly re-edited image under **After**. On the **Before & After** tab, you'll be able to compare the newly edited version to either the original image or the edited image. When you re-edit a previously edited image, your changes overwrite the previous ones, resulting in a new **_edited** image file. (Strangely, though, while you're making changes to an already edited file, the title bar of the **Fix Photo** dialog box shows the image's original filename.) The original file remains intact, but still absent from the photo well.

Fix Photo remembers all the changes you make to an image, in the order you made them. So you can use the **Undo** button to recall the state of your image from before you made the previous change, and keep using that button to back up all the way to the beginning (the image as it looked before displaying the **Fix Photo** dialog box and making changes), if necessary. The **Redo** button lets you step forward and reapply the previously undone change, so you can use **Undo** and **Redo** to rock back and forth between edits, from before to after, in the same frame. The **Undo** and **Redo** buttons, by the way, undo and redo only those changes made during the current editing session. However, if you click the **Revert to Original** button (even while re-editing an already edited image) you'll undo all changes, delete the edited image file (if one exists) and replace it in the catalog with the original image. See **69** **Revert Back to an Original Image** for more information on this option.

TIP

On the bottom of the **Fix Photo** dialog box is a toolbar that includes zoom tools. To zoom in on a portion of an image, click the **Zoom In** tool, then point the magnifying glass to the spot you want to magnify and click to double the magnification and focus in on that spot. Click the **Zoom Out** tool to divide magnification in half from that spot. Specific magnification factors can be chosen from the **Set Preview Zoom** list.

NOTE

When you change functions in **Fix Photo**—for instance, when you change from **Brightness and Contrast** to **Lighting**—the **Undo** button remembers that change in function and "unchanges" it. So if you've just changed to **Lighting** but have done nothing else yet, and you click **Undo**, **Fix Photo** returns to **Brightness and Contrast**. However, it will not undo the last brightness or contrast change you made until you click **Undo** again.

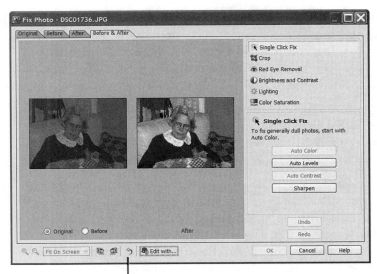

Revert to Original Button

When re-editing an image you've already edited with **Fix Photo**, *the window is divided into four tabs.*

You do not have to save the altered image yourself (that is, you don't have to select the **File, Save** command you'd find in other applications); instead, **Fix Photo** finalizes the changes and saves the file when you click **OK** to dismiss the **Fix Photo** dialog box. If you don't like your changes at all and want to discard them, just click **Cancel** instead. **Fix Photo** refrains from creating a new **_edited** file.

Back in the main Photoshop Album window, the edited version of the image replaces the original in the photo well. If you want to try multiple, separate edits on an original image, you can duplicate the original first, and then use **Fix Photo** to apply separate edits to the duplicate or duplicates. See **71 Duplicate an Image for Editing**.

If you want to make an **_edited** version permanent, you can remove the original file from the hard disk and rename the edited file back to the original image filename. See **70 Replace an Original Image with an Edited One**.

NOTE

If the original image is a JPEG with *EXIF* data, **Fix Photo** retains the EXIF data and saves it along with the edited image. So none of the data that describes your camera settings (for example) is lost. However, the TIFF header of the image file (which is present in both TIFF and JPEG formats) is amended to show that the image was re-edited with Adobe Photoshop Album.

87 Make Automatic Corrections

In many cases, the strategies for making a particular image more pleasing to the eye are the same for any image. With **Fix Photo's Single Click Fix** tools, you can attempt four of the most common image corrections safely and automatically. Here, you can reduce color bias in an image (remove a bluish *color cast*, for example), reduce an over-saturated image or increase *saturation* when needed, improve the contrast in a generally dull image, or sharpen a fuzzy image. These strategies are not guaranteed to work with every photo you try to fix, but they may save you several extra steps, or a trip over to your *graphics editor* (Photoshop Elements, Photoshop, or Paint Shop Pro) to attempt a more sophisticated solution.

Of the four **Single Click Fix** options (**Auto Color**, **Auto Levels**, **Auto Contrast**, and **Sharpen**), two are similar in purpose: **Auto Levels** and **Auto Contrast**. With both **Auto Levels** and **Auto Contrast**, the darkest darks and the lightest lights are adjusted while the medium tones are not affected. Because of the way **Auto Levels** goes about this process, however, its result may introduce a color cast in some images. Each image is made up of pixels blended from separate red, green, and blue color channels. A well-balanced digital image contains a full range of light to dark pixels in each of the three channels. To adjust each of these three color channels separately, so that the brightness values of its pixels (its *levels*) extend from darkest to brightest, use **Auto Levels**.

With **Auto Contrast**, a full range of light to dark pixels is achieved by darkening the darks and lightening the lights in the final image rather than within each color channel. If you're not sure which option to pick, try one, undo it, then try the other and pick the result that works best for the image you are attempting to fix.

1 Open Image in Fix Photo

In the photo well, choose the image you want to edit. Click the **Fix** button on the **Shortcuts bar**, or simply double-click the image if it's currently displayed in **Single Photo** view. If you are shown a warning, click **OK**. The **Fix Photo** dialog box appears, with the image displayed on the **After** tab. The **Single Click Fix** option, located on the right side of the window, is already selected, and the **Single Click Fix** pane, on the lower right, displays four options: **Auto Color**, **Auto Levels**, **Auto Contrast**, and **Sharpen**. You can apply any or all of these options as you see fit.

Before You Begin

✔ **86** About Fix Photo

See Also

→ **91** Manually Adjust Brightness and Contrast

→ **94** Manually Adjust Color Saturation

→ **95** Fix a Photo Using Another Program

🔍 **KEY TERM**

Color cast—A shift in an image toward a particular color, such as blue or red. This happens in digital images when the camera is not properly white balanced; it also happens to printed images as they age when a single color ink fades faster than the others.

Saturation—The amount of color in an image. A faded image is under-saturated; a vibrant image may contain too much color and be over-saturated.

NOTE

One of the side benefits of **Auto Levels** is that it generally increases contrast within an image. But unlike **Auto Contrast,** which deals with lights and darks, **Auto Levels** focuses on red, green, and blue channels individually. As a result, it can actually create color *imbalance* for some images that already have a color bias. For example, for a photo that has a predominantly blue sky, **Auto Levels** can add dark reds to the *midtone* areas and yellow borders around the clouds. **Auto Contrast,** on the other hand, adds no color cast.

NOTE

You should not apply both the **Auto Levels** and **Auto Contrast** adjustments to the same image. Doing so might introduce a color cast or ruin the perfect contrast you were trying to achieve.

NOTE

You can click the **Sharpen** button more than once to increase the contrast along the edges of objects in a photo.

② **Click Auto Color to Restore Color Balance**

To normalize the colors throughout the image so that any unnatural color cast is removed, or so that any over- or under-saturation is compensated for, click **Auto Color** in the **Single Click Fix** pane. In a moment, **Fix Photo** applies color corrections to the **After** image.

③ **Click Auto Levels to Repair Contrast**

To adjust the contrast within each color channel separately, click **Auto Levels** in the **Single Click Fix** pane. In a moment, **Fix Photo** adjusts the image contrast. Skip to step 5.

④ **Click Auto Contrast to Repair Contrast**

To adjust the contrast within an image rather than within each color channel, click **Auto Contrast** in the **Single Click Fix** pane. In a moment, **Fix Photo** adjusts the image contrast.

⑤ **Click Sharpen to Distinguish Edges**

To sharpen an image, **Fix Photo** increases the contrast along the edges of objects in a photo. To determine where the edges are, **Fix Photo** looks for significant differences in lightness between adjacent pixels and then makes those differences greater. The **Sharpen** option cannot fix a photo that is really fuzzy or out of focus.

To harden the edges of objects in the image, click **Sharpen** in the **Single Click Fix** pane. In a moment, notice that blurrier zones in-between light and dark regions are eliminated. You might also notice, especially in large areas of primarily one shade, an increase in graininess and the possible inclusion of spots.

⑥ **View the Result**

Click the **Before & After** tab to compare the original and edited images side by side. Click **OK** to save the changes to a new file; click **Cancel** to return to the **Before** image.

After saving changes to an image, you can delete the edited file and restore the original file to the *catalog* if you want (see **69** **Revert Back to an Original Image**) or permanently delete the original file as needed (see **70** **Replace an Original Image with an Edited One**).

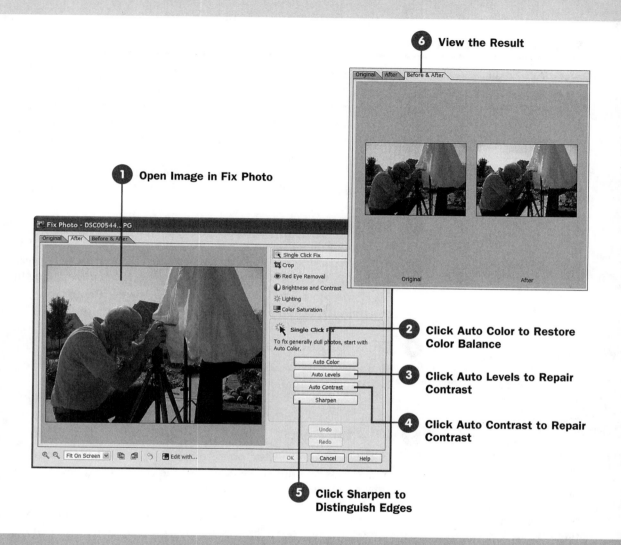

6 **View the Result**

1 **Open Image in Fix Photo**

2 **Click Auto Color to Restore Color Balance**

3 **Click Auto Levels to Repair Contrast**

4 **Click Auto Contrast to Repair Contrast**

5 **Click Sharpen to Distinguish Edges**

The photo I took of my brother capturing images of objects he wanted to auction was suffering from a number of easily correctable problems. Applying the **Auto Color** correction removed a bluish color cast. I then increased the contrast a bit by applying the **Auto Levels** function, and ended up with a much improved photo.

88 Rotate an Image

Before You Begin

✔ **86** About Fix Photo

The single most common fix you'll ever perform on digital photos is to rotate them right-side up. Freshly imported images are always wider than they are tall—in other words, in *landscape orientation*. When you tilt your camera 90 degrees for a tall shot using *portrait orientation*, your camera doesn't recognize the different orientation (not even in the *EXIF* data), so Photoshop Album doesn't know that the image is laying on its side. Thus, when you import such an image into the *catalog*, it's sideways. To fix the problem, rotate the image, as described in this task.

① Open Image in Fix Photo

In the photo well, choose the image you want to edit. Double-click the image (if it's currently displayed in **Single Photo** view) or select the image and click **Fix** on the **Shortcuts** bar to open the image in **Fix Photo**. If you see a warning, click **OK**. The **Fix Photo** dialog box appears, with the image displayed on the **After** tab.

② Click Rotation Button

To rotate the image counterclockwise 90 degrees, click the **Rotate Left** button. To rotate it clockwise 90 degrees, click the **Rotate Right** button.

③ View the Result

> **NOTE**
>
> You can also rotate images without bringing up **Fix Photo**. Click any image appearing in the photo well, then from the **Options** bar at the bottom of the window, click **Rotate Left** or **Rotate Right**. Rotating an image this way, however, changes the original image, without making an _edited copy first.

Click the **Before & After** tab to compare the original and edited images side by side. Click **OK** to save the changes to a new file; click **Cancel** to return to the **Before** image.

To capture this image of my daughter during a recent ballet class, I turned the camera 90 degrees. Because all images are saved on a digital camera in landscape orientation, I needed to rotate the photo after importing it into the Photoshop Album catalog. A single click on the **Rotate Right** button did the trick.

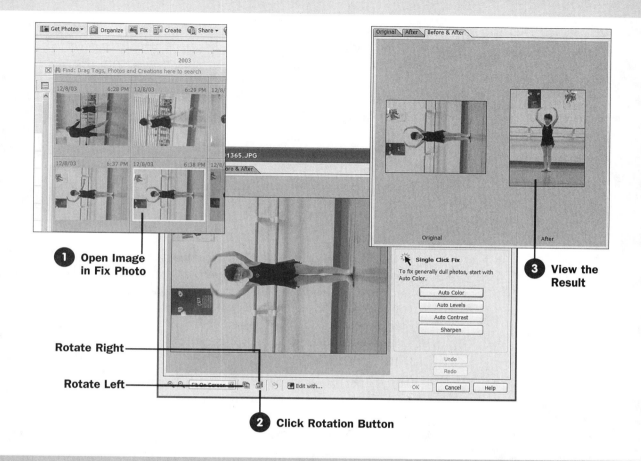

① **Open Image in Fix Photo**

Rotate Right

Rotate Left

② **Click Rotation Button**

③ **View the Result**

89 Crop an Image

In ① **About Photography**, you learned the importance of properly framing the photograph before you shoot. A digital camera's built-in display can be even more helpful than its viewfinder (if it has one) in enabling you to place your subjects in a proper and pleasing location within the frame. Nonetheless, unwanted objects do tend to creep in along the border—including my personal favorite, my *thumb*. The **Fix Photo** tool can't mask out an unwanted object—for that, you need a

Before You Begin

✔ **86** About Fix Photo

See Also

→ **1** About Photography

graphics editor such as Photoshop Elements—but if the intruder is small enough, you can use **Fix Photo** to crop the image along its borders to eliminate it, and possibly to resituate your subjects in a more pleasing location.

① Open Image in Fix Photo

In the photo well, choose the image you want to edit. Click the **Fix** button on the **Shortcuts** bar, or simply double-click the image if it's currently displayed in **Single Photo** view. If you are shown a warning, click **OK**. The **Fix Photo** dialog box appears, with the image displayed on the **After** tab.

② Click Crop

In the right pane of the **Fix Photo** dialog box, click **Crop**. A white cropping border appears in the center of the **After** image. The borders of this rectangle feature a moving marquee, so that you can tell it doesn't belong to the content of the image itself. The portions of the image outside this border will eventually be cropped away, so be sure that everything you want to keep is within the cropping border.

At the corners and along the edges of the cropping border are *handles* you can use to resize the cropping rectangle.

③ Choose Aspect Ratio

From the **Select Aspect Ratio** drop-down list, choose the option you want to use. The **No Restriction** option allows you to reshape the cropping border to any size you like, as well as to move it wherever you want it to be. The **Use Photo Ratio** option ensures that the resulting cropped image will maintain the photo's original proportions. For images taken with most digital cameras, that proportion is 1.33:1. For a 1:1 ratio, choose **Square**. Common print sizes are also available, such as **4 x 6** and **5 x 7**. You can also choose between *portrait orientation* and *landscape orientation* in these standard photo sizes.

④ Position Cropping Border

To stretch or shrink the cropping border, drag a handle inward or outward, and release.

① **Open Image in Fix Photo**

② **Click Crop**

③ **Choose Aspect Ratio**

④ **Position Cropping Border**

⑤ **Click Apply Crop**

⑥ **View the Result**

To move the cropping border to a new location on the image while retaining its shape, position the mouse pointer *inside* the border. Note the pointer takes the shape of a hand. Click and drag the mouse in the direction you want to move the border. The border follows your mouse pointer. When the border is where you want it to appear, release the mouse button.

5 Click Apply Crop

When the cropping border precisely frames the region of the image you want to keep, click **Apply Crop**. In a moment, the extraneous portion outside the border is removed, and the remainder is zoomed in to fill the **After** frame.

6 View the Result

Click the **Before & After** tab to compare the original and edited images side by side. Click **OK** to save the changes to a new file; click **Cancel** to return to the **Before** image.

During a recent visit to the local zoo, we noticed the last part of a trained seal act happening nearby. I didn't have time to properly frame the images as I was taking them, so I improved this photo after arriving home by cropping away some of the background and making the subject more dominant. I also removed a color cast and improved the contrast using the **Auto Color** and **Auto Contrast** commands discussed in **87** **Make Automatic Corrections**.

90 Remove Red Eye

Before You Begin

✔ **86** About Fix Photo

See Also

→ **1** About Photography

→ **25** Shoot an Indoor Portrait with On-Camera Flash

KEY TERM

Red eye—A reddening of the pupil caused by a reflection of the intense light from a camera flash against the retina in the back of the subject's eyes.

If you use your camera's on-board flash as your primary light source when shooting portraits, the phenomenon of *red eye* is almost unavoidable. Digital cameras typically offer an option called red eye reduction, which causes the flash to prefire in an attempt to dilate the subject's eyes and prevent red eye. If you're shooting a series of photos (such as a series of group shots, in the hopes of getting one good one where everyone is smiling), you may not want to use this feature because the increased flashing can cause your subjects to complain and even grow a bit dizzy. Thankfully, when red eye creeps into one of your photos, you can remove it easily using the **Fix Photo** tool.

To remove red eye, you identify the area of the photograph in which the eyes are located. Photoshop Album searches this area for red patches and paints them with black, returning the pupils to their original color. Of course, this method isn't perfect; if your subject had a red dot on her forehead between her eyes, for example, that red dot would also be painted black as a result of using this tool. In such a case, you could apply the red eye removal in two steps, isolating each eye, or you could

use the more sophisticated tools in a *graphics editor* such as Photoshop
Elements to remove the red eye while retaining the red dot.

① Open Image in Fix Photo

In the photo well, choose the image you want to edit. Click the **Fix**
button on the **Shortcuts** bar, or simply double-click the image if
it's currently displayed in **Single Photo** view. If you are shown a
warning, click **OK**. The **Fix Photo** dialog box appears, with the
image displayed on the **After** tab.

② Click Red Eye Removal

Click **Red Eye Removal**. A white rectangle appears in the center of
the **After** image. The borders of this rectangle feature a moving
marquee so that you can tell that the rectangle doesn't belong to
the content of the image itself. At the corners and along the edges
of this rectangle are *handles* you can use to resize the border. The
border represents the region of the image where **Fix Photo** will
search for red spots.

③ Position Search Border

So that **Fix Photo** won't accidentally recolor something that isn't
an eye, relocate the search border so that it fits neatly and tightly
around your subject's eyes. Resize the border by dragging a handle
inward or outward. To move the border, click within it and drag.

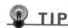
TIP

For best results, if there are
multiple people in a photo,
recolor only one pair of
eyes at a time.

④ Click Apply Red Eye Removal

When the border fits snugly around your subject's eyes, click the
Apply Red Eye Removal button. Red areas within the selection
borders are painted black, and the red eye is removed.

⑤ View the Result

To see the result clearly, click the **Zoom In** tool at the bottom of
the **Fix Photo** dialog box and click on the eyes until they fill the
window. You might notice that the **Red Eye Removal** feature has a
more true-to-life effect with subjects whose eyes are blue, blue-gray,
or hazel, rather than bright brown.

Click **OK** to save the changes to a new file; click **Cancel** to return
to the **Before** image.

1 Open Image in Fix Photo

2 Click Red Eye Removal

3 Position Search Border

4 Click Apply Red Eye Removal

5 View the Result

Even though my daughter was looking down in this photo, the camera flash still managed to cause red eye. With just a few clicks, however, I was able to remove the red eye and rescue this photo.

91 Manually Adjust Brightness and Contrast

The **Brightness and Contrast** command in the **Fix Photo** dialog box enables you to make the kind of subtle enhancements to perk up an image that **Auto Contrast**—in the interest of making everything "even"—might miss. (The **Auto Contrast** tool is explained in **87** **Make Automatic Corrections**.) When a picture is just a bit drab, or the overall tone is just to one side or the other of normal, a slight manual adjustment might be all you need to rediscover the true impact of the scene you photographed.

That said, this feature can also be a bit dangerous. Because there are only 256 grades of each of the optical primaries in a digital photo, making everything twice as bright cuts the total range of colors in the image by one half. So the darkest possible pixel becomes not 0 but 128, a middle value. Similarly, doubling an image's contrast extends the differences between color values, but in so doing, bunches certain color values together—so once again, there can only be 128 possibilities. This is why some say an image "loses information" when you use these features to the extreme. If you overcompensate for brightness, save the result, then come back later and tone *down* the brightness, the resulting image will have fewer colors than it would had you increased brightness by a lesser value to begin with. The lesson here is to use the brightness and contrast features in moderation and with caution.

1 Open Image in Fix Photo

In the photo well, choose the image you want to edit. Click the **Fix** button on the **Shortcuts** bar, or simply double-click the image if it's currently displayed in **Single Photo** view. If you are shown a warning, click **OK**. The **Fix Photo** dialog box appears, with the image displayed on the **After** tab.

2 Click Brightness and Contrast

In the right pane of the **Fix Photo** dialog box, click **Brightness and Contrast**.

Before You Begin

✔ **86** About Fix Photo

See Also

→ **87** Make Automatic Corrections

In **Fix Photo**, brightness and contrast adjustments affect the entire image equally. So when making changes you'll want to be careful that objects you had intended to fade into the background don't suddenly become noticeable and detract attention from your main subject.

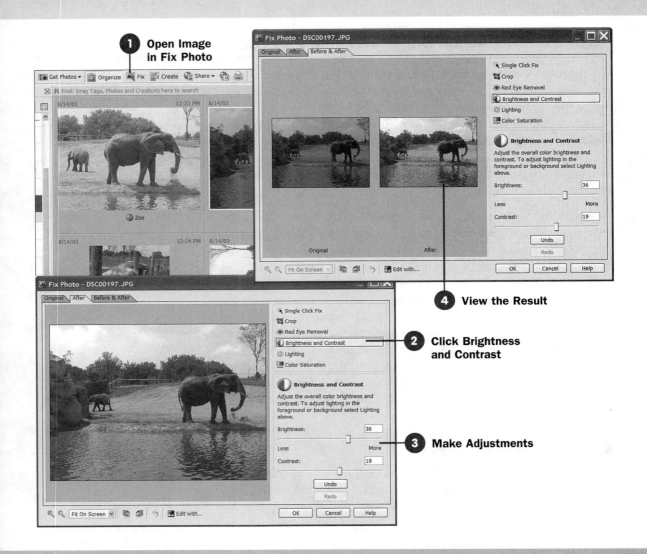

① Open Image in Fix Photo

④ View the Result

② Click Brightness and Contrast

③ Make Adjustments

③ Make Adjustments

To change the brightness level, move the **Brightness** slider toward **Less** or **More** as desired, or enter a value in the box marked **Brightness**. Moving the slider changes this number as well. The number represents a percentage, so 100 represents "twice as bright as the original," while 50 represents "50% brighter." You can enter a negative number to reduce the brightness level.

To change the contrast level, move the **Contrast** slider toward **Less** or **More** as desired, or enter a value in the box marked **Contrast**. Moving the slider changes this number as well. Here, 100 represents "double the difference between the brightness of pixels along the edges of objects." Again, you can enter a negative number to reduce contrast.

4 View the Result

Click the **Before & After** tab to compare the original and edited images side by side. Click **OK** to save the changes to a new file; click **Cancel** to return to the **Before** image.

As we passed by the elephant exhibit during a recent visit to the zoo, I noticed a baby out for a stroll with its mother, so I quickly snapped a few photos. This one turned out a bit dark, but the **Brightness and Contrast** command quickly remedied the problem.

NOTE

As you're using the **Brightness and Contrast** feature, note that the changes you make are not cumulative. In other words, all the changes you try are changes to the original, not changes to the previous change. This lets you avoid a situation where you turn brightness up, down, up again, and down again, and in so doing lose information in the image. Only when you save the edited (**After**) image by closing the **Fix Photo** dialog box do the changes become permanent.

92 Lighten Dark, Backlit Subjects

The **Fix Photo** tool's **Lighting** command enables you to make brightness adjustments to only the brightest and darkest areas of an image, leaving the other regions as they are. The **Lighting** function, **Fill Flash**, is used to lighten dark shadow areas which typically occur when a subject is lit by *backlight*. In **29 Shoot a Backlit Portrait**, you learned how you can use *exposure compensation* to compensate for strong backlighting as you take the photo. Here, I'll show you what to do if you took a backlit photo using a film camera or a digital camera that doesn't support the exposure compensation feature.

1 Open Image in Fix Photo

In the photo well, choose the image you want to edit. Click the **Fix** button on the **Shortcuts** bar, or simply double-click the image if it's currently displayed in **Single Photo** view. If you are shown a warning, click **OK**. The **Fix Photo** dialog box appears, with the image displayed on the **After** tab.

Before You Begin

✔ **86** About Fix Photo

See Also

→ **2** About Lighting

→ **21** Capture a Snowy or Sandy Scene

→ **29** Shoot a Backlit Portrait

→ **93** Darken Overexposed Subjects

KEY TERM

Backlight—Light that comes from behind a subject, throwing that subject into shadow.

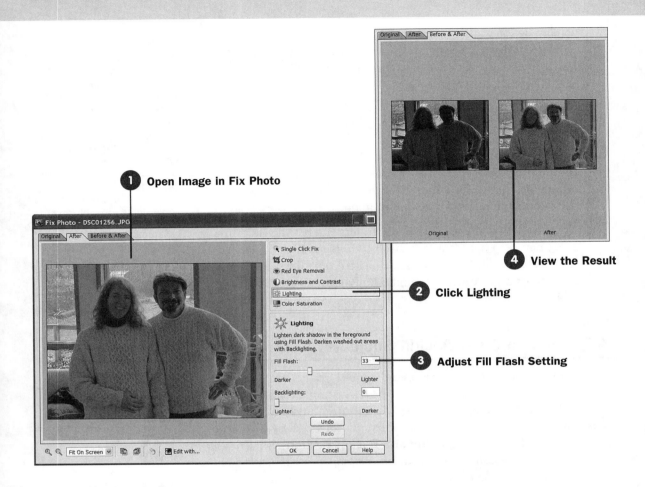

① **Open Image in Fix Photo**

④ **View the Result**

② **Click Lighting**

③ **Adjust Fill Flash Setting**

NOTE

Although the terms can fool you, the tool for fixing improper backlighting is *not* the **Backlighting** function. You'll see how **Backlighting** function can compensate for areas that are *too well lit* in **93 Darken Overexposed Subjects**.

② **Click Lighting**

In the right pane of the **Fix Photo** dialog box, click **Lighting**.

③ **Adjust Fill Flash Setting**

In the **Lighting** pane, move the **Fill Flash** slider to the right to brighten the darker areas of the image, or type a number in the box marked **Fill Flash**. This number is a relative value, where 100 represents the darkest *half* of the photo being brightened by *half*, and 50 represents the darkest *quarter* of the photo being brightened by *one-fourth*.

4 View the Result

Click the **Before & After** tab to compare the original and edited images side by side. A subtle change to the **Fill Flash** setting can perk up an image so that dark spots and crevasses don't command the viewer's attention. Click **OK** to save the changes to a new file; click **Cancel** to return to the **Before** image.

My sister took this photo of my husband and me at our cousin's cabin over Thanksgiving weekend. I love our expressions, but unfortunately, we were backlit and therefore underexposed. To rescue the photo, I gave **Fill Flash** a try. Although the results are not perfect (my face looks blotchy because when a subject is underexposed, it loses detail that you can't restore), the final photo is pretty decent.

93 Darken Overexposed Subjects

On bright sunny days, the sky in a landscape photo may appear almost featureless. By darkening this very light area of an image, you can bring out the clouds and other details. As discussed in **2 About Lighting**, overexposure of portions of an image may occur whenever large dark objects fill the frame, the subject is positioned in front of a dark background, or you're trying to take a landscape photo when the light is poor, during early morning or evening. Overexposure may also occur when you're shooting photos in the woods or other shadowy areas. What happens in each of these situations is that the camera's meter reads the light in the overall scene, senses that there's a lot of dark stuff, and compensates by increasing the exposure. These types of errors can be corrected, if only partly, by the **Fix Photo** tool's **Lighting** command (specifically, its **Backlighting** function), which tones down the brightness of only the brightest areas in an image.

Before You Begin

✔ **86** About Fix Photo

See Also

→ **2** About Lighting

→ **14** Shoot a Landscape

→ **92** Lighten Dark, Backlit Subjects

NOTE

The **Fill Flash** and **Backlighting** functions are the manual equivalent of the **Auto Levels** automatic button in the **Single Click Fix** pane, covered in **87** Make Automatic Corrections.

1 Open Image in Fix Photo

In the photo well, choose the image you want to edit. Click the **Fix** button on the **Shortcuts** bar, or simply double-click the image if it's currently displayed in **Single Photo** view. If you are shown a warning, click **OK**. The **Fix Photo** dialog box appears, with the image displayed on the **After** tab.

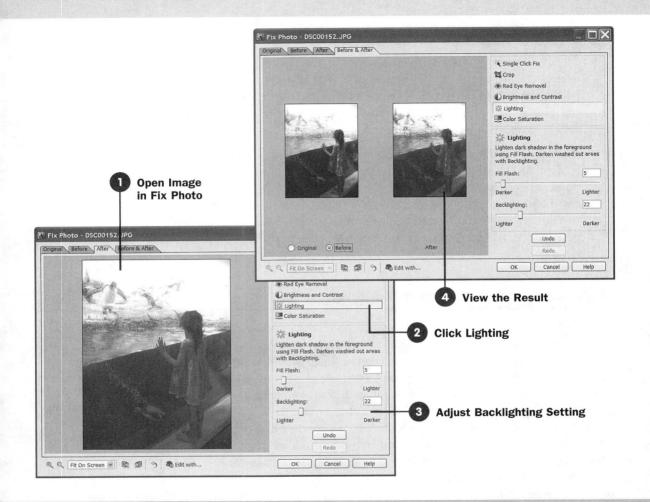

1 Open Image in Fix Photo

4 View the Result

2 Click Lighting

3 Adjust Backlighting Setting

2 Click Lighting

In the right pane of the **Fix Photo** dialog box, click **Lighting**.

3 Adjust Backlighting Setting

In the **Lighting** pane, move the **Backlighting** slider to the right to darken the brighter areas of the image, or type a number in the box marked **Backlighting**. This number is a relative value, where 100 represents the brightest *half* of the photo being darkened by *half*, and 50 represents the brightest *quarter* of the photo being darkened by *one-fourth*.

4 **View the Result**

Click the **Before & After** tab to compare the original and edited images side by side. Click **OK** to save the changes to a new file; click **Cancel** to return to the **Before** image.

I love this photo of my daughter watching Emperor penguins cavort during feeding time, but the detail in the lightest area (the "ice") was almost lost. So I used the **Backlighting** function to darken the top portion of the photo and bring out the details. I wanted to lighten the water area at the bottom of the photo, so that the diving penguin could be seen more clearly, so I also used the **Fill Flash** function.

94 Manually Adjust Color Saturation

Printed photos fade as they age, causing a loss in color *saturation*. In addition, even if a printed photo is not old, the scanning process may cause it to lose saturation. Even if you take images solely with a digital camera, you may still encounter under-saturated images whenever a photo is accidentally overexposed. As discussed in **2** **About Lighting**, images are overexposed when the meter is fooled by predominance of large dark objects or shadowy areas.

The **Fix Photo** tool's **Saturation** adjustment is capable of both restoring more colorful tones to an image and reducing the intensity of an image whose color is too rich. It's a simple adjustment that, when performed conservatively, does not sacrifice the overall brightness and contrast of the image.

1 **Open Image in Fix Photo**

In the photo well, choose the image you want to edit. Click the **Fix** button on the **Shortcuts** bar, or simply double-click the image if it's currently displayed in **Single Photo** view. If you are shown a warning, click **OK**. The **Fix Photo** dialog box appears, with the image displayed on the **After** tab.

2 **Click Color Saturation**

In the right pane of the **Fix Photo** dialog box, click **Color Saturation**.

Before You Begin

✔ **86** About Fix Photo

See Also

→ **2** About Lighting

→ **87** Make Automatic Corrections

 TIP

As they fade, older images typically also experience a color shift because different color inks do not fade at the same rate. To remove a color cast from an image, use the **Auto Color** command as explained in **87** **Make Automatic Corrections**.

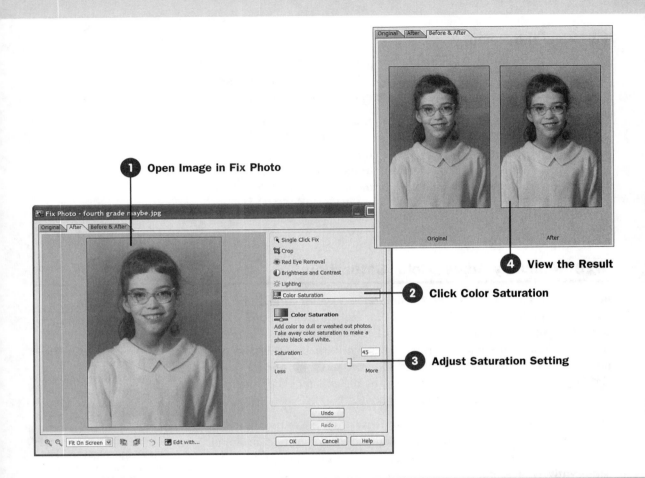

① **Open Image in Fix Photo**

② **Click Color Saturation**

③ **Adjust Saturation Setting**

④ **View the Result**

③ **Adjust Saturation Setting**

To change the saturation level, move the **Saturation** slider toward **Less** or **More** as desired, or enter a value in the box marked **Saturation**. Moving the slider changes this number as well. The number is a relative value, where –100 represents a complete removal of all color bias from the image (rendering it black-and-white), –50 represents toning down all colors in the image by one *half* (by adding one half of their optical opposites, shifting them toward gray), and 100 represents a complete removal of all optical opposites from colors that tend toward one hue, leaving that hue predominant and thus fully saturated.

4 **View the Result**

Click the **Before & After** tab to compare the original and edited images side by side. Click **OK** to save the changes to a new file; click **Cancel** to return to the **Before** image.

This old school photo had faded a bit, but a gentle increase in its saturation levels brought it back to life.

95 Fix a Photo Using Another Program

Certainly the quick fixes attainable through Photoshop Album's **Fix Photo** feature are nice to have around, but they are by no means the key reason to own or use this product. When you have a more powerful and capable *graphics editor* such as Photoshop Elements or Paint Shop Pro on hand, you might prefer to have its wealth of tools available to you, even if you end up using only the simplest among them. Still, Photoshop Album's key cataloging and organizational features would be of little use to you if you had to jump out to Windows to locate and edit an image, or if the resulting changes didn't appear in the *catalog*.

If you own a graphics editor and like to use it, you will appreciate how Photoshop Album enables you to bring up any image from the photo well in the graphics editor of your choice, bypassing the Windows filing system altogether. In the most polite way, Photoshop Album steps aside while you're editing your image, and puts a kind of visual "clamp" (a red bar) on the image's *thumbnail* as a reminder that the image is currently undergoing changes. When you're done editing, and the newly edited image is saved, you can return to Photoshop Album and release this "clamp" yourself. The thumbnail updates itself to reflect your new changes. And all this magic can be accomplished without exiting Photoshop Album at any time.

1 **Choose Image to be Edited**

If necessary, set your choice of graphics editor in Photoshop Album's **Preferences** dialog box by following the steps in the Tip.

In the photo well, click the photo you want to edit.

Before You Begin

✔ **86** About Fix Photo

See Also

→ **54** Update an Image in the Catalog

⚡ TIP

Photoshop Album has to know the location of your graphics editor so that it can call it up on demand. So before you perform this task the first time, select **Edit, Preferences** and click **Editing** in the left pane. Under **Other Editors**, click **Choose Application** (unless you want to leave it to Windows to decide), then click **Browse**. Locate the **.EXE** file for the program (probably in a subdirectory of the **Program Files** folder on drive **C**), then click **Open**. Click **OK**. Photoshop Album remembers this preference, so you have to set it only once.

2 **Contact External Application**

From the menu bar, select **Edit**, **Edit with XXX**, where **XXX** is the actual name of your graphics editor. If you see a warning, click **OK**. In a moment, the graphics editor program will start, and the selected image will appear in its window.

Meanwhile, in Photoshop Album's photo well, a red bar with the words **Edit in Progress** appears on top of the image's thumbnail. This bar indicates that the image (as well as any *creation* that makes use of it) is temporarily inaccessible from Photoshop Album. However, the remainder of the Photoshop Album program remains fully functional.

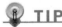 **NOTE**

If for some reason, you forget and edit an image in the catalog using a graphics editor without starting the process from within Photoshop Album, that image's thumbnail will not reflect your changes. To update the thumbnail after the fact, see **54** **Update an Image in the Catalog**.

3 **Make Edits**

In the graphics editor, make all the changes you need and desire to the image. Take your time; Photoshop Album can wait.

4 **Save Changes**

When you're done editing the image, save your changes and exit the graphics editor as you usually would.

5 **Release Lock on Image**

To notify Photoshop Album that your editing process is now complete, click the thumbnail in the photo well that has the red bar over it. From the menu bar, select **Edit**, **Finish External Edit**.

6 **View the Result**

The red bar is removed, and the thumbnail is updated in Photoshop Album to reflect the changes you made in the external graphics editor.

This photo of my husband and daughter at her first baseball game was a winner, but it could do with some improvements. Using the high-end tools in Photoshop, it was easy to crop the image to improve its composition, brighten it a bit, and paint over a few of the distractions in the foreground.

TIP

Some graphics editors (especially older editions such as Photoshop LE) strip the *EXIF* data from saved images, discarding information about your camera and the conditions in which the original photo was taken. Because this information can be important when printing a photo, be sure to choose a graphics editor such as Photoshop Elements or Jasc Paint Shop Pro that does not strip EXIF data. See **83** **About Color Management** for more information.

2 Contact External Application

1 Choose Image to be Edited

3 Make Edits

4 Save Changes

5 Release Lock on Image

6 View the Result

Notice that, just as when you edit an image using Photoshop Album's editor, a copy of the original file is automatically created and given the name ***XXX*_edited**, where *XXX* is the original filename, as in **First Ballgame 01_edited**. This duplication enables you to return to the original file if you decide you don't like your changes at a later date. See **69** **Revert Back to an Original Image**. Of course, you can also permanently remove the original file from the hard disk and keep only the copy you edited. See **70** **Replace an Original Image with an Edited One**.

PART IV

Making Creations: Sharing and Printing Images

IN THIS PART:

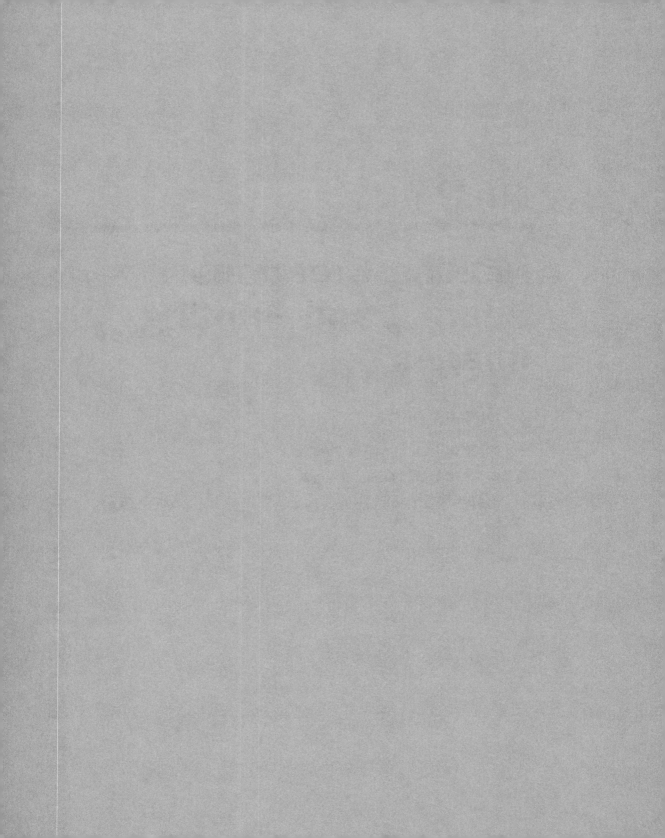

11

Creating Gifts

IN THIS CHAPTER:

NOTE

If you want to share a lot of images, you might want to create a *slideshow*, Web gallery, or video CD instead of emailing the images. You can even share large groups of images through an online photo service such as Shutterfly.

After you have imported images into the Photoshop Album *catalog*, you can easily organize, edit, and print them. If that was all you could do with the program, it would be well worth the price. As you'll learn in this chapter, however, you can do a whole lot more with the images in the catalog. Using Photoshop Album's **Creations** wizard, you can create wonderful greeting cards, calendars, and *photo books*. You can even create an electronic greeting card (*eCard*) that you can easily email to friends and family.

96 About Creations

See Also

→ **98** Create a Greeting Card

→ **99** Send an eCard

→ **100** Create a Calendar

→ **101** Create a Photo Book

→ **102** Create a Photo Album

→ **108** Create a Slideshow of Images

→ **109** Create a Video CD

You can use the images and video files you've imported into the Photoshop Album *catalog* to make many different kinds of *creations*. For example, you might gather a series of photos taken at a birthday party and create a *photo album* to print on a color printer.

To make a creation, you follow these basic steps:

1. Copy the items you want to use in a creation to the *Workspace*, which is a kind of holding area for images you want to use in creations.

2. Arrange the items in the Workspace as you want them to appear in the creation. You'll learn how to manipulate images within the Workspace in **97** **About the Workspace**.

3. Display the **Creations** wizard and follow its steps to select a template and set the options you want to use to make your creation.

KEY TERM

Creations—Greeting cards, calendars, Web galleries, slideshows, and other things you make using the images in the catalog.

Using the **Creations** wizard, you can produce many different kinds of creations, each of which allows you to share your images in a unique way. You can create a greeting card, calendar, or photo album you then print on your home photo printer. If you prefer higher-quality printing, you can create a customized *photo book*, upload it to a printing service, and receive a professionally bound album in the mail. You can also have your calendar professionally printed using an online service.

Like the ease of email? Then create an *eCard* or a *slideshow* to share with friends and family. (If you share a slideshow in this way, the file is converted to *PDF format* so that it can be played on a computer). If you're looking for something you can use to share your images with a large group of people, you might make a video CD (for playback in a

DVD player) or a slideshow (for playback on a CD player or a CD drive) using the **Creations** wizard.

Using the Creations Wizard

To make a creation, you start by copying the images and video clips you want to use to the Workspace (see **97** **About the Workspace**). You cannot add audio clips to the Workspace, although you may be able to select an audio clip for a particular creation later on in the process. After adding images and video clips to the Workspace, you start the **Creations** wizard, which displays a series of dialog boxes that leads you through the process of making a specific creation such as an eCard, photo album, or slideshow. You save your creation in the catalog with a unique name that allows you to open and edit the creation anytime you want.

NOTE

Some creations allow you to include video clips from the catalog, while others do not. See the steps for the specific creation you want to make for details. Occasionally, you can also include audio clips in a creation, although those are added not from the catalog, but from the hard disk's file system. (So it doesn't matter if the audio file is in the catalog or not).

Current Step

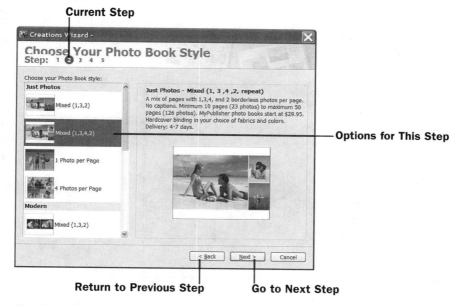

Options for This Step

Return to Previous Step **Go to Next Step**

*The **Creations** wizard steps you through the process of making a creation.*

In the first step of the **Creations** wizard, you select the type of creation you want to make. To continue to the next step, click the **Next** button; return to a previous step by clicking the **Back** button. At the top of the wizard window, notice that the current step number is highlighted; you can click any step in this list to jump directly to that step.

 TIP

Occasionally, new templates for specific creations will become available for download. To add new templates to your system, click the **Download New Templates** button in step 1 of the **Creations** wizard.

NOTE

If you've added text captions to your images, you can typically display them alongside each image within the creation. Captions help your audience identify the content of each photo. See **58** **Add a Text Caption**.

Each step of the wizard presents you with a series of options. Typically, in the second step, you select a template (layout) for your chosen creation. The template determines how the images in the Workspace will appear within the creation. Not all creations use multiple images, but for those that do, *the images appear in the creation in the order in which you arrange them in the Workspace.*

In the third step of the **Creations** wizard, you typically add text, such as a greeting card message or a photo album title. Options specific to the creation (such as displaying *captions* or including an audio file) also appear in step 3. Finally, in step 4, you get a chance to review the creation with the selected images in place. The navigation buttons under the preview window allow you to view the next/previous page or the first/last page of the creation. You can click the **Full Screen Preview** button at the bottom of the wizard window to view the creation in a larger, slideshow format (press **Esc** anytime during this slideshow to return to the **Creations** wizard). If you want to make adjustments to the order in which the images appear or add or delete images, you can return to the Workspace by clicking the **Rearrange Photos** button.

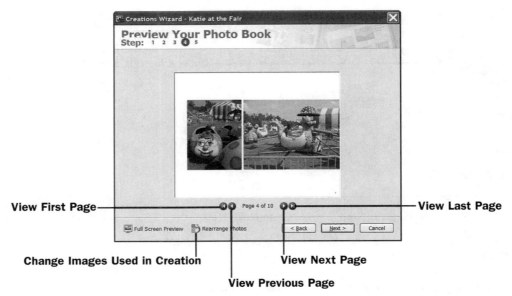

After making selections, you can review how your creation will look.

In the final step of the **Creations** wizard, you'll name your creation and save it to the catalog. Typically, the title you entered in step 2 is used

here, but you can enter a unique name if you like. After entering a name for your creation, click **Done** and the creation appears in the photo well.

You'll see several output options on this final step as well. For example, you can click **Save as PDF** to save your creation in PDF format for sharing online or through email. The benefit of using PDF format for documents that combine images and text is that your viewer will see them exactly as you intended, in the format you wanted, and not scrambled up with text appearing in random spots and images resized. Specifically, selecting PDF format from the **Creations** wizard saves your images in a document that's easily viewed, even by novice computer users. See **104** **Save a Creation in PDF Format** for more help.

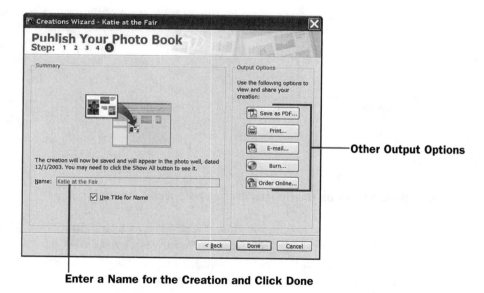

Other Output Options

Enter a Name for the Creation and Click Done

Save your creation.

You can also print or email your creation by choosing that option from the **Creations** wizard. You might choose the **Print** option, for example, to print a calendar, greeting card, or photo album using your photo printer. See **121** **Print a Creation at Home**. Select the **E-mail** option to immediately email your completed creation (in PDF format). See **113** **Email an Item**. The **Burn** option creates a slideshow of the images in the creation and copies that to a CD along with the image files themselves, as described in **105** **Burn a Creation to a CD**. The

TIP

As you'll learn in **97** **About the Workspace**, you can print the images directly from the Workspace using the **Print** option in the Workspace dialog box. This option doesn't print the creation itself, just the images included in the creation. See **117** **Print Images** for help.

NOTE

A *Web Photo Gallery* and an *Adobe Atmosphere 3D Gallery* are not created using the **Creations** wizard, and therefore do not appear in the photo well as thumbnails. In addition, you cannot edit these particular creations or redisplay the images used in creating them.

TIP

Creations do not appear in the photo well if you are sorting items by import batch or folder, so change to **Date (Newest First)** or **Date (Oldest First)** order if necessary. To quickly display only the creations in the photo well, select **Find, By Media Type, Creations**.

Burn option also allows you to copy the images to a CD in a special format that's playable on a DVD player. See **109** **Create a Video CD**. Finally, with particular creations such as a photo book or calendar, you can order professional printing for your creation through an online service by clicking the **Order Online** button. See **122** **Print a Creation Using an Online Service**.

Editing Creations

After you've saved a creation, it appears as a *thumbnail* in the catalog along with your images, video, audio files, and other creations. Creations appear with a small creation icon in the upper-right corner of the thumbnail. You can redisplay the **Creations** wizard at any time to make changes to the creation (changing set up options or adding/removing images) or to access any of the output options on step 5 of the **Creations** wizard. For example, you might return to a creation to use the output options to email it to a friend.

Creations appear as thumbnails in the photo well.

To make changes to a creation, simply double-click its thumbnail. The creation reappears in the **Creations** wizard, with step 4 displayed. In step 4, you can preview the creation using the navigation buttons provided. Click **Back** or **Next** to navigate from step to step in the wizard, making any changes to the options you originally selected, including changing the creation to some other type.

To change the images used in the creation—to add or remove images or edit them—click the **Rearrange Photos** button on the step 4 page of the **Creations** wizard. The Workspace window appears, displaying only the images currently included in the creation. See **97** **About the Workspace** for help in adding, removing, or editing images.

97 About the Workspace

The *Workspace* is a special area in which you can collect images and videos for use in *creations*. You can also print, email, archive, export, tag, and rename items in the Workspace. In addition, you can create a Web Photo Gallery or an Adobe Atmosphere 3D Gallery with the items in the Workspace.

Select a Command to Apply to Images

Attach a Tag to Images

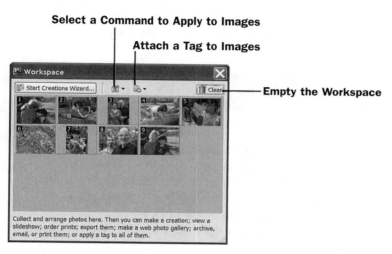

Empty the Workspace

Collect images in the Workspace that you want to use in a creation.

To display the Workspace, you can click the **Create** button on the **Shortcuts** bar, select **View**, **Workspace** from the menu, or click the **Show or Hide Workspace** button on the **Options** bar. After the Workspace is displayed, you can add images to it. If you clicked the **Create** button to display the Workspace, any images that might have already been in the Workspace are removed so that you can begin a new collection of images for the creation you wish to make. If you displayed the Workspace using the **View**, **Workspace** command or the **Show or Hide Workspace** button, any images already in the Workspace are left there so that you can add or remove only the ones you want. If you want to empty the Workspace manually at any time, click its **Clear** button. The images are removed from the Workspace, but they are still in the *catalog*.

Before You Begin

✔ **96** About Creations

See Also

→ **47** Copy Items onto CD-ROM or DVD

→ **48** View Images in a Slideshow

→ **57** Rename a Group of Images

→ **64** Attach a Tag to an Item

→ **113** Email an Item

→ **117** Print Images

KEY TERM

Workspace—A special dialog box in which you arrange the images you want to use in a creation such as a calendar or slideshow.

TIP

You can resize the Workspace window to view more or fewer images at one time. Just position the mouse pointer over a window edge and drag to resize the window.

After displaying the Workspace, perform any of the following to add, remove, or change its contents:

- Drag images or video files from the photo well and drop them in the Workspace to add to the collection.

- Drag images or video files within the Workspace to rearrange their order. Arranging items in the Workspace is important because that's the order in which they are used in whatever creation you make. As you drag items within the Workspace, you'll notice a yellow line that marks where the selected items will be moved when you release the mouse button to drop them.

- Drag an image or video file to the **Clear** button to remove it from the Workspace (but not the catalog); click the **Clear** button to remove all images from the Workspace (but not the catalog).

NOTE

The Workspace remains onscreen as you work, until you close its window. That way, you can move back and forth between the Workspace and the photo well as you add and remove items, edit, rotate, and crop images, add captions, and so on. If the Workspace is in the way, move it by dragging it by the title bar. Close the Workspace by clicking its **Close** button.

- Double-click an image to select it in the photo well. (You may have to drag the Workspace out of the way so that you can see that the image is selected in the photo well beneath it.) When the image is selected, you can edit, crop, or rotate the image by clicking the **Fix** button on the **Shortcuts** bar. (See **86** **About Fix Photo**.) You can also add a *caption* to an item that's selected in the photo well if desired; remember that captions can be made to appear in some creations. Display the **Properties** pane by clicking the **Show or Hide Properties** button on the **Options** bar and then type some text in the **Caption** box. (See **58** **Add a Text Caption**.)

After you've added the items you want to the Workspace and arranged them in the order you want to use them, click the **Start Creations Wizard** button to make a creation using the images and video files you've collected. Then follow the steps detailed in upcoming tasks to complete your creation.

As I mentioned earlier, you can do other things with the images and video files in the Workspace than simply make creations:

- To attach the same tag to all the items in the Workspace, click the **Attach tag to all items in Workspace** button at the top of the Workspace window. A menu appears; select the appropriate category and subcategories until you finally select the tag you want to apply. See **64** **Attach a Tag to an Item** for more information.

- Email, print, and perform other actions on the items in the Workspace by clicking the **Select command to apply to all items in the Workspace** button at the top of the Workspace window and then selecting the command you want to use:

 - If you choose **Play Slideshow**, the images are displayed one by one onscreen in a temporary slideshow. See **48** **View Images in a Slideshow**.

 - If you choose **Order Prints**, the images in the Workspace are uploaded to an online service for professional printing. See **120** **Print Images Using an Online Service**.

 - If you choose **Rename**, you can rename the items using a common basename, such as **Company Picnic 2004**. See **57** **Rename a Group of Images**.

 - If you choose **Export**, you can prepare the images for use in another program such as Microsoft Word. See **72** **Export Images for Use in Another Program**.

 - If you choose **Web Photo Gallery**, you can create an online gallery using the Workspace items. See **106** **Create a Web Gallery of Images**.

 - If you choose **Adobe Atmosphere 3D Gallery**, you can create an online 3D gallery with the Workspace items. See **107** **Create an Adobe Atmosphere 3D Gallery**.

 - If you choose **Archive**, you can copy the collected images and video files to a CD-ROM or DVD for storage. See **47** **Copy Items onto CD-ROM or DVD**.

 - If you choose **E-mail**, you can send the collected images or video files to a friend or colleague. See **113** **Email an Item**.

 - If you choose **Print**, you can print the images in a variety of ways. See **117** **Print Images**, **118** **Print a Contact Sheet**, and **119** **Print a Picture Package**.

98 Create a Greeting Card

Before You Begin

✔ **96** About Creations
✔ **97** About the Workspace

See Also

→ **99** Send an eCard
→ **121** Print a Creation at Home

TIP

You don't have to wait for a special occasion to send a card; simply create an *eCard* and send it instantly using email. See **99** Send an eCard.

NOTE

If you already have images in the Workspace, you can use the first image to create a greeting card. Skip steps 1 and 2, display the Workspace, and drag the image to use into the first position. Continue to step 3.

Greeting cards have a rich tradition, dating back almost 200 years. At first only the wealthy could afford to send greeting cards, but since the 1850s, they have become less expensive and more common. So common in fact that today many people use stamping, embossing, and trims to create one-of-a-kind cards for all occasions. Using Photoshop Album, you can create unique printable greeting cards adorned by your own photos and a special message.

1 Select Image

Only one image is used in the creation of your greeting card, so in the photo well, click the image you want to feature in the greeting card.

2 Click Create

Click the **Create** button on the **Shortcuts** bar. The *Workspace* appears with only one image—the image you selected in step 1.

3 Click Start Creations Wizard

Click the **Start Creations Wizard** button. The **Creations** wizard appears, displaying the **Step 1** page.

4 Select Greeting Card Template

On the **Step 1** page of the wizard window, choose **Greeting Card** from the **Select the template type** list. Click **Next**.

5 Select Card Style

On the **Step 2** page, select a greeting card style from the **Choose your Greeting Card style** list. A sample of the style you select appears on the right. Be sure to scroll through the style list before making a selection—there are quite a lot card styles to choose from! Click **Next**.

6 Enter Title and Message

On the **Step 3** page, type a title for the card in the **Title** box. This title appears with the photo on the first page of the card. Type a **Greeting** and **Message**. The greeting appears in larger type on the inside of the card, just above the message. Click **Next**.

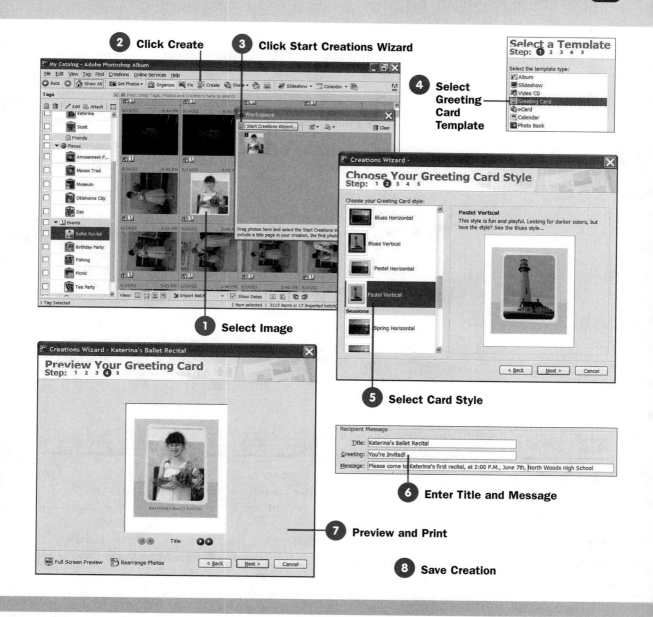

2 Click Create

3 Click Start Creations Wizard

4 Select Greeting Card Template

1 Select Image

5 Select Card Style

6 Enter Title and Message

7 Preview and Print

8 Save Creation

7 Preview and Print

On the **Step 4** page, preview the card using the navigation controls. If desired, return to any of the previous steps and make new selections. Click **Rearrange Photos** to redisplay the Workspace so that you can edit the image or make a substitution. Click **Next** to continue.

On the **Step 5** page, click **Print** to print the card. The **Print** dialog box appears. You can print multiple copies of the card by increasing the **Number of copies** value. You might also want to change the paper type if you are using photo paper or a special card stock, and increase the print quality by changing the printer **Properties**. See **121** **Print a Creation at Home** for more help.

When you're ready, click **Print** in the **Print** dialog box. After the card is printed, you must fold it in half vertically, then horizontally, so that the message appears on the inside and the photo appears on the front.

8 Save Creation

The **Step 5** page of the wizard is still displayed. The **Title** you typed on the **Step 3** page appears in the **Name** box. This title will be used to name your saved creation. If you want to use an alternative name, disable **Use Title for Name** and type a new title in the **Name** box.

Click **Done** to save the creation using the text in the **Name** box as the creation name. You may see a warning box reminding you that the creation now appears at the top of the photo well, with other items in the catalog. Click **OK**. The Workspace is closed for you automatically.

99 Send an eCard

Before You Begin

✔ **96** About Creations

✔ **97** About the Workspace

✔ **113** Email an Item

See Also

→ **98** Create a Greeting Card

You don't have to print a greeting card and truck down to the post office to keep in touch with your friends and relatives. You can send a customized message instantly, with an *eCard* you design yourself. The eCard includes a photo or video file you select from the photo well, along with whatever special text message you wish to include. You can also add music and the image's *audio caption* if you like. (See **59** **Record an Audio Caption** for help in adding an audio caption to the item you want to use.) Sending eCards is a nice way to share special photos or short video clips with friends, or to make timely announcements, such as the birth of a new baby.

1 Select Item

Only one image or video clip is used in the creation of your eCard, so in the photo well, click the image or video file you want to feature in your eCard.

2 Click Create

Click the **Create** button on the **Shortcuts** bar. The *Workspace* appears with only one image or video file—the item you selected in step 1.

3 Click Start Creations Wizard

Click the **Start Creations Wizard** button. The **Creations** wizard appears, displaying the **Step 1** page.

4 Select eCard Template

On the **Step 1** page, choose **eCard** from the **Select the template type** list. Click **Next**.

5 Select Card Style

On the **Step 2** page, select a greeting card style from the **Choose your eCard style** list. A sample of the style you select appears on the right. Click **Next**.

6 Enter Title and Message

On the **Step 3** page, type a title for the card in the **Title** box. This title appears with the photo or video on the first page of the card. Type a **Greeting**, **Message**, and **Signature**. The greeting appears in larger type on the inside of the card, just above the message. The signature appears below the message.

7 Add Audio

You can choose various options to present your message in a special way. To add background music to the presentation, click **Browse**, navigate your hard disk's file system to select an audio file in MP3 or WAV format, and click **Open** to return to the wizard. (This audio file does not have to be in the catalog.) If you selected a video file in step 1, you should know that the audio file you choose here will play softly in the background *while the video is playing,* which might prevent someone from hearing the video clearly.

KEY TERM

eCard—Electronic greeting card sent using email rather than snail mail (regular mail), and displayed on a computer rather than printed. An eCard includes a photo or video file and a text message accompanied by optional music and audio caption.

 NOTE

If you already have images and video files in the Workspace, you can use the first item to create an eCard. Skip steps 1 and 2, display the Workspace, and drag the item to use into the first position. Continue to step 3.

TIP

If you've played the audio file you want to use recently, click the arrow on the **Background Music** list in the wizard window and select that audio file from the drop-down list.

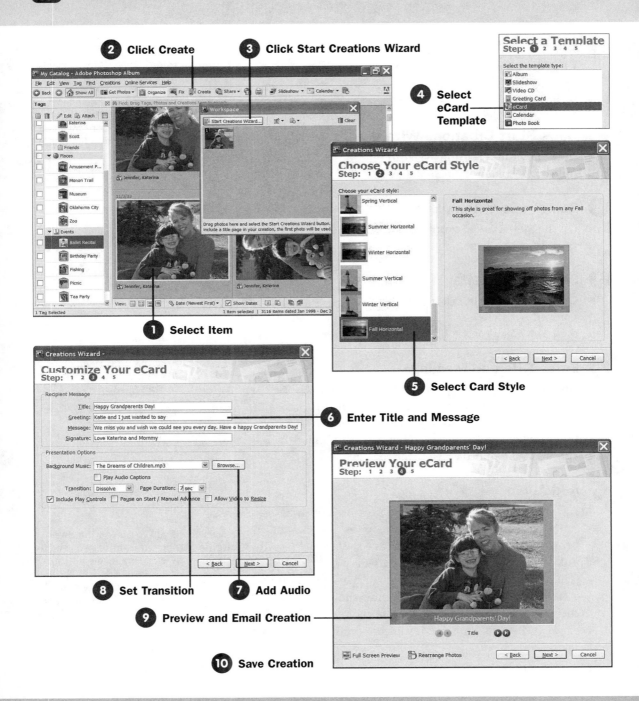

2 Click Create

3 Click Start Creations Wizard

4 Select eCard Template

1 Select Item

5 Select Card Style

6 Enter Title and Message

8 Set Transition

7 Add Audio

9 Preview and Email Creation

10 Save Creation

If you want to play the audio caption attached to the item you selected in step 1, enable the **Play Audio Captions** check box. If you have also chosen an audio file to play, remember that the audio file will continue to play softly in the background *while the audio caption is playing,* which might prevent someone from hearing your comments clearly.

8 Set Transition

You can control how the second page of the card appears by adjusting the transition settings. First, select how you want the display to shift from the first page to the second page of the eCard by selecting an option from the **Transition** drop-down list. To control how long each page appears onscreen, choose a time limit from the **Page Duration** drop-down list. You can also edit the time limit to create a custom duration if you like.

If you want, you can display controls under the greeting card when it is viewed to allow the user to shift from page to page freely. Enable the **Include Play Controls** check box. If you include the play controls, you can disable the **Pause on Start/Manual Advance** check box so that the second page does not appear until the user chooses to display it. If you turn on this option, the second page appears automatically after the **Page Duration** has passed, whether or not the play controls are also displayed.

If you selected a video file in step 1, you can select the **Allow Video to Resize** check box to allow the video window to be resized so that it fits the width and height of the eCard more fully. Resizing the video, however, may affect its playback quality. Click **Next**.

9 Preview and Email Creation

On the **Step 4** page of the wizard window, preview the eCard using the navigation controls. To view the eCard as your recipient will see it (as an automatic PDF slideshow, with accompanying audio, if any), click **Full Screen Preview**. If desired, return to any of the previous steps and make new selections. Click **Rearrange Photos** on the **Step 4** page to redisplay the Workspace so that you can edit the image, select an alternative image or video file, or add an audio caption if needed. Click **Next** to continue.

On the **Step 5** page, click **E-mail** to send the card. See **113** **Email an Item** for more help in addressing and sending the eCard.

 NOTE

Many Internet service providers stop email messages they receive if those messages are over 1MB in size. For best results, select only small image or video files for use in an eCard.

10 **Save Creation**

The **Step 5** page of the wizard is still displayed. The **Title** you typed on the **Step 3** page appears in the **Name** box. This text is used to name your saved creation. If you want to use an alternative name, deselect the **Use Title for Name** check box and then type a new title in the **Name** box.

Click **Done** to save the creation using the text in the **Name** box as the creation name. You might see a warning box reminding you that the creation now appears at the top of the photo well along with other items in the catalog. Click **OK**. The Workspace is closed for you automatically.

100 Create a Calendar

Before You Begin

✔ **96** About Creations

✔ **97** About the Workspace

See Also

→ **121** Print a Creation at Home

→ **122** Print Images a Creation Using an Online Service

TIP

You can also include *captions* with each photo, if you've added them to your images. See **58** Add a Text Caption for help.

Everyone has photos they like to look at—photos that remind them of family, faraway places, or special events. Why not include your favorite photos in something you look at every day, such as a calendar? Personalized photo calendars also make great gifts for grandparents, siblings, and friends, and they are easy to create using Photoshop Album.

A calendar can include any range of months you want. For example, you might create a calendar that includes just the summer months, and take it with you to your cabin on the lake. Or you might create an 18-month calendar in July (which runs from July of the current year until December of the next year) so that you can use it right away. After creating a calendar, you can print it from your home computer using photo paper or a special heavy bond, or you can upload it to an online printing service to have it professionally printed.

1 **Click Create**

Click the **Create** button on the **Shortcuts** bar. The *Workspace* appears with no images.

2 **Select Images**

Each month of the calendar prints on its own page; you can include only one photo for each month. However, you can also choose a photo to use on the cover page. Drag and drop each image you want to use from the photo well into the Workspace.

Make sure that you've selected one image for each month you want to include in the calendar, plus an extra image for its cover. If needed, rearrange the images so that they appear in the order in which they will be used, cover image first.

③ Click Start Creations Wizard

Click the **Start Creations Wizard** button. The **Creations** wizard appears, displaying the **Step 1** page.

④ Select Calendar Template

On the **Step 1** page, choose **Calendar** from the **Select the template type** list. Click **Next**.

⑤ Select Calendar Style

On the **Step 2** page, select a calendar style from the **Choose your Calendar style** list. A sample of the style you select appears on the right. Click **Next**.

⑥ Enter Title

On the **Step 3** page, type a title for the calendar in the **Title** box. This title appears on the calendar's cover page.

⑦ Select Calendar Range

Open the **Starting** drop-down list and select the first month and year you want to include in the calendar. Open the **Ending** drop-down list and select the last month and year you want to include.

⑧ Add Captions

If you added text captions to your photos, you can print them next to each image on the calendar by selecting the **Include Captions** check box. (See **58** **Add a Text Caption**.) Click **Next**.

⑨ Preview and Print Creation

On the **Step 4** page, preview the calendar using the navigation controls. If desired, return to any of the previous steps and make new selections. Click **Rearrange Photos** to redisplay the Workspace so that you can edit an image, add or remove images, or add text captions if needed. Click **Next** to continue.

 TIP

If you want to select a group of related images such as all the images of your daughter, use the **Find** bar to display them in the photo well (see **73** About Finding Items). Then press **Ctrl+A** or choose **Edit, Select All** to quickly select the displayed items. If the catalog is sorted by batch or folder, you can click the gray bar above a group to select all the items in that group. With either of these two methods, you might also end up selecting video, audio, and creation files, so press **Ctrl** and click the files you don't want to deselect them.

 TIP

The number of months you include should match the number of images currently in the Workspace.

🖊 **NOTE**

Captions are not printed on the calendar cover, even if you select the **Include Captions** check box.

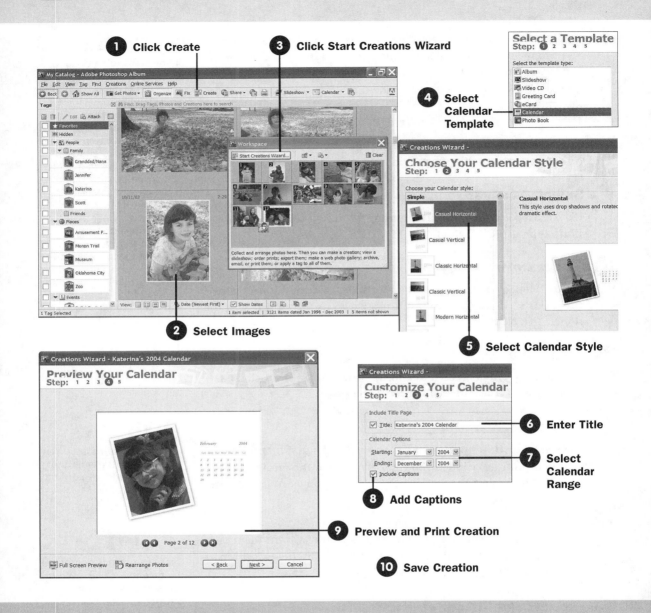

① Click Create

③ Click Start Creations Wizard

④ Select Calendar Template

② Select Images

⑤ Select Calendar Style

⑥ Enter Title

⑦ Select Calendar Range

⑧ Add Captions

⑨ Preview and Print Creation

⑩ Save Creation

On the **Step 5** page, click **Print** to print the calendar on your home printer. The **Print** dialog box appears. You might want to change the paper type if you are using photo paper or a special card stock, and also select a higher print quality by changing the printer Properties. See **121** **Print a Creation at Home** for help.

When you're ready, click **Print** in the **Print** dialog box. A single image and its corresponding month are printed together on each page of the calendar. A title page is printed as well.

⑩ Save Creation

The **Step 5** page of the wizard is still displayed. The **Title** you typed on the **Step 3** page appears in the **Name** box and is used to name your saved creation. If you want to use an alternative name, deselect the **Use Title for Name** check box and type a new title in the **Name** box.

Click **Done** to save the creation using the text in the **Name** box to label the creation. You might see a warning box reminding you that the creation now appears at the top of the photo well along with other items in the catalog. Click **OK**. The Workspace is closed for you automatically.

🔆 TIPS

For a more professional look, have your printed calendar pages spiral bound at your local copier store.

If you'd rather have your calendar professionally printed and spiral bound, upload it to an online service such as MyPublisher by clicking **Order Online** on the **Step 5** page of the wizard. See **122** **Print a Creation Using an Online Service**.

⑩ Create a Photo Book

For a special keepsake of a party, vacation, family reunion, or other event, create a *photo book*—the **Creations** wizard makes the process simple. Just select the images you want to include in the book, choose a layout and set other options, then upload the completed work to an online service such as MyPublisher for printing. In a short time, you'll receive your one-of-a-kind, hardcover photo book in the mail. What could be easier?

① Click Create

Click the **Create** button on the **Shortcuts** bar. The *Workspace* appears with no images.

② Select Images

A photo book has a minimum of 10 pages. The number of images per page varies based on the template you select in **Step 3** of the wizard. There's also a cover and a title page, so you'll need a minimum of 12 images for your book, although you can include a lot more (up to 40 images in a standard 10-page book, with a maximum book size of 100 images, based on the current standards posted on the MyPublisher.com Web site).

Before You Begin

✔ **96** About Creations
✔ **97** About the Workspace

See Also

→ **102** Create a Photo Album
→ **122** Print a Creation Using an Online Service

🔍 KEY TERM

Photo book—A photo album that's created with the intention that you will have it professionally printed and bound into a book. In a photo book, images and text captions are arranged in a pattern that matches the template you select, which may include a decorative background.

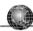 **WEB RESOURCE**

Visit MyPublisher.com to see how your printed photo book might look.

www.mypublisher.com

Drag and drop each image you want to use into the Workspace. Rearrange the images so that they appear in the order you want to use them, cover image first and title page second.

You might be able to create photo books using online services such as Shutterfly, by simply uploading images and using the service's program to lay out the book. See **115 Share Images Using an Online Service** for help.

TIP

If you want to select a group of related images (such as all the images of a recent family reunion), use the **Find** bar to display them first. (See **73 About Finding Items**.) Then press **Ctrl+A** or choose **Edit, Select All** to quickly select the displayed items. If the catalog is sorted by batch or folder, you can click the gray bar above a group to select all the items in that group. With either of these two methods, you might also end up selecting video, audio, and creation files, so press **Ctrl** and click the files you don't want to deselect them.

3 Click Start Creations Wizard

Click the **Start Creations Wizard** button. The **Creations** wizard appears, displaying the **Step 1** page.

4 Select Photo Book Template

On the **Step 1** page, choose **Photo Book** from the **Select the template type** list. Click **Next**.

5 Select Book Style

On the **Step 2** page, select a photo book style from the **Choose your Photo Book style** list. A sample of the style you select appears on the right. Click **Next**.

6 Enter Title Text

On the **Step 3** page, type a title for the photo book in the **Title** box. This title will appear on the book's cover page, and also on the title page (page two).

Enter a **Subtitle** if desired. The subtitle will appear beneath the title on both the cover and title pages.

Type your name in the **Author** box. Your name will appear below the title and subtitle, on both the cover and title pages.

KEY TERMS

Header—Text that appears at the top of every page in a document. Headers do not appear on the cover page of a creation.

Footer—Text that appears at the bottom of every page in a document. Footers do not appear on the cover page of a creation.

7 Add Header and Footer Text

Depending on the template you select, you might be able to add a *header* and *footer*. Select the **Header** and/or **Footer** check box and type the desired text in the box.

3 Click Start Creations Wizard

1 Click Create

4 Select Photo Book Template

5 Select Book Style

Step: **1** 2 3 4 5

Select the template type:
- Album
- Slideshow
- Video CD
- Greeting Card
- eCard
- Calendar
- Photo Book

Choose Your Photo Book Style
Step: 1 **2** 3 4 5

Choose your Photo Book style:
- 1 Photo per Page
- 4 Photos per Page

Modern
- Mixed (1,3,2)
- Mixed (1,3,4,2)
- 1 Photo per Page
- 4 Photos per Page

Modern - Mixed (1, 3, 2, repeat)
A mix of pages with 1, 3, and 2 photos per page. Optional captions. Minimum 10 pages (20 photos) to maximum 50 pages (98 photos). MyPublisher photo books start at $29.95. Hardcover binding in your choice of fabrics and colors. Delivery: 4-7 days.

6 Enter Title Text

2 Select Images

Customize Your Photo Book
Step: 1 2 **3** 4 5

Book Options
Title: A Day at the Zoo
Subtitle: with Granddad and Nana
Author: Jennifer Fulton

Body Pages
☐ Header:
☑ Footer: August 2003
☑ Include Captions
☑ Include Page Numbers

Captions will not appear on the Title page. Read more about adding captions in Help.

Preview Your Photo Book
Step: 1 2 3 **4** 5

A Day at the Zoo
with Granddad and Nana
Jennifer Fulton

Cover

Full Screen Preview Rearrange Photos

8 Add Captions

7 Add Header and Footer Text

9 Preview and Upload Creation

10 Save Creation

If you want page numbers to appear next to the footer text (if any), select the **Include Page Numbers** check box.

8 Add Captions

If you added text captions to your photos, you can print them next to each image by selecting the **Include Captions** check box. (See **58** **Add a Text Caption.**) Captions, by the way, are not printed on the cover, even if you choose the **Include Captions** option. Note that the **Include Captions** option is not available with certain book templates. Click **Next**.

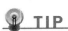

TIP

Before uploading the photo book for printing, you might want to review it full screen by clicking the **Full Screen Preview** button on **Step 4** of the wizard. Doing so will allow you to catch any misspellings in the text, or less than perfect images.

9 Preview and Upload Creation

On the **Step 4** page, preview the photo book using the navigation controls. If desired, return to any of the previous steps and make new selections. Click **Rearrange Photos** to redisplay the Workspace so that you can edit an image, add or remove images, or add text captions if needed. Click **Next** to continue.

On the **Step 5** page, click **Order Online** to upload the photo book to an online service such as **MyPublisher** to have it professionally printed and bound. After the photo book is uploaded to MyPublisher, you'll get an opportunity to select from a linen or leather cover in your choice of color. See **122** **Print a Creation Using an Online Service** for more information.

10 Save Creation

The **Step 5** page of the wizard is still displayed. The **Title** you typed on the **Step 3** page appears in the **Name** box and is used to name your saved creation. If you want to use an alternative name, deselect the **Use Title for Name** check box and then type a new title in the **Name** box.

Click **Done** to save the creation using the text in the **Name** box to label the creation. You might see a warning box reminding you that the creation now appears at the top of the photo well along with other items in the catalog. Click **OK**. The Workspace is closed for you automatically.

102 Create a Photo Album

For a simple, do-it-yourself home project, a *photo album* is hard to beat. Using the **Creations** wizard, you can select a group of images, choose a layout, and in minutes, create a photo album ready for printing at home. You might create a photo album to commemorate a special event such as a 50th birthday, retirement party, anniversary, or family vacation. And best of all, you don't have to mess with photo corners or glue sticks to create your album! Instead, all you'll need is a good photo printer and some nice, heavy paper.

You don't have to print your photo album if you don't want to; you can create one and save it in *PDF format* for easy distribution to friends and family using email or a CD-ROM disc. See **104** **Save a Creation in PDF Format** and **113** **Email an Item** for help. If a printed keepsake is your goal, you might want to create a professionally printed *photo book* instead, as explained in **101** **Create a Photo Book.**

① Click Create

Click the **Create** button on the **Shortcuts** bar. The *Workspace* appears with no images.

② Select Images

Drag and drop each image you want to use into the Workspace. Rearrange the images so that they appear in the order they will be used, cover image first.

A photo album can have any number of pages, so there's no limit to the number of images you can include. The number of pages in the final result and the number of images per page depends on the **Photos per page** option you set in **Step 3** of the wizard. The first image in the Workspace will be used on the title page (essentially, the "cover") so keep that in mind as you select and arrange images.

③ Click Start Creations Wizard

Click the **Start Creations Wizard** button. The **Creations** wizard appears, displaying the **Step 1** page.

Before You Begin

✔ **96** About Creations
✔ **97** About the Workspace

See Also

→ **101** Create a Photo Book

KEY TERM

Photo album—Similar to a photo book, except the intention is that you will print the result yourself. In a photo album, images and captions are arranged in the template you select, which can include a decorative background.

TIP

If you want to select a group of related images such as all the images of a recent holiday, use the **Find** bar to display them first. (See **73** About Finding Items.) Then press **Ctrl+A** or choose **Edit, Select All** to quickly select the displayed items. If the catalog is sorted by batch or folder, you can click the gray bar above a group to select all the items in that group. With either of these two methods, you might also end up selecting video, audio, and creation files, so press **Ctrl** and click the files you don't want to deselect them.

1 Click Create

3 Click Start Creations Wizard

Select a Template
Step: 1 2 3 4 5

4 Select Album Template

2 Select Images

5 Select Album Style

6 Enter Title Text

7 Select Number of Photos per Page

8 Add Header or Footer Text

9 Add Captions

10 Preview and Print Creation

11 Save Creation

4 Select Album Template

On the **Step 1** page, choose **Album** from the **Select the template type** list. Click **Next**.

5 Select Album Style

On the **Step 2** page, select a photo album style from the **Choose your Album style** list. A sample of the style you select appears on the right. Click **Next**.

6 Enter Title Text

On the **Step 3** page, type a title for the photo album in the **Title** box. This title will appear on the album's cover page (page one).

7 Select Number of Photos per Page

From the **Photos per Page** drop-down list, select the number of photos you want to appear on each page of the album. The default is one photo per page, but you can choose two, three, or four photos per page if you like. You can also choose a sequence that varies the number of photos per page. For example, if you choose **Sequence 1, 3, 2, repeat**, then one photo will appear on page two (the page after the title page), three photos appear on page three, two photos on page four, and so on.

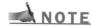

NOTE

If you select a sequence from the **Photos per Page** drop-down list, the images might not appear in the order they are arranged in the Workspace. Images might be rearranged to better suit the sequence you select.

8 Add Header or Footer Text

Add *header* or *footer* text as desired. Select the **Header** or **Footer** check box and type the desired text in the box provided.

If you want page numbers to appear next to the footer text (if any), select the **Include Page Numbers** check box.

9 Add Captions

If you added text captions to your photos, you can print them next to each image by selecting the **Include Captions** check box. (See **58** **Add a Text Caption**.) Captions, by the way, are not printed on the cover, even if you choose the **Include Captions** option. Click **Next**.

⑩ Preview and Print Creation

On the **Step 4** page, preview the photo album using the navigation controls. If desired, return to any of the previous steps and make new selections. Click **Rearrange Photos** to redisplay the Workspace so that you can edit an image, add or remove images, or add text captions if needed. Click **Next** to continue.

On the **Step 5** page, click the **Print** button to print the album on your home printer. The **Print** dialog box appears. You might want to change the paper type if you are using photo paper or a special card stock, and increase the print quality by changing the printer **Properties**. See **121** **Print a Creation at Home** for help.

When you're ready, click **Print** in the **Print** dialog box. The title page is printed first, followed by each page in the album.

⑪ Save Creation

The **Step 5** page of the wizard is still displayed. The **Title** you typed on the **Step 3** page appears in the **Name** box and is used to name your saved creation. If you want to use an alternative name, deselect the **Use Title for Name** check box and type a new title in the **Name** box.

Click **Done** to save the creation using the text in the **Name** box as the creation name. You might see a warning box reminding you that the creation now appears at the top of the photo well along with other items in the catalog. Click **OK**.

> **📍 TIP**
>
> For a more professional look, have your printed album pages spiral bound at your local copier store.

103 Use an Image as Your Windows Desktop

See Also

→ **86** About Fix Photo

The Windows Desktop is the first thing you see when you start your computer each day. On it you might have placed icons for each of your favorite programs, so you probably return to the Desktop often to start applications. As a Windows user, you are probably already aware that you can choose another color or can replace the color completely and use a graphic such as a photograph. Windows comes with a small supply of interesting graphic images such as a beach scene, blue sky, and so on. In addition, you can use your own images as the Windows Desktop. After improving a favorite photo using Photoshop Album's editor or another *graphics editor*, why not place it where you will notice it every day, such as on the Windows Desktop?

1 Select Image

2 Replace Desktop with Image

3 View the Result

You can also use your images in the Windows screensaver. Simply place all the images you want to use in the same folder. Then right-click the desktop, choose **Properties**, and click the **Screen Saver** tab. Select **My Pictures Slideshow** from the **Screen Saver** list, then click the **Settings** button. Click **Browse** and select the folder in which you've placed the images you want to use, and then click **OK** three times.

1 Select Image

In the photo well, click the image you want to use as your Desktop wallpaper. The selected image appears with a yellow border.

TIP

Use the **Find** bar to locate an image quickly. (See **73** About Finding Items.) For example, if you've tagged all your holiday images with a **Holiday** tag, you could use the **Tags** pane to quickly locate a Fourth of July image to place on the Desktop during July.

NOTE

If you want some color other than black to appear around the edges of your image on the Desktop, you'll have to skip Photoshop Album altogether. Right-click the desktop, choose **Properties**, and click the **Desktop** tab. Click **Browse** and select the image you want to use, then click **OK**. Open the **Position** list and select **Center**. Then open the **Color** list and choose the color you want to surround the image with. Click **OK**.

② **Replace Desktop with Image**

Choose **Edit, Set as Desktop Wallpaper** from the menu.

③ **View the Result**

The image you selected in step 1 is resized proportionately and placed on the Windows Desktop. If there's some room around the image (as there will be if the image uses *portrait orientation*), black appears around the edges of the photograph.

You can drag icons around the desktop to place them in unimportant areas of your image, if you like. Rearranging the icons in this manner enables you to see the best parts of the photograph.

104 Save a Creation in PDF Format

Before You Begin

✔ **96** About Creations

✔ **97** About the Workspace

KEY TERM

PDF format—Short for *Portable Document Format*, PDF ensures that a document's images and text are displayed exactly how they appeared when you created the document, even when that document is displayed on a different computer. The PDF format was developed by Adobe, and documents in this format can be viewed on any computer using Adobe Reader.

In the last step of the **Creations** wizard (the **Step 5** page), you are presented with a lot of options for sharing your masterpiece. You can print the *creation* at home or through an online service, or convert the creation to a DVD compatible format (*Video CD* format) for playback on a DVD player. You can convert the creation to a *slideshow* and burn it to a disc (this process also creates a copy of the creation in *PDF format*). You can also convert the creation to PDF format and immediately send it in an email to friends and family. The advantage of using PDF format is that it protects the layout of your creation so that it looks the same on every computer; in addition, viewing a document in PDF format is simple and easy for anyone to do.

The only requirement to sharing a creation in this manner is that the recipient of your creation must have Adobe Reader installed on his computer. Luckily, most people already have this little application installed because PDF documents are so prevalent on the Internet. As long as Adobe Reader is installed, a recipient of one of your creations can easily view the PDF file (typically by double-clicking its filename on the CD or within the email message).

WEB RESOURCE

If your user doesn't have Adobe Reader installed, they can download it for free from Adobe.

www.adobe.com/support/downloads/main.html

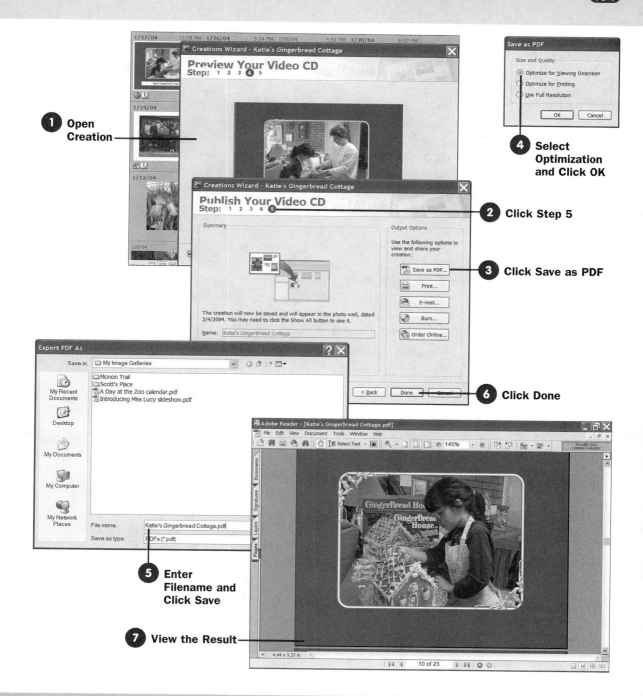

1 Open Creation

4 Select Optimization and Click OK

2 Click Step 5

3 Click Save as PDF

6 Click Done

5 Enter Filename and Click Save

7 View the Result

Regardless of the type of creation you share, if the recipient uses Adobe Reader 6.0 or higher, Reader's **Picture Tasks** toolbar will allow the user to easily export all the included images; export and edit the images in one simple step; print the images individually, in a *portrait sheet*, or as a *contact sheet* (in the same way you perform these same tasks within Photoshop Album); upload the images to an online service and have them professionally printed (as explained in **120** **Print Images Using an Online Service**); or upload the creation to an online service and have it professionally printed and bound, as explained in **122** **Print a Creation Using an Online Service** (assuming that the creation is a calendar or a photo book).

You can also save the PDF file to the hard disk for your own personal use or for distribution later on. This is the process discussed in this task. To learn how to email a creation after converting it to PDF format, see **113** **Email an Item**; to learn how to copy a creation to a CD in both slideshow and PDF formats, see **105** **Burn a Creation to a CD**.

 TIP

The resulting PDF file will not play automatically unless the creation you've chosen is a slideshow. You can change to a slideshow format by returning to **Step 1** of the **Creations** wizard. If the creation is already in slideshow format, you can change whether you want it to play automatically on startup and whether you want to display the video controls by returning to **Step 3** of the wizard. Make changes to the creation as desired before continuing to step 3 of these instructions.

❶ Open Creation

If it is not already open, open the creation in the **Creations** wizard by double-clicking its *thumbnail* in the photo well. (If you're currently making the creation, skip this step.)

❷ Click Step 5

In the **Creations** wizard, click the **Step 5** icon at the top of the window to display the **Step 5** page. You can also click the **Next** button as many times as needed to display the **Step 5** page.

❸ Click Save as PDF

On the **Step 5** page of the wizard, click the **Save as PDF** button to save this creation in PDF format. The **Save as PDF** dialog box appears.

❹ Select Optimization and Click OK

In the **Save as PDF** dialog box, select the optimization type you prefer. Choose **Optimize for Viewing Onscreen** to reduce the image quality a bit and make the resulting file smaller; choose

Optimize for Printing to reduce file size only where critically necessary; choose **Use Full Resolution** to leave each image as is. If you select the third option, your final PDF file size might be very large, but no detail will be lost from your images.

After making a selection, click **OK**. The **Export PDF As** dialog box appears.

 TIP

If you want to ensure that any images your recipients might want to print from your creation will be of good quality, select **Optimize for Printing**.

5 Enter Filename and Click Save

First, change to the folder in which you want to save the PDF file by selecting it from the **Save in** drop-down list.

Photoshop Album suggests that you use a filename for the PDF file that's similar to the creation's name. If you want to use a different filename, select the suggested filename and type a new name in the **File name** text box. Click **Save** to save the file.

6 Click Done

Step 5 of the **Creations** wizard is still displayed; click **Done** to save any changes you made to the creation; click **Cancel** if you don't want to save the changes. The wizard is closed and you are returned to the photo well.

7 View the Result

To view the PDF file you've just created, open **Windows Explorer** and change to the folder in which you saved it. Then double-click the PDF file to display it in **Adobe Reader**.

After the PDF file is opened, **Adobe Reader** does one of two things: For most creations, it simply presents the first page of the creation and waits for the user to navigate to the other pages. For slideshow creations, it displays the first page in a full-screen slideshow format. Depending on the options you chose when you created the slideshow, it may play automatically or the user might have to click a **Play** button to start the show. Also during the slideshow, a control panel might be displayed, with VCR-like controls for fast forward, pause, rewind, and stop. In any case, after the last page is displayed, a dialog box appears so that the user can easily rerun the slideshow if they like.

105 Burn a Creation to a CD

Before You Begin

✔ **96** About Creations

✔ **97** About the Workspace

NOTE

If you want to share the images used in a creation only, and not present them within a slideshow, open the creation; on the **Step 4** page, click **Rearrange Photos**. In the Workspace, click the **Select command to apply to all items in the Workspace** button, and select **Archive** from the menu that appears. See **47** Copy Items onto CD-ROM or DVD for more help.

TIP

The resulting PDF file does not play automatically unless the creation you've chosen is a slideshow. You can change to a slideshow format by returning to **Step 1** of the **Creations** wizard. If the creation is already in slideshow format, you can change whether you want it to play automatically on startup and whether you want to display the control panel by returning to **Step 3** of the wizard. Make changes to the creation as desired before continuing to step 3 of these instructions.

Photoshop Album provides many ways in which you can share your *creations*, such as emailing them or printing them out at home. Another simple way to share a creation is to convert it to a *slideshow* and copy it to a CD. This slideshow works just the way it does within Photoshop Album; the screen goes blank, and the first image is displayed. (See **48** View Images in a Slideshow.) Video controls appear so that the user can start, stop, and pause the show or jump instantly from image to image. The creation is also saved in *PDF format* along with each of the image files, in a special **files** folder on the disc.

In this task, you'll learn how to convert a creation to a slideshow and save it to a disc. This slideshow does not play automatically, but video controls are included to help display the slideshow. If you want to control these and other options, create a slideshow yourself, and then burn it to CD as described here. See **108** Create a Slideshow of Images for more help. During the burn process, the creation is also converted to PDF format and copied to the disc along with the actual image files. If you want to simply convert the creation to PDF format and save it on your computer instead, see **104** Save a Creation in PDF Format. To convert the creation to PDF format and send it immediately in an email, see **113** Email an Item.

● **1** Open Creation

If it's not already open, open the creation in the **Creations** wizard by double-clicking its *thumbnail* in the photo well. (If you're currently making the creation, skip this step.)

● **2** Click Step 5

In the **Creations** wizard, click the **Step 5** icon at the top of the window to display the **Step 5** page. You can also click the **Next** button as many times as needed to display the **Step 5** page.

● **3** Click Burn

On the **Step 5** page of the wizard, click the **Burn** button to convert this creation to PDF format and save it on a CD. The **Select Disc Settings** dialog box appears.

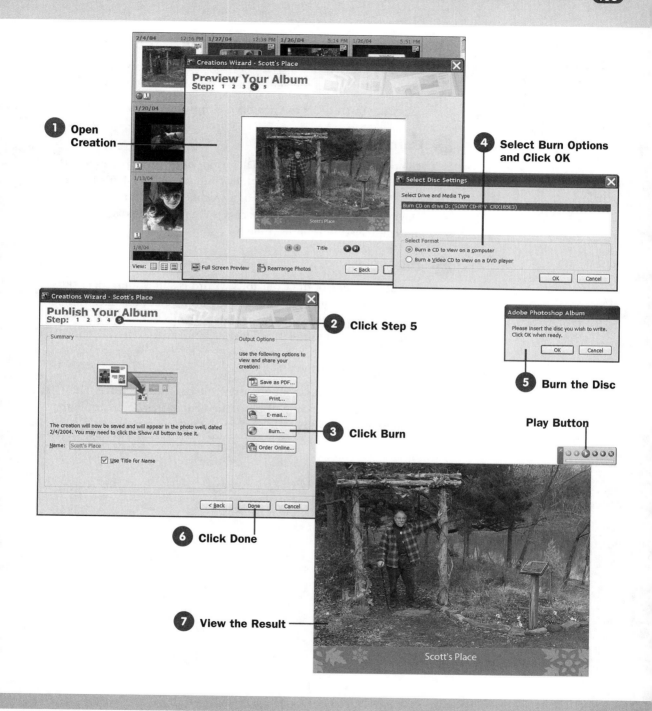

1 Open Creation

4 Select Burn Options and Click OK

2 Click Step 5

3 Click Burn

5 Burn the Disc

Play Button

6 Click Done

7 View the Result

NOTE

The **Burn a Video CD to view on a DVD player** option is used to convert the creation to Video CD format. See **109** Create a Video CD for more information.

4 Select Burn Options and Click OK

In the **Select Disc Settings** dialog box, select the drive you prefer from those listed in the **Select Drive and Media Type** list.

Select the **Burn a CD to view on a computer** option and click **OK**.

5 Burn the Disc

The creation is converted to PDF format and you're prompted to insert a CD. Do so and click **OK** to continue. The PDF file is burned to the CD; be patient because this process can take a while on older computers. When the process is complete, the disc is automatically ejected from its drive.

6 Click Done

The **Step 5** page of the **Creations** wizard is still displayed; click **Done** to save any changes you made to the creation; click **Cancel** if you don't want to save the changes. The wizard is closed and you are returned to the photo well.

7 View the Result

To view the slideshow, simply insert the disc into its drive. The slideshow automatically displays the first image. To continue the slideshow, click the **Play** button on the video controls.

12

Sharing Images

IN THIS CHAPTER:

If there's anything *less* convenient about the new world of digital photography than the old days when you took pictures with a film camera and then waited days or even weeks to see them, it's how difficult it is to share your digital photos with friends and family. Granted, you can print your digital photos any number of times, but even then, you have to do the preparation and the processing yourself. And if you want to share the digital photo *files* with your friends, there's no easy medium for you to do so. Assuming that your computer has a drive with the capability to write data, you could just copy a group of images to an optical disc, but even then, how can you be assured that your recipient can easily locate, open, and view your pictures?

Photoshop Album makes it possible for you to share your image files in such a way that you'll *know* your friends and family can view them without hassle. For example, you could create a **Web Photo Gallery** or an **Adobe Atmosphere 3D Gallery** to publish the images to your Web site. If you don't have a Web site, you can upload images to an online service to share them. If your friends or relatives don't have an Internet connection, you can create a **Video CD** or a **slideshow** where images appear one after the other automatically, with fancy backgrounds and music. If you have just a few images you want to share, Photoshop Album provides a simple method for emailing them.

NOTE

Your recipients *do not* have to own Photoshop Album themselves to enjoy the various *creations* (slideshows, Video CDs, or image galleries) you might make.

106 Create a Web Gallery of Images

See Also

→ **58** Add a Text Caption
→ **107** Create an Adobe Atmosphere 3D Gallery
→ **108** Create a Slideshow of Images
→ **109** Create a Video CD

The problem many ambitious people have when they lease Web space on a public server is that they suddenly come face-to-face with how little they know about producing a Web page or a Web site. If you weren't born speaking **HTML** as your native language, creating a Web page from scratch can be an enormously difficult skill to pick up secondhand. Luckily, the **Web Photo Gallery** feature of Photoshop Album automatically creates a series of Web pages filled with the correct HTML codes for displaying your images properly through a Web browser. On these Web pages, images are displayed as **thumbnails** so that all the images in the gallery can be quickly viewed. Any visitor to your Web site can click one of these thumbnails to see that image close up. Because the gallery pages are in HTML format, they can be viewed on a Macintosh or Linux computer as well as a Windows computer.

The Web Photo Gallery feature generates the files you need for an image gallery that you can then upload to your Web site using Windows Explorer or an FTP program such as WS_FTP. These files include large, reduced-*resolution* copies and small thumbnail copies of your image files plus various Web pages. If you don't have a Web site or you like the idea but don't want your photos on the Internet, you can still create a Web Photo Gallery and copy these files to optical discs such as CD-Rs, which you can then give to your friends and family to be shared and viewed in private (not over the Internet).

① Select Images

In the photo well, select the images you want to include in your Web Photo Gallery. To select contiguous images, press **Shift**, click the first image, then click the last image in the group. To select noncontiguous images, press **Ctrl** and click each one. Selected files appear with a yellow border.

② Choose Creations, Web Photo Gallery

From the menu bar, select **Creations, Web Photo Gallery**. The **Web Photo Gallery with Selected Items** dialog box appears.

③ Create Destination Folder

In the **Site Folder** text box, type a name for a new folder where you want Photoshop Album to place the Web gallery files. Photoshop Album creates this new folder for you and places it as a subfolder within the **My Documents** folder.

If you want your new folder to be placed within some other folder instead, click **Browse** and select that folder now. Click **OK** to return to the **Web Photo Gallery with Selected Items** dialog box.

④ Choose a Gallery Style

Your users will navigate the image gallery by clicking a thumbnail of an image to see that image close up. Some gallery styles display the thumbnails in a single row or column, with the close-up image alongside; others arrange all the thumbnails as a single group, so that the close-up appears on its own separate page. Sample layouts (with someone else's photos) appear in the **Preview** area. To select a different style, choose from the **Gallery Style** drop-down list.

KEY TERMS

Web Photo Gallery—An organized collection of images that can be viewed using a Web browser.

HTML (Hypertext Markup Language)—A series of codes that tell a Web browser how to properly display the text, graphics, animations, and other elements of a Web page.

TIP

If you want to select a group of related items such as all the images from a recent vacation, use the **Find** bar to display them first. (See **73** About Finding Items.) Then press **Ctrl+A** or choose **Edit, Select All** to quickly select the displayed images. If the catalog is sorted by batch or folder, you can click the gray bar above a group to select all the items in that group.

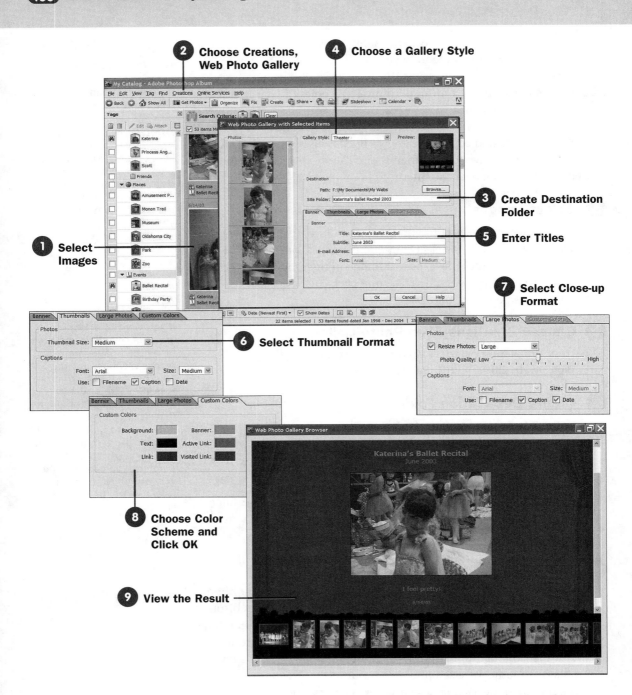

2 Choose Creations, Web Photo Gallery

4 Choose a Gallery Style

3 Create Destination Folder

5 Enter Titles

1 Select Images

7 Select Close-up Format

6 Select Thumbnail Format

8 Choose Color Scheme and Click OK

9 View the Result

⑤ Enter Titles

A title and subtitle for your gallery appear at the top of each Web page. On the **Banner** tab, in the boxes marked **Title** and **Subtitle**, type the text for these titles. If you want to make it easy for a user to send an email comment to you about the Web Photo Gallery, type your email address in the **E-mail Address** box. A hyperlink will then be placed beneath the subtitle on each page; should a user click the link, an email message addressed to you will automatically display.

⑥ Select Thumbnail Format

Click the **Thumbnails** tab and select the size for the image miniatures from the **Thumbnail Size** list. (Note that changing this setting does not change the **Preview** in the upper-right corner of the dialog box.)

Normally, the image's filename appears under each thumbnail. With some gallery styles, you can display the image **Caption** or **Date** instead. See **58** **Add a Text Caption** for help in changing the image *caption*; see **60** **Change Image Date and Time** for help in adjusting the *file date*. You can also select a different **Font** and relative **Size** setting for displaying this information.

⑦ Select Close-up Format

Click the **Large Photos** tab. To have the Web gallery resize all close-up photos to fit the same area (whether it has to expand or shrink them), select the **Resize Photos** check box. Select the size of this area from the list provided. This size is relative and can vary from viewer to viewer, depending on monitor resolution. However, "large" will be fairly large in relation to the browser window, and "small" will be fairly small.

If you do not select the **Resize Photos** option, images will appear in their native size and might overrun the space apportioned for them if they happen to be too large. (In such a case, the Web browser may provide scroll bars.)

When Photoshop Album generates the large photos for your Web gallery, it makes medium-resolution copies of the images so that the images will display quickly in the user's browser (the higher

> **NOTE**
>
> Because all computers are not the same, Web pages typically use fonts that most people have. By default, the **Font** setting for your banner is set to Arial, which is a common sans serif font. With some of the gallery styles you can change the display font, but only to one of a few options: Courier New (typewriter-style with fixed widths per character), Helvetica (often the default page font for Macintosh and Linux), Times New Roman (the most common serif font), and Default (to let the user's Web browser decide). You can change the font **Size** setting as well.

TIP

If you plan to copy the Web Photo Gallery onto an optical disc (CD-R, CD-RW, DVD-RAM) rather than uploading it to the Internet, the display time is not a factor. Thus, set the **Photo Quality** slider to **High** to ensure the highest quality viewing experience.

TIP

The home page for your Web gallery is the file **index.html**, located in the destination directory you selected in step 3. In Windows Explorer, you can double-click this file at any time to view the gallery in your Web browser. If you copy the files to a disc, your user must double-click the **index.html** file to view the gallery as well.

the **Photo Quality** setting, the better the photo detail, and the longer it takes to display the image). You can increase or decrease the quality (and the relative size of the close-up images) by moving the **Photo Quality** slider. If you skimp on the photo quality (by selecting a **Low** setting), a viewer might be able to load images quickly but might have trouble making out the contents of particular images, even when viewed in a large size because low-resolution images do not contain much detail.

Select the check boxes for the options you want to appear beneath each close-up (large) image: **Filename**, **Caption**, and **Date**. With some gallery styles, you can choose a **Font** and relative **Size** setting for the display of this information from the drop-down lists.

8 Choose Color Scheme and Click OK

Web gallery styles with white page backgrounds in the **Preview** (the **Horizontal Frame**, **Simple**, and **Vertical Frame** styles) allow you to choose the colors used for these elements: background color, banner background and text colors, and hyperlink colors for unvisited, active, and already visited links. Click the **Custom Colors** tab to see the current color settings for these elements. To change any color, click that color; from the **Color** dialog box that opens, choose a new color and click **OK**.

To finalize your choices, click **OK** in the **Web Photo Gallery with Selected Items** dialog box. If an existing Web gallery has been created in this folder and you want to delete it and create a new one in its place, click **OK**. Photoshop Album creates the new folder and places copies of the chosen image files, along with HTML pages and other components that enable these images to be displayed in a browser, in that folder.

9 View the Result

Photoshop Album automatically opens a browser window for you to examine and tour your newly created gallery. To view a close-up of a particular image, click its thumbnail. If you don't like the colors or fonts you chose, if you forgot to add an image caption, or if you want to make other changes, you can repeat these steps to create a new gallery to replace the old one.

107 Create an Adobe Atmosphere 3D Gallery

If you've ever wondered how it might feel to view images inside a three-dimensional, virtual photo gallery similar to those computer games in which you walk around hallways, caverns, or courtyards, here at last is your opportunity. An *Adobe Atmosphere 3D Gallery* uses the same 3D rendering technology from the realm of gaming to hang the photos of your choice along virtual walls in simulated halls. It then gives you the tools to go walking down these halls through your screen, using your mouse. You can even display an *avatar* within the 3D gallery to make the viewing experience even more realistic and personal.

The "player" that helps a user properly display an Adobe Atmosphere 3D Gallery is called the Viewpoint Media Player. It's an ActiveX control that plugs into the Internet Explorer Web browser for Windows only. When you installed Photoshop Album, its setup procedure installed this control on your system. Users who don't have Photoshop Album installed can still view your 3D gallery, but only if they allow your gallery files to trigger the installation of the Viewpoint Media Player on their systems. In such a case, the user must reduce or turn off security for his Web browser and disengage any pop-up blockers that may have been installed.

① Select Images

In the photo well, select the images you want to include in your 3D gallery. To select contiguous images, press **Shift**, click the first image, then click the last image in the group. To select noncontiguous images, press **Ctrl** and click each one. Selected files appear with a yellow border.

② Choose Creations, Adobe Atmosphere 3D Gallery

From the menu bar, select **Creations, Adobe Atmosphere 3D Gallery**. The **Adobe Atmosphere 3D Gallery with Selected Items** dialog box appears.

③ Create Destination Folder

In the **Site Folder** text box, type a name for a new folder where you want Photoshop Album to place the 3D gallery files. Photoshop Album creates this new folder for you and places it as a subfolder within the **My Documents** folder.

See Also

→ **58** Add a Text Caption

→ **106** Create a Web Gallery of Images

→ **108** Create a Slideshow of Images

→ **109** Create a Video CD

🔍 KEY TERMS

Adobe Atmosphere 3D Gallery—A collection of images presented (in a Web browser window) within a three-dimensional art gallery, with the help of a special viewer called the Viewpoint Media Player.

Avatar—A 3D animated image that represents a particular user within a multiuser virtual world.

📝 NOTE

If you or your users encounter any problems displaying your Adobe Atmosphere 3D Gallery within Internet Explorer, try installing the new viewer, available at **www. viewpoint.com** (look for the **Download Player** link at the bottom of the page).

TIP

If you want to select a group of related items such as all the images of a visit to a science museum, use the **Find** bar to display them first. (See **73** About Finding Items.) Then press **Ctrl+A** or choose **Edit**, **Select All** to quickly select the displayed images. If the catalog is sorted by batch or folder, you can click the gray bar above a group to select all the items in that group.

NOTE

If you plan to publish your 3D gallery to your Web site, the **Enable Chat** check box provides a way for multiple simultaneous viewers of your gallery to "see" one another, say hello, and share their critiques. This option requires more resources and bandwidth than some leased Web sites are capable of providing, and it might also violate the security protocols of some Web sites. Check with your Internet service provider for details.

If you want your new folder to be placed within some other folder instead, click **Browse** and select that folder now. Click **OK** to return to the **Adobe Atmosphere 3D Gallery with Selected Items** dialog box.

④ Choose a Gallery Style

Your users will browse your images within the gallery setting you select. Sample galleries (using someone else's photos) appear in the **Preview** area in the upper-right corner of the dialog box. To select a different style, choose it from the **Gallery Style** drop-down list.

The description for the gallery you select tells you how many images it can hold; if you selected more than that number of images in step 1, images are placed into groups, and Adobe provides a way for your user to switch between groups. (If you look at the final result figure, you'll notice a list box in the upper-left from which a visitor to my gallery can select the particular group of images he wants to view.) The musical background listed in the description plays while your user is wandering your gallery's halls—you cannot change this musical selection.

⑤ Enter Titles

A title and subtitle for your gallery appears in a separate pane within the user's Web browser. On the **Banner** tab, in the boxes marked **Title** and **Subtitle**, type the text for these titles. If you want to make it easy for a user to send an email comment to you about the 3D Gallery, type your email address in the **E-mail Address** box. A hyperlink will then be placed beneath the subtitle on each page; should a user click the link, an email message addressed to you automatically displays.

⑥ Set Close-up Format

When your gallery patron single-clicks a photo hanging on a wall, a close-up rendering of that photo appears in the right pane of the Web browser. Click the **Large Photos** tab. To have the 3D gallery resize all close-up photos to fit the same area (whether it has to expand or shrink them), select the **Resize Photos** check box. Select the size of this area from the list provided. This size is relative and can vary from viewer to viewer, depending on monitor resolution. However, "large" will be fairly large in relation to the browser window, and "small" will be fairly small.

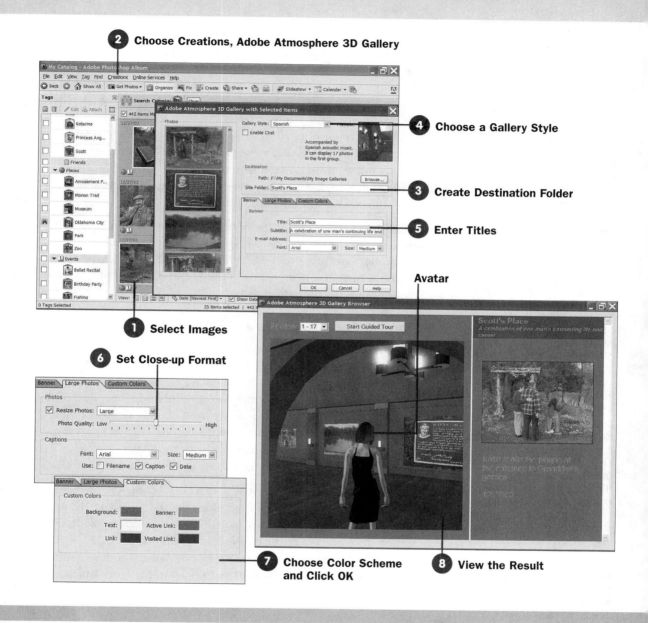

2 Choose Creations, Adobe Atmosphere 3D Gallery

4 Choose a Gallery Style

3 Create Destination Folder

5 Enter Titles

Avatar

1 Select Images

6 Set Close-up Format

7 Choose Color Scheme and Click OK

8 View the Result

If you do not select the **Resize Photos** option, images appear in their native size and might overrun the space apportioned for them if they happen to be too large. (In such a case, the Web browser may provide scroll bars.)

NOTE

Because everybody's computers are not the same, Web pages typically use fonts that most people have. By default, the **Font** setting for your banner is set to Arial, which is a common sans serif font. With some of the gallery styles you can change the display font for the Banner text, but only to one of a few options: Courier New (typewriter-style with fixed widths per character), Helvetica (often the default page font for Macintosh and Linux), Times New Roman (the most common serif font), and Default (to let the user's Web browser decide). You can change the font **Size** setting as well.

TIP

If you plan on copying the 3D gallery onto an optical disc (CD-R, CD-RW, DVD-RAM) rather than uploading it to the Internet, display time is not a factor. Thus, set the **Photo Quality** slider to **High** to ensure the highest quality viewing experience.

TIP

The home page for your 3D gallery is the file **index.html**, located in the destination directory you selected in step 3. In Windows Explorer, you can double-click this file at any time to view the gallery in your Web browser. If you copy the files to a disc, your user must double-click the **index.html** file.

When Photoshop Album generates the large photos for your 3D gallery, it makes medium-*resolution* copies of the images so that the images will display quickly in the user's browser (the higher the **Photo Quality** setting, the better the photo detail and the longer it takes to display the image). You can increase or decrease the quality (and the relative size of the close-up images) by moving the **Photo Quality** slider. If you skimp on the photo quality (by selecting a **Low** setting), a viewer might be able to load images quickly but might have trouble making out the contents of particular images, even when viewed in a large size, because low-resolution images do not contain much detail.

Select the check boxes for the options you want to appear in a separate pane of the Web browser when each image is viewed: **Filename**, **Caption**, and **Date**. With some gallery styles, you can choose a **Font** and relative **Size** setting for the display of this information from the drop-down lists.

⑦ Choose Color Scheme and Click OK

Text pertaining to the 3D gallery appears in the right pane, with the user's view of the gallery itself in the left pane. You can set preferences for the colors of the following elements in the right pane: background color, banner background and text colors, and hyperlink colors for unvisited, active, and already visited links. Click the **Custom Colors** tab to see the current color settings for these elements. To change any color, click that color. From the **Color** dialog box that appears, choose a new color and click **OK**.

To finalize your choices, click **OK** to close the **Adobe Atmosphere 3D Gallery with Selected Items** dialog box. If an existing 3D gallery has been created in the folder you selected in step 3, and you want to delete it and create a new one in its place, click **OK**. Photoshop Album creates the new folder and places copies of the chosen image files, along with *HTML* pages and other components that enable these images to be displayed in a browser, in that folder.

⑧ View the Result

When the gallery files have been generated, Photoshop Album opens a browser window for you to examine and tour your newly created gallery. To have the gallery walk you through automatically, click **Start Guided Tour**.

To manually navigate the gallery, click anywhere inside the gallery window. Then use the arrow keys on your keyboard to move around. Hold down the ↑ key to walk forward through the gallery; hold down the ↓ key to step backward. Press ← and → to twist your "body" left and right. To move with your mouse instead, simply drag in the direction you want to move yourself.

To display an image close-up in the right pane, click on its 3D representation in the gallery pane.

If your gallery contains more images than fit into a single room, you can switch between image groups by selecting an image group number range (such as **1–17**) from the list at the top of the gallery window.

Click the close box (the **X** in the title bar) to close the gallery browser.

To see yourself as you walk around the gallery, right-click the 3D gallery pane and select **Navigation**, **Show My Avatar** from the context menu. To change to a different person (avatar), right-click the gallery pane and select **Window**, **Avatars**. Double-click the avatar you prefer.

NOTE

To copy the 3D gallery files on your own Web site, you must upload the contents of the folder you created, with its **pages**, **Gallery**, and **images** subfolders intact. For many Web sites, this is possible using Windows Explorer, although you might prefer using a dedicated FTP client instead. You can also burn the main folder and its subfolders to a CD-R so that you can distribute your gallery personally to friends or family with any type of computer.

108 Create a Slideshow of Images

A Photoshop Album *slideshow* is an orchestrated collection of images displayed in sequence, complete with *transitions* between frames and optional background music. In **48** View Images in a Slideshow, you learned how to instantly view a collection of images, arranged in the format of a slideshow, minus the music. In this task, you'll learn how to create a slideshow *package*—a single file that contains copies of all the resources required for Adobe Reader (formerly Adobe Acrobat Reader) to display a slideshow presentation.

What makes a slideshow package so versatile is the fact that it is *only one file*, which you can easily publish on your Web site, email to friends and family, or copy onto disc. Anyone who has Adobe Reader 6.0 installed on their computer (it's also available for Macintosh, Linux, Unix, and even OS/2) can see and hear your slideshow production exactly the way you produced it.

Before You Begin

✔ **96** About Creations
✔ **97** About the Workspace

See Also

→ **48** View Images in a Slideshow
→ **58** Add a Text Caption
→ **59** Record an Audio Caption
→ **106** Create a Web Gallery of Images
→ **107** Create an Adobe Atmosphere 3D Gallery

NOTE

A Photoshop Album slideshow can contain video in addition to still images, but not audio files or *creations*. However, Adobe Reader might have difficulty with excessively long videos, especially on computers that are slow or have less than 512MB of RAM.

TIP

If you want to select a group of related images such as all the images of a recent celebration, use the **Find** bar to display them first. (See **73** **About Finding Items.**) Then press **Ctrl+A** or choose **Edit, Select All** to quickly select the displayed items. If the catalog is sorted by batch or folder, you can click the gray bar above a group to select all the items in that group. With either of these two methods, you might also end up selecting video, audio, and *creation* files, so press **Ctrl** and click the files you don't want to deselect them.

NOTE

If you select a sequence from the **Photos per Page** list, the images might not appear in the order in which they are arranged in the Workspace. Images might be rearranged to better suit the sequence you select.

1 Click Create

Click the **Create** button on the **Shortcuts** bar. The *Workspace* appears with no images.

2 Select Images

Drag and drop each image you want to use from the catalog into the **Workspace**. If necessary, rearrange the images so that they appear in the order you want them to appear in the slideshow.

3 Click Start Creations Wizard

When the sequence of image and video files in the Workspace is exactly the way you want it, click the **Start Creations Wizard** button. The **Creations Wizard** appears, displaying the **Step 1** page.

4 Select Slideshow Template

On the **Step 1** page, choose **Slideshow** from the **Select the template type** list. Click **Next**.

5 Select Slideshow Style

On the **Step 2** page, select a slideshow style from the **Choose your Slideshow style** list. A sample of the style you select appears on the right. Click **Next**.

6 Enter Title

On the **Step 3** page, to have the slideshow begin with a title page, select the **Title** check box and type a title in the box to the right. The first image in the **Workspace** appears on this title page.

7 Select Number of Photos per Page

From the **Photos per Page** drop-down list, select the number of photos you want to appear onscreen simultaneously. The default is one photo at a time, but you can choose 2, 3, or 4 if you like. You can also choose a sequence that varies the number of photos shown together. For example, if you choose **Sequence 1, 3, 2, repeat**, one photo will appear, then three photos, then two photos, and so on.

If you want image *captions* to appear below each image, enable the **Include Captions** check box. (See **58** **Add a Text Caption.**)

8 Set Audio Options

To have music play during the slideshow, select a music file from the **Background Music** drop-down list. If you don't see anything you like in the list of recently played music, click **Browse**, choose a file (in MPG or WAV format) on the hard disk, and click **Open** to return to the wizard. (The audio file you select by clicking **Browse** does not have to be in the catalog to be used in a slideshow.) The background music plays softly while video files are playing, which might prevent someone from hearing the video clearly, so keep that in mind if your slideshow also includes video files. To have your slideshow be silent, choose **None** from the **Background Music** list.

To have the slideshow play *audio captions* for images (when available), select the **Play Audio Captions** check box. Audio captions are played over top of the background music. (See **59 Record an Audio Caption**.)

9 Set Transition Options

Photoshop Album can produce eight different *transition* effects between each page of the slideshow. From the **Transition** drop-down list, select the transition you want to use throughout the slideshow; choose **Random** to vary the transitions; or choose **None** to simply have the slideshow replace each page with a new one.

The slideshow automatically switches between pages during the presentation, with each page containing one or more images (based on the **Photos Per Page** setting). To set how long each page should remain onscreen, choose a length of time from the **Page Duration** drop-down list. The slideshow waits for audio captions to play out before switching pages, so this setting represents a minimum duration.

10 Select Playback Options

To enable the user to move through the slideshow freely, select the **Include Play Controls** check box. The standard **Play**, **Stop**, **Pause**, **Rewind**, and **Fast Forward** buttons appear in a console on the slideshow display screen. (See **48 View Images in a Slideshow** for details about the individual controls.)

🔍 **KEY TERM**

Transition A visual effect between two images onscreen. One example is **Wipe Left**, where the next image is revealed gradually from left to right.

1 Click Create

2 Select Images

3 Click Start Creations Wizard

5 Select Slideshow Style

4 Select Slideshow Template

6 Enter Title

7 Select Number of Photos per Page

8 Set Audio Options

9 Set Transition Options

10 Select Playback Options

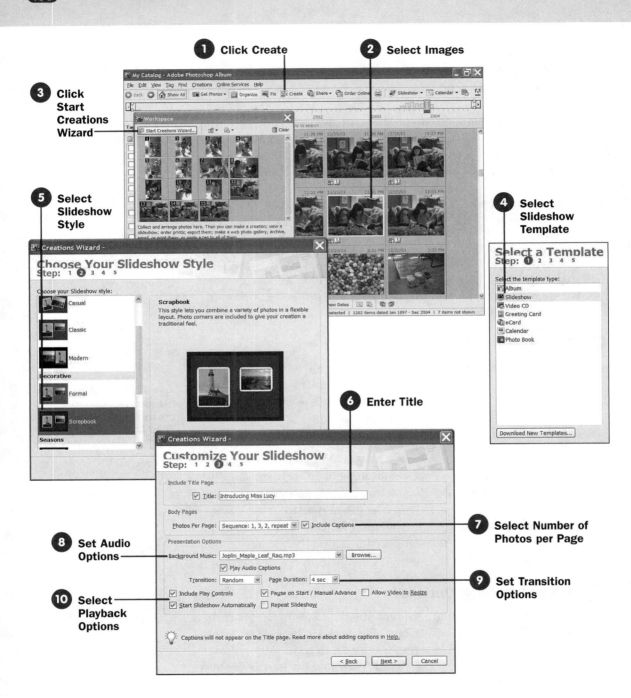

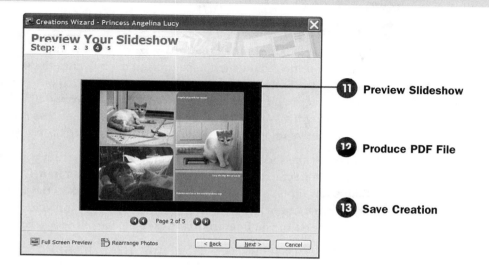

11 Preview Slideshow

12 Produce PDF File

13 Save Creation

To have the slideshow start playing on startup, select the **Start Slideshow Automatically** check box. If you don't select this option, Adobe Reader greets your viewer with a message and a **Play** button. The viewer must then click this button to darken the screen and start the show.

To cause the slideshow to pause at startup on the title page, select the **Pause on Start/Manual Advance** check box. The slideshow starts playing when the viewer clicks the **Play** button on the console or after the **Page Duration** time period has passed.

If your slideshow contains video files, select the **Allow Video to Resize** check box if you want those videos to play full screen. This option might make the video appear blocky or choppy (as is the case with low-*resolution* videos shot with digital still cameras), so you might not want to select this option.

Select the **Repeat Slideshow** check box to have the slideshow repeat itself automatically until the user clicks the **Stop** button on the console.

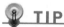 **TIP**

You can designate default playback settings for all your slideshows ahead of time. Select **File**, **Preferences** and click **Slideshow**. Select the settings you want to use most often when creating a slideshow, and click **OK**. You can still change these settings when creating a slideshow.

11 **Preview Slideshow**

On the **Step 4** page of the **Creations Wizard**, preview the slideshow using the navigation controls. If desired, click the **Back** button at the bottom of the wizard window to return to any of the previous steps and make new selections. Click **Rearrange Photos** to redisplay the Workspace so that you can edit an image, select an alternative image or video file, or add an audio caption.

To preview the slideshow with sound, the way your viewer will see it, click **Full Screen Preview**. See **48** **View Images in a Slideshow** for help in using the console that appears in the upper-right corner of the screen. When the slideshow ends (or when you stop it yourself), you'll return to the **Step 4** page of the wizard.

Click **Next** to continue.

TIP

To print the images in the slideshow, click **Print**. See **117** **Print Images** for information on using this option. To learn how you can create a *Video CD* of your slideshow for playback on a DVD player, see **109** **Create a Video CD**.

12 **Produce PDF File**

The **Step 5** page of the wizard displays. To convert the slideshow to *PDF format* and send it in an email message to someone, click **E-mail** (see **113** **Email an Item** for more help). To save the slideshow in PDF format and burn it to a CD in one step, click **Burn** (see **105** **Burn a Creation to a CD** for more information). To convert the slideshow to PDF format and save it to the hard disk so that you can distribute it later on, click **Save as PDF** (see **104** **Save a Creation in PDF Format** for details). Note that **Adobe Reader** is required to view a PDF slideshow.

13 **Save Creation**

You're returned to **Step 5** of the wizard. The **Title** you typed on the **Step 3** page appears in the **Name** text box and will be used to name your saved slideshow creation. If you want to use a different name, deselect the **Use Title for Name** check box and type a new title in the **Name** box.

Click **Done** to save the slideshow creation to the catalog. You might see a warning box reminding you that the creation now appears at the top of the photo well, with other items in the catalog. Click **OK**. The Workspace closes automatically.

109 **Create a Video CD**

What distinguishes a *Video CD* from a regular CD onto which you've copied some images (as discussed in **47** **Copy Items onto CD-ROM or DVD**) or a CD onto which you've burned a *slideshow* (as discussed in **105** **Burn a Creation to a CD** and **108** **Create a Slideshow of Images**) is the Video CD's capability to be played on a common DVD player (as long as the player supports the VCD format, as most do) using the DVD's remote control to operate and navigate the presentation. A Video CD can also be played in a computer's DVD or CD drive (with the help of a VCD player such as Windows Media Player). If you burn a CD of images and give it to someone, you have to worry whether she can easily locate and view each photo. If you burn a slideshow to disc, you have to worry whether your recipient has **Adobe Reader** on her computer. A Video CD, on the other hand, is almost universally accessible, assuming that your recipient has a DVD player with Video CD support. Just about every DVD player meets this requirement, but you can always view a list of compatible players to make sure.

Before You Begin

✔ **96** About Creations

✔ **97** About the Workspace

See Also

→ **58** Add a Text Caption

→ **105** Burn a Creation to a CD

→ **108** Create a Slideshow of Images

WEB RESOURCE

www.dvdrhelp.com

Visit this Web site to verify that a particular DVD player supports the VCD format.

Strangely enough, you can burn either a Video CD creation or a slideshow creation to a disc using the VCD format discussed in this task. So what's the difference? Frankly, not much. With a slideshow creation, you actually have more options. You can include *audio captions* and have multiple images per page; with the Video CD creation, you cannot have either audio captions or multiple images per page. However, you can include text *captions* beneath each of your Video CD images; with a slideshow, you cannot include text captions. The differences seem arbitrary, so when creating a VCD disc in Photoshop Album, your choice of creation depends on what and how much you want your VCD slideshow to include. For this task, I'll assume that you want to make a Video CD creation and burn it to a VCD disc; if you prefer to use a slideshow creation instead, complete the creation and burn the VCD by jumping to step 11.

KEY TERM

Video CD—Also known as a VCD. In Photoshop Album, a Video CD is a CD disc of images and video files formatted in such a way that a DVD player can play those images/videos in a controllable slideshow.

1 **Click Create**

Click the **Create** button on the **Shortcuts** bar. The *Workspace* appears with no images.

1 Click Create

3 Click Start Creations Wizard

4 Select Video CD Template

2 Select Images

6 Enter Title

7 Choose Background Music

5 Choose Video CD Style

8 Set Transition Options

9 Select Playback Options

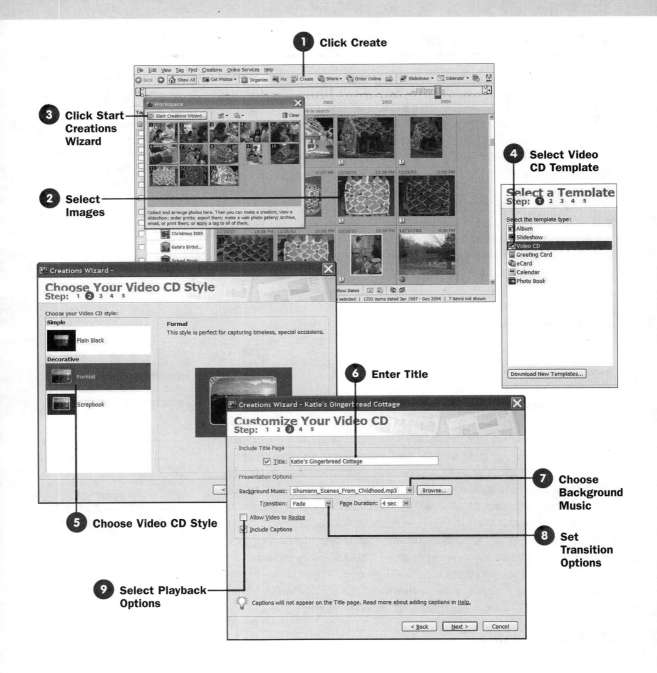

10 Preview Production

11 Burn Video CD Disc

12 Save Creation

2 Select Images

Drag and drop each image you want to use from the catalog into the **Workspace**. Rearrange the images so that they appear in the Workspace in the order you want them to appear in the Video CD production.

3 Click Start Creations Wizard

When the sequence of images and videos in the Workspace is exactly the way you want it, click the **Start Creations Wizard** button. The **Creations Wizard** appears, displaying the **Step 1** page.

4 Select Video CD Template

On the **Step 1** page, choose **Video CD** from the **Select the template type** list. Click **Next**.

5 Choose Video CD Style

On the **Step 2** page, select a video style from the **Choose your Video CD style** list. A sample of the style you select appears on the right. Click **Next**.

✎ NOTE

To complete this task, your computer must have a recordable CD drive designed to burn CD-R and CD-RW discs. You can burn a Video CD production, which can even include full-motion video and a sound-track, in less than an hour with the process described here.

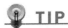

TIP

If you want to select a group of related images such as all the images of a recent vacation, use the **Find** bar to display them first. (See **73** About Finding Items.) Then press **Ctrl+A** or choose **Edit, Select All** to quickly select the displayed items. If the catalog is sorted by batch or folder, click the gray bar above a group to select all the items in that group. With either of these two methods, you might end up selecting video, audio, and creation files, so press **Ctrl** and click the files you don't want to deselect them.

6 Enter Title

To have the production begin with a title page, select the **Title** check box on the **Step 3** page, and type a title in the box to the right. The first image in the **Workspace** appears on this title page.

7 Choose Background Music

To have music play during the slideshow, select a music file from the **Background Music** drop-down list. If you don't see anything you like in the list of recently played music, click **Browse**, choose a music file (in MPG or WAV format) on the hard disk, and click **Open** to return to the wizard. (The audio file you select by clicking **Browse** does not have to be in the catalog to be used in the Video CD creation.) The background music plays softly while video files are playing, which might prevent someone from hearing the video clearly, so keep that in mind if your creation includes video files. To have your slideshow be silent, choose **None** from the **Background Music** list.

8 Set Transition Options

Photoshop Album can produce eight different *transition* effects between each page in the production. From the **Transition** drop-down list, select the effect you want to use throughout; choose **Random** to vary the transitions; or choose **None** to simply have the production replace each page with a new one.

The production automatically switches between images during the presentation. To set how long each image should remain onscreen, choose a length of time from the **Page Duration** drop-down list.

9 Set Playback Options

If your production contains video files, select the **Allow Video to Resize** check box if you want those videos to play full screen. This option might make the video appear blocky or choppy (as is the case with low-*resolution* videos shot with digital still cameras), so you might not want to select this option.

Select the **Include Captions** check box to display captions beneath images or videos in your production. See **58** Add a Text Caption.

To finalize all your options choices, click **Next**.

⑩ Preview Production

On the **Step 4** page of the **Creations Wizard**, preview the production using the navigation controls. If desired, click the **Back** button at the bottom of the wizard window to return to any of the previous steps and make new selections. Click **Rearrange Photos** to redisplay the Workspace so that you can edit an image, select a different image or video file, or add a caption.

To preview the production with sound, the way your viewer will see it, click **Full Screen Preview**. See **48** **View Images in a Slideshow** for help in using the console that appears in the upper-right corner of the screen. When the production ends (or when you stop it yourself), you are returned to the **Step 4** page of the wizard.

Click **Next** to continue.

⑪ Burn Video CD Disc

The **Step 5** page displays. To burn the production to a disc using the Video CD format, click **Burn**. The **Select Disc Settings** dialog box appears.

Select the **Burn a Video CD to View on a DVD Player** check box and then click **OK**. If you don't have a blank disc in your writable (CD-R, CD-RW, DVD-RAM, DVD-R, or DVD-RW) drive, Photoshop Album asks you to insert one now.

If Windows launches its own process for writing to a CD after you insert a blank disc in your writable drive, click **Cancel** to close the Windows dialog box.

With the blank disc in your drive, Photoshop Album immediately begins the burning process. Depending on the speed of your drive, this may take from several minutes up to an hour. When the burning process is completed, your computer automatically ejects the disc.

⑫ Save Creation

You return to the **Step 5** page of the wizard. The **Title** you typed on the **Step 3** page appears in the **Name** box and will be used to name your saved creation. If you want to use a different name, deselect the **Use Title for Name** check box and then type a new title in the **Name** box.

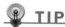

TIP

If you want to email your production, simply click the **E-mail** button on the **Step 5** page of the wizard to convert the production to *PDF format* and attach it to an email message for you. See **113** **Email an Item**. If you want to convert the production to PDF format and burn a CD in one step, click the **Burn** button and select the **Burn a CD to view on a computer** option. See **105** **Burn a Creation to CD**. To print the images in the production, click **Print**. To create a PDF version of your production for distribution to a variety of computers, click **Save as PDF**. See **104** **Save a Creation in PDF Format**.

Click **Done** to save the creation to the catalog. You might see a warning box reminding you that the creation now appears at the top of the photo well, with other items in the catalog. Click **OK**. The Workspace closes automatically.

110 About Emailing

Part of the purpose of Photoshop Album is to enable you to think of your digital photos as more than files on your Windows computer—they are versatile entities you can store, catalog, and include in *creations*. A natural extension of cataloging your media files is sharing them. One of the easiest ways to do that is to attach selected items to an email message. When attaching items to a message, you don't want to have to revert to thinking of your media collection as individual files—which means remembering their filenames, locating their home folders, and attaching them to the message one by one. Instead, it would be nice to simply select some items from the photo well and tell Photoshop Album, "Send *these*."

KEY TERM

Email client—A program that sends and receives email on behalf of another application. Popular email clients/programs include Outlook and Outlook Express.

Although Photoshop Album does manage the first step in collecting photos and other items and marking them as email attachments, it does not actually perform the email process itself. Instead, it prepares the attachment of these items for the benefit of the *email client* you generally use. By default, Windows's email client is Outlook Express. If you use Microsoft Office, your email client might actually be the full version of Outlook; or you might be using Eudora, Pegasus Mail, or Netscape Mail as your email client.

Each of these email clients is MAPI enabled, which means that it can communicate with Windows and handle email on behalf of Windows programs. So when any other program—for instance, Microsoft Excel or Photoshop Album—tries to send one of its own documents or items as an attachment to an email message, the application can pass that item over to the currently recognized MAPI-enabled email client. Photoshop Album knows how to attach any item in its photo well to the body of an email message that is actually generated by that email client program, such as Outlook or Outlook Express.

NOTE

If you use Web mail, Photoshop Album might not be able to send items in email messages for you. It will, however, create the attachments and prompt you to manually attach the files to an email message yourself.

You can email any number of recipients any item in your photo well at any time. One way you can start this process (as explained in detail in

113 **Email an Item**) is by choosing the items you want to send from the photo well and then selecting **File**, **Attach to E-mail** from the menu bar. This command brings up a dialog box from which you can select or verify the items you want to send, choose your recipients, and optimize images as desired (lower their quality to make the image files smaller and easier to send). Although the steps for emailing various items is essentially the same, this dialog box differs slightly if you are sending a creation instead of a collection of image, video, and audio files.

Email Attachments **Recipients** **Optimization Settings**

— **Dialog Box for Multiple Items**

—**Dialog Box for Creations**

The **Attach Selected Items to E-mail** dialog box is where you prepare the items you want to send.

If you've just finished making a creation—such as a *slideshow* or an *eCard*—there's another way you can send the creation in an email message: The **Step 5** page of the **Creations Wizard** includes an **E-mail** button. Clicking this button brings up the same **Attach Selected Items to E-mail** dialog box, so there's nothing different you need to learn.

*On the **Step 5** page of the **Creations Wizard**, an **E-mail** button lets you send a freshly produced work of art.*

TIP

If you email images and creations to a very small group of friends and relatives, you might prefer to add them to the Photoshop Album contact list instead of using your email client's address book, simply for ease of use.

As a way to help you designate your email recipients, Photoshop Album maintains its own contacts list. In **112** **Manage Contacts**, you'll see how to add names to this list, and even how to group and categorize clusters of names so that you can send items to large groups of people with a single click. However, you don't really have to create a separate contacts list in Photoshop Album because you can always wait until the email message is created and then call up the contact list in your email program and use that contact list to designate recipients. If you plan on sharing your images online, however (as explained in **115** **Share Images Using an Online Service**), you must pull recipient names for the notification message from either the Photoshop Album contact list or the Shutterfly contact list, so keep that in mind when deciding whether or not you want to maintain a contact list inside Photoshop Album.

The key roadblock to your being able to email items in the catalog to whomever you choose is the file sizes of images. Because a digital photo

is often a huge chunk of digits, from a network perspective, it could lead to any one of the following bad situations:

- **Sending images might take a long time.** If you have a dial-up Internet connection, the process of sending a large item such as a slideshow could take an *hour or more.*

- **Attachments might be rejected if they are too large.** After uploading an email message with one or more items attached (whether the process took you several minutes or several hours) you might only then learn that your Internet or email service provider is incapable of handling attached files over a particular size, typically 1MB. Even if your email provider or ISP can handle the size of your various email attachments, the email provider or ISP of your *recipient* might not be able to accept the huge attachment files.

- **The attached files might be automatically removed.** Because of the volatile nature of modern Internet security, many email providers and many email client applications routinely strip attachments from received messages. (Yahoo Mail is one example.) So you could conceivably send an email that says, "Hi, look what we've just made!" and the message would contain no attachments.

- **Receiving images might take forever, and your recipient might just give up.** Even if both your ISP and your recipient's mail service handle large attachments, and even if your recipient's email client passes the attachments through, if your recipient has a dial-up connection, the process of *downloading* large items can take an unreasonably long time. Because some email clients actually do not inform their users as to *what they're doing*—that they are in the process of downloading a large file, for example—your recipient could be downloading your creation *and not know it*, wonder why nothing *appears* to be happening, and cancel the process in midstream.

Unfortunately, because Photoshop Album is not really an email client, it can't deal with these contingencies when they crop up. You might want to try sending small, benign attachments *to yourself* first, using only your email client, then using Photoshop Album, before you attempt sending attachments to others. With this test, you can at least clear up any discrepancies that may occur on your end of the Internet cloud. As an additional guideline, always select the **Optimize for Viewing Onscreen** option in the **Attach Selected Items to E-Mail** dialog box whenever feasible, to compress the size of your image files before you email them.

NOTE

One small bit of hope for dial-up users: It does not take any longer for you to send a single email message with one or more attachments to *multiple* recipients than it does to *one* recipient. Just specify *all* your recipients on the **To** line of the email message. Your email provider handles the job of duplicating your message and sending copies of it to everyone you've designated.

Set Up Photoshop Album for Emailing

Before You Begin

✔ **110** About Emailing

See Also

→ **112** Manage Contacts

→ **113** Email an Item

For Photoshop Album to be able to send photos, videos, audio clips, or *creations* as attachments to email messages, it has to know what program is responsible for your email, and how you want Photoshop Album to handle the "handoff," if you will, of those items to that other program. For instance, items might have to be compressed to reduce download time.

When sending images in an email message, Photoshop Album allows you to select from three different image sizes (**Big**, **Medium**, and **Small**). The resolution and amount of compression associated with each size cannot be easily adjusted during the emailing process. You can, however, adjust the settings associated with each size before sending images through Photoshop Album by following the steps in this task. For example, Photoshop Album defines **Big** as an image with a maximum resolution of 1024×768 pixels, with a level 7 quality (compression) setting (out of 10). If you tried to send an image larger than 1024×768 pixels and you chose the **Big** size in the **Attach Selected Items to E-mail** dialog box, Photoshop Album would compress the image and reduce its size before attaching the image to an email message. Using the steps in this task, you can redefine **Big** as an image with a maximum size of 1280 × 960 pixels, and a quality (compression) setting of 8, for example. After that, images sent using the **Big** setting would be reduced in size only if they were larger than 1280×960 pixels, and they would not be compressed as much. You can define what is meant by all three sizes, and you can select a default size that you want to use most often.

❶ Choose Edit, Preferences

Select **Edit**, **Preferences** from the menu bar. The **Preferences** dialog box appears.

❷ Click E-mail

From the list of categories along the left side of the dialog box, click **E-mail**. A list of options for emailing appears on the right.

❸ Choose a Preferred Client

From the **Send E-mail Using** drop-down list, choose the application you use to handle your email. This list should contain all the MAPI-enabled *email client* applications on your system, including

Outlook Express. If you've installed Microsoft Office, then **Microsoft Outlook** (or **Microsoft Office Outlook** for Office 2003) will appear in this list.

Another choice in the list is **Hotmail**, an email service sponsored by Microsoft that can be launched and maintained entirely through your Web browser. You need an account with Hotmail to be able to use this service.

4 Set Compression Preferences and Click OK

From the **Presets For** drop-down list, select any size and tweak its meaning as desired. For example, if you selected **Big**, then by default, Photoshop Album adjusts the image's maximum resolution to 1024×768 pixels and the quality to **Medium**. You can choose a different maximum from the **Maximum Photo Size** drop-down list if you like. Adjusting this setting changes an image's maximum number of pixels, level of detail, and onscreen size. Select **Use Original Size** from this list if you don't want Photoshop Album to adjust the image resolution at all. You can also change the **Quality** setting associated with the **Big** preset (the amount of compression or file size reduction). Higher numbers here mean larger file sizes and essentially better quality.

Select a different size from the **Presets For** list and adjust its associated photo size and quality settings as you want; repeat to adjust each preset, or at the very least, to verify that the settings associated with each preset are what you want when you select that size when emailing images.

After adjusting the settings associated with each preset size (**Big**, **Medium**, and **Small**), open the **Presets For** list again and select the default size in which you want images attached to email messages to be sent most often (you can always make a different selection during the emailing process). If you select **Big**, for example, images are sent using a fairly high-quality *resolution* and large file size. This default might be appropriate if download times are not an issue and the ISPs involved do not set size limits on attachments.

Click **OK** to save all your size and quality setting adjustments and your default size selection.

NOTE

If your email client of choice is not MAPI-enabled and does not appear in this list, your only option for emailing a creation or other item from the photo well is if you save a copy of it to disk and use your email client to load that copy as an attachment to your email message. If this is the only method that will work for you, choose **Other (save to disk)** from the **Send E-Mail Using** list.

NOTE

Contrary to appearances, the **Quality** scale for an emailed image cannot *add* detail or quality to an image. At its maximum setting, the emailed image simply does not *lose* any detail or quality it already has.

NOTE

If you set the default to **Leave as Is**, each image is sent without adjustments, unless you select a different size preset when emailing.

3 Choose a Preferred Client

2 Click E-mail

4 Set Compression Preferences and Click OK

1 Choose Edit, Preferences

112 Manage Contacts

Before You Begin

✔ **110** About Emailing

See Also

→ **113** Email an Item

If you send photos or other *creations* to certain individuals or groups on a regular basis, you can keep track of their email addresses in Photoshop Album's contact list (called the **Contact Book**). The **Contact Book** can make the process of selecting recipients for your email messages potentially easier than selecting recipients from your *email client*'s address book after the message is actually created. In addition, selecting recipients from the Photoshop Album **Contact Book** is an integral part of sending notification messages when you share images online through Shutterfly. If you plan on doing that, you'll want to set up the Photoshop Album **Contact Book** ahead of time. (See **115** **Share Images Using an Online Service**.)

As I mentioned earlier, you can add individual contact addresses to the Photoshop Album contact list. You can also group these contacts together using a special group name that allows you to send items to multiple people with a single click. In this task, you'll learn how to add individuals and groups to the Photoshop Album **Contact Book**.

1. **Choose View,** **Contact Book**

2. **Click New Contact**

3. **Enter Email Data**

4. **Add or Organize** **Groups as Desired**

1 Choose View, Contact Book

Select **View**, **Contact Book** from the menu bar. The **Contact Book** dialog box appears.

2 Click New Contact

To add a new person to the Photoshop Album contacts list, click the **New Contact** button. The **New Contact** dialog box appears.

3 Enter Email Data

On the **Name** tab, enter your recipient's **First Name**, **Middle Name** (if you know it), **Last Name**, and **E-mail Address**.

You can save additional information about this contact (such as their home address) by clicking the **Address** tab and entering that data in the appropriate text boxes. Because this information is not used within Photoshop Album in any form, you might want to enter it only if you don't already have this information recorded in your email client's address book.

Click **OK**. You're returned to the **Contact Book** dialog box; note that this contact has been added to the list. Repeat steps 2 and 3 to add more contacts, or click **OK** to close the **Contact Book** dialog box. To group contacts together, continue to step 4.

TIP

To change the email address or other data for a contact later on, click that person's name in the **Contact Book** dialog box, and then click **Edit**. Make changes as desired and click **OK**. To remove a name or a group from the list, click the name in the **Contact Book** dialog box and then click **Delete**. To verify, click **OK**.

4 Add or Organize Groups as Desired

In the **Contact Book** dialog box, you can create a group that represents multiple email addresses. Click the **New Group** button. The **New Group** dialog box appears.

Type the name for this new group in the **Group Name** box. To add a member to this group, click a name in the **Contacts** list at left (this list represents all the individual names you've already added to the **Contact Book**). Then click **Add** to copy the name into the **Members** list at right (this list represents the contacts who are members of this particular group). Repeat this process to add as many names as you like to the group.

To remove a name from the **Members** list (for example, if you accidentally added someone you didn't mean to), click that name in the list at the right and then click **Remove**. When the **Members** list reflects all the names you want to include, click **OK** to create the group. You're returned to the **Contact Book** dialog box. Note that the group name has been added to the contact list. In the figure, you can see that I've added a group called **Grandparents** to my contact list. I use this group to send images to both sets of grandparents with a single click.

NOTE

The **Contact Book** shows the names of your contacts and the names of groups, together as one list. Items are sorted last name first.

You can repeat this step to create additional groups. When you're done, click **OK** to close the **Contact Book** and return to Photoshop Album.

113 Email an Item

If you have an Internet connection, you can send anything you see in the Photoshop Album photo well to anyone who has an Internet email address, at any time. Photoshop Album cooperates with the most widely used email applications available today, including the one shipped with every copy of Windows, Outlook Express. Chances are, you probably use one of these *email clients* yourself. After Photoshop Album and your email program have been set up to recognize each other (as instructed in **111** **Set Up Photoshop Album for Emailing**), all you have to do is select what you want to send, select who to send it to, type an accompanying message, and click **Send**. In this task, you'll learn all the details.

❶ Select Items to Send

In the photo well, select the items you want to send in an email message. All these items will be sent to all the recipients you designate.

To select contiguous items, press **Shift**, click the first item, then click the last item in the group. To select noncontiguous items, press **Ctrl** and click each one. Selected files appear with a yellow border.

❷ Click Share and Choose E-mail

Click the arrow on the **Share** button on the **Shortcuts** bar and select **E-mail** from the menu that appears. You can also select **File**, **Attach to E-mail** from the menu bar. If your selection includes audio clips, you might receive a warning telling you that audio files will not be sent if you choose the **PDF Slideshow** option in step 4 (if it's available); click **OK** to continue. The **Attach Selected Items to E-mail** dialog box appears. The appearance of this dialog box varies depending on whether you are sending a creation or a collection of images, audio, and video files.

❸ Designate Recipients

Select one or more names of groups or individual recipients from the **Send To** list by selecting the check box in front of each recipient. The same message and attachments are sent to every contact you select.

Before You Begin

✔ **110** About Emailing

✔ **111** Set Up Photoshop Album for Emailing

See Also

→ **96** About Creations

→ **115** Share Images Using an Online Service

💡 TIP

If you want to select a group of related items such as all the images from a recent outing with your family, use the **Find** bar to display them first. (See **73** About Finding Items.) Then press **Ctrl+A** or choose **Edit**, **Select All** to quickly select the displayed items. If the catalog is sorted by batch or folder, you can click the gray bar above a group to select all the items in that group.

📝 NOTE

You can send photo, video, or audio files to someone, or you can send a *creation* (such as a *slideshow*) to someone. However, using Photoshop Album, you cannot send a creation *and* any other type of file in the same message.

If you want to add a name that doesn't appear on this list, click the **Add Recipient** button; enter the person's first name, last name, and email address; and then click **OK**. To make changes to someone's information or to create email groups, click **Contact Book** and refer to **112** **Manage Contacts** for details.

4 Set Attachment Type

If you are emailing a selection of images, audio, and video files, select a **File Type** from the list on the right. If you selected multiple image and video files in step 1 and want to send a *slideshow* instead of multiple separate files, select the **PDF Slideshow** option and enter a name for the resulting file in the **File Name** box. Photoshop Album will create the slideshow for you before it attaches the file to your email message. This option prevents any selected audio files from being sent.

If your selection includes audio files, or if you simply prefer to send the items as individual files, select the **Individual Attachments** option instead. When this option is enabled, if one or more of your selected images are not already in *JPEG* format (the most common high-compression format), select the **Convert Photos to JPEGs** check box to have Photoshop Album re-render images in the JPEG format.

If you are emailing a creation, the **Attach Selected Items to E-Mail** dialog box is slightly different. Here, the creation is automatically converted to *PDF format* for emailing. You simply type a name for the resulting PDF file in the **File Name** box.

5 Set Resolution and Click OK

If you are emailing any JPEG images (or letting Photoshop Album re-render your image files as JPEGs by selecting the **Convert Photos to JPEGs** option), you can adjust the size and quality of the resulting JPEG files. From the **Size** drop-down list, select the *resolution* you desire, or leave the **Size** setting to the default (which you specified in **111** **Set Up Photoshop Album for Emailing**). Associated with the size is a quality setting (JPEG compression rate); to change that, click **Customize**. See **111** **Set Up Photoshop Album for Emailing** for more information on adjusting the settings associated with each size. Choose **Leave As Is** from the **Size** list to prevent Photoshop Album from changing the size or resolution of any of your attached images.

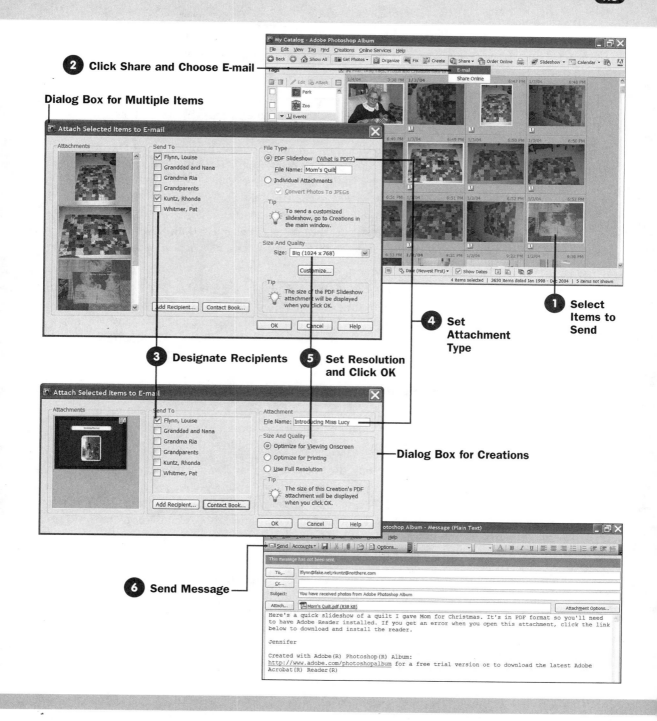

2 Click Share and Choose E-mail

Dialog Box for Multiple Items

1 Select Items to Send

3 Designate Recipients

5 Set Resolution and Click OK

4 Set Attachment Type

Dialog Box for Creations

6 Send Message

If you are converting your images to a PDF slideshow, you can adjust the size and quality of the included images by changing the **Size** setting.

If you are emailing a creation, you can adjust the quality of the images in the resulting PDF file by choosing an option from the **Size and Quality** list. If you think your user will only view the resulting slideshow on her computer monitor, select **Optimize for Viewing Onscreen** to decrease the resolution and make the PDF file smaller. To set the resolution high enough for printing (and increase the size of the PDF file—compared to a PDF file optimized for viewing onscreen), select **Optimize for Printing**. To leave the resolution of the images as is, select **Use Full Resolution** (which doesn't affect the size of the image files incorporated into the PDF file).

Click **OK** to proceed. You might see a warning about possibly long download times for telephone modem users; click **OK**. If you are sending more than 1MB of attachments, you'll see a warning; click **OK**. In a moment, your email client displays an email message with your items attached.

6 Send Message

If you didn't select any recipients from the Photoshop Album contact list in step 3, follow the normal procedure for adding recipients using your email client's address book now.

You can edit the body of the message as you wish (including removing the little advertisement for Adobe products), just as you would for any other email message. By default, the subject line reads, **You have received photos from Adobe Photoshop Album**. You can change this subject line to something more reflective of your subject matter if you like.

Make sure that you are connected with your Internet Service Provider. Then click **Send** (or the equivalent button in your email client) to send the message. After the message is sent, you'll be returned to Photoshop Album.

114 Register with an Online Service

Through its association with various venders, Photoshop Album offers a seamless way to take advantage of a wide array of imaging services. For example, you can upload images to one of the many printing services associated with Photoshop Album, and have those images professionally printed and mailed back to you. (See **120** **Print Images Using an Online Service**.) Most of the printing services offer other choices as well, such as printing an image on a t-shirt, cup, magnet, or set of greeting or post cards.

By choosing a publishing service such as MyPublisher, you can upload a calendar or *photo book creation* and have it professionally printed and bound. (See **122** **Print a Creation Using an Online Service**.) By choosing an online image sharing service such as Shutterfly, you can upload images and share them with friends and family through the Internet. (See **115** **Share Images Using an Online Service**.) Before you can take advantage of any of these wonderful services, however, you must register to use that service. Not much is involved in the registration process, as you'll see in this task. All that's typically required is a valid email address.

1 **Choose Online Services, Manage Accounts**

Make sure that your Internet connection is active, then choose **Online Services, Manage Accounts** from the menu bar. The **Create or Modify Online Service Accounts** dialog box appears.

2 **Select a Service**

Select a service from the list then click the **Select** button to continue. If you see a warning box reminding you that these services are not guaranteed by Adobe, click **OK**. The **Online Services Wizard** appears.

3 **Complete Registration**

The screens you're required to complete to register with a particular service vary depending on the service you selected in step 2, but typically you'll have to supply an email address and enter the password you want to use when logging on to the service's system. Complete each screen presented by the **Online Services Wizard** and click **Next** to continue to the next screen. Be sure to read carefully any terms or conditions that apply to your membership.

See Also

→ **96** About Creations

→ **115** Share Images Using an Online Service

→ **120** Print Images Using an Online Service

→ **122** Print a Creation Using an Online Service

NOTE

From time to time, service providers are added to the list of online services associated with Photoshop Album. To make sure that your provider list is current before you start this task, choose **Online Services, Check for New Services** from the menu.

NOTE

Unlike the other online service providers (which offer either a printing *or* a sharing service), Shutterfly offers two services—printing *and* sharing. You can register as a member of Shutterfly by selecting either service from the **Choose a Service** list.

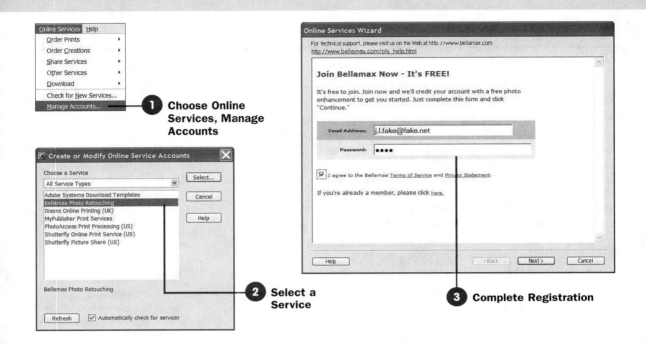

1 Choose Online Services, Manage Accounts

2 Select a Service

3 Complete Registration

After completing the registration, you return to the photo well. You are now ready to use this or any other online service for which you have registered.

115 Share Images Using an Online Service

Before You Begin

✔ **114** Register with an Online Service

See Also

→ **113** Email an Item

→ **120** Print Images Using an Online Service

→ **122** Print a Creation Using an Online Service

It's often difficult in this day and age to stay in contact with friends and family. Through email, you can sometimes keep in touch by sending quick "Hello, how have you been?" messages, and occasionally attaching a recent photo or two. As you learned in **113** **Email an Item**, Photoshop Album can help you quickly send your favorite images to friends and family. But although most people have email addresses through work, those who do might not be able to accept emails with attachments, especially large attachments such as high-*resolution* graphics. Also, not everyone has an Internet connection at home, so sending personal images through email is sometimes a problem.

Instead of sharing your images through email, why not use an online service? Using Photoshop Album, you can upload a set of images to Shutterfly, an online image sharing service. You can then send email messages to invite selected friends or relatives to view the images using the password you provide. A user can then visit Shutterfly, view your images, and even order prints or have other gifts made from your images.

① Select Images to Upload

Before choosing images to share, you might want to review each one and edit them as desired—improving contrast, cropping, and sharpening as needed. (See **86** **About Fix Photo**.) You might also want to add text *captions* to the images you want to share, because these captions will appear with the images on the Shutterfly page. (See **58** **Add a Text Caption**.)

Select a single image by clicking it in the photo well. To select multiple images, press **Shift**, click the first image in the group, and then click the last image. Alternatively, press **Ctrl** and click each image you want. If images are grouped by folder or import batch, you can click the gray bar above a group to select all its images.

② Click Share and Choose Share Online

Click the arrow on the **Share** button on the **Shortcuts** bar and then select **Share Online** from the list that appears. The **Share Items Using Online Service** dialog box appears.

③ Select Recipients

From the **Recipients** list, select the names of the people you want to invite to view your images online. This list contains all the names and groups you've added to your Photoshop Album contact list. Add a new contact to the Photoshop Album contact list by clicking the **Contact Book** button. See **112** **Manage Contacts** for help.

If you want to use the addresses in your Shutterfly address book (which is different than both your Photoshop Album contact list and your email client address book), do not select any recipients from the **Recipients** list in this dialog box; when the email message window appears later on, you can use its buttons to select recipients from your Shutterfly address book.

NOTES

Currently, Shutterfly is the only online image sharing service associated with Photoshop Album. From time to time, other services might be added; to update the list before attempting this task, choose **Online Services**, **Check for New Services** from the menu.

Before beginning this task, make sure that you have registered to become a member of Shutterfly. See **114** **Register with an Online Service** for help.

TIP

If you want to select a group of related images such as all the images of your new kitten, use the **Find** bar to display them first. (See **73** **About Finding Items.**) Then press **Ctrl+A** or choose **Edit**, **Select All** to quickly select the displayed items. With this method, you might also select video, audio, and *creation* files, so press **Ctrl** and click the files you don't want to deselect them.

TIP

To keep the link to your uploaded images on file so that you can send it along to other friends or relatives later on, be sure to include your email address in the **Recipients** list or the **To** list in the email message.

2 Click Share and Choose Share Online

4 Select a Service and Click OK

3 Select Recipients

1 Select Images to Upload

5 Log On to Service

6 Type a Subject and Message

7 Review Images

4 Select a Service and Click OK

If an online sharing service other than Shutterfly is available and you want to use it, open the **Choose the online service for this session** drop-down list and select that service.

Click **OK** to continue. The **Online Services Wizard** appears.

5 Log On to Service

If your login information for the service is not already filled in, enter your **Email Address** and **Password**. Select the **Always Remember Password** check box if you don't want to enter your email address and password each time you use this service.

When you're ready, click **Next** to continue. The **Enter Message** window appears within the **Online Services Wizard**.

6 Type a Subject and Message

The recipients you selected in step 3 appear in the **To** list. You can add recipients from your Shutterfly address book by clicking the **Choose from Address Book** link. If you want to be able to view your images on the Shutterfly Web site, make sure to include your own email address in the **To** list.

Type a **Subject** and a **Message** for the email notification. The link to your images on Shutterfly's Web site is inserted into the message text automatically.

Click **Next**. The images you selected are automatically uploaded from your computer to the Shutterfly Web site. The **Online Services Wizard** displays a confirmation; click **Finish** to redisplay the Photoshop Album photo well.

7 Review Images

Each group of images you upload to the Shutterfly Web site are collected into a single "album." When your recipient receives your message, she should click the link provided. A browser window opens, displaying the page on Shutterfly's Web site that contains the album you just created. Your recipient can easily browse these images and order prints. She can also save the images to her Shutterfly account (assuming she signs up for one). This enables her to share the images with other people as she chooses or to

> **NOTE**
>
> If you have forgotten your password, you can have the service email it to you by clicking the **Forgot My Password** button. If for some reason you have forgotten to sign up for this service before beginning this task, register for the service now by clicking **Sign Up**.

order note cards, greeting cards, or other gifts using the images. Your recipient cannot, however, browse other albums you may have created.

If you want to review, edit, or print any of the images you just uploaded, start your Web browser and display the Shutterfly Web site (**www.shutterfly.com**). Log in using your email address and password. The **My recent albums** page automatically appears. The album shown on the far left contains the images you just uploaded. Its name is based on today's date.

If you like, click the **View all albums** link to display a page listing all the albums you've uploaded to Shutterfly. Click the dot underneath the album icon to select the album, and then click the **Rename album** link on the right to give the album a more descriptive name.

To review the images in an album, click the album icon to "open" it. The **View pictures** page appears (as shown in the figure), displaying an icon for each image in the album. Click the button below an image to select it, and then use Shutterfly's tools to edit images, order prints, edit an image title and description, and reorganize the images in the album.

NOTE

Currently, there are no limits to the number of images you can upload or the number of albums you can keep on the Shutterfly Web site. You should, however, periodically remove albums from the site that you no longer need to share or print.

13

Printing Images

IN THIS CHAPTER:

In Photoshop Album, printing is the final step you take in rendering a picture, a group of pictures, or a printed *creation*. When you start the printing process, the brightness, *saturation*, contrast, and sharpness of an image have already been corrected. With a *photo book*, greeting card, or other printed creation, the layout process is complete and you've reviewed the result. Printing is the *coup de grace*. If you've set up your printer properly and calibrated its output with the color you see on your monitor (see **83** **About Color Management** and **84** **About Adobe Gamma** for instructions), what you see onscreen in Photoshop Album will soon become what you get on paper.

There are, however, a few steps you must complete before you click that **Print** button. You should, for example, change the print options so that your printer is aware that you're using photo paper. And then there are the endless choices you can make about what to print: single prints from each image, a set of prints in standard photo sizes, or small *thumbnails* of each image you can use as a reference. As a final option, you may choose not to print your images at all, but to upload them to an Internet printing service instead. In this chapter, you'll learn how to complete all these tasks.

116 Set Print Options

Before You Begin

✔ **83** About Color Management

✔ **84** About Adobe Gamma

See Also

→ **117** Print Images

ⓚEY TERMS

Portrait orientation—A page printed across its shortest edge.

Landscape orientation—A page printed across its longest edge.

Before printing, you should use the **Page Setup** dialog box to set various print options. There are actually two **Page Setup** dialog boxes you can view through Photoshop Album. One is fairly simple, and it governs general print options for the program such as paper size and print orientation: *portrait orientation* or *landscape orientation*. The selections you make in this first dialog box affect any printing you initiate within Photoshop Album *until you exit the program*. The second dialog box allows you to set specific printer options such as paper type and quality. These settings affect jobs sent to the printer by Photoshop Album *during this session only*, so don't worry that your Word documents will suddenly start printing in photo quality. You should check, however, to make sure that these printer settings are still in place before printing a second time from Photoshop Album; some printers reset these selections with each print job while others do not.

❶ Choose File, Page Setup

From the menu bar, select **File**, **Page Setup**. The **Page Setup** dialog box for Photoshop Album appears.

❷ Choose Basic Options and Click Printer

There's typically nothing you need to change in this first dialog box, but you can change the **Orientation** of the page if you like. You might also make a different selection from the **Size** list, if you are printing on 4"×6" paper, for example. You can also change the **Source**, which tells the printer which printer tray to use. These same selections can also be made from somewhere within your printer's **Page Setup** dialog box, so you don't have to do that here.

After making selections (if any) from this first **Page Setup** dialog box, click the **Printer** button. A second **Page Setup** dialog box appears.

❸ Choose Printer

In the second **Page Setup** dialog box, choose your printer from the **Name** drop-down list (if necessary). If, for example, you use both an inkjet and a photo printer, make certain that the printer named here is the one you intend to use.

❹ Click Properties

Click the **Properties** button. The **Properties** dialog box specific to your printer appears.

❺ Set Printer Options

At this point, the dialog box that appears is specific to your printer, so what you see might only look similar to what's illustrated here. Consult your printer's manual for specific instructions regarding your printer's options. (The example shown here is for an HP DeskJet printer.) For my printer, I open the **Media** list to select the paper type I plan to use, such as glossy photo paper. I can change the **Quality** settings as well; for example, I select **Best** quality when printing photos.

TIP

When you use Windows *color management* (see **83** About **Color Management** and **84** About Adobe Gamma for how), the colors you see in your Photoshop Album images are adjusted to approximate the colors and tones your printer is capable of reproducing. However, if you have more than one printer or printer driver, color management adjusts onscreen colors only for the "current" printer—which is either the Windows default printer or the one most recently used. If your photo printer isn't the default, and you intend to use it to print images in Photoshop Album, follow these steps to change printers *now*, so that images onscreen look as they will when printed.

TIP

If you use a photo printer, you can typically print using any brand of photo paper. If you're printing on an ordinary inkjet printer, however, you'll get the best quality using that same manufacturer's photo paper. Also, if you're printing to a dye-sublimation printer, use only that manufacturer's paper.

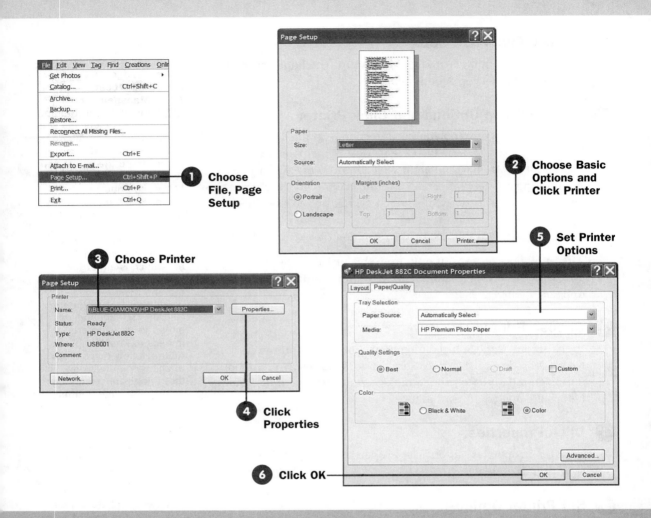

Choose File, Page Setup ①

Choose Basic Options and Click Printer ②

Set Printer Options ⑤

Choose Printer ③

Click Properties ④

Click OK ⑥

Many printer dialog boxes include an **Advanced** feature, usually attainable through a button or tab. When you click this button or tab, all the printer's major options are listed *categorically*, on one screen. Click the name of the category to see all the options for that category, such as **Paper/Output** for the size and thickness of paper you intend to use, or **Graphic** for *resolution* and color management options. If the **Advanced** settings are located on a separate dialog box, click **OK** to finalize your changes and return to the main **Properties** dialog box.

6 Click OK

To finalize your printer settings, click **OK**. Then click **OK** to exit the second **Page Setup** dialog box, and **OK** again to exit the first **Page Setup** dialog box.

Now that you've specified the printer and options you intend to use for this Photoshop Album printing session, you can select the images you want to print. For most printers, these printer options will remain in effect until you exit Photoshop Album. Because some printers reset these options with each print job, you should check them each time you prepare to print.

117 Print Images

You can print one or more images from the photo well at any time. After selecting one or more images and clicking the **Print photos to a local printer** button, you're shown a dialog box from which you can choose the print size and the number of copies of each image you want to print. You can also choose whether or not you want Photoshop Album to adjust the photos to fit the size you've selected (a process that may result in portions of the image being cropped, or not printed). Before printing, you can preview your selections to see how your images will look.

Before You Begin

✔ **116** Set Print Options

See Also

➔ **119** Print a Picture Package

➔ **120** Print Images Using an Online Service

1 Select Images to Print

If necessary, set up your printer for photo printing (see **116** Set Print Options). Then press **Shift** and click the first image in the group you want to print and then click the last image in the group. Alternatively, press **Ctrl** and click each image you want to print.

If you want to select a group of related images such as all the images of your garden, use the **Find** bar to display them first. (See **73** About Finding Items.) Then press **Ctrl+A** or choose **Edit, Select All** to quickly select all the displayed items. If the *catalog* is sorted by batch or folder, you can click the gray bar above a group to select all the items in that group. With either of these two methods, you might also end up selecting video, audio, and *creation* files, so press **Ctrl** and click the ones you don't want to deselect them.

🖌 NOTE

Printing low-*resolution* images in a large size results in poor quality (grainy) photos. If you took the photos using a low-resolution setting on your digital camera (or scanned them using a low resolution setting), choose a small print size for best print results.

TIP

If you have a creation you want to print, do not follow these steps; instead, see **121** Print a Creation at Home or **122** Print a Creation Using an Online Service for help.

NOTE

To print each image using a size that's not listed in the **Print Sizes** list, choose the **Custom Size** option. In the dialog box that appears, enter a **Width** and **Height** (based on the unit of measurement you select) and then click **OK**.

2 Click Print Photos Button

Click the **Print photos to a local printer** button on the **Shortcuts** bar, or select **File**, **Print** from the menu. The **Print Selected Photos** dialog box appears.

3 Click Individual Prints

In the **Layout** pane, select the **Individual Prints** option. This option instructs Photoshop Album to print each image the number of times you choose. Depending on the size and other options you select, Photoshop Album might fit as many photos as it can onto one page and break up pages accordingly; or it may print one photo on each page.

4 Set Print Format

From the **Print Sizes** list, select the size you want to print each image. The first five options are the sizes commonly used by photo processing shops when you order prints.

Choose the **Fit on Page** option to have Photoshop Album expand (or reduce) the image to fit neatly and proportionally within the page margins. Unless you have cropped the images to a matching proportion already, or resized them using a *graphics editor* to match this proportion, choosing this option results in some areas of the image being cropped (not printed).

5 Set Layout Options

By default, Photoshop Album arranges as many images on a page as it can fit. To override this setting so that only one image appears on a page, no matter how small the image, enable the **Print Single Photo Per Page** check box.

When you choose a print size, by default, Photoshop Album crops as little from each image as it possibly can (proportionally from opposite sides) to fit the size you specify. For images that don't naturally fit that size's proportions, some content along the outside edges may be lost. To override this setting so that Photoshop Album crops nothing from your image, even if it leaves excess margins instead, disable the **Crop to Match Print Proportions** check box.

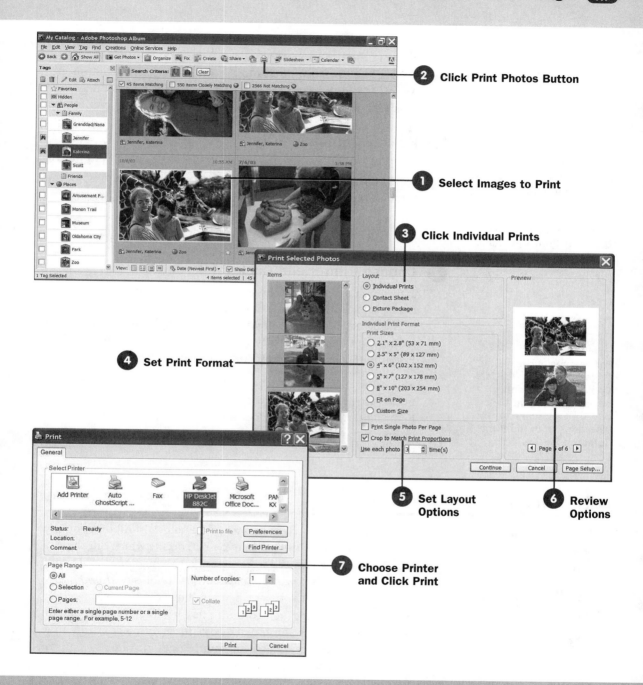

2 Click Print Photos Button

1 Select Images to Print

3 Click Individual Prints

4 Set Print Format

5 Set Layout Options

6 Review Options

7 Choose Printer and Click Print

To print each chosen photo more than once, enter the number of prints in the **Use each photo...time(s)** text box. Unless you've selected the **Print Single Photo Per Page** check box, Photoshop Album will make room for as many multiple copies per page as possible.

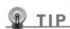

TIP

You can click the **Page Setup** button at the bottom of the **Print Selected Photos** dialog box to change (or simply review) your printer options. See **116** **Set Print Options** for more information.

6 **Review Options**

Previews of the pages you're about to print appear in the **Preview** pane on the right. Click the left or right arrow button to scroll through multiple page printouts.

When the pages appear in the **Preview** pane the way you want them to print, click **Continue**. The **Print** dialog box appears.

7 **Choose Printer and Click Print**

Typically, there are no changes you need to make in the **Print** dialog box, except to verify that the printer you want to use is selected in the **Select Printer** list. If you haven't completed page setup, you might want to at least verify your printer settings by clicking **Preferences**. See **116** **Set Print Options** for help.

TIP

For best results, leave the **Page Range** and **Multiple Copies** options as they appear in the **Print** dialog box. Instead, make those selections from the **Print Selected Photos** dialog box.

Make sure that you have the appropriate paper loaded in the printer tray, then click **Print** to begin the printing process. Photoshop Album sends information to your printer. When the printer begins printing, it is safe for you to resume working with your computer.

118 **Print a Contact Sheet**

Before You Begin

✔ **58** Add a Text Caption

✔ **116** Set Print Options

See Also

→ **60** Change Image Date and Time

→ **117** Print Images

After importing a new batch of images into Photoshop Album, you may want to print a *contact sheet* so that you can decide which ones are worth saving, which ones need working on, and which ones are ready to print. A contact sheet is a printout of miniature photos or *thumbnails*, similar to the index sheet you get when you have photos commercially printed. Under each image, you can print its filename, text *caption*, and *file date*. Such a reference can make it easy, for example, to verify that the captions, filenames, and dates for your images make sense. You can quickly mark any information that seems wrong or incomplete so that you can later change it in Photoshop Album's *catalog*.

You can select any number of images from the photo well to print on a contact sheet. The images do not have to belong to the same import batch or have the same *tags*, although that might be one reason to print them together.

① Select Images to Print

If necessary, make adjustments to your printer setup (see **116** **Set Print Options**). Then press **Shift** and click the first image in the group you want to print, and then click the last image in the group. Alternatively, press **Ctrl** and click each image you want to print.

② Click Print Photos Button

Click the **Print photos to a local printer** button on the **Shortcuts** bar, or select **File**, **Print** from the menu. The **Print Selected Photos** dialog box appears.

③ Click Contact Sheet

In the **Layout** pane, enable the **Contact Sheet** option.

④ Set Layout Options

Control the size of each image by changing the number of thumbnails you want to appear in each row of the contact sheet using the box marked **Columns**.

Choose whether you want to display the **Caption**, **Filename**, and **Date** below each image by selecting the appropriate check boxes.

If you're printing multiple pages, you might want the page number to appear at the bottom center of each page. If so, select the **Show Page Numbers** check box.

⑤ Review Options

Previews of the pages you're about to print appear in the **Preview** pane on the right. Click the left or right arrow button to scroll through multiple-page printouts.

Notice that you can click the **Page Setup** button at the bottom of the dialog box to change your printer options. See **116** **Set Print Options** for more information.

When the pages appear in the **Preview** pane the way you want them to print, click **Continue**. The **Print** dialog box appears.

🔍 KEY TERM

Contact sheet—A printout of a group of images, along with identifying labels, as a collection of miniatures. The term originates from film photography, where contact sheets are often produced to record the contents of a roll of film.

💡 TIP

If you want to select a group of related images such as all the images of your son or daughter, use the **Find** bar to display them first. (See **73** **About Finding Items**.) Then press **Ctrl+A** or choose **Edit, Select All** to quickly select the displayed items. If the catalog is sorted by batch or folder, you can click the gray bar above a group to select all the items in that group. With either of these two methods, you might also end up selecting video, audio, and creation files, so press **Ctrl** and click the ones you don't want to deselect them.

💡 TIP

Before printing, you can view and change an image's caption, filename, or file date using the **Properties** pane. See **58** **Add a Text Caption** and **60** **Change Image Date and Time** for help.

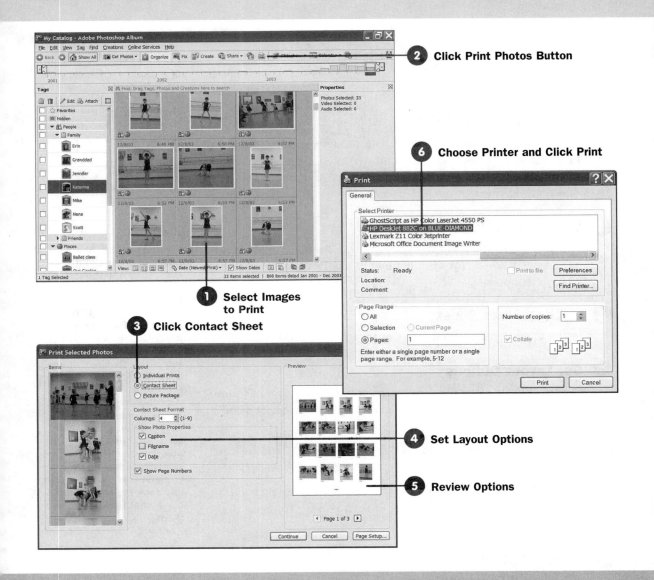

2 Click Print Photos Button

6 Choose Printer and Click Print

1 Select Images to Print

3 Click Contact Sheet

4 Set Layout Options

5 Review Options

6 Choose Printer and Click Print

Typically, there are no changes you need to make in the **Print** dialog box, except to verify that the printer you want to use is selected in the **Select Printer** list. If you haven't completed page setup, you might want to at least verify your printer settings by clicking **Preferences**. See **116** Set Print Options for help.

PART IV: Making Creations: Sharing and Printing Images

Because contact sheets are typically for your reference only, you might want to use less expensive paper when printing them. Just make sure that the paper type you choose is selected in your printer's **Page Setup** dialog box before printing.

Make sure you have the appropriate paper loaded in the printer tray and click **Print** to begin the printing process. Photoshop Album sends information to your printer. When the device begins printing, it is safe for you to resume working with your computer.

119 Print a Picture Package

When you order prints from a professional photo lab, you're generally offered package deals where you can choose from multiple sizes of prints. To make the deal more economical, the lab lays out the different photo sizes on as few sheets of photo paper as possible, minimizing waste. Photoshop Album gives you similar options—the difference here being, of course, that you've already paid for the paper. A picture package enables you to make maximum use of store-bought premium photo paper (generally 8 1/2"×11") so that you can print wall, table, and wallet size photos all at the same time. Some sizes may be rotated 90 degrees to make room for other sizes. The program leaves enough margin between photos for you to cut between them with scissors.

Before You Begin

✔ **116** Set Print Options

See Also

→ **117** Print Images

1 Select Images to Print

If necessary, make adjustments to your printer setup to prepare for photo printing (see **116** **Set Print Options**). Press **Shift** and click the first image in the group you want to print, and then click the last image in the group. Alternatively, press **Ctrl** and click each image you want to print.

2 Click Print Photos Button

Click the **Print photos to a local printer** button on the **Shortcuts** bar, or select **File**, **Print** from the menu. The **Print Selected Photos** dialog box appears.

3 Click Picture Package

In the **Layout** pane, enable the **Picture Package** option.

> **NOTE**
>
> As Photoshop Album lays out a picture package, each image you've chosen from the photo well has its own page, and each of the various preplanned layout packages makes maximum use of that page. So you'll be printing as many pages as there are images.

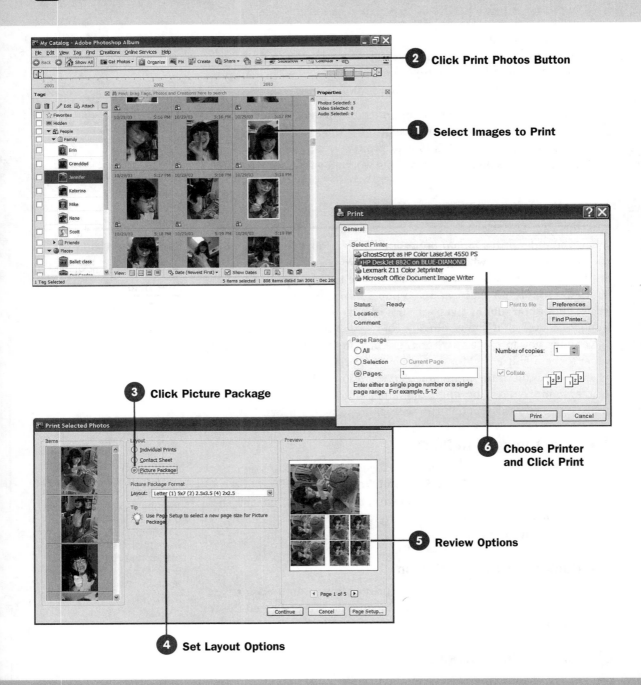

2 Click Print Photos Button

1 Select Images to Print

3 Click Picture Package

6 Choose Printer and Click Print

5 Review Options

4 Set Layout Options

4 Set Layout Options

Choose a package layout from the **Layout** drop-down list. This list features all the layout possibilities for your current printer paper size. Each entry in the list shows the quantity and size of the images that will be printed per page. For example, **Letter (2) 4x5 (2) 2.5x3.5 (4) 2x2.5** represents two 4x5 prints, two 2.5x3.5 prints, and four 2x2.5 prints, all on a single letter-sized (8.5"×11") piece of paper.

If you decide to make a late change to your paper size, make certain to inform Photoshop Album about your change. In the **Print Selected Photos** dialog box, click **Page Setup**; in the dialog box that appears, choose your new paper size from the **Size** list and click **OK**. The choices available in the **Layout** drop-down list in the **Print Selected Photos** dialog box change to reflect the new paper size.

5 Review Options

In the **Preview** pane on the right, you'll see how the photos in your chosen package are arranged. Click the left or right arrow buttons to scroll through multiple-page printouts.

Notice that you can click the **Page Setup** button at the bottom of the dialog box to change your printer options. See **116** **Set Print Options** for more information.

When you've confirmed your layout choice, click **Continue**. The **Print** dialog box appears.

6 Choose Printer and Click Print

Typically, there are no changes you need to make in the **Print** dialog box, except to verify that the printer you want to use is selected in the **Select Printer** list. If you haven't completed page setup, you might want to at least verify your printer settings by clicking **Preferences**. See **116** **Set Print Options** for help.

Make sure that you have the appropriate paper loaded in the printer tray and click **Print** to begin the printing process. Photoshop Album sends information to your printer. When the device begins printing, it is safe for you to resume working with your computer.

🔔 TIP

If you want to select a group of related images such as all the images of your dog, use the **Find** bar to display them first. (See **73** **About Finding Items.**) Then press **Ctrl+A** or choose **Edit, Select All** to quickly select all the displayed items. If the catalog is sorted by batch or folder, you can click the gray bar above a group to select all the items in that group. With either of these two methods, you might also end up selecting video, audio, and creation files, so press **Ctrl** and click the ones you don't want to deselect them.

📝 NOTE

Photoshop Album crops equal amounts of content from opposite sides of an image where necessary for certain sizes to make that image fit the proportions of that size. For certain packages, you might notice that some sizes are cropped more than others.

120 Print Images Using an Online Service

Before You Begin

✔ **114** Register with an Online Service

See Also

→ **115** Share Images Using an Online Service

→ **119** Print a Picture Package

NOTE

To complete this task, you need a working Internet connection—dial-up is fine, broadband is better. You will also need to complete a user setup process with the lab you choose; see **114** Register with an Online Service.

If you don't have a photo printer yet, or a printer capable of printing on photo paper, you can still make wonderful, high-quality photo prints directly from Photoshop Album, *right now*. Using your Internet connection, you can link directly from Photoshop Album to your choice of national photo labs in the United States and Canada, upload your images, have the service print them (perhaps with professional corrections), and ship you the results—in some cases, by next-day air!

1 **Choose Images**

Verify that your computer is online with your Internet service provider. Then select the images you want to upload for printing: Press **Shift** and click the first image in the group you want to print and then click the last image in the group. Alternatively, press **Ctrl** and click each image you want to print.

Photoshop Album doesn't give you a tool or a method to shop the various online print services before making a choice from the **Order Prints** menu. So look up the home pages of the supported online print services using your Web browser first, *before* selecting a service to print your images.

WEB RESOURCES

Click the **Services** link from the home page to review Bellamax's current offerings.

http://www.bellamax.com

Visit Shutterfly to review its current structure and pricing.

http://www.shutterfly.com

In Great Britain and Western Europe, Dixons is the online print service of choice.

http://download.pixology.com/dixons

See PhotoAccess for special offers, which often include free prints.

http://www.photoaccess.com

2 **Select Online Print Service**

From the menu bar, select **Online Services**, **Order Prints**, and then select the name of the service you want to use for printing. The **Print Items Using Online Service** dialog box appears.

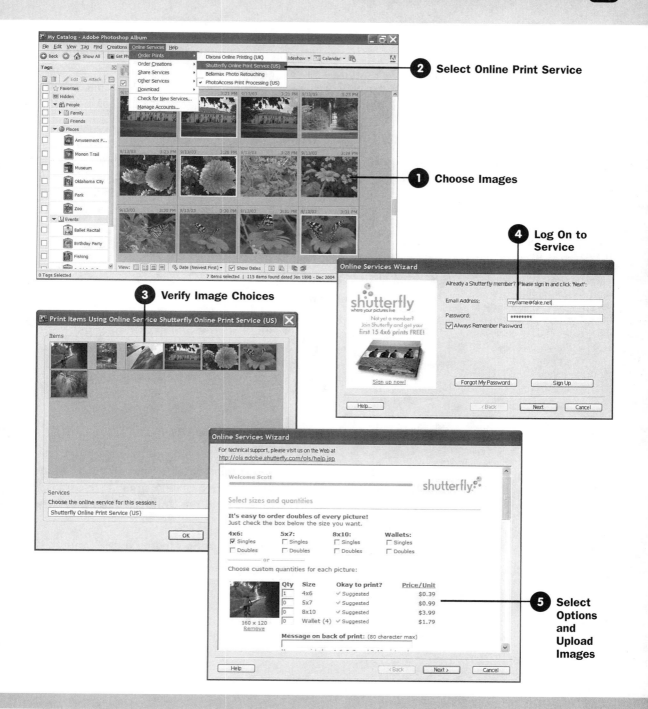

2 Select Online Print Service

1 Choose Images

4 Log On to Service

3 Verify Image Choices

5 Select Options and Upload Images

TIP

If you want to select a group of related images such as all the images of your cat, use the **Find** bar to display them first. (See **73** About Finding Items.) Then press **Ctrl+A** or choose **Edit, Select All** to quickly select the displayed items. If the catalog is sorted by batch or folder, you can click the gray bar above a group to select all the items in that group. With either of these two methods, you might also end up selecting video, audio, and creation files, so press **Ctrl** and click the ones you don't want to deselect them.

You can also select a series of images and click the **Order prints and books from online services** button, located on the **Shortcuts** bar. Using this method, you must select the service to use from the **Print Items Using Online Service** dialog box that appears; see step 3 of this task for details.

3 Verify Image Choices

The **Print Items Using Online Service** dialog box contains *thumbnails* of the images you selected, along with the name of the online service you chose. If you have changed your mind, you can choose a different service from the **Choose the online service for this session** drop-down list at the bottom of the dialog box. When you're ready to proceed, click **OK**.

4 Log On to Service

What happens from here on out depends on the service you've chosen. The **Online Services Wizard** appears next, inviting you to enter your user name or e-mail address and password for the account you've set up with this service. Enter the required information. Click **Always Remember Password** to have Photoshop Album enter this data for you the next time you print using this service. Click **Next**.

5 Select Options and Upload Images

Again, what happens next varies depending on the service, but at some point you will be asked to select the sizes and quantity of the prints you want. You might also be required to enter credit card information. Complete each screen in the **Online Wizard** and click **Next**.

Toward the end of the wizard, Photoshop Album sends thumbnails of your chosen images to the service. Typically, you'll receive an email message confirming your order and providing a delivery date.

Now simply wait for the U.S. Postal Service or other carrier service to deliver your prints!

121 Print a Creation at Home

When you're ready to print a *creation*, such as a calendar or a *slideshow*, you've already done all the work you have to do to lay it out. So Photoshop Album already knows not only *what images* you want to print, but also *where* and *what size*. All you have to do next is make certain that your printer is set up properly and tell the printer to print only selected pages of that creation if you don't want to print the entire creation.

Before You Begin

✔ **96** About Creations
✔ **116** Set Print Options

See Also

→ **122** Print a Creation Using an Online Service

1 Select Creation to Print

To make it easier to locate the creation you want to print, you might want to have the photo well show only creations and not images. From the menu bar, select **Find, By Media Type, Creations**. When you see the creation you want to print, click its *thumbnail* in the photo well.

2 Click Print Photos Button

Click the **Print photos to a local printer** button on the **Shortcuts** bar, or select **File, Print** from the menu. If you see a warning about the content of your creation, and you find that warning significant (for example, if the warning is telling you that some of the images are low resolution and you've decided that you want to substitute higher-resolution images), click **Cancel**; otherwise, click **Continue**. The **Print** dialog box appears.

TIP

This process does not give you a way to review the contents of your creation before you print it. If you want to refresh your memory about the contents of a creation, or to make sure that all your pages are in place, double-click the creation in the photo well and use the **Step 4** page of the **Creations** wizard to review your creation. See **96** **About Creations** for more on the **Creations** wizard.

3 Set Printer Options

Verify that the printer you want to use is selected in the **Select Printer** list. If you haven't completed page setup, you might want to at least verify your printer settings by clicking **Preferences**. See **116** **Set Print Options** for help.

To print your entire creation, leave the settings under **Page Range** as they are. Otherwise, to print specific pages, type their numbers in the **Pages** box. To print two nonconsecutive pages, separate their numbers with a comma, as in **6,9**. To print a range of pages, enter the numbers at the beginning and end of the range separated by a hyphen, as in **6-9**.

TIP

You can print a creation immediately after making it; on the **Step 5** page of the **Creations** wizard, simply click the **Print** button, then continue to step 3 of this task.

2 Click Print Photos Button

3 Set Printer Options

1 Select Creation to Print

4 Click Print

NOTE

When you print the contents of a slideshow or *Video CD* creation, the margins along the edges of many of your pages will be dark black. For many inkjet printers, this may make the pages wet immediately after printing and might even smear the backs of the next pages to emerge from the printer.

4 **Click Print**

Make sure that the printer is loaded with the paper type you intend to use and click **Print** to print the creation. In a moment, pages will appear from your printer.

122 Print a Creation Using an Online Service

You might prefer to print a *creation* such as a calendar on very heavy grade paper and have it cut, stapled, and perforated for you, rather than attempting such a complicated task at home. You might also prefer professional quality printouts of your *photo book* and *photo album* creations. Using an online print service, you can print and bind such creations professionally, using a linen or leather cover in the color of your choice. Note that *slideshow*, greeting cards, *eCards*, and *Video CD* creations cannot be printed through an online publishing service.

Before You Begin

✔ **114** Register with an Online Service

See Also

→ **121** Print a Creation at Home

http://www.mypublisher.com

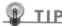 **WEB RESOURCE**

Click the **Pricing** link from the home page to see MyPublisher's current package options.

❶ Choose a Creation

Verify that your computer is online with your Internet service provider and then choose the creation you want to print professionally from the photo well. To make it easier to locate the creation you want to print, you might want the photo well to show only creations and not images. From the menu bar, select **Find**, **By Media Type**, **Creations**. Then from the photo well, select the creation you want to upload for printing.

You can upload only one calendar, photo book, or photo album at a time; repeat these steps as needed to print multiple creations.

❷ Select Online Print Service

From the menu bar, select **Online Services**, **Order Creations** and then select the name of the service you want to use for printing. The **Print Items Using Online Service** dialog box appears.

You can also select a creation and click the **Order prints and books from online services** button, located on the **Shortcuts** bar. Using this method, you must select the service to use from the **Print Items Using Online Service** dialog box that appears; see step 3 of this task for details.

💡 **TIP**

At the time of this writing, MyPublisher is the only preferred supplier of creation printing services for Photoshop Album. Check its Web site for current offers and pricing.

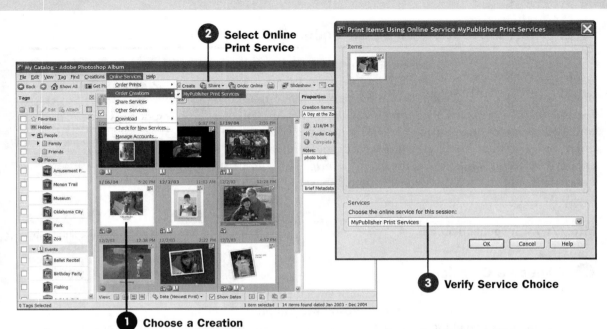

2 Select Online Print Service

3 Verify Service Choice

1 Choose a Creation

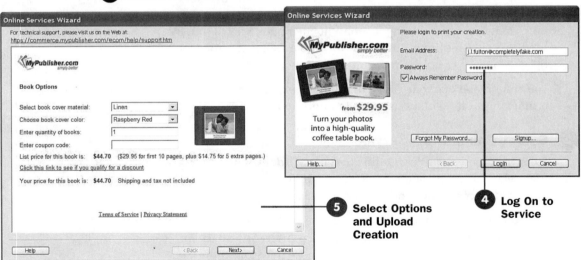

4 Log On to Service

5 Select Options and Upload Creation

3 Verify Service Choice

The **Print Items Using Online Service** dialog box contains a *thumbnail* of the first page of the creation you selected, along with the name of the online service you chose. If there are other creation printing services available and you have changed your mind about using the current service, you can choose a different service from the **Choose the online service for this session** drop-down list at the bottom of the dialog box. When you're ready to proceed, click **OK**.

If you see a warning about the content of your creation, and you find that warning significant (for example, if the warning is telling you that some of the images are low *resolution* and you decide that you want to substitute higher resolution images), click **Cancel**; otherwise, click **Continue**.

4 Log On to Service

What happens from here on out depends on the service you've chosen. The **Online Services Wizard** appears next, inviting you to enter your username or email address and password for the account you've set up with the service. Enter the required information. Click **Always Remember Password** to have Photoshop Album enter this data for you the next time you print using this service. Click **Login**.

5 Select Options and Upload Creation

Again, what happens next varies depending on the service; if you are having a photo book or photo album printed, at some point you'll be asked to choose a cover type (linen or leather, for example) and a cover color. Currently, MyPublisher offers no options for calendars other than quantity desired.

Typically you'll be asked to verify the total for your order, and to enter credit card information. Complete each screen in the **Online Services Wizard** and click **Next**.

After you've completed the wizard, you'll typically receive an email message confirming your order and providing a delivery date. Now, all that's left for you to do is wait for your carrier of choice to show up with your printed creation—which, these days, won't be too long.

Index

Symbols

3D rendering, avatar creation, 353-357

A

accessories, 18
 additional lenses, 20
 camera cases, 19
 card readers, 20
 external flash, 21
 lavaliere mic, 21
 LCD sunshade, 21
 lens cleaning kits, 20
 lens shade, 20
 memory cards, 18
 memory cases, 19
 neck straps, 19
 PC Card adapters, 20
 polarizing filters, 20
 portable image storage devices, 20
 tripods, 21
 TV display devices, 21
 underwater housings, 21
adding
 captions to media files, 27
 tags to media files, 27
 text captions to images (Properties pane), 205-207
additive color process, 33-34
adjusting exposure
 via f-stop, 54-56
 via shutter speed, 54-56
Adobe Atmosphere 3D Gallery, avatar creation, 353-357
Adobe Gamma
 color profiling tool, 34
 Control Panel mode, 280
 ICC color profiles, 272
 monitors

 calibrating, 275, 280-285
 chromaticity charts, 275-278
 Wizard mode, 280
Adobe Reader, downloading, 340
Adobe.com Web site, 340
Adorama Web site, 133
AE Lock, exposure locks, 54
animals (zoo), shooting tips, 103-105
apertures, 5
archival inks for photo printers, 24
archiving
 catalog images with CD/DVD storage, 179-182
 Workspace items (Creations), 321
artificial lighting, 47
 indoor portrait photography, 120-133
aspect ratios, 294
attaching
 notes to images (Properties pane), 213
 tags to media files (Tags pane), 225-226
attachments (email), 368-370
 potential disadvantages, 371
auction goods, shooting tips, 75-77
audio, supported file types, 28
audio captions
 eCards, recording (Creations), 324-328
 images
 playing, 188
 recording (Properties pane), 207-209
 slideshows, adding (Creations), 359
audio files
 catalog
 organizing, 189-191
 playing, 189-191
 MP3 format, 189-191
 WAV format, 189-191
auto-focus, 44

automatic corrections
 color balance (Fix Photo), 289-291
 contrast repair (Fix Photo), 289-291
 edge sharpening (Fix Photo), 289-291
available lighting, 47
 indoor portrait photography, 118-120
avatars, 3D rendering, 353-35
AVI audio format, 192

B

background music, video CDs, selecting (Creations), 366
backgrounds, blurring, 37
backing up catalogs, 27
backlighting, 49
 outdoor portrait photography, 136
 settings (Fix Photo), 301-303
Backup command (File menu), 176
backups (catalogs)
 importance of, 245
 performing, 176-177
batteries
 extra on hand, 36
 Lithium-ion, 5, 14
 NiMH, 5, 14, 18
 standard, 5
Bellamax.com Web site, online imaging services, 400
binding calendars (Creations), 331
birds, shooting tips, 106-109
black-and-white portrait photography, 148-151
blurring backgrounds, 37
bracketing exposure, 54
brightness settings
 images (Fix Photo), 299-301
 monitor gamma, 279

How can we make this index more useful? Email us at indexes@samspublishing.com

411

D

E

How can we make this index more useful? Email us at indexes@samspublishing.com

413

G - H

I - K

How can we make this index more useful? Email us at indexes@samspublishing.com

415

images

How can we make this index more useful? Email us at indexes@samspublishing.com

417

M

N

O

P

How can we make this index more useful? Email us at indexes@samspublishing.com

419

How can we make this index more useful? Email us at indexes@samspublishing.com

421

How can we make this index more useful? Email us at indexes@samspublishing.com

423

W - Z

Key Terms

Don't let unfamiliar terms discourage you from learning all you can about digital photography and Photoshop Album. If you don't completely understand what one of these words means, flip to the indicated page, read the full definition there, and find techniques related to that term.

Adobe Atmosphere 3D Gallery *A collection of images, presented (in a Web browser window) within a three-dimensional art gallery with the help of the Viewpoint Media Player.* **Page 353**

Aperture priority mode *A camera setting in which the user sets the desired aperture, and the camera selects the appropriate shutter speed.* **50**

Aperture *The size of the lens opening when an image is recorded; also known as the f-stop.* **5**

Audio caption *A short audio description of an image, recorded and associated with the image file.* **188**

Backlight *Light that comes from behind a subject, throwing that subject into shadow.* **301**

Bracketing *The process of taking several copies of the same image, with slightly different exposure values.* **54**

Bulb mode *Otherwise known as timed-exposure, bulb mode holds the shutter open for as long as you press the shutter release, allowing you to capture more of the available light.* **51**

Caption *A text or audio description of a media file.* **27**

Catalog *A collection of organized media files.* **27**

CCD sensor *Light-sensing device used in high-end cameras because of its superior light sensitivity and the fact that it adds little noise during the conversion to digital data.* **15**

Center-weighted metering *A metering method in which light is measured from the entire frame, with the light measurement from the center taking precedence.* **52**

CMOS sensor *Light-sensing device that uses less power, produces images of lower quality, and costs less to produce than a CCD sensor* **15**

Color cast *A shift in an image toward a particular color, such as blue or red.* **289**

Color management *The process of coordinating the color gamut of your monitor with that of your scanner and printer so that the same colors are represented throughout.* **270**

Contact sheet *A printout of a group of images, along with identifying labels, as a collection of miniatures.* **395**

Dedicated flash *A flash unit designed to be used only with a specific camera.* **123**

Depth of field *The distance between the closest in-focus object to your camera and the furthest in-focus object away from your camera.* **42**

Digital zoom *A process that extends the natural limit of a digital camera's lens by cropping a portion of the image and increasing its size by adding pixels.* **9**

DPOF (Digital Print Order Format) *A system that allows you to insert a DPOF-enabled camera's memory card into a DPOF-enabled printer, select photos to print, and choose other options.* **Page 23**

Email client *A program that sends and receives email on behalf of another application. Popular email clients/programs include Outlook and Outlook Express.* **368**

EXIF (Exchangeable Image File) *Data that tells a printer or monitor how to properly print or display an image.* **245**

Exposure compensation *A method of adjusting an exposure by entering the amount of adjustment, such as +1 (which increases the exposure and lightens the image) or –1 (which darkens the image).* **90**

Exposure *The amount of light used to capture an image; the exposure depends on the aperture and shutter speed settings.* **49**

External flash *A more powerful flash that is separate from the on-camera flash. External flashes can be dedicated or non-dedicated.* **123**

First curtain sync *The flash is fired when the shutter opens, at the beginning of the exposure.* **124**

Flash diffuser *A soft box with a translucent front that snaps onto the flash head to create a diffuse, soft light.* **125**

Flash exposure *The amount by which a particular flash will illuminate a subject under certain lighting conditions.* **124**

Flash reflector *An inexpensive flash accessory that snaps around the head of an external flash, allowing you to bounce the flash light and soften its effect.* **125**

Focal length *The distance in millimeters between the center of the focusing lens and the film—or, for a digital camera, the light detector chip—when the lens is sharply focused on the most distant object in its field of view.* **11**

Focal range *The range between a lens's minimum focal length when the lens is zoomed out and its maximum focal length when it is zoomed in.* **11**

F-stop *The size of the lens opening or aperture when the image is recorded.* **12**

Gamma *The measure of the contrast of an image or imaging device such as a monitor.* **279**

Gamut *A palette comprised of all the individual colors that can be reproduced by a device.* **270**

Graphics editor *An application that allows you to edit your digital images.* **3**

Guide number *A measurement of a flash's output, based on the use of ISO 100 film.* **124**

Hot shoe *A camera connector that allows an external flash to be easily connected.* **15**